NEW YORK
365 DAYS

FROM THE PHOTO ARCHIVES OF
The New York Times

NEW

ABRAMS
NEW YORK

YORK

365 DAYS

INTRODUCTION BY
GAY TALESE

Introduction

I have lived in New York for fifty years, and while I routinely stroll knowingly along most of the side streets and thoroughfares of the city I think of myself mainly as an eternal tourist, a longtime newcomer to surroundings both familiar and foreign. New York is the international capital of reinvention.

It is a port city, a grand bazaar, a smuggler's paradise. Every night multitudes of people dine out at one of the city's seventeen thousand tablecloth restaurants in which illegal aliens commonly are employed in the kitchens washing dishes and preparing food. A vast underground population has always dwelled here, and I can personally identify with it because during the 1930s two relatives of mine were banished from New York after laboring in construction for a few years without working papers. I saw them briefly during a visit to Italy in the mid-1950s, shortly before they died. They expressed sadness about being deported. They said they had loved New York.

Nowadays it seems that whenever I am riding in taxicabs the drivers wear cell-phone headsets and are busily chatting in a foreign language. The other night I asked my driver a question, but he waved me off. He later explained, as we moved slowly in traffic on the Brooklyn Bridge and his cell phone was temporarily out of order, that he had been communicating with his girlfriend in Latvia.

The Brooklyn Bridge has existed for well over a century and is one of New York's most immutable landmarks, being resistant to everything but rust. It was designed by a German immigrant engineer named John Augustus Roebling. He died during the thirteen-year project, and the bridge was completed in 1883 under the auspices of his son, whose first name was Washington.

Most of the great bridges of New York, including the George Washington, the Triborough, and

Opposite *New York Times* photographer Art Brower, with his son Ricky, uses an early telephoto lens to capture close-up action on the field at Yankee Stadium during the World Series in October 1956. *The New York Times Photo Archives*

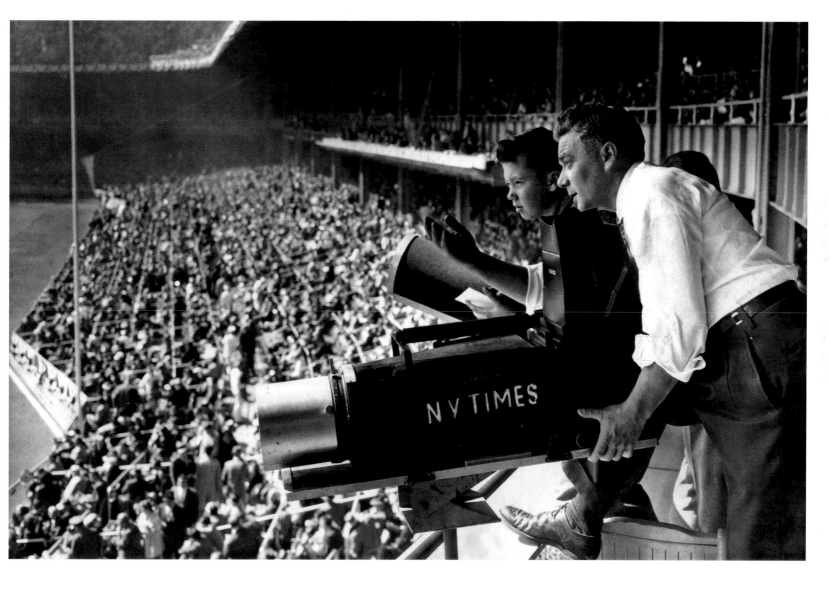

the Verrazano-Narrows, were built by an engineer from Switzerland named Othmar H. Ammann. I interviewed Mr. Ammann in 1964 when I was a *New York Times* reporter. He was a lean and agile gentleman of eighty-five wearing a gray tweed suit and a high starched collar. As we met in his penthouse apartment on the thirty-second floor of the Carlyle Hotel on the Upper East Side of Manhattan, he was standing at a window looking through a large telescope pointed in the direction of the then-unfinished Verrazano-Narrows Bridge, which stood ten miles away with its 4,260-foot steel rainbow span linking the shorelines of Brooklyn and Staten Island.

He could see cranes swooping atop the two towers, chunks of steel hoisted from river barges, men swinging from cables. And the sounds, he could imagine them all: the rattling of the riveters, the clanging of the wrenches, the echoes of the superintendent shouting instructions through a bullhorn. To master this gigantic design, Mr. Ammann explained, required that he take into account the curvature of the earth: The two 680-foot Verrazano-Narrows towers, though exactly perpendicular to the earth's surface, are one and five-eighths inches farther apart at their summits than at their bases.

Throughout his long career none of his bridges collapsed or experienced tragedy arising from any engineering miscalculations; but during our interview he conceded that he had been "lucky."

"Lucky!" interjected his wife, Klary, who had just joined us and preferred to regard her husband's achievements as reflecting his genius. "Lucky," he repeated, silencing her with gentle authority. As I listened, I recalled the famous line written by E. B. White: "No one should come to New York to live unless he is willing to be lucky."

This is a book of photographs showing thousands of people who have been lucky and unlucky in New York. It is a collective portrait of strangers and strivers who bridged most of the gaps that had separated them and have combined their energies and aspirations to create and restlessly re-create what is called the Empire City.

All the images assembled in this volume — some appearing for the first time — are from the Photo Archives of *The New York Times*, a collection of seven million photographs, including several million of the city. They show people who were or are famous, or infamous, or whose only claim to distinction lies in having their image represented on one occasion in the 155-year-old newspaper.

I always enjoyed working with *Times* photographers. As a group, they were lively, smart, talented, and helpful. If a photographer was assigned to one of my stories it meant I probably could get space for a longer piece, maybe a larger headline, and a better display. Finally, working together was always useful — a chance to hear another point of view from a visual perspective, which helped to compose my thoughts before I faced the typewriter.

There are photos here that have a special meaning for me, showing the city as a port of entry (Ellis Island in the 1920s as it looked when my immigrant father passed through it), as a huge construction site (Rockefeller Center being built in 1931, with one of its gang of laborers being a spitting image of one of my deported uncles), and as a city targeted by terrorists on September 11, 2001. I once knew an Ecuadoran kitchen worker who was employed in a Midtown restaurant I frequent, and I recall how pleased he was after he got a higher-paying job at Windows on the World atop the World Trade Center, where he would months later perish along with seventy-two other employees of the restaurant.

This book is a collage of New York in splendor and struggle, and of people who personify a survivor's city.

Gay Talese

Two Icons

Eight years after their maiden flight on a North Carolina beach, the Wright brothers' airplanes were becoming as familiar as this famous New York landmark. Wilbur Wright made sure of that when, in September 1909, he flew the Wright Flyer III around the Statue of Liberty and into New Yorkers' hearts. Seen here is the 1911 Wright Model B, the world's first production airplane, in a handsome photo op with Lady Liberty.

Brown Brothers

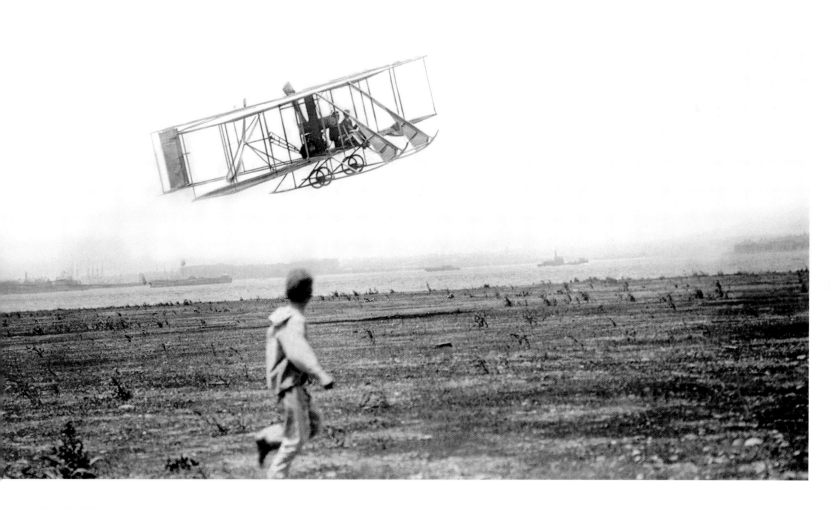

Opposite

A Bumpy Ride

There she was in the distance, keeping silent watch as ferryboats carrying thousands of commuters bobbed and bounced toward Manhattan in the choppy winter waters of New York Harbor.

Nicole Bengiveno/*The New York Times*

Overleaf and pages 14-15

Jubilation Reigns

A copy of the Statue of Liberty became a Times Square fixture during World War II, and presided over the celebration on V-E Day. The flags were still at half-staff for a commander in chief who did not live to see the allied victory in Europe — Franklin D. Roosevelt had died less than a month before Germany surrendered. Millions rejoiced as the new president, Harry S. Truman, announced the end of the fighting in Europe.

The New York Times Photo Archives

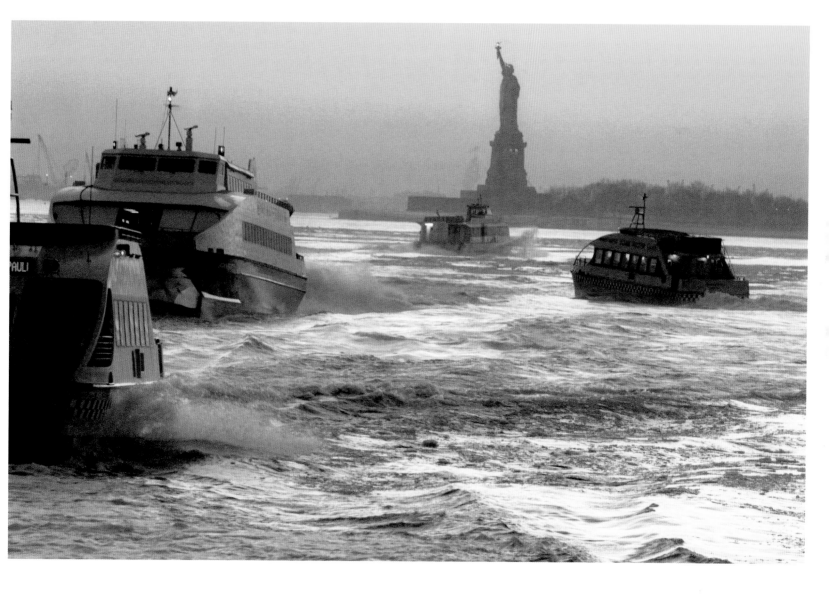

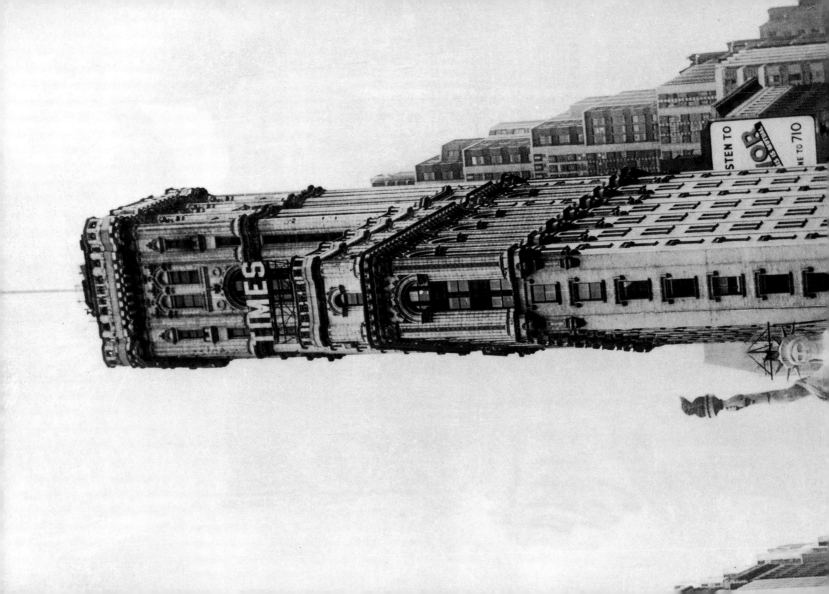

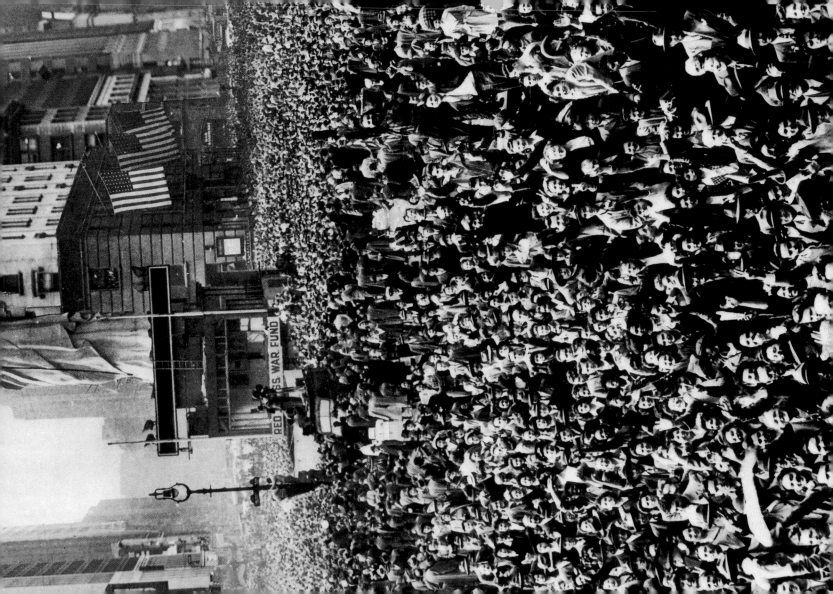

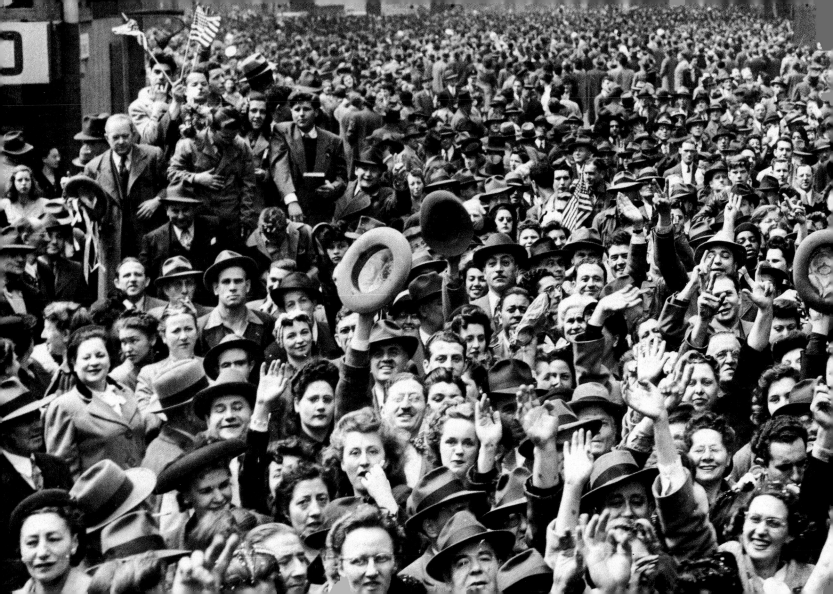

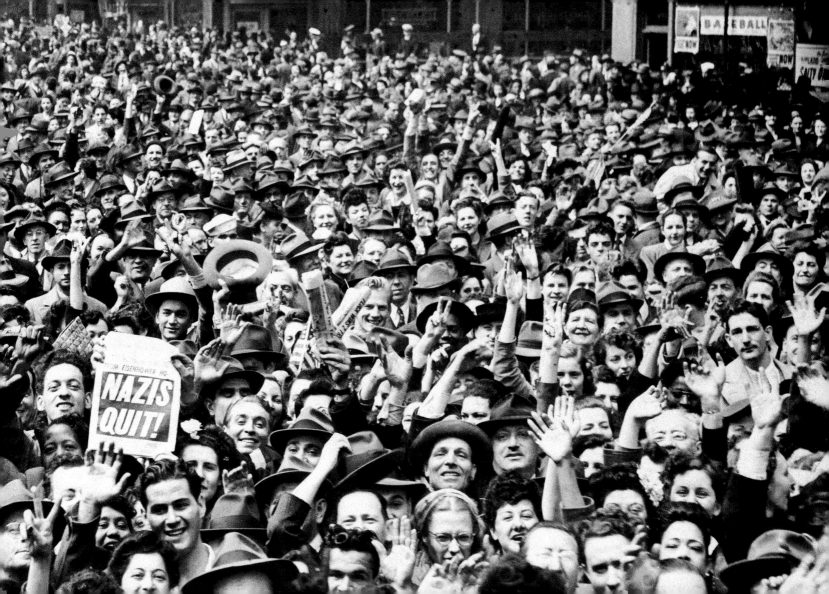

APRIL 16, 2002

Opposite

Baking in Bryant Park

Sweltering New Yorkers played "beach blanket bingo" in Bryant Park without the beach or the blanket. The mercury hit a record ninety-two degrees on this day.

Vincent Laforet/*The New York Times*

JULY 25, 1967

Overleaf

Perspectives

From an upstairs window, a Harlem street becomes an almost painterly study in composition: the board games painted on the pavement, the people passing by, and the shadows they cast in the midday heat.

Jack Manning/*The New York Times*

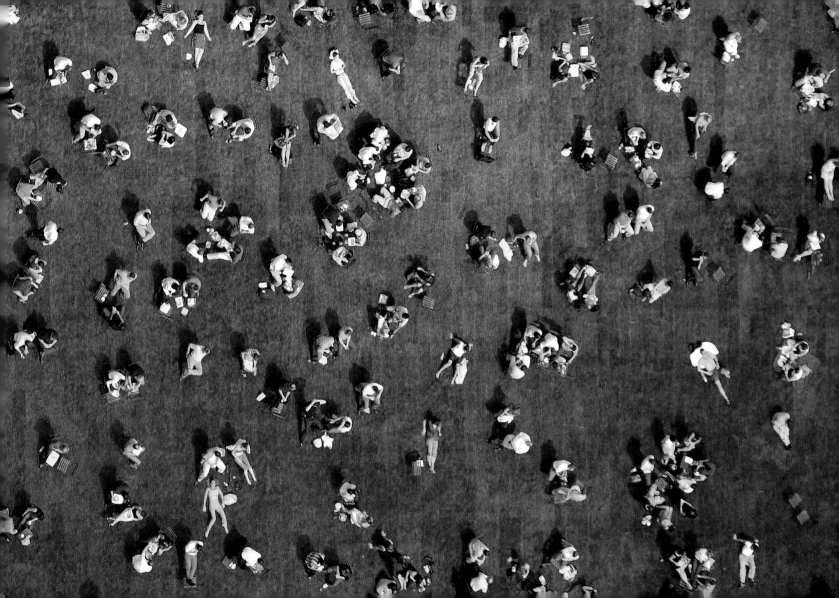

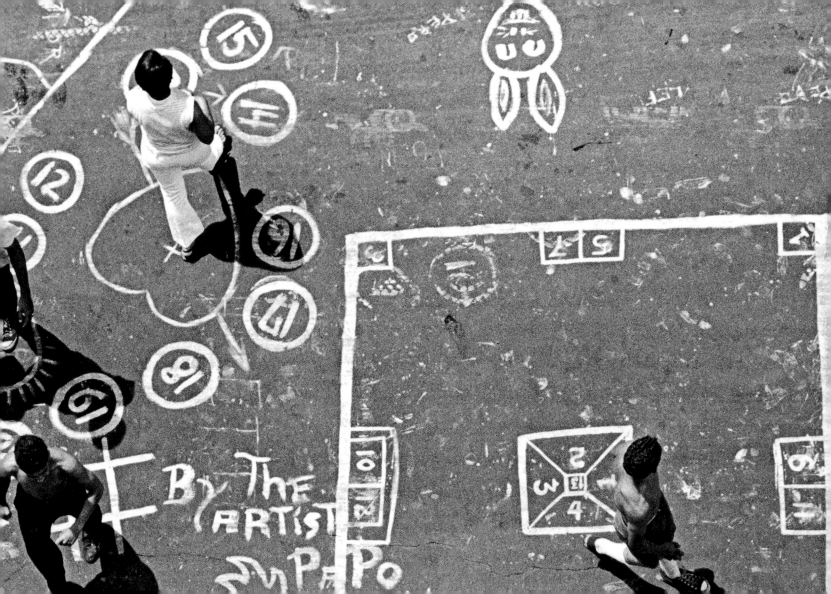

The Quiet Hours of the Night

Two sailors embark on a search-and-enjoy mission in Times Square. It's only midnight. There's lots of time for romantic maneuvers.

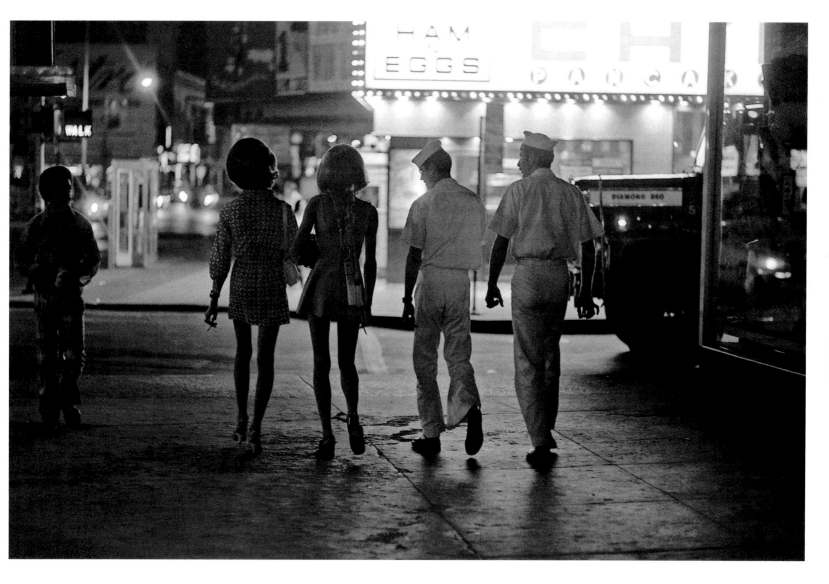

The Answer Is: One

The question, of course, is how many guys does it take to put the lightbulbs on the ball in Times Square before New Year's Eve? This ball had 432 lightbulbs and 96 high-intensity strobe lights.

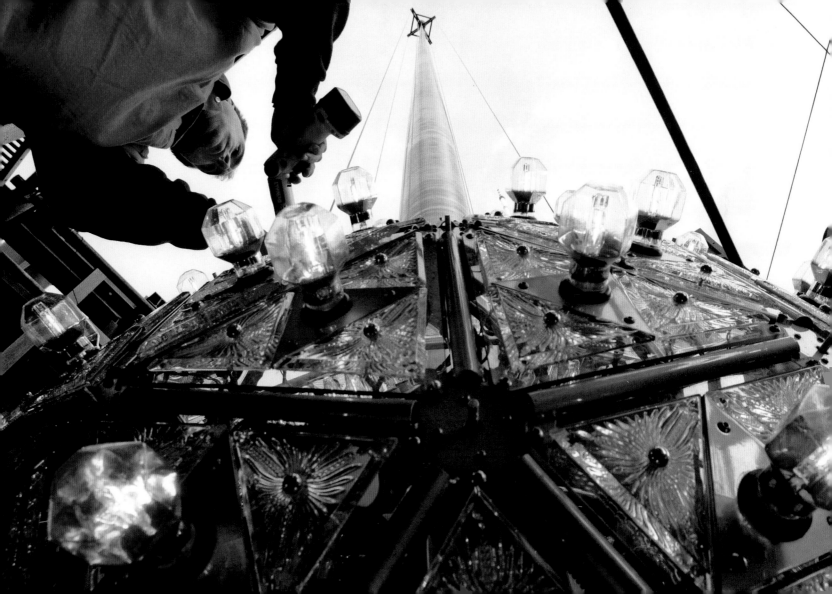

Fun-house Reflections

As taxis whirled around Columbus Circle on a snowy day, the shiny, Fun-house-mirror skin of the Time Warner Center reduced them to toy-car size.

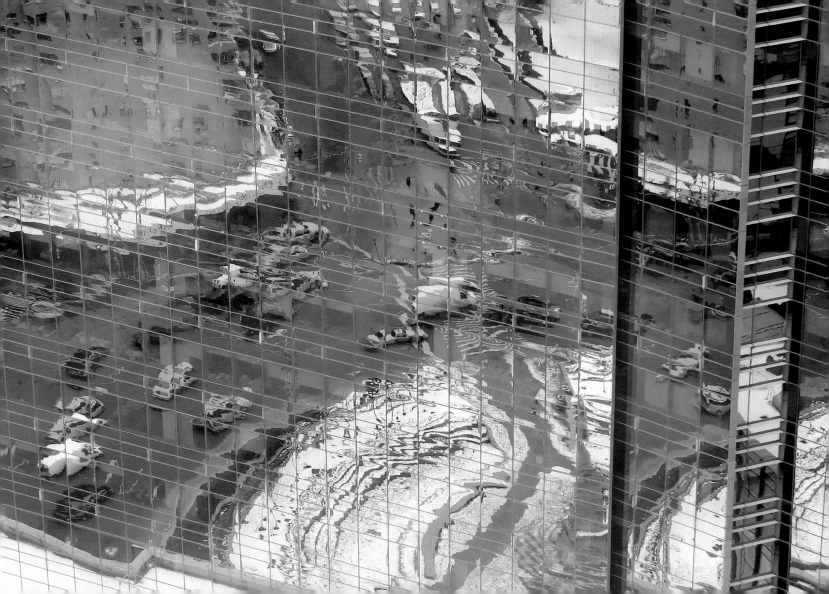

Gotham Geometry

There are corners of New York that are filled with old-fashioned curves and columns, but this stretch of high-rise country on Third Avenue near 90th Street is all hard-edged rectangles: the buildings, the windows, the balconies.

Ruth Fremson/*The New York Times*

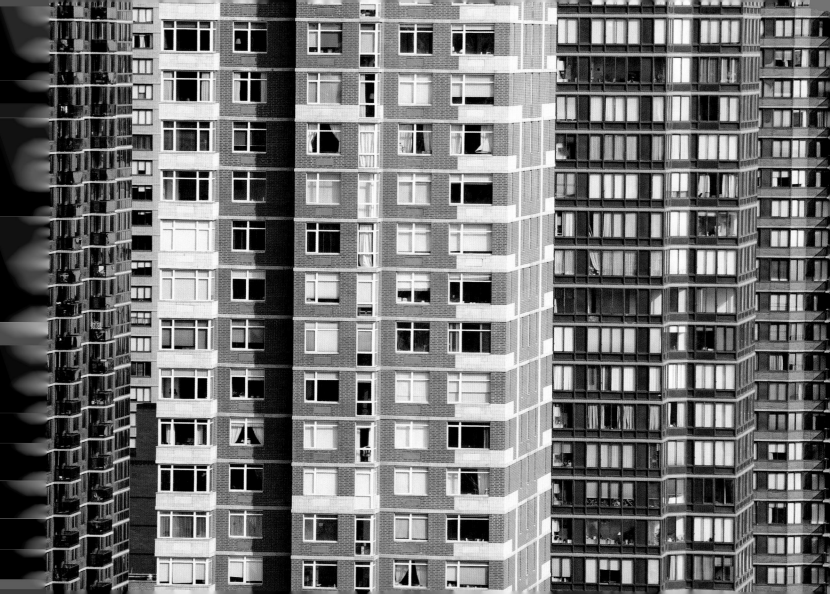

Rx at the Stock Exchange

Five years after the market panic that brought on the Great Depression, the New York Stock Exchange did its work under the flag of the American Red Cross, which was raising money for relief and education work. The market soldiered on in the 1930s; many stocks did not surpass their pre-Depression highs until the mid-1950s.

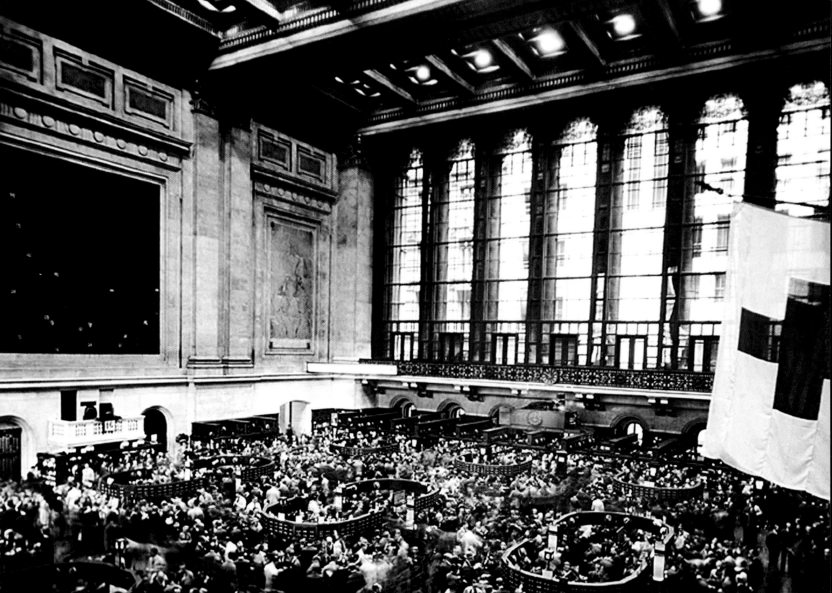

Urban Geyser

Of course it is illegal to open a hydrant without the Fire Department's permission. But tell that to a sweaty citizen in the summer. As one said in 2005, "It's ninety degrees . . . if they give us a ticket, we'll start a riot."

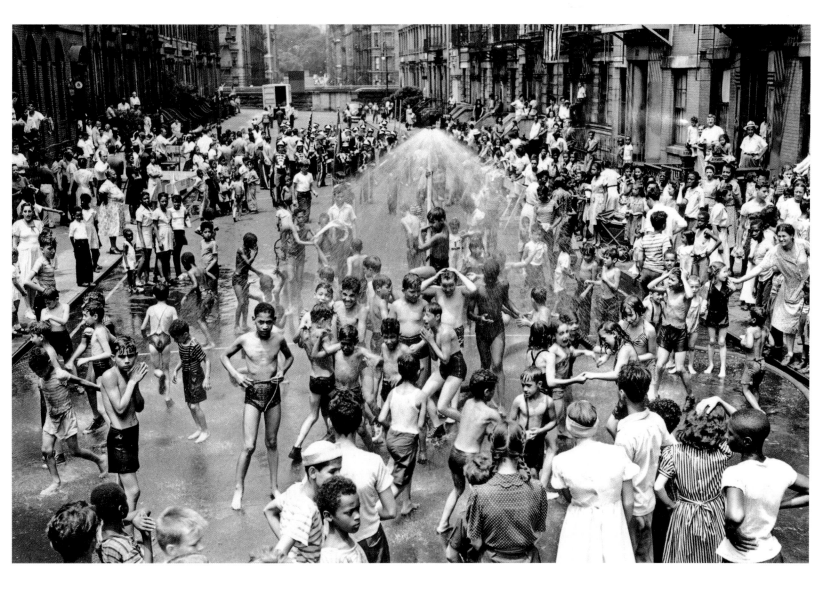

JUNE 25, 2003

Relief, and a Rainbow

On a hot day in a Harlem playground, Pedro Corsero cooled down in the splash of a well-aimed ribbon of water — so well-aimed that the photographer caught the rainbow it created.

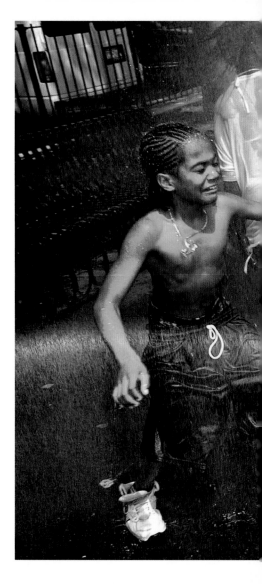

Vincent Laforet/*The New York Times*

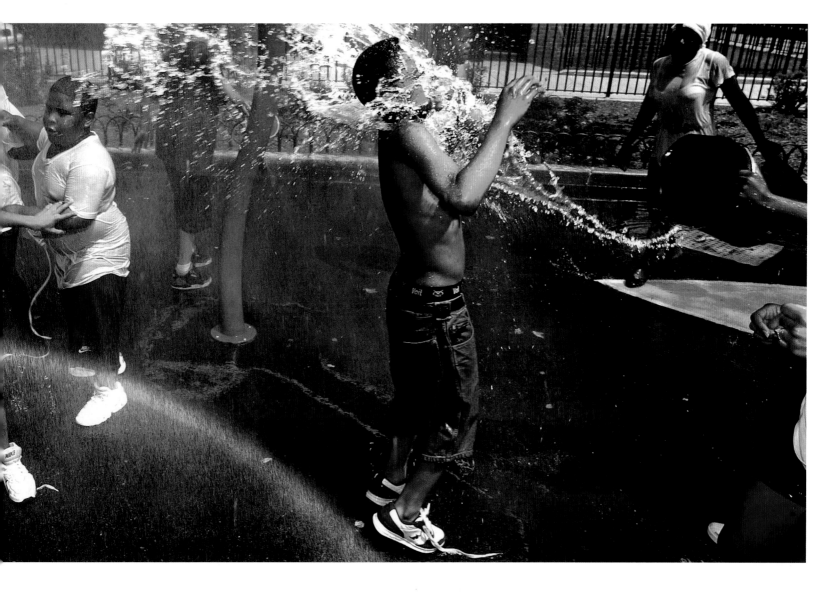

Taking a Spin on the Staten Island Ferry
Theirs was not the kind of swirling,
twirling, and swooping that George
Balanchine would have choreographed or
Mikhail Baryshnikov would have danced.
Theirs was only an energetic spin on a
Staten Island ferry, to music they heard
only in their heads. Around and around
and around they went, with Manhattan
bobbing in the background.

Sam Falk/*The New York Times*

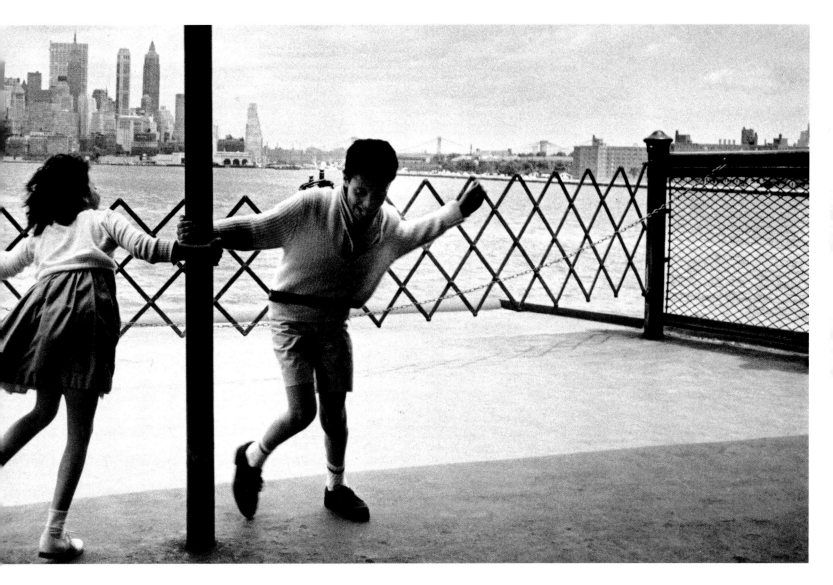

Bond Rally

As the war news from Europe grew more ominous, the stars came out to sell Uncle Sam's Liberty Loans. On Wall Street, the crowd roared as Douglas Fairbanks lifted Charlie Chaplin off his feet. No doubt the ticker-watchers who jammed the street hoped for a glimpse of "America's Sweetheart," Mary Pickford, who also happened to be Fairbanks's sweetheart. Never mind that she and Fairbanks were still married to other people.

Underwood & Underwood

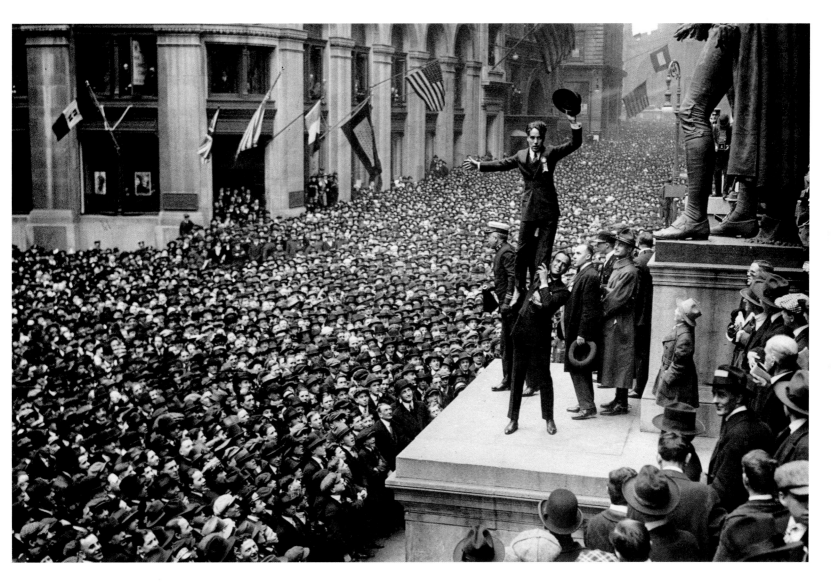

Irving Berlin's Baton

When you are Irving Berlin and a school band strikes up "God Bless America," you conduct, even if the only baton available is a rolled-up sheet of paper.

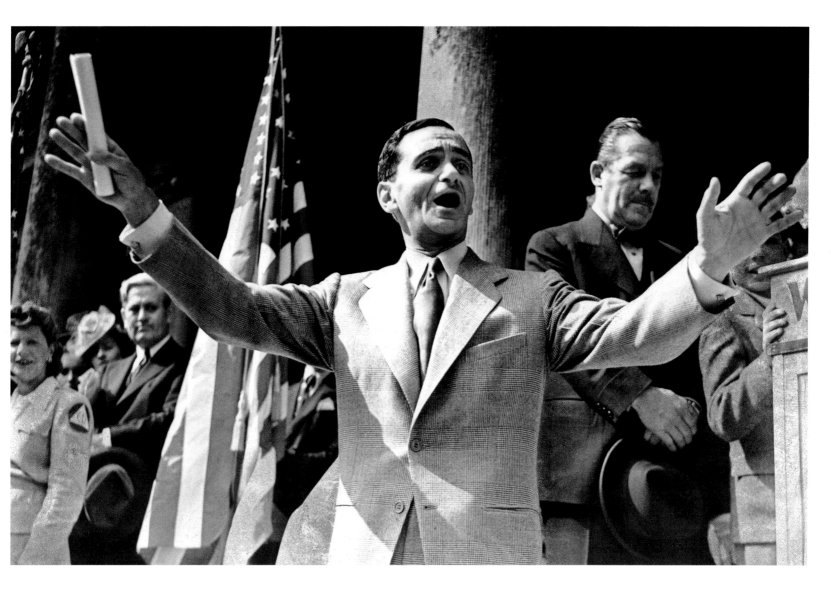

Breaking the Color Barrier

The soprano Marian Anderson is rehearsing for her Metropolitan Opera debut, when she became the first African-American to appear at the previously all-white Met. She is perhaps best remembered for a 1939 concert at the Lincoln Memorial, arranged by Eleanor Roosevelt and Secretary of the Interior Harold Ickes after the Daughters of the American Revolution refused to let her appear in its Constitution Hall, a few blocks away.

Ernie Sisto/*The New York Times*

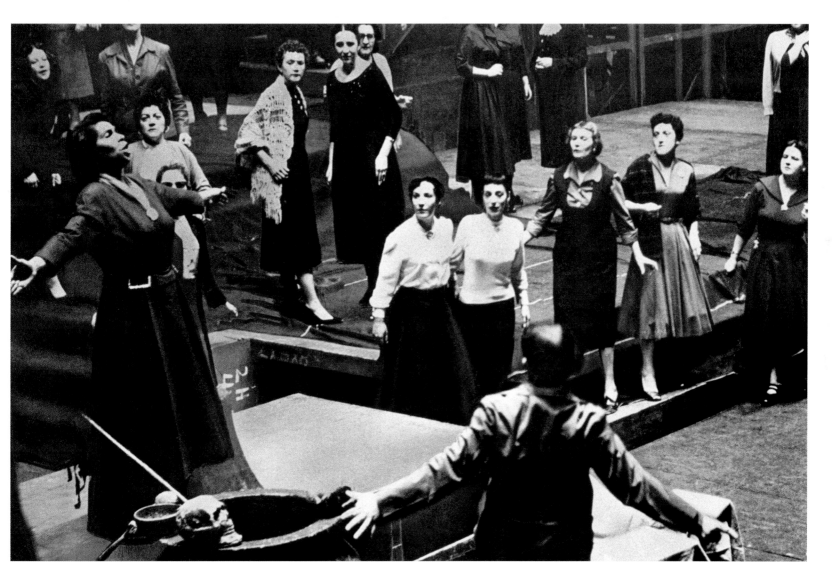

Taxi!

It is an unchanging fact of life in New York: on a rainy day, even champion cab-hailers must stand and wait, hands in the air.

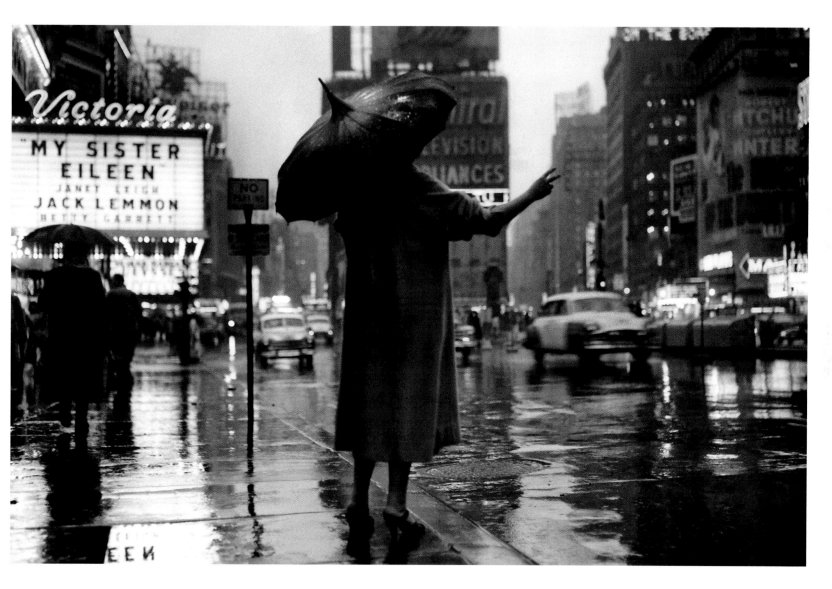

Through an "O," Clearly

Times Square, as glimpsed through one of the O's in the tall letters that spelled "Hotel Astor" on the marquee. On this rainy Christmas night, it was the streets and not the treetops that glistened, though not with snow.

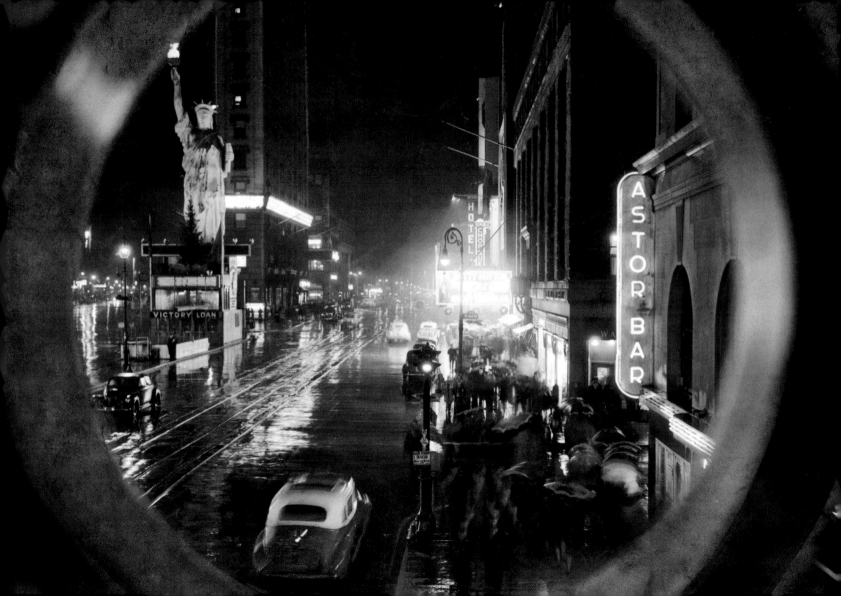

1965

Live, From the Apollo

Crowds gather at the Apollo Theater on 125th Street in Harlem, where Amateur Night was a tradition that helped launch performers like Ella Fitzgerald, James Brown, Michael Jackson, and Lauryn Hill.

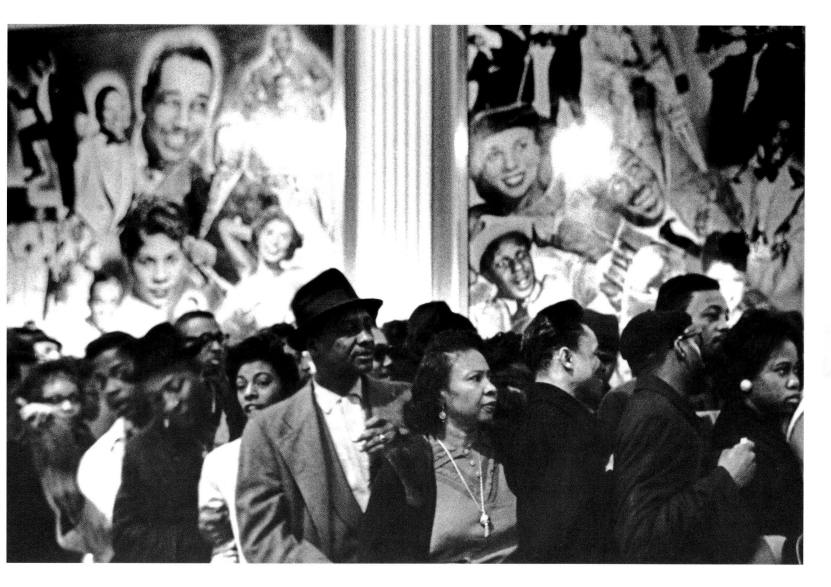

Recording Sessions

"The most important thing that Benny Goodman did," said Lionel Hampton, "was to put Teddy Wilson and me in the quartet. It was instant integration. Black people didn't mix with whites then. Benny introduced us as Mr. Lionel Hampton and Mr. Teddy Wilson. He opened the door for Jackie Robinson. He gave music character and style." (For this number, at a recording session of the Benny Goodman Quintet, Hampton took a break. Wilson is the pianist; Gene Krupa is the drummer and Slam Stewart is the bass player.)

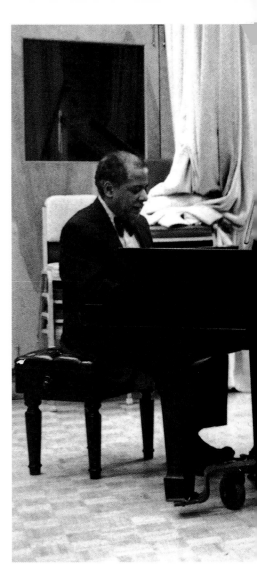

Jack Manning/*The New York Times*

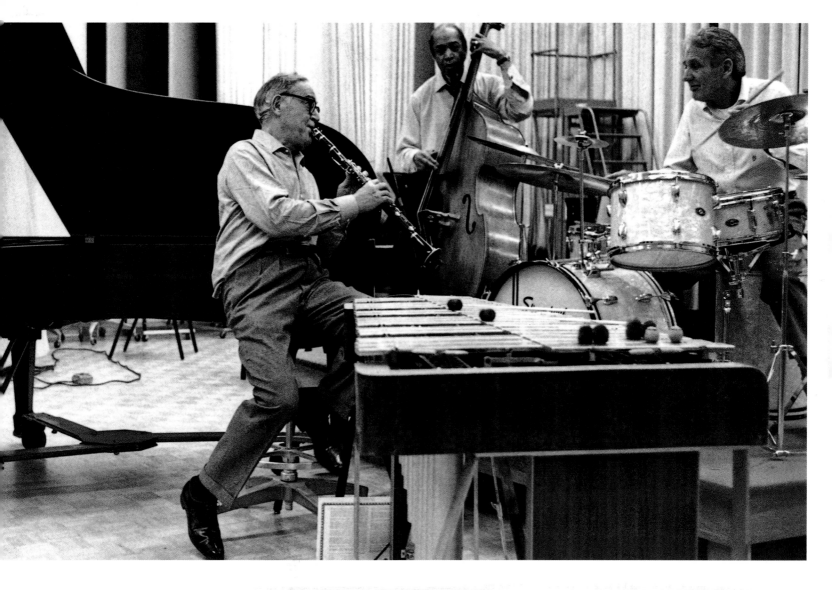

Music in the Air

A trumpeter scores the background music for a block party on the street below his window in Harlem.

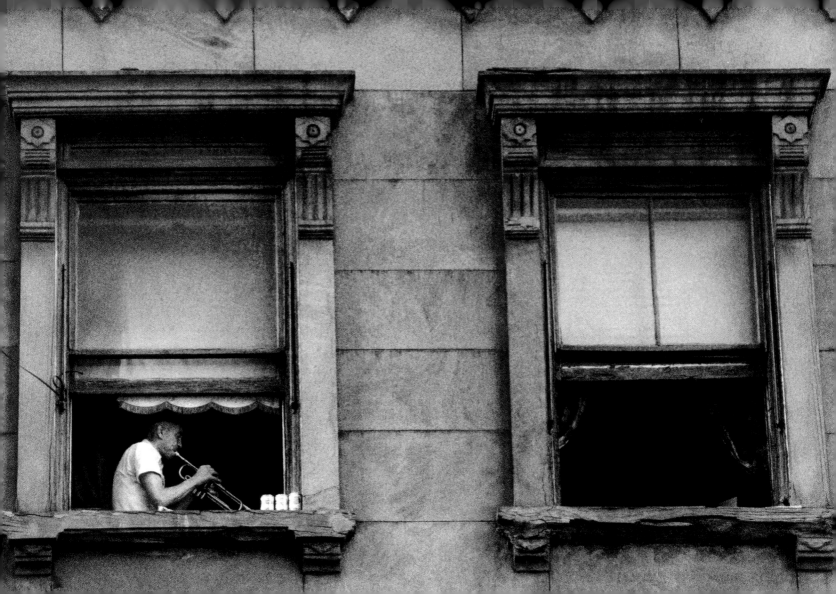

MAY 11, 2004

Sound Check
The new home of Jazz at Lincoln Center had not been finished when Wynton Marsalis, the trumpet virtuoso who is the group's artistic director, stopped by. Being Wynton Marsalis, he just had to test the acoustics in what was still a $128 million construction site at the Time Warner Center at Columbus Circle.

Tyler Hicks/*The New York Times*

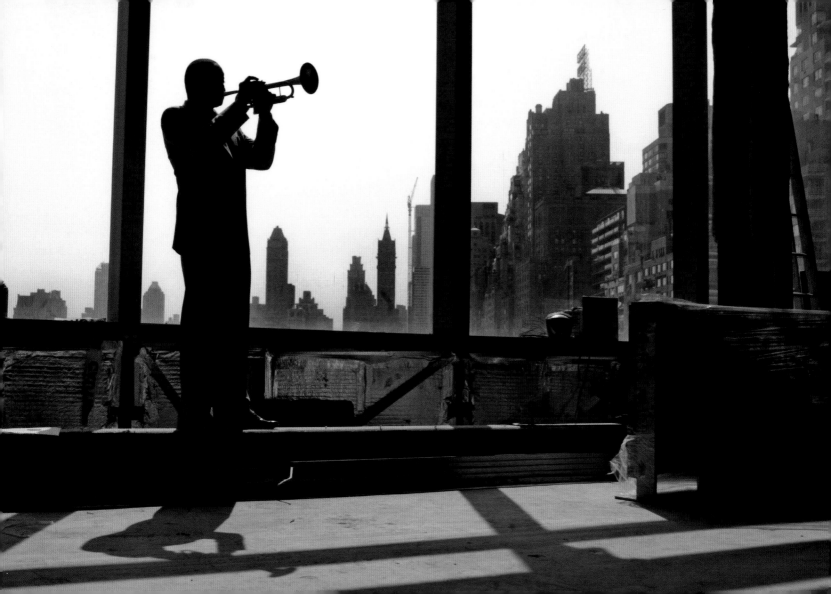

DECEMBER 11, 1948

The House That Bop Built

The jazz great Charlie Parker, a founder of bebop, performing in what was known as the Metropolitan Bopera House. The club called itself the Royal Roost, not because of Parker's nickname ("Yardbird," or simply "Bird") but because it was originally a chicken restaurant. Birdland, another jazz club in Manhattan, was in fact named for Parker.

Sam Falk/*The New York Times*

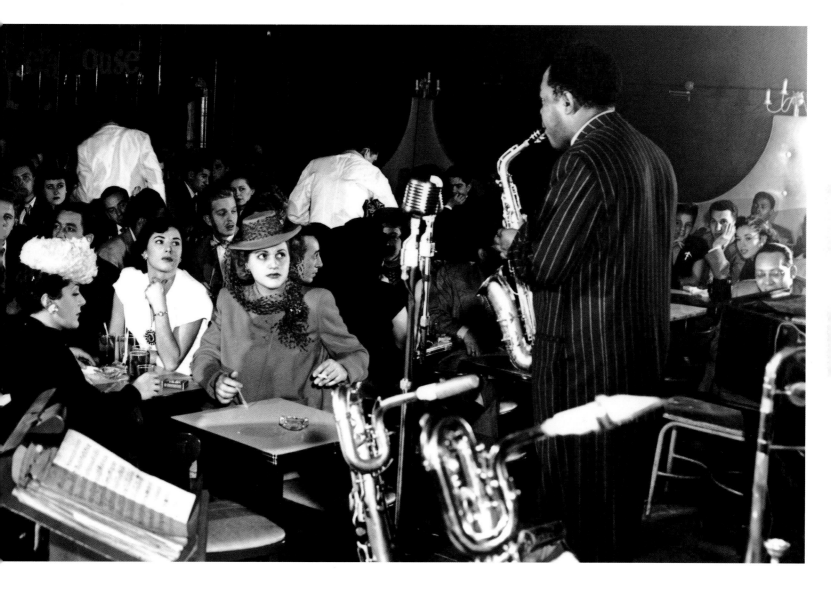

Cabaret to Remember

"I never knew how good our songs were,"
Ira Gershwin once said, "until I heard Ella
Fitzgerald sing them."

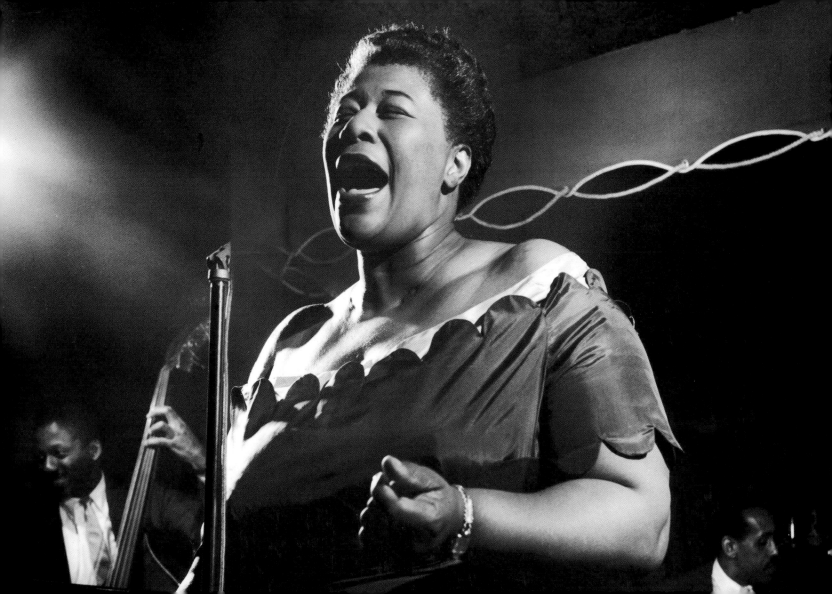

The Wee Small Hours

Even in round-the-clock New York, the bars close eventually — 4 a.m. on weeknights in the years after World War II, 3 a.m. on Sundays. On Fifty-second Street, where jazz legends like Billie Holiday, Dizzy Gillespie, and Thelonious Monk played the clubs, the musicians packed up and headed on. But for some couples, the curfew came too soon.

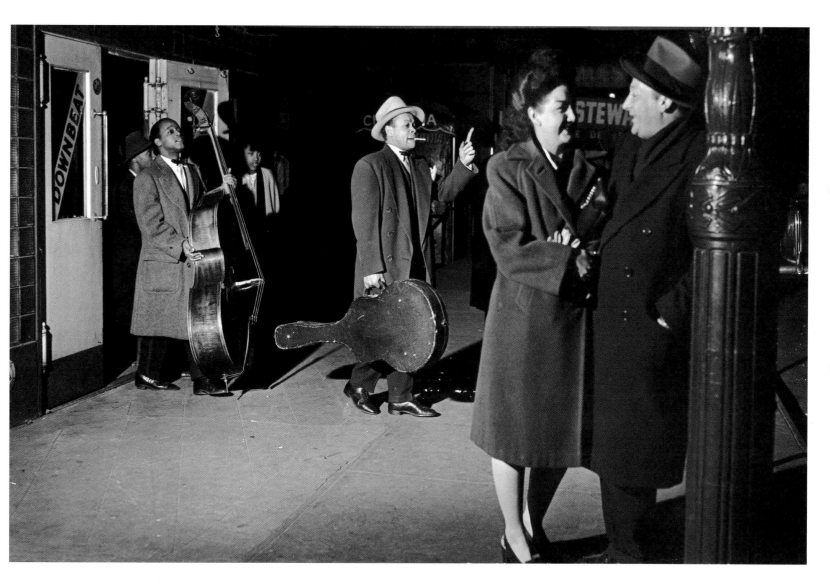

Deadheads Unite

What a long, strange trip it was for the Grateful Dead, coming out of San Francisco and playing the East Coast for the first time. It was a peaceful day of free music in Tompkins Square Park in the East Village, but hours after the Dead left the stage, tensions between hippies and others in the park boiled over. More than two hundred police officers were called in to restore order.

Meyer Liebowitz/*The New York Times*

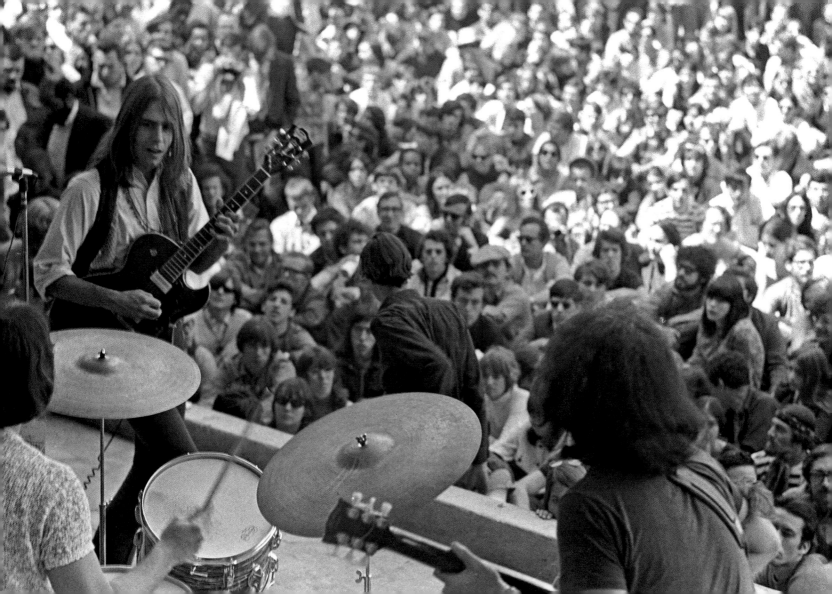

Opposite

AUGUST 13, 1975

Born to Rock

Bruce Springsteen was a superstar in the making when he appeared at the Bottom Line, a Greenwich Village Club, to promote his just-released album *Born to Run.* Thirty years later, when he re-released the album, along with two DVDs of concert footage, the Bottom Line was no more. It had been evicted in 2004, despite the Boss's best efforts and a campaign by other Bottom Line fans.

Larry C. Morris/*The New York Times*

Overleaf

APRIL 10, 1977

Hot Jazz

The northern stretch of the Bowery became one of the hottest entertainment districts in Manhattan in the mid-1970s as theaters took up residence there. Around the corner, on Bond Street, hot jazz in a loftlike setting appealed to after-theater crowds.

Fred R. Conrad/*The New York Times*

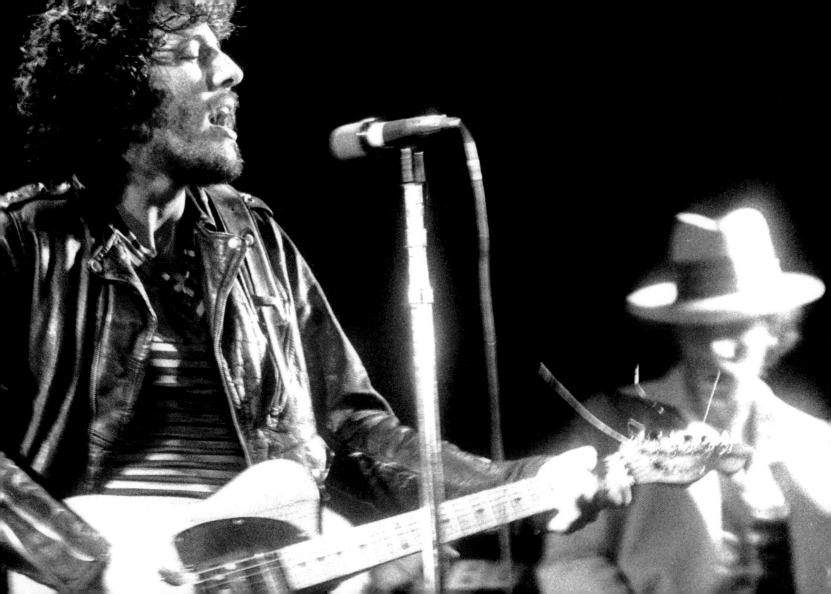

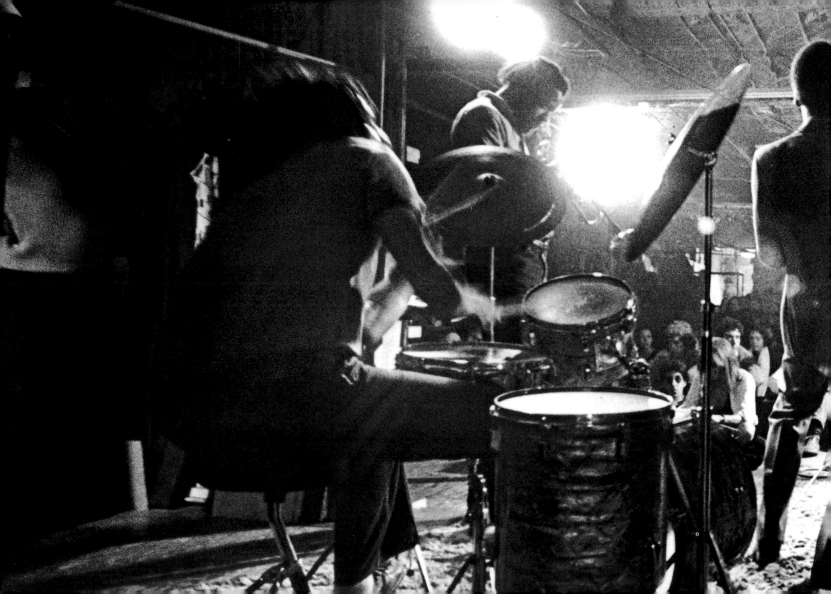

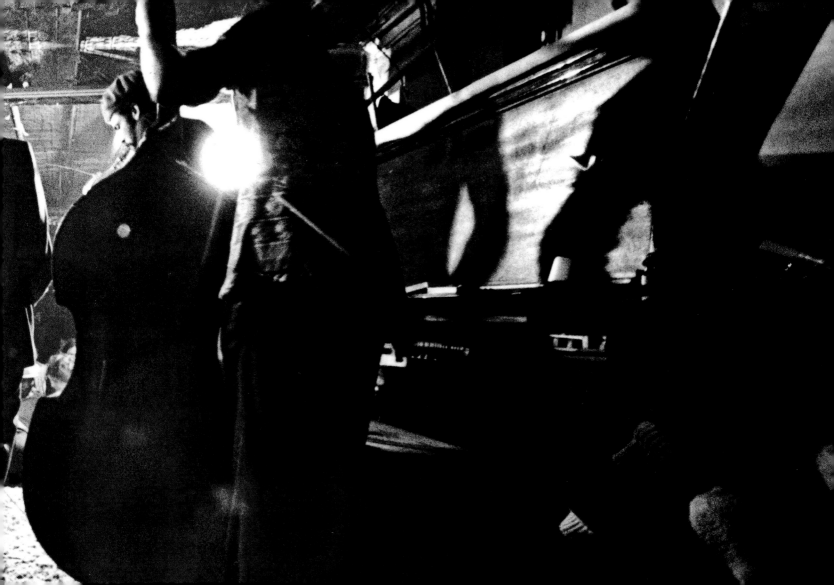

NOVEMBER 12, 1932

Open-Air Market

Hot dogs, pretzels, fresh vegetables, newspapers, drugs: you can buy almost anything outdoors in New York — even stocks, way back when. After all, the New York Stock Exchange began under a tree. During the Depression, this painter was one of several hundred who showed their canvases in an outdoor sale held in the shadow of the Washington Square Arch.

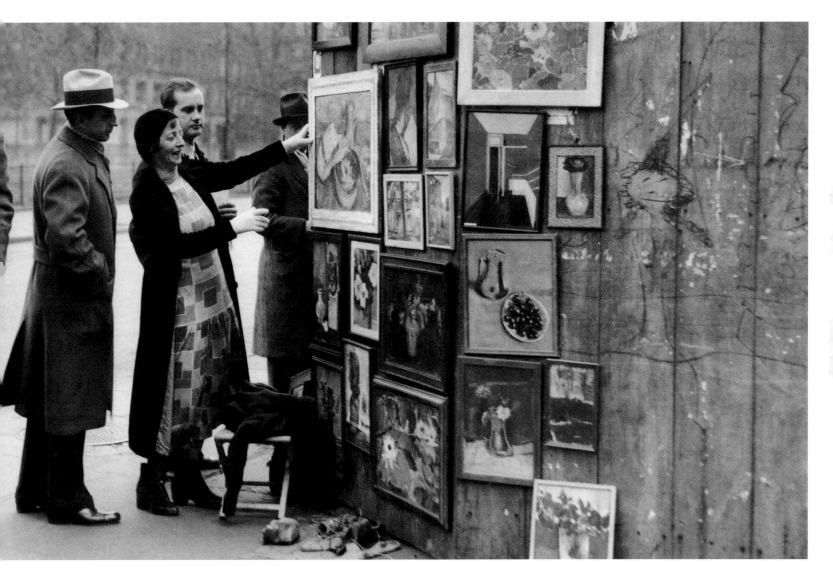

NOVEMBER 20, 2004

Opposite

How Tall the Wall?

On the day the Museum of Modern Art reopened after a two-and-a-half-year renovation, some art lovers discovered their old friends in new places. A visitor studies Ellsworth Kelly's *Sculpture for a Large Wall*, installed in a vast gallery upstairs, where *Times* critic Holland Cotter said it looked "fantastic."

Chang W. Lee/*The New York Times*

AUGUST 2004

Overleaf

Murals Are Back

It was an eye-popping genre that angered mayors and editorial writers and was romanticized by the likes of Norman Mailer. Subway passengers called it "graffiti." Curators called it "street art" and organized auctions or invited graffiti artists to make a masterpiece on the walls of buildings like this museum on Jackson Avenue in Long Island City, Queens.

Tony Cenicola/*The New York Times*

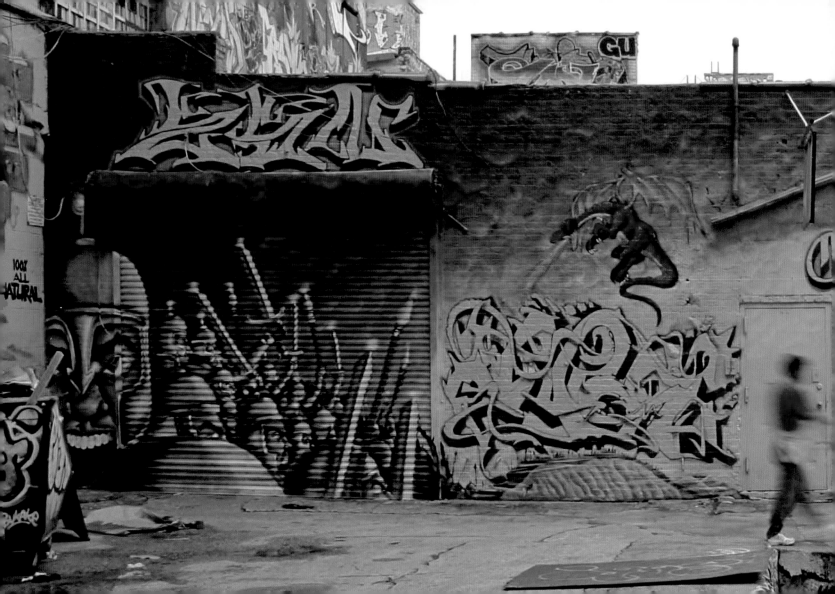

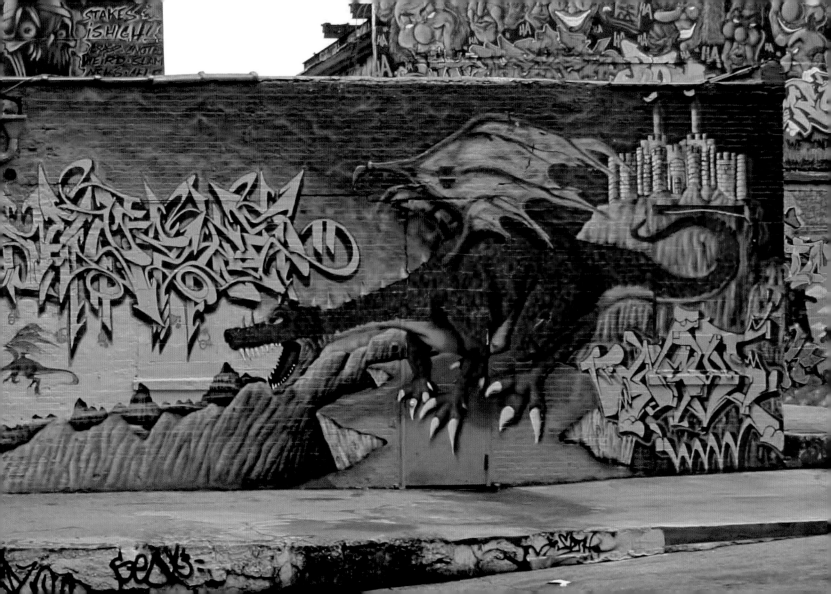

**The Husband, the Portraitist,
and the Subject**

"Street art" used to mean art you could
buy on the sidewalk. That was in the days
before graffiti went mainstream.

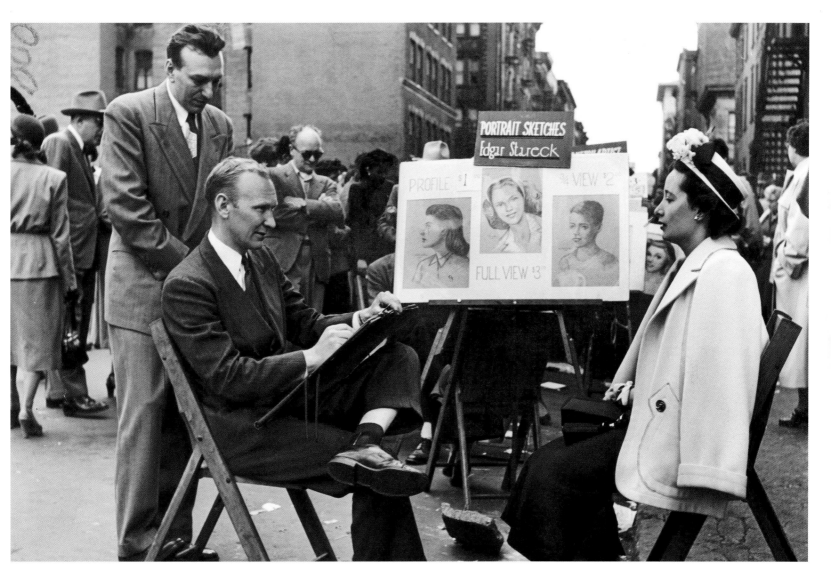

Watching the Lunchtime Crowd

In the garden at the Museum of Modern Art, Charles Despiau's *Assia* keeps watch over an unusual lunchtime crowd — construction workers hired after a small fire. They installed smoke-detection equipment and replaced sections of the walls with fire proof materials in the museum's original 1939 building.

Carl T. Gossett Jr./*The New York Times*

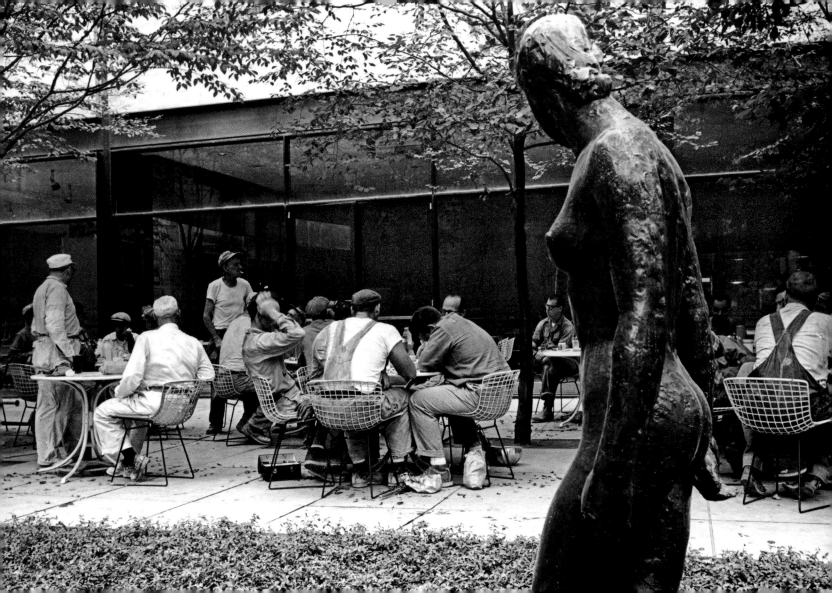

The New Modern

The Museum of Modern Art's newest expansion was designed by the Japanese architect Yoshio Taniguchi with Kohn Pedersen Fox. Nicolai Ouroussoff of *The Times* called it "comforting" and added, "The building's clean lines and delicately floating planes are shaped by the assumption that Modernity remains our central cultural experience."

Fred R. Conrad/*The New York Times*

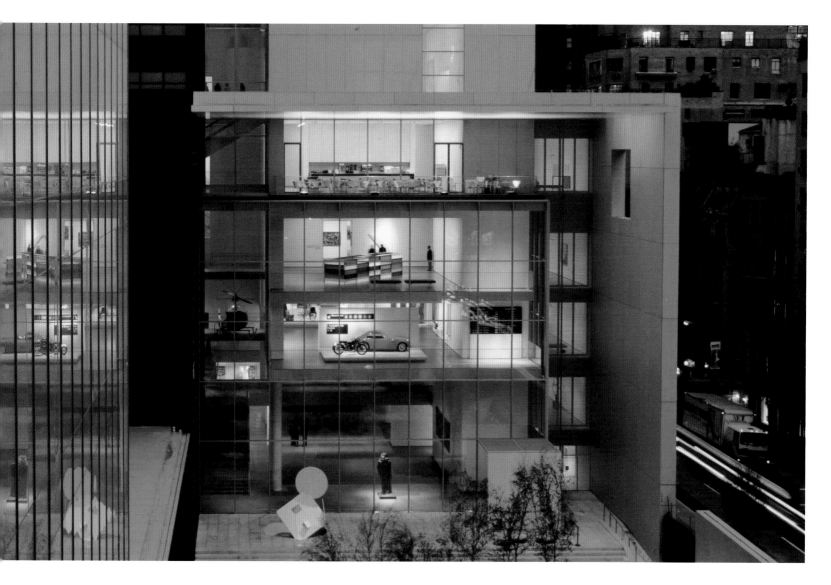

Migrating Bumbershoots
Melissa Brody plays among three thousand umbrellas, each painted with a monarch butterfly, that were set up for Victor Matthew's temporary art installation "Beyond Metamorphosis" in Battery Park.

James Estrin/*The New York Times*

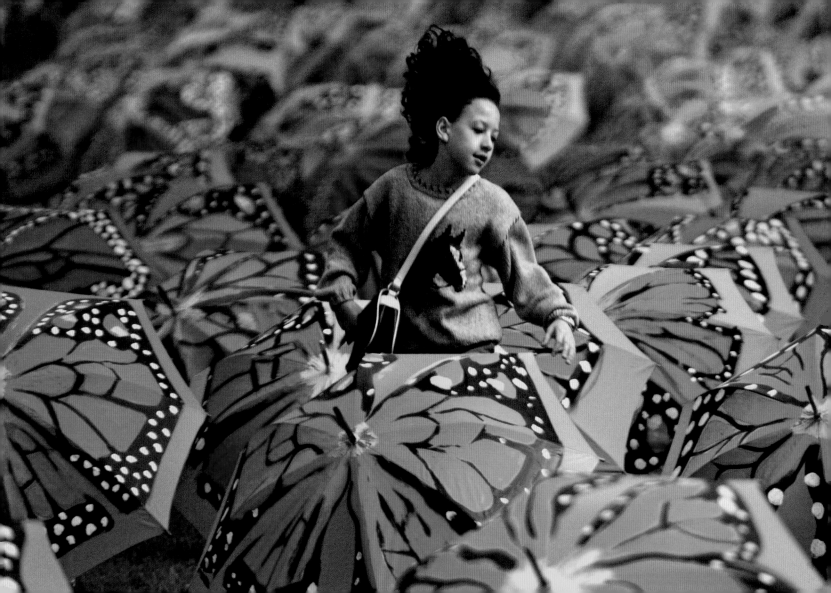

Inside the Factory

Andy Warhol, already famous, already
controversial, peeks out from behind his
newest works, wooden boxes on which he
had silk-screened the labels of products
like corn flakes, scouring pads, ketchup,
and apple juice.

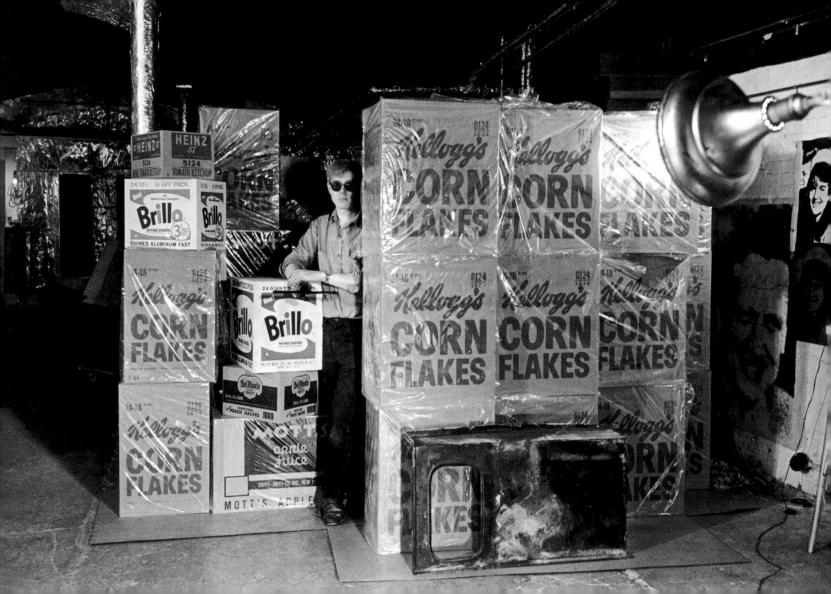

Chelsea Days

The ceilings are high, the walls a couple of feet thick, and the lobby raffish. The Chelsea Hotel is a famously seedy landmark inhabited by poets, painters, and punks. It was home at various times to Janis Joplin, the composer Virgil Thomson, and Sid Vicious, who stabbed Nancy Spungen to death in Room 100. It was where Thomas Wolfe wrote *You Can't Go Home Again*, and where Dylan Thomas walked in one night and announced, "I've had eighteen straight whiskeys. I think that's the record."

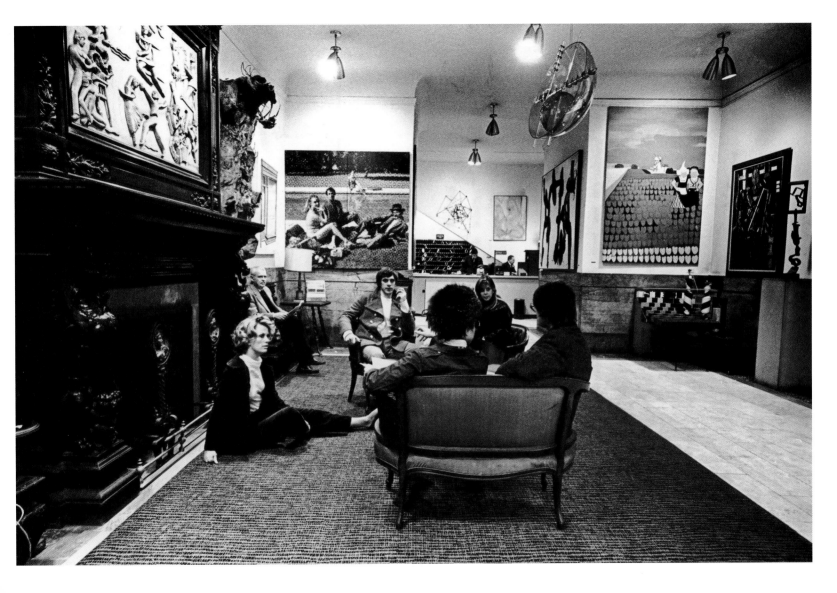

Opposite

JANUARY 5, 1954

The New Met

The Metropolitan Museum of Art spent three years in the early 1950s modernizing its exhibition halls. When the new European Painting galleries opened to the public, the works from the era of Louis XIV (the equestrian figure on the right) included Nicolas Poussin's *Rape of the Sabine Women*.

Eddie Hausner/*The New York Times*

Overleaf

JANUARY 18, 1986

Squirting and Scrubbing

When Keith Haring installed this characteristically colorful piece against a monochromatic, rectilinear backdrop of office towers, he brought along a spray bottle of detergent. Like the firefighter who keeps polishing a pumper that looks sparkling to everyone else, he could not resist climbing to the top for a touchup.

Dith Pran/*The New York Times*

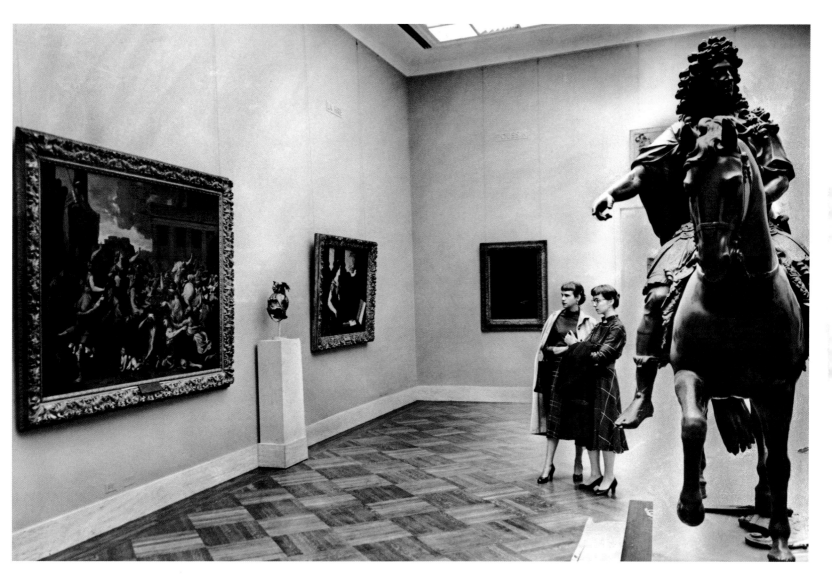

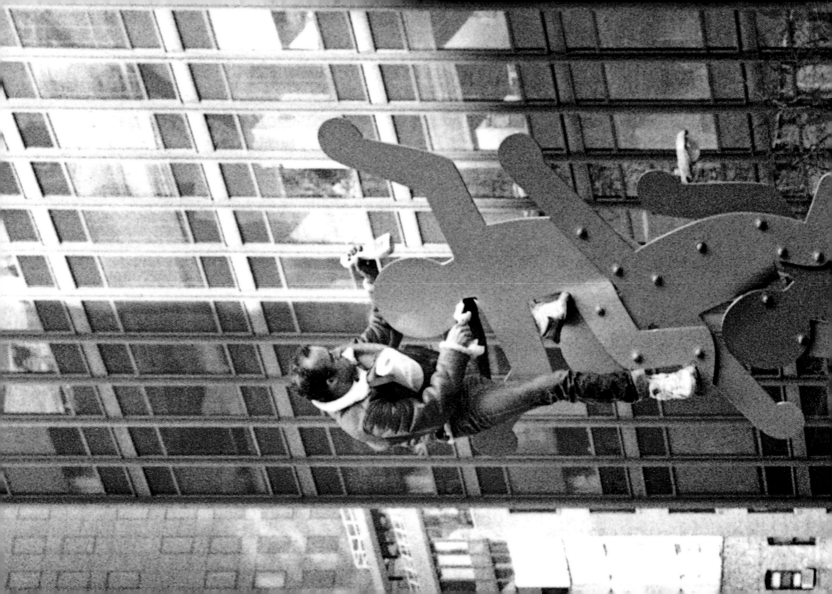

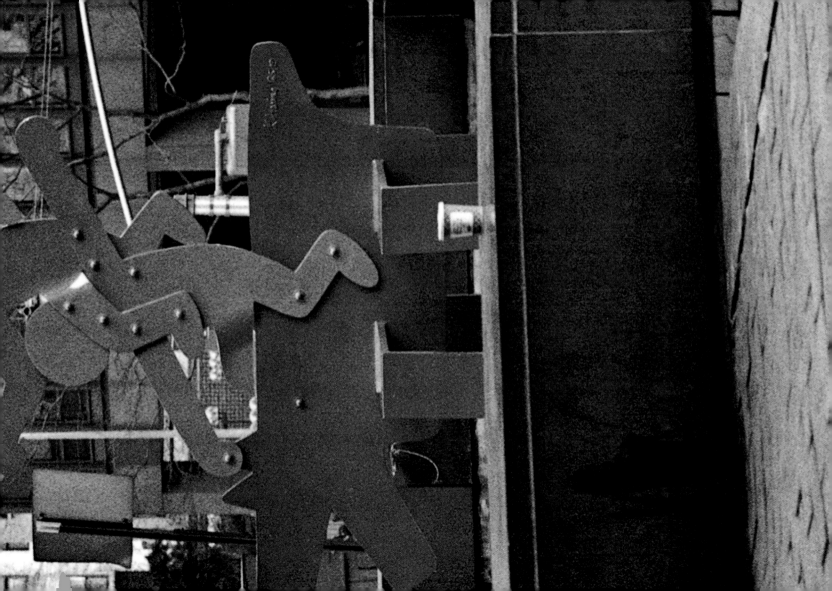

The Gates

The artists Christo and Jeanne-Claude spent the 1980s and 1990s wrapping the Pont Neuf in Paris with fabric and rope, planting blue umbrellas in a twelve-mile-long valley in Japan and yellow ones in a twenty-four-mile valley in California, and wrapping the Reichstag in Berlin with more than a million square feet of silvery fabric and bright blue rope. In 2005 they installed a different kind of art project in Central Park — a million yards of saffron-colored fabric attached to seventy-five hundred 100-foot vinyl poles. Some people said the orange-yellow gates looked like too-short window shades dangling in the breeze. Some people were intrigued by the play of light on the fabric. As the peekaboo winter sun came and went, the nylon had a touchable texture one minute and a one-dimensional look the next.

Vincent Laforet/*The New York Times*

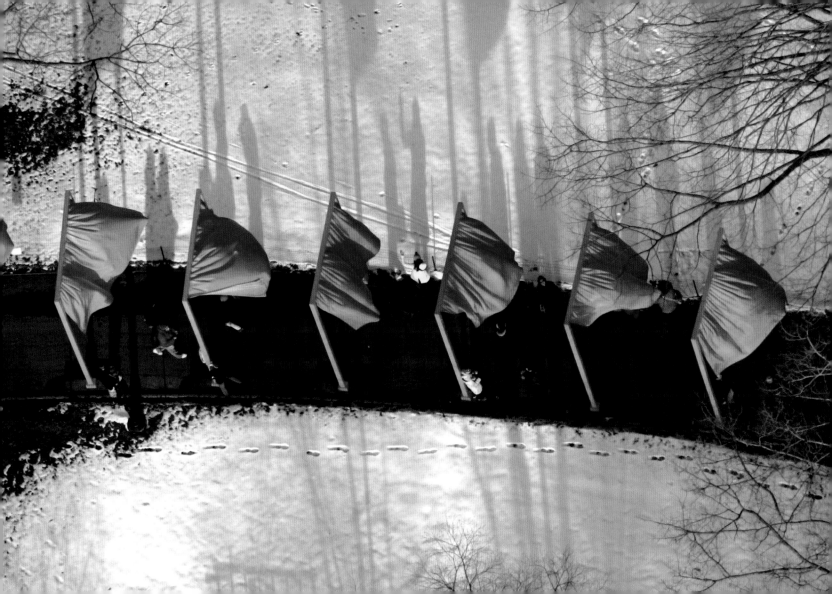

DECEMBER 1982

How You Get to Carnegie Hall

There it is, Carnegie Hall, home to the greats: Tchaikovsky and Gershwin and Toscanini and Bernstein and Stokowski and Heifetz and Horowitz and Perlman and Brendel and Ma. And there you are, after all those lessons and all that practicing, awaiting your moment on that famous stage.

Jim Wilson/*The New York Times*

Overleaf

MARCH 7, 1964

Inner Workings

It looks like a soft-drink bottling machine in a tent, but these pipes and valves and pumps are for the fountain at Lincoln Center. Architect Philip Johnson, in coat and tie, explained that the fountain was meant to provide "the focal point a fireplace gives a home." But no fireplace glows with twenty-six thousand watts of brightness or has 577 jets to spray water.

Ernie Sisto/*The New York Times*

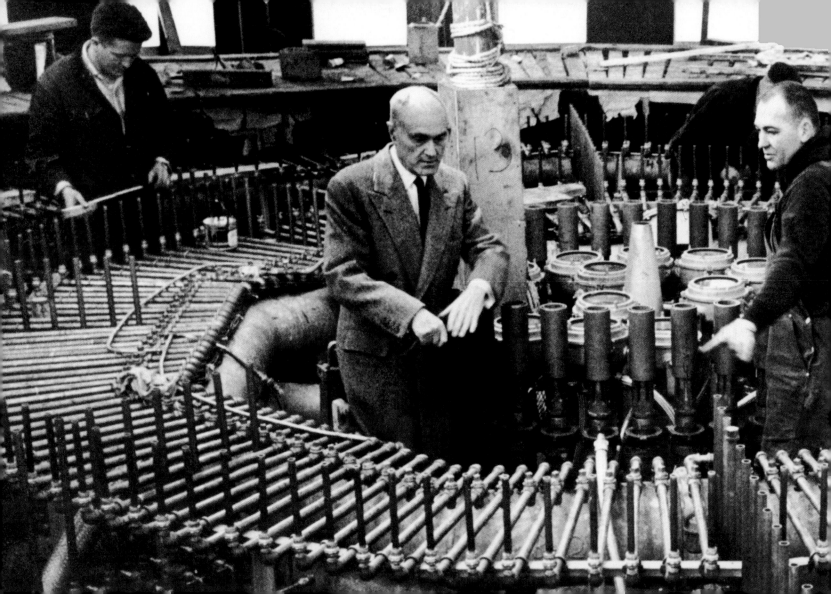

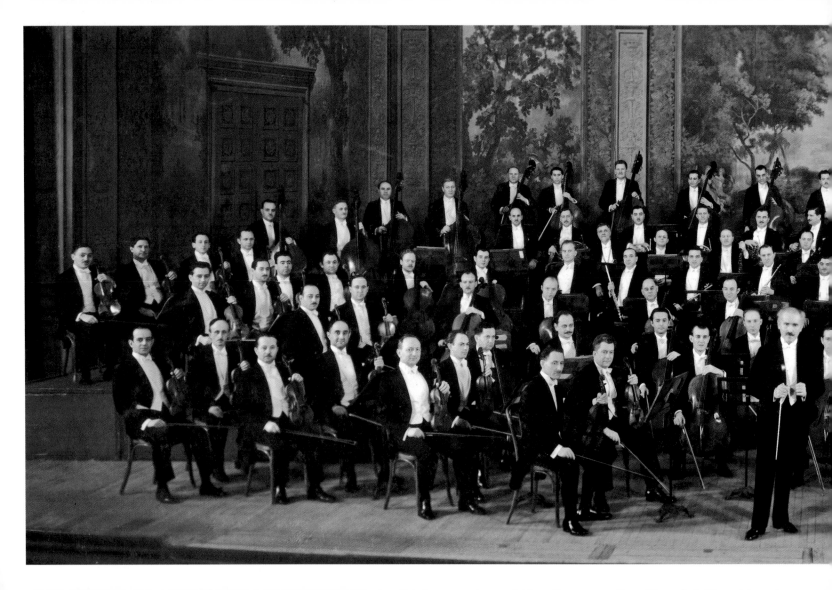

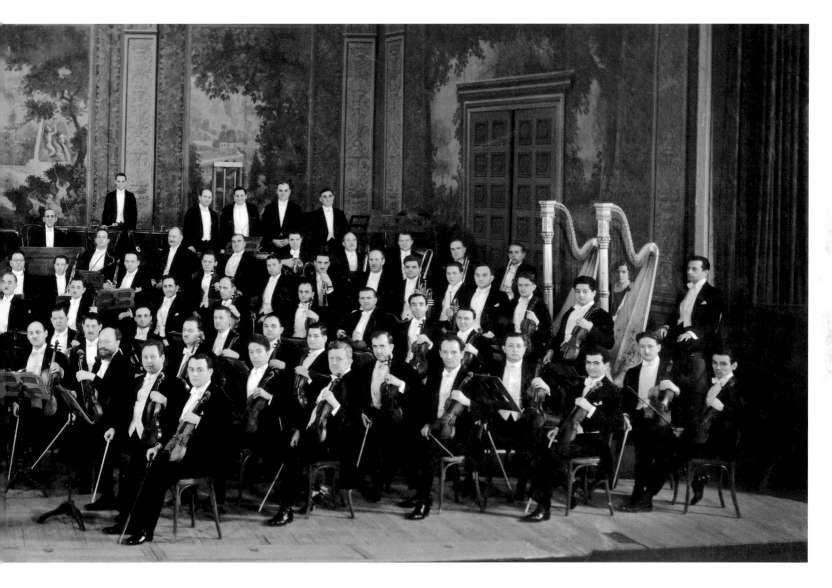

MARCH 23, 1930

Previous

One Maestro . . .

"The power that welded it into a unit came from the top, from the absolute and omniscient dictatorship wielded by Toscanini," one musician declared, describing the New York Philharmonic under Arturo Toscanini.

The New York Times Photo Archives

MAY 3, 1974

Opposite

. . . And Another

In the orchestra pit at the New York State Theater at Lincoln Center as he ran through music he had written for the Jerome Robbins ballet *Dybbuk*, Leonard Bernstein hopped and leaped and danced around the podium. His arms were a blur, and he jabbed at the musicians with a prizefighter's energy.

Don Hogan Charles/*The New York Times*

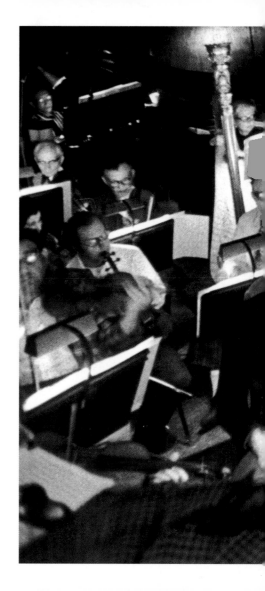

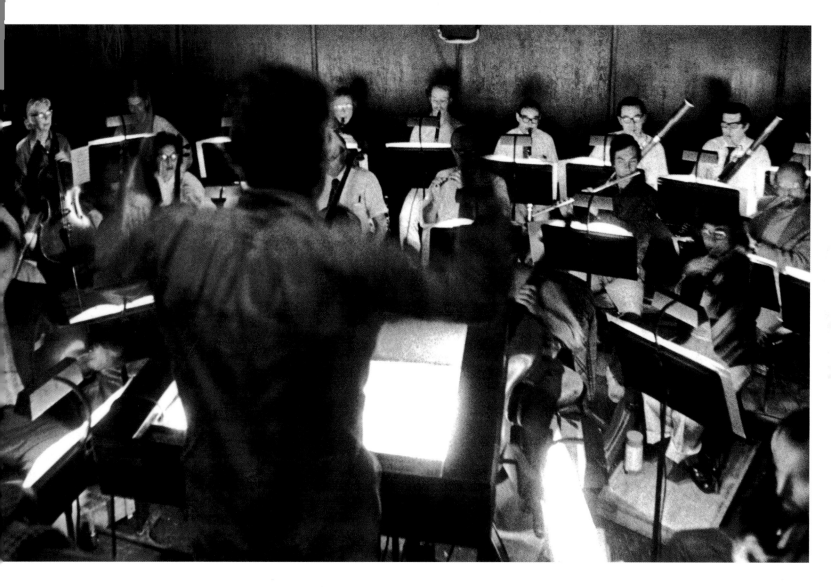

Genius Rehearses

A slightly stooped man at a piano: a sight many music lovers never expected to see. Vladimir Horowitz had not played in public since 1953. On his return to Carnegie Hall in 1965, the audience gave him a standing ovation before he played the first note. "A few seconds thereafter," one critic wrote, "he reaffirmed beyond any possible doubt his place among the supreme musicians of all time."

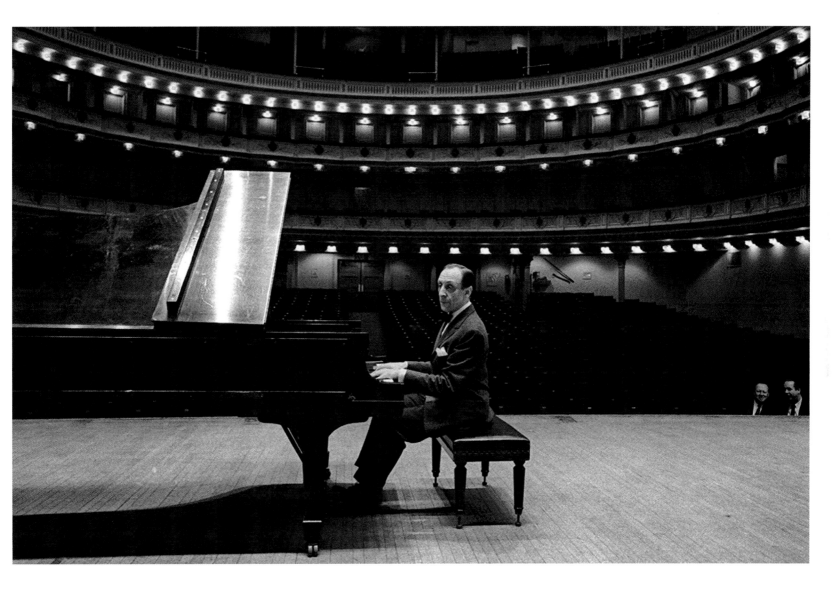

Golden Anniversary

This was the view from the stage of the
Metropolitan Opera House — the "old"
Met, on Broadway a couple of blocks
south of Times Square. On this night in
1933, the well-dressed crowd was waiting
for the downbeat celebrating the Met's
fiftieth anniversary.

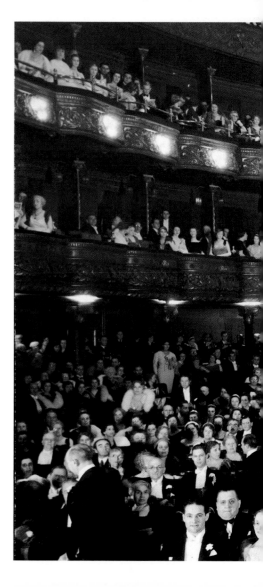

The New York Times Photo Archives

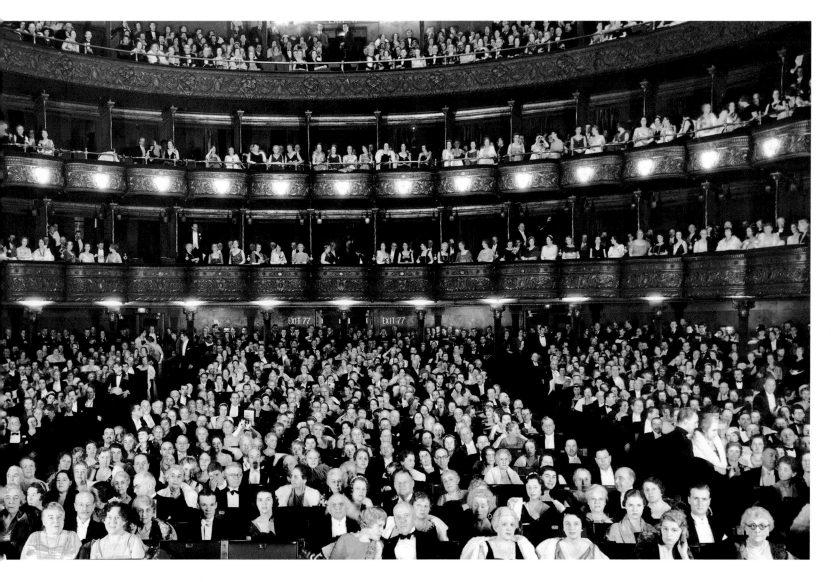

Pageantry in the Park

The Times called the Delacorte Theater in Central Park the "heavy hitter of alfresco Shakespeare." New Yorkers endure long lines for performances like this one of *Romeo and Juliet*. "Real sky overhead, real grass underfoot, a darkness nearly visible with the artificial twilight of the city's glow — these things make the metaphors onstage seem incandescent, truer than true."

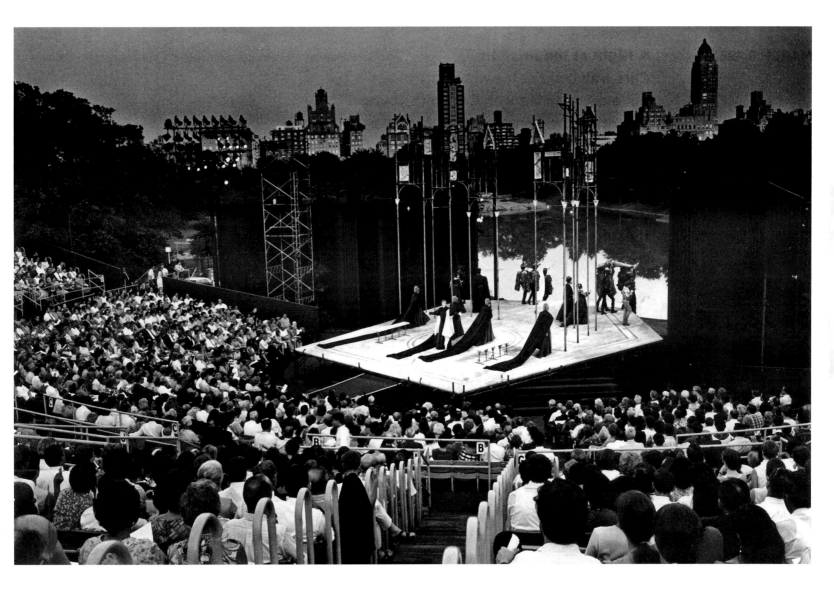

MARCH 9, 1952

Opposite
A Night at the Drive-In

Cars with couples for whom the movie is but a secondary event. Cars with youngish parents in the front and sleepy toddlers in the back. Cars that will pull away with the drive-in's speaker still inside. It's just another night at the drive-in. This one was in the Bronx. Today, there are no drive-in movie theaters in the New York city limits.

Eddie Hausner/*The New York Times*

MAY 6, 2004

Overleaf
A Small-Screen Finale on a Big Screen

Friends brought their lawn chairs and blankets to watch the two-hour finale of the long-running sitcom *Friends* on a pier by the Hudson River. *Friends* followed six twentysomething New Yorkers through the ups and downs of careers, relationships, and even pregnancy and parenthood. The finale drew the fourth-biggest audience ever for the end of a television series.

Richard Perry/*The New York Times*

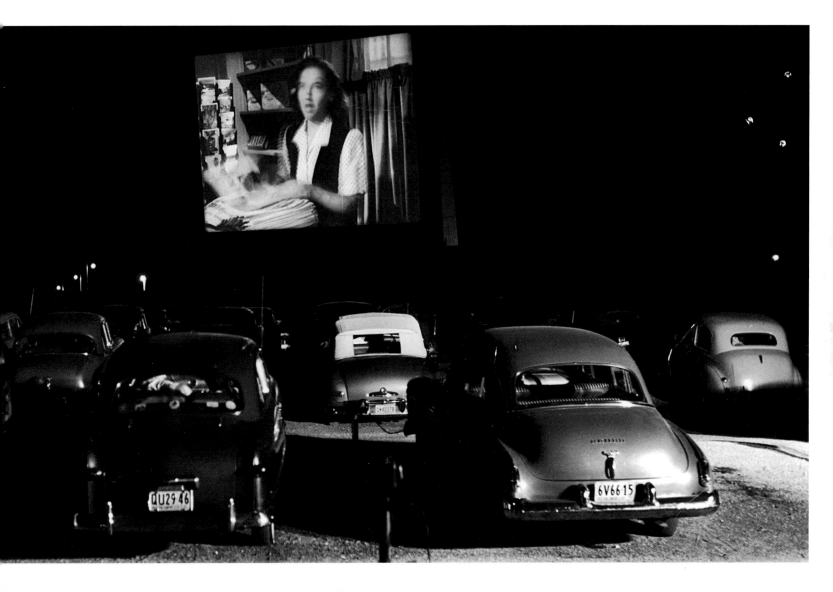

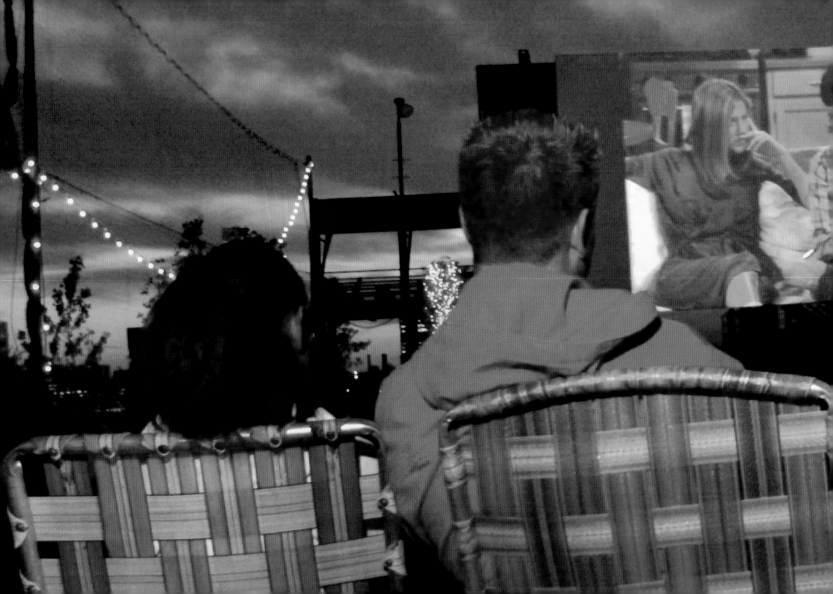

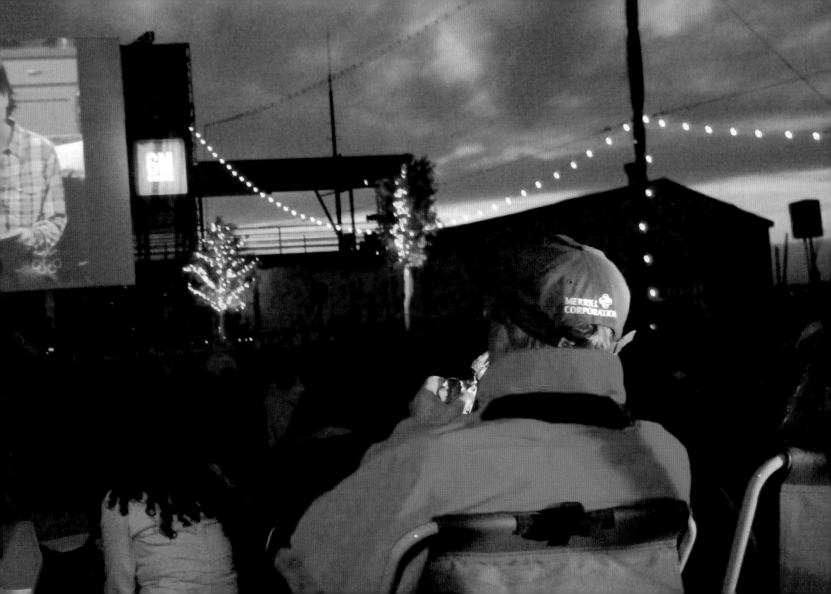

AUGUST 8, 1974

Opposite

Fit to Print on the Building

The Motograph News Bulletin, better known as the zipper, started flashing the news on the Times Tower in 1928. Here, its 14,800 bulbs reported on a first in American history: the resignation of a president, Richard M. Nixon.

Barton Silverman/*The New York Times*

JULY 4, 1910

Overleaf

Times Square as Town Square

Before instant messaging and the Internet, before radio and television, there were hot-off-the-presses "extras." And there was Times Square, where crowds watched for the latest headlines, posted in the window of *The New York Times* tower — in this case, about the Jim Jeffries—Jack Johnson heavyweight championship fight.

The Pictorial News Company

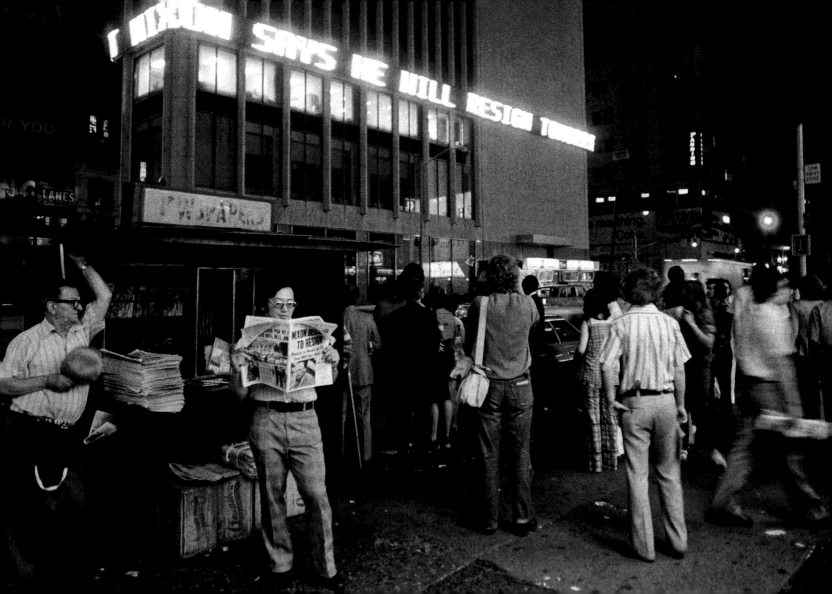

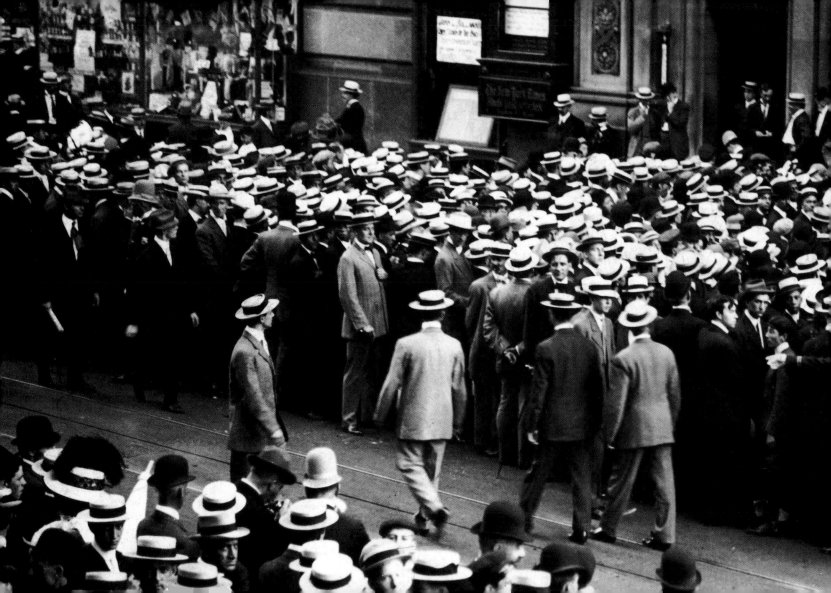

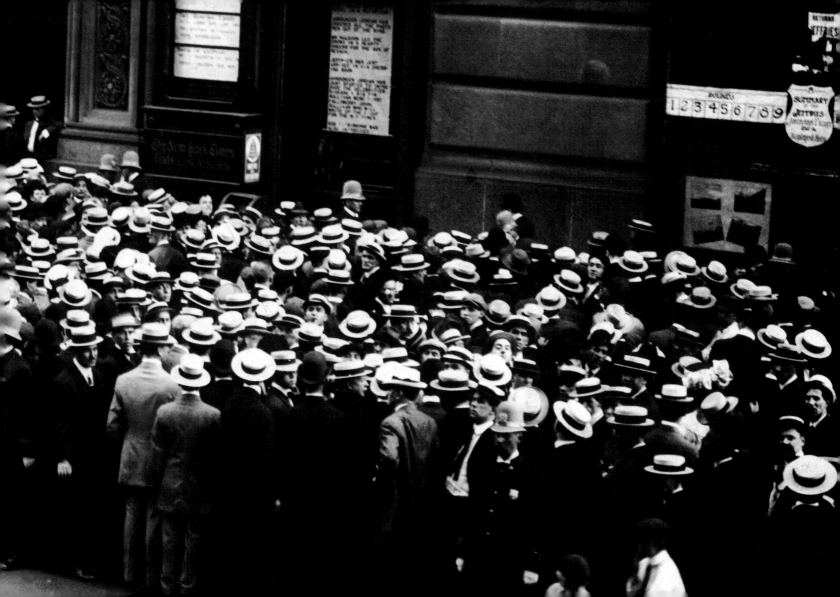

The First Lady as Candidate

When Hillary Rodham Clinton appeared at this televised town meeting moderated by Katie Couric of *The Today Show*, Mrs. Clinton was both the First Lady of the United States and a candidate for the Senate from New York. She won the election and took office on January 3, 2001, seventeen days before her eight years as First Lady ended.

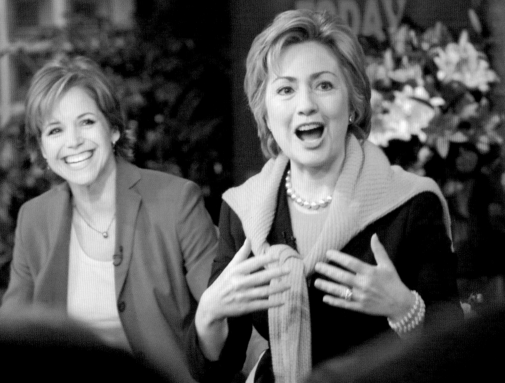

Who Wants to Be a President

By the time the 2000 presidential campaign was in full swing, candidates were making the rounds of daytime talk shows, the same as actors, chefs, and fitness gurus. They made small talk and humored the host, as George W. Bush did here by wearing a dark tie and matching shirt, a sly allusion to Regis Philbin's wardrobe.

On-Air Shooting Match

When the script said "gunshots rang out" on a whodunit in the days of big-time radio, the sound-effects technicians were standing by to pull the triggers.

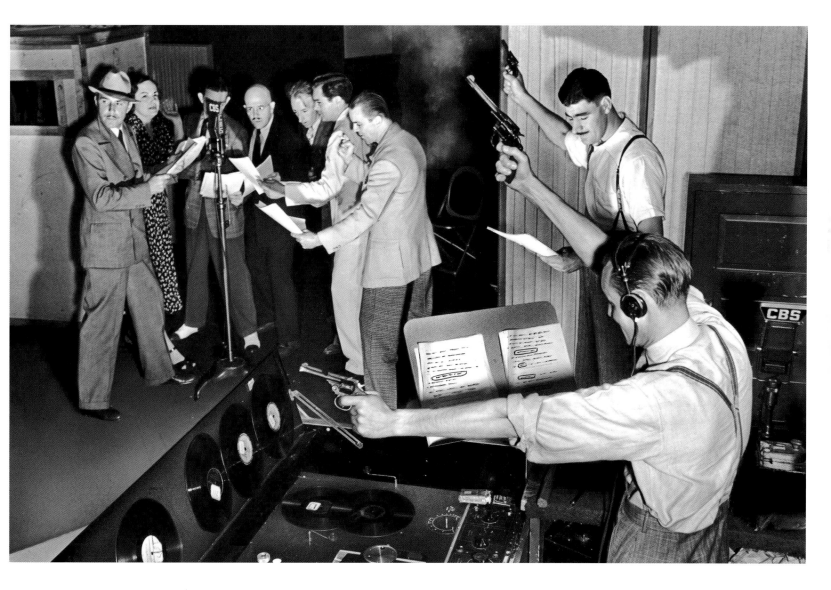

1914

Opposite

The Back Lots of Brooklyn

In the early days of silent films, before movie companies decamped for Southern California, New York was movie country. Mary Pickford and D. W. Griffith worked at the Biograph Studios in Manhattan; Vitagraph built studios in Brooklyn. When a battle scene was called for, as in this Vitagraph film, the cameraman, the director, and the cast simply went outside.

The New York Times Photo Archives

Overleaf

OCTOBER 9, 1967

Special Effects

Sometimes, New York is its own stand-in. For the comedy *The Night They Raided Minsky's*, starring Jason Robards, Bert Lahr, Forrest Tucker, Elliott Gould, and Britt Ekland, this block on East Twenty-sixth Street near Bellevue Hospital was made to resemble a stretch of the Lower East Side in the 1920s.

Patrick A. Burns/*The New York Times*

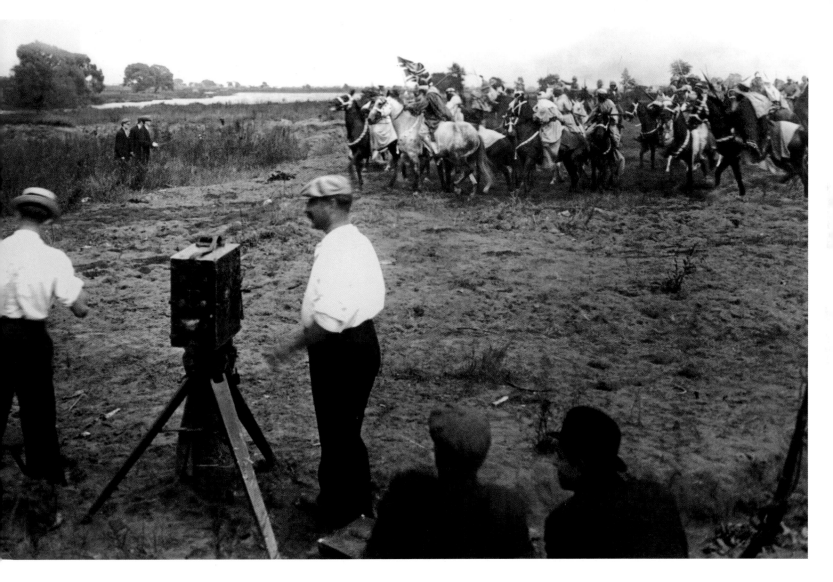

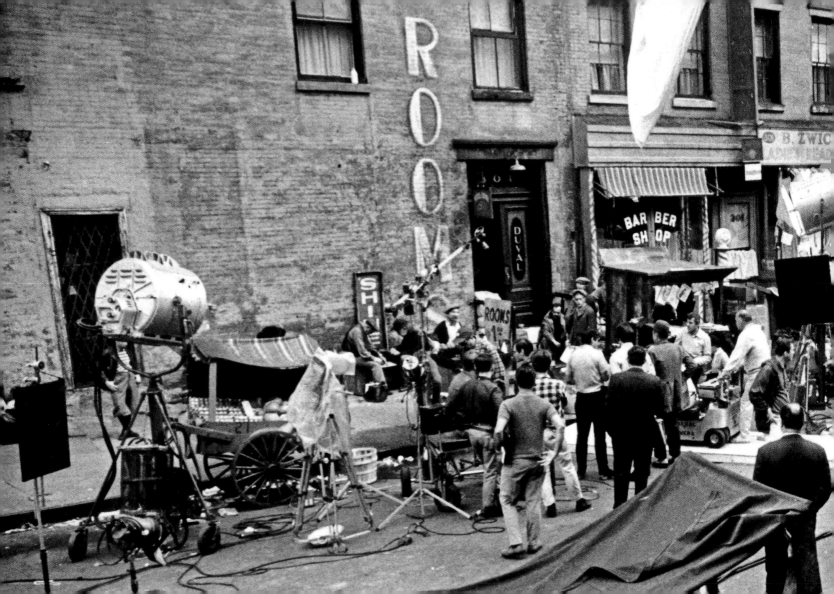

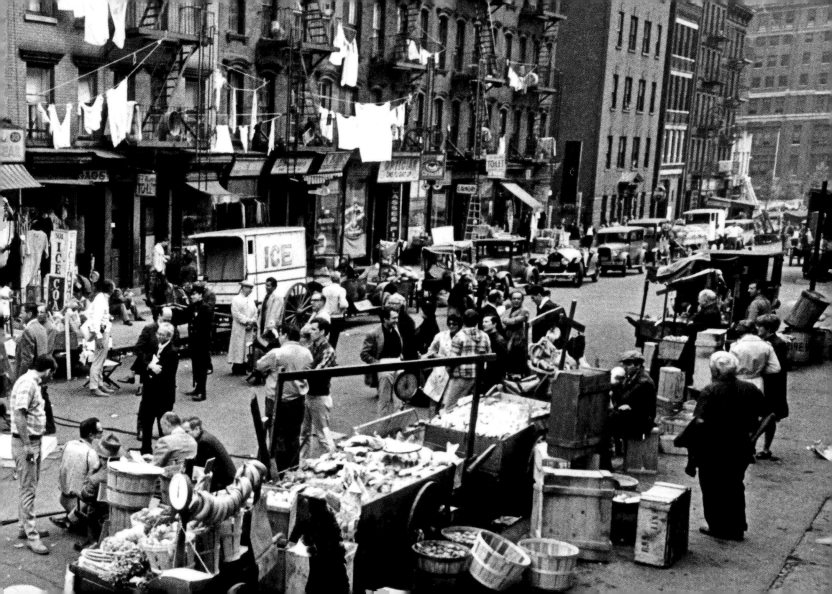

Tinseltown East

Three Days of the Condor — Final scene

Location: West Forty-third Street, between Broadway and Eighth Avenue, outside the building that *The New York Times* occupied from shortly before World War I.

TURNER (Robert Redford) informs HIGGINS (Cliff Robertson) that he has told the press everything.

HIGGINS: "How do you know they'll print it?"

TURNER: "They'll print it."

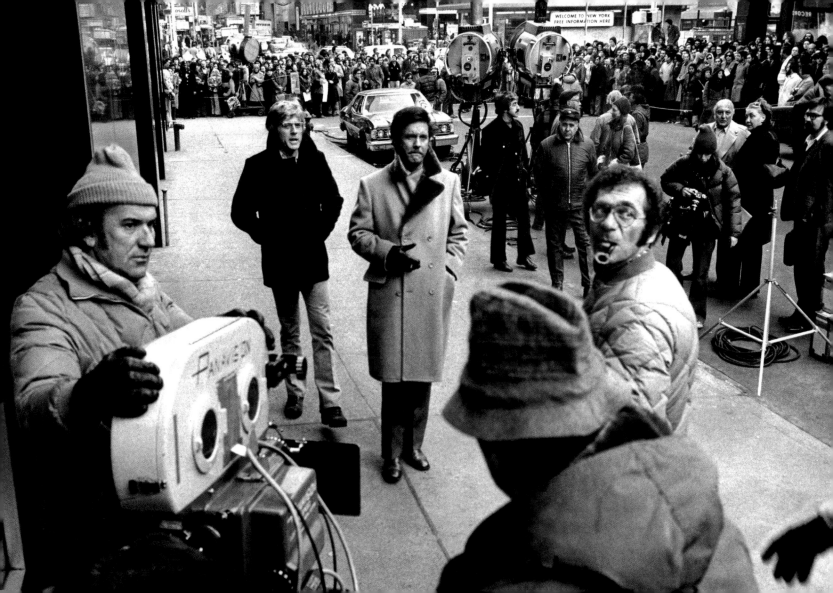

CIRCA 1910

Five-cent Movie Palace

The "ingredients" needed for operating a nickelodeon, according to the trade paper *Motion Picture World*, were "200-500 people (audience), phonograph (with extra large horn), women cashier, electric sign, machine and operator and films, canvas screen, piano, barker, chairs." The operator "needs few brains and little tact." This five-cent movie palace was on Third Avenue.

The New York Times Photo Archives

Overleaf

DECEMBER 11, 1948

Bright Lights, Big City

The big names in giant lights! The blinding billboards! After his first glimpse of Times Square, the novelist G. K. Chesterton recoiled, declaring, "What a garden of earthly delights this would be if only one had the gift of not being able to read."

Sam Falk/*The New York Times*

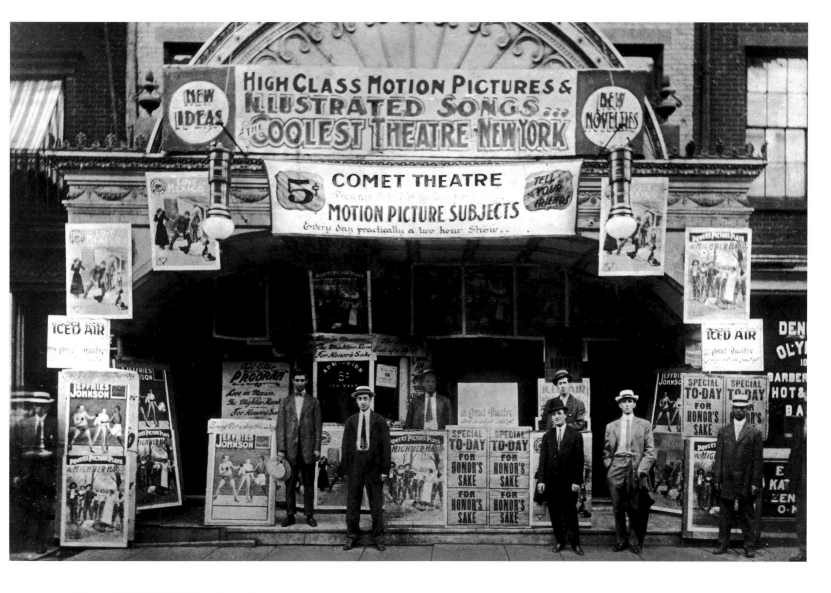

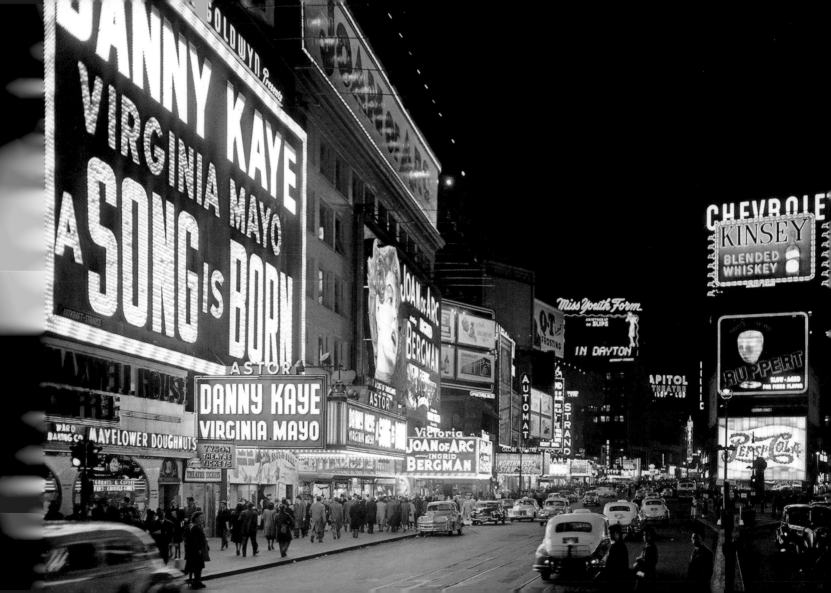

The Trouble With Times Square

Mayor Fiorello H. La Guardia and a group called the New York Society for the Suppression of Vice pushed to outlaw bump-and-grind acts after forcing theater owners to remove the word "burlesque" from their marquees in 1937. This "follies" show in Times Square was soon shut down. Burlesque houses were revived by court order in 1955.

Opposite

Giddy Goings-On

OCTOBER 11, 1939

The Times's drama critic, Brooks Atkinson, noted the "giddy goings-on of a giddy opening" in his review of *Skylark* at the Morosco Theater. His reaction to the play — "a brawl in a drawing room," he called it — was lukewarm. But he judged the cast, which included Gertrude Lawrence and Vivian Vance, "uncommonly good."

The New York Times Photo Archives

Overleaf

Hellzapoppin'

DECEMBER 1939

Why wait for the critics to weigh in? Judging by the smiles at this performance of *Hellzapoppin'*, the slapstick Depression-era musical created by two vaudevillians, the audience's review is in. *Hellzapoppin'*, which ran for 1,404 performances from 1938 to 1941, briefly held the Broadway record.

Morse Pix

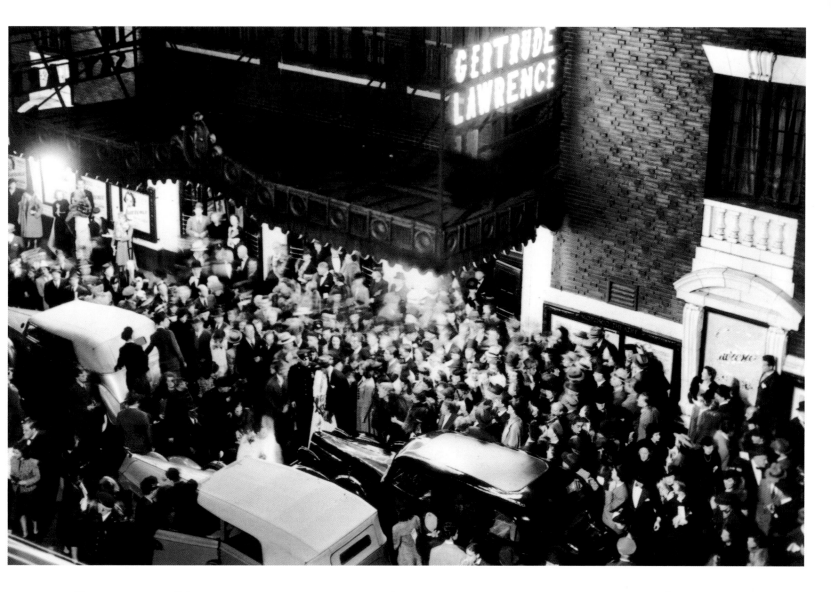

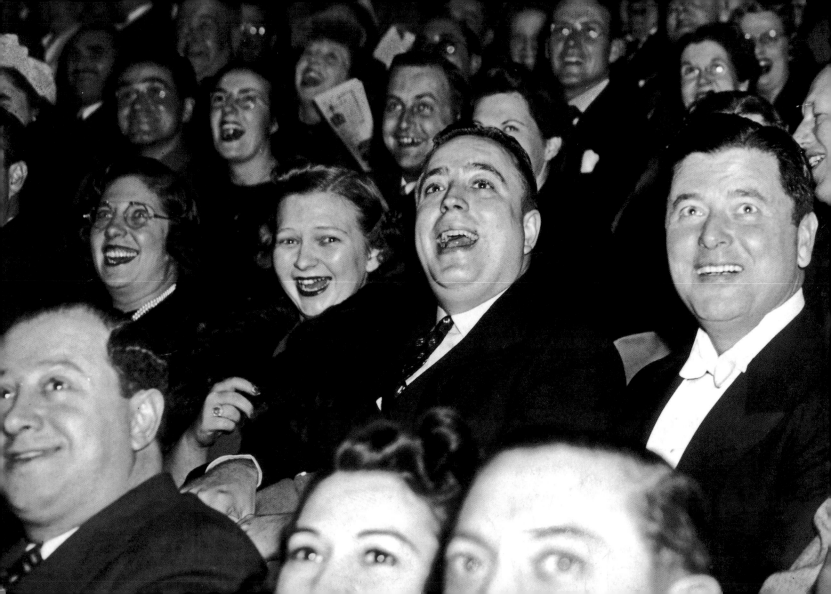

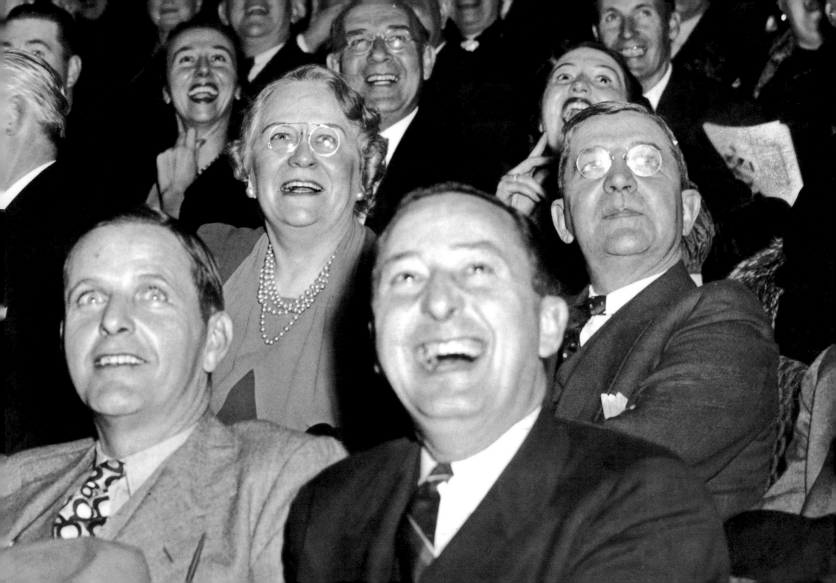

Master Class

To the director Mike Nichols's résumé, add teacher. Leading a class at the New Actors Workshop, he recalled the time he confronted an actor who had been playing a role for three months: "What do you think your job is? To learn the words? The usher can do that. Your job is to say them for the first time. Each time."

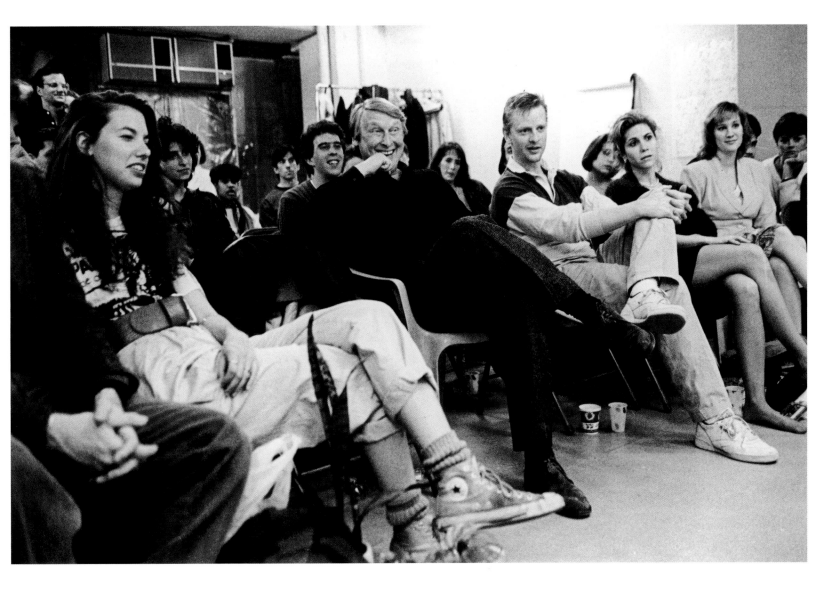

Hearts of Darkness

"Tragedy will probably always elude Woody Allen's grasp," *The Times* critic said, reviewing Allen's unrelentingly glum play *A Second Hand Memory*, "but he certainly has a firm grip on misery." It ran for two months.

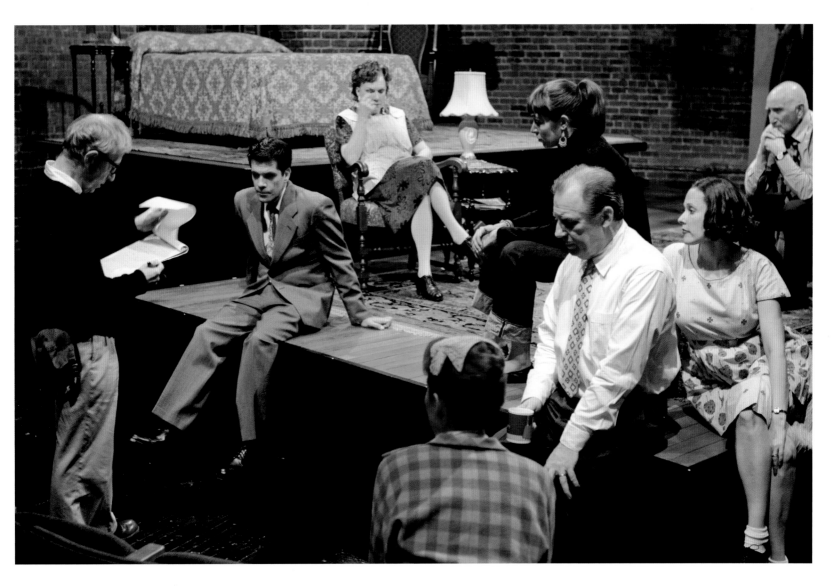

Music of the Night, Every Night

Much as she had for the past seventeen years, Thelma L. Pollard applies makeup to Howard McGillin for the title role the night *The Phantom of the Opera* broke the Broaway record for longest-running musical, held previously by another Andrew Lloyd Webber extravaganza—*Cats*.

Sara Krulwich/*The New York Times*

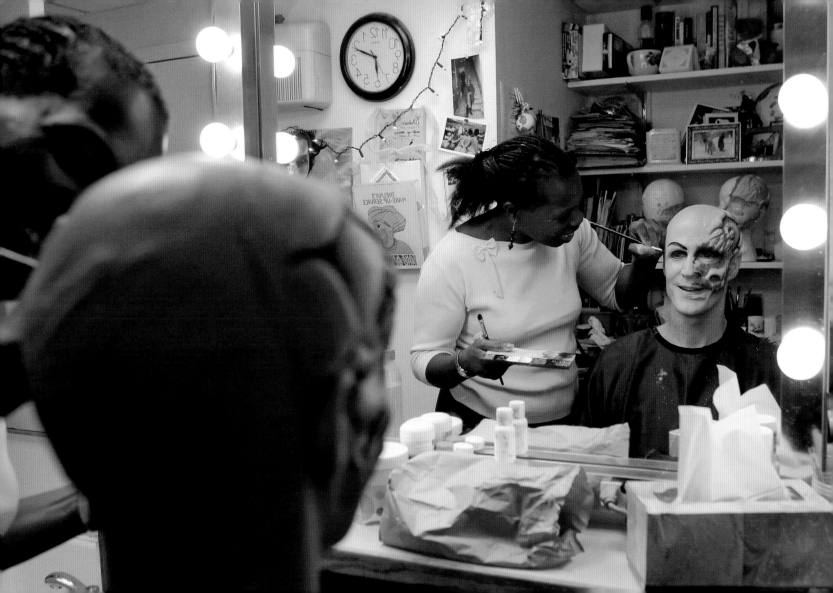

SEPTEMBER 29, 1983

One Night in 3,389

For once, on this night in 1983, *A Chorus Line* was not about getting the part; it was about setting the record as Broadway's longest-running musical. Its 3,389th performance was celebrated by the 332 actors who had rotated in and out of the cast in the eight-year run. Backstage, they put on their makeup and tried on their old top hats and gold-lamé jackets. Onstage, they sang "What I Did for Love" and danced their way into the history books. They also worked up an appetite: at the invitation-only supper that followed, the waiters served thirty pounds of caviar and thirty-five cases of champagne.

Fred R. Conrad/*The New York Times*

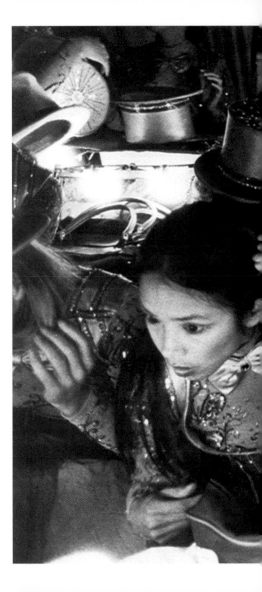

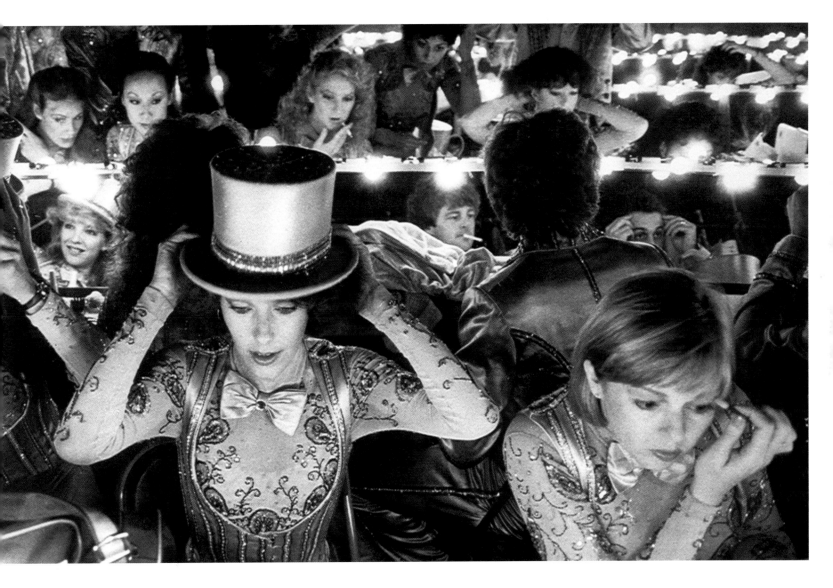

Opposite

Dancin' Man

"This show is about the sheer joy of dancing," director-choreographer Bob Fosse explained as he worked out a routine with Jill Cook, who starred in *Dancin'*. A year later, Fosse made a film that was all about him: *All That Jazz* was a portrait of a chain-smoking, caffeine-fueled director-choreographer who, like Fosse, underwent heart surgery, only to die later of a heart attack.

Jack Manning/*The New York Times*

Overleaf

Christmas Spectacle

In the vast darkness of Radio City Music Hall, parents lean close to children they have dragged along and whisper what parents always whisper when the Rockettes are strutting or kicking or tumbling like dominoes on the stage — Christmas just would not be Christmas without them.

Ruby Washington/*The New York Times*

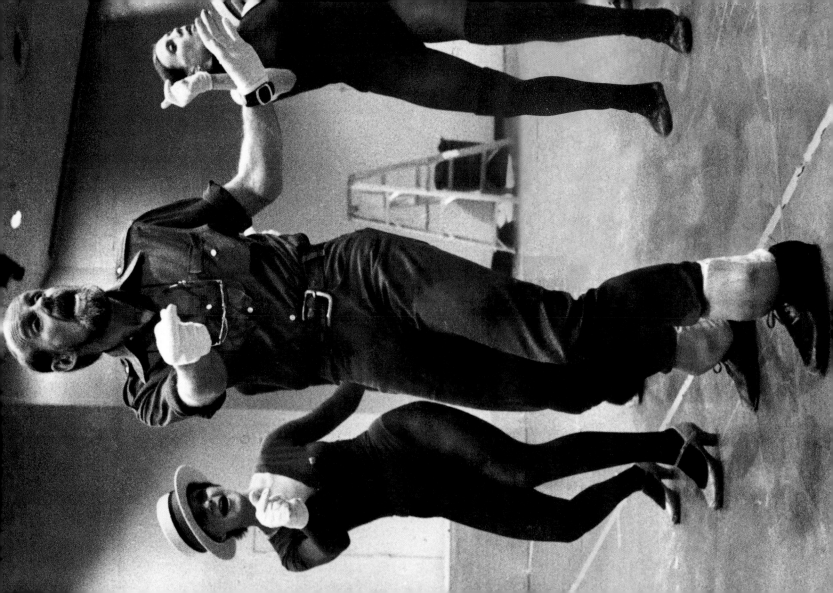

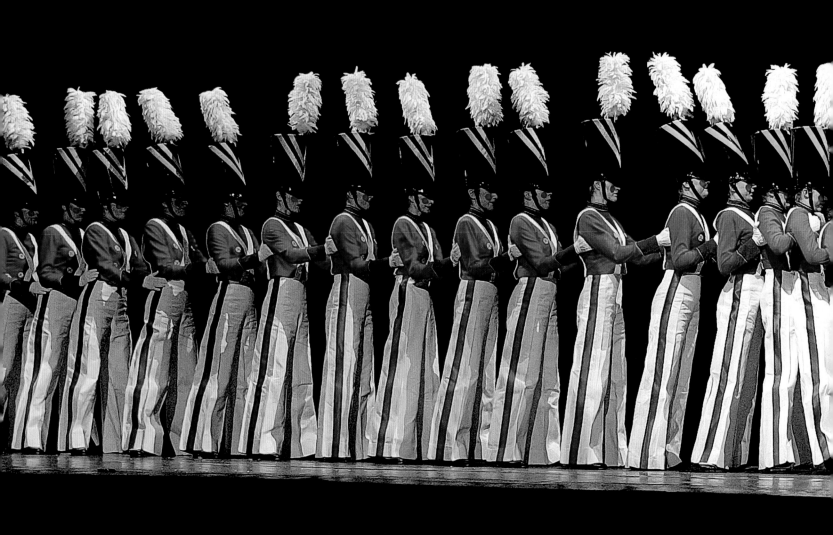

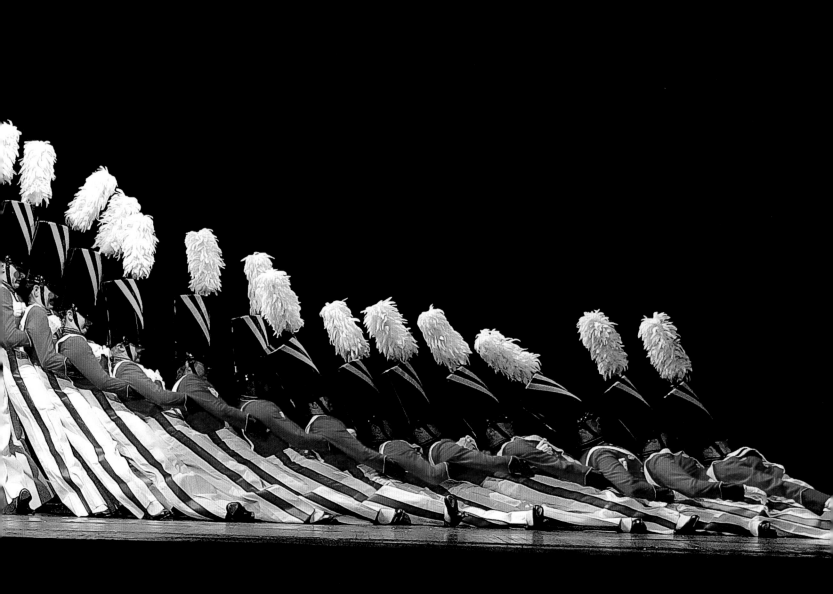

Opposite

JUNE 15, 1972

A Final Touch

He had escaped the Soviet Union, founded the School of American Ballet and made *The Nutcracker* a Christmas tradition in New York. Here, George Balanchine adjusted a dancer's headdress during a rehearsal for a week-long Stravinsky festival at the New York City Ballet.

Jack Manning/*The New York Times*

Overleaf

SEPTEMBER 9, 1990

Ballet by Martha

At ninety-six, the peerless choreographer Martha Graham was still at the center of things as her company rehearsed the lighthearted "Maple Leaf Rag" for a performance at City Center. The music was written by the ragtime king Scott Joplin. Graham said that her longtime pianist, who called her "Mirthless Martha," had often played Joplin to lift her "out of the fog I was in, trying to create."

Jim Wilson/*The New York Times*

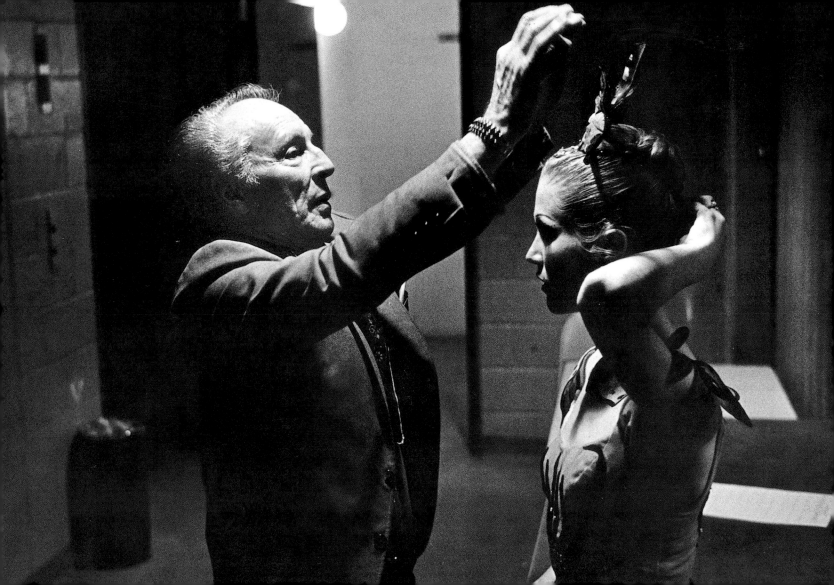

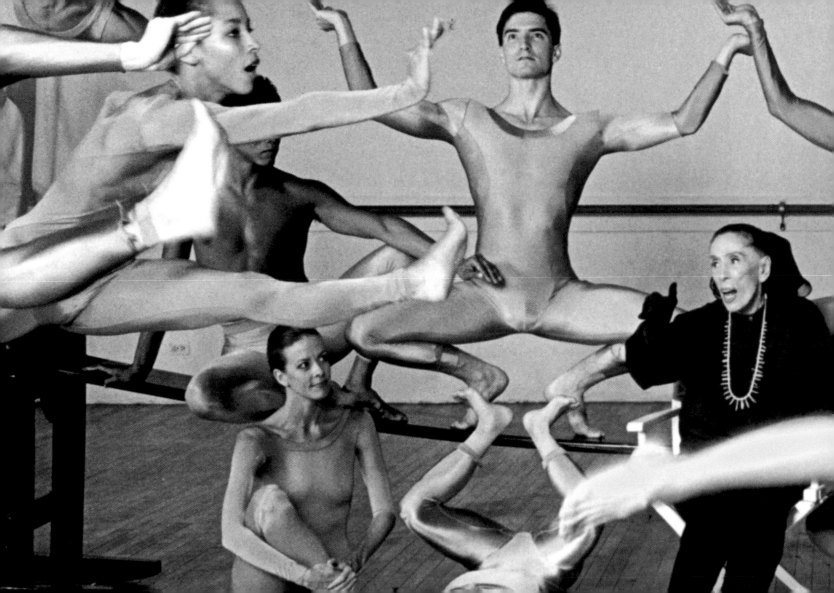

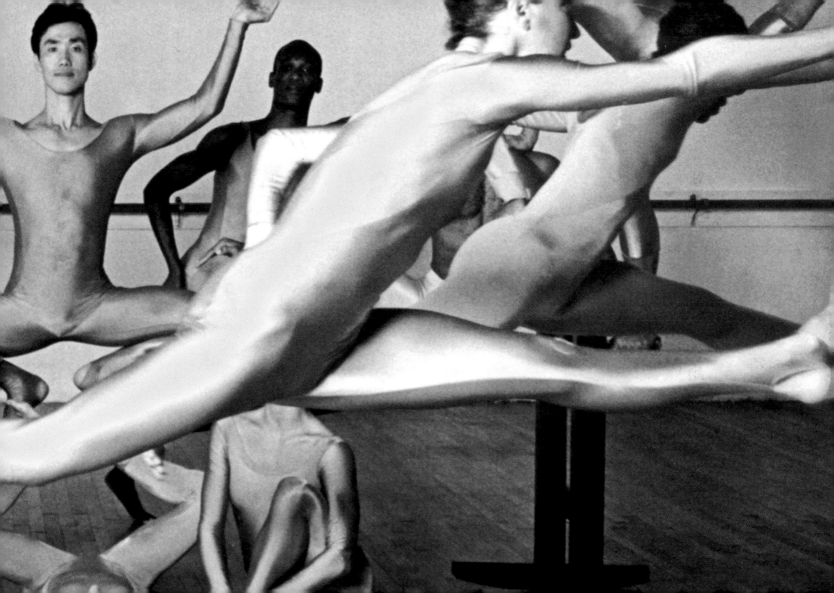

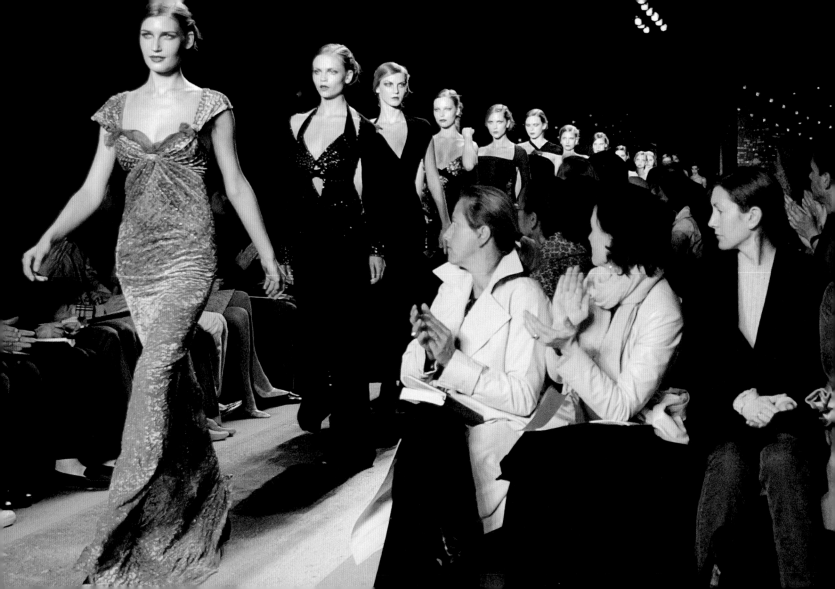

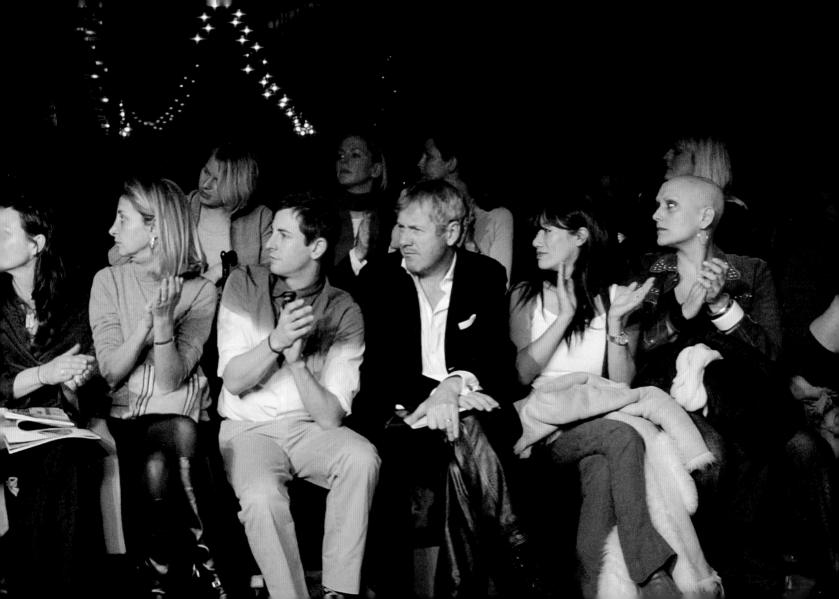

Previous

FEBRUARY 13, 2004

Fall Fashions, in February

For the audience, a fashion show is a see-and-be-seen social event. For the designers, a fashion show can be a chaotic, down-to-the-wire ritual — and an important clue to future trends and sales.

Richard Perry/The New York Times

Opposite

MARCH 23, 1965

My Name Is Barbra

A ten-foot scaffold astride the handbag counter, cables snaking through the shoe salon, half-eaten delicatessen sandwiches littering the stationery display: this was Bergdorf Goodman on the night it became Barbra Streisand's personal television studio. For the special *My Name Is Barbra*, she sang, danced, and clowned her way through a fashion show in the store, wearing outfits and hats by Halston, seen here prepping the star.

Jack Manning/*The New York Times*

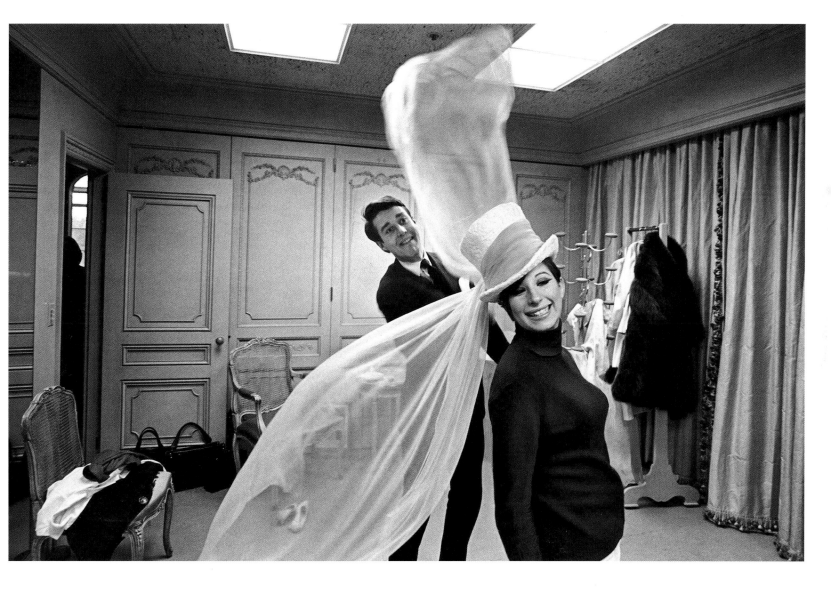

Singing in the Rain

Dripping wet in an orange sequined bodysuit, Diana Ross kept singing when a thunderstorm drenched Central Park during a free concert. Finally, after about twenty-five minutes of a percussion-and-light show from the sky, she told the crowd to leave. About thirty people had to be hospitalized because fights broke out. Ross returned to the park several days later for a makeup concert under cloudless skies.

Jim Wilson/*The New York Times*

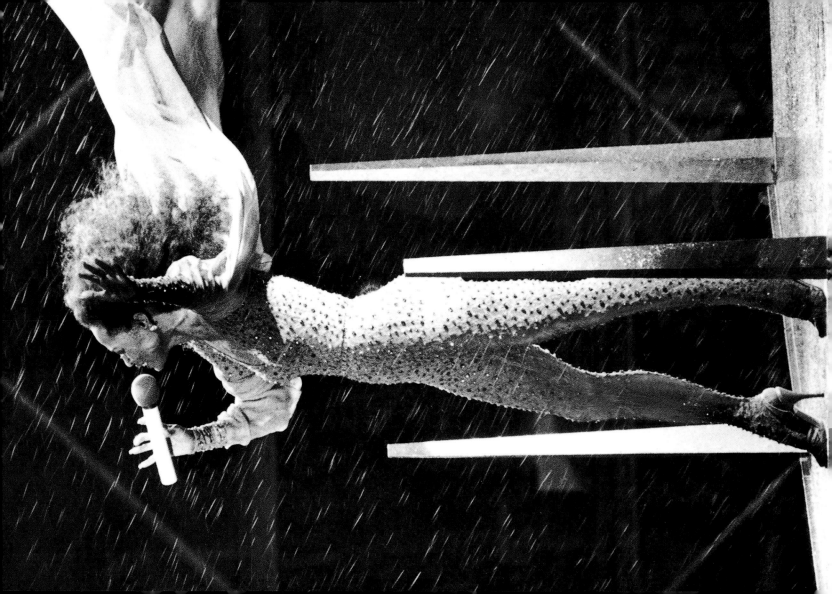

Opposite

Song and a Sandwich

For generations of down-on-their-luck songwriters and waiting-to-be-discovered actresses, the Automat was a cheap, no-frills hangout. Then, in 1972, *The Times* reported that the Automat in Times Square had decided to add "fun to the food" by hiring a former vaudevillian named Edna Thayer as "the Jenny Lind of the steam tables."

Jack Manning/*The New York Times*

Overleaf

Beatlemaniacs

When the Beatles arrived in New York, *The New York Times* reported: "There were girls, girls, and more girls. Whistling girls. Screaming girls." Here they whistled and screamed on the sidewalk opposite the Plaza Hotel, where the Beatles stayed.

Carl T. Gossett Jr./*The New York Times*

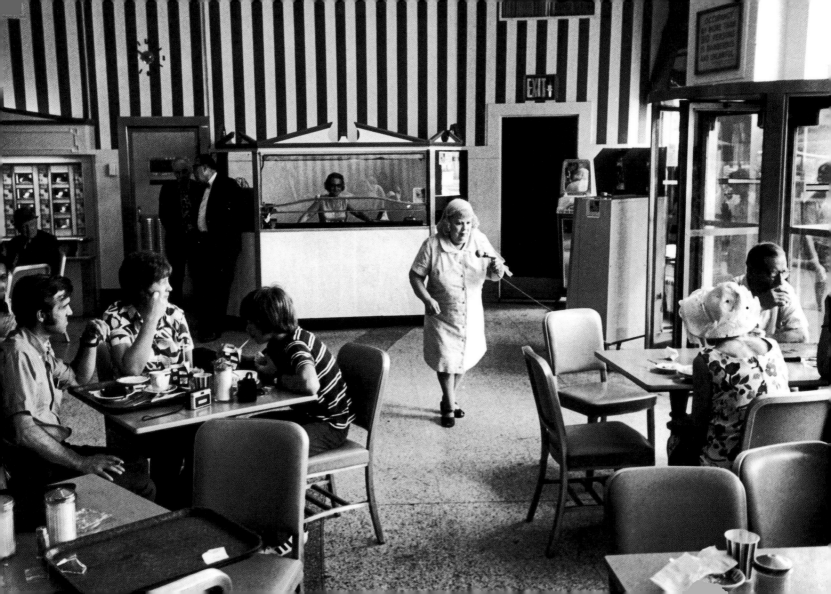

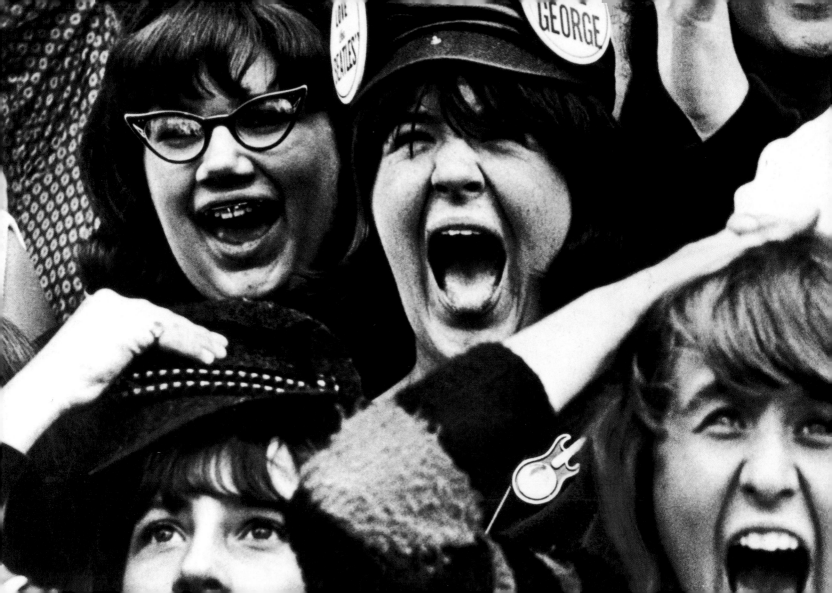

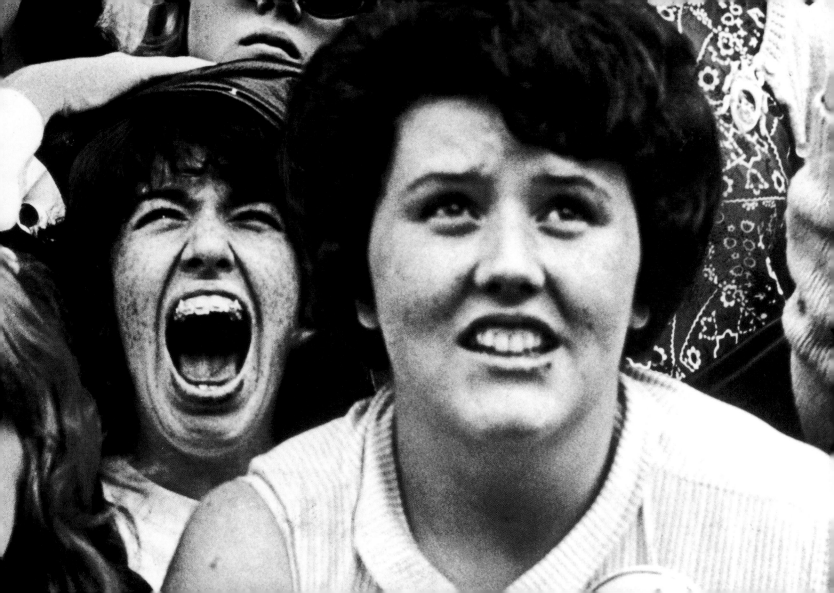

Princes of Pop

After storming the hip-hop world in the
1990s, the Neptunes — Pharrell Williams,
center, and Chad Hugo, right — became
two of the most sought-after producers
in the pop industry. They were the brains
behind the beats for hit songs by everyone
from Britney Spears to Ludacris to Marilyn
Manson. The addition of the vocalist Shay
Haley, left, transformed the Neptunes into
N.E.R.D. for *In Search Of . . .*, their 2002
rap-rock album.

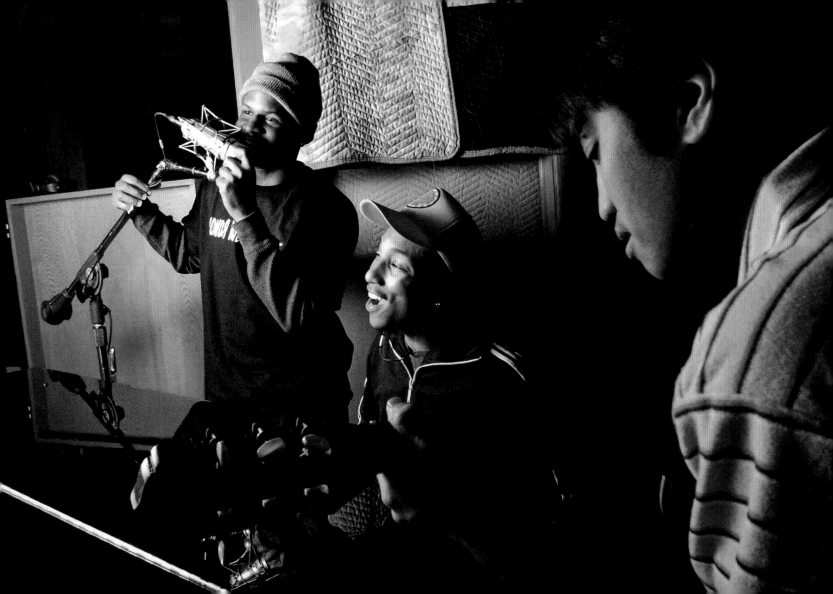

JANUARY 17, 2003

The Sexagenarian Stones

"It's All Over Now," they sang in 1964. Except that it wasn't: thirty-nine years later, with Mick Jagger and Keith Richards months away from turning sixty, the Rolling Stones were still going strong. As Ben Ratliff wrote in *The Times*, "The context of popular culture prevents the group from seeming like venal laughingstocks."

Richard Perry/*The New York Times*

Overleaf

SEPTEMBER 26, 2002

Northward Ho

Its name is the Flatiron Building, but its shape is not really that of a turn-of-the-century household flatiron, which would have been curved on the sides. So what does the Flatiron Building look like? To many neck-craning pedestrians, the answer is: an elegant ship, bound for somewhere uptown.

Vincent Laforet/*The New York Times*

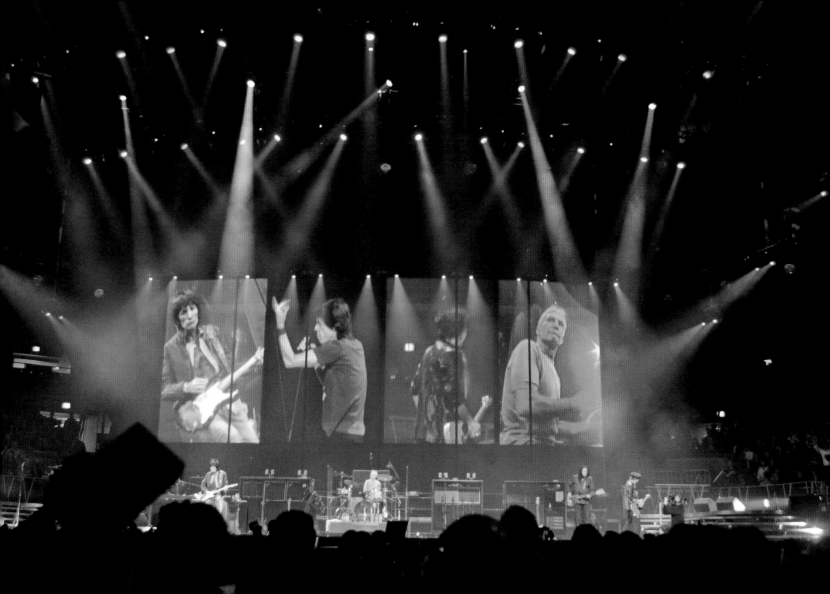

JANUARY 2, 1962

Dance, Baldini, Dance

Some cops walked the beat. Bernardino Lawrence Baldini, Patrolman First Grade, Traffic Safety Unit B, did a daily ballet on the pavement — a step back to block a cab turning left from the right lane, a step to the side to let a blur of chrome and fins zip by. In his double-breasted winter uniform and his white gloves, he was something to see. But he never danced off the job. "Not even with my wife, I'm afraid," he said.

Sam Falk/*The New York Times*

Overleaf

APRIL 14, 1934

Disarming Practice

Before they are sworn in as full-fledged officers, police recruits attend the New York City Police Academy, where they learn various ways to disarm criminals. Don't try this at home.

The New York Times Photo Archives

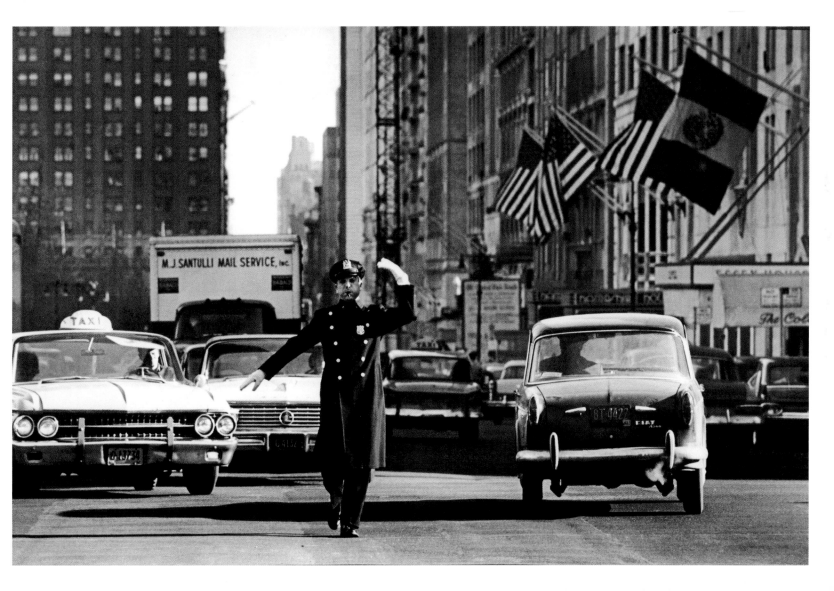

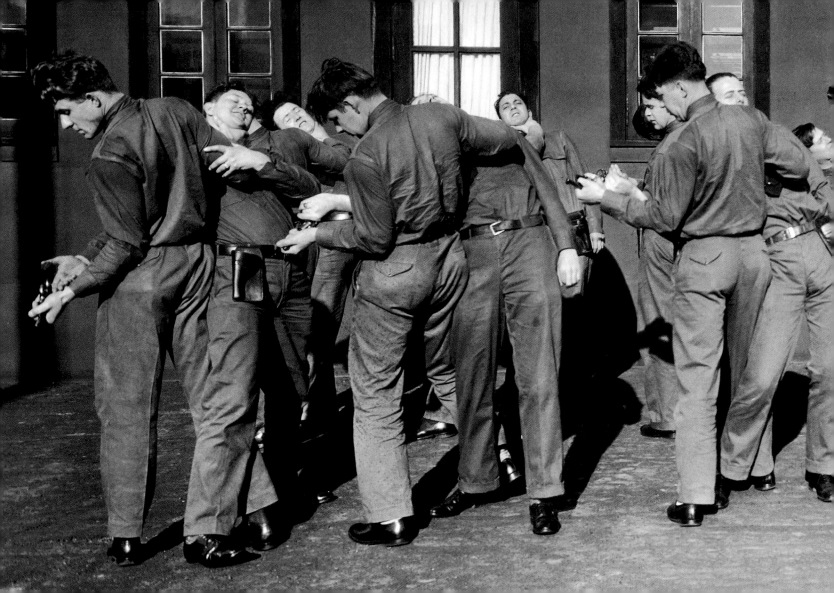

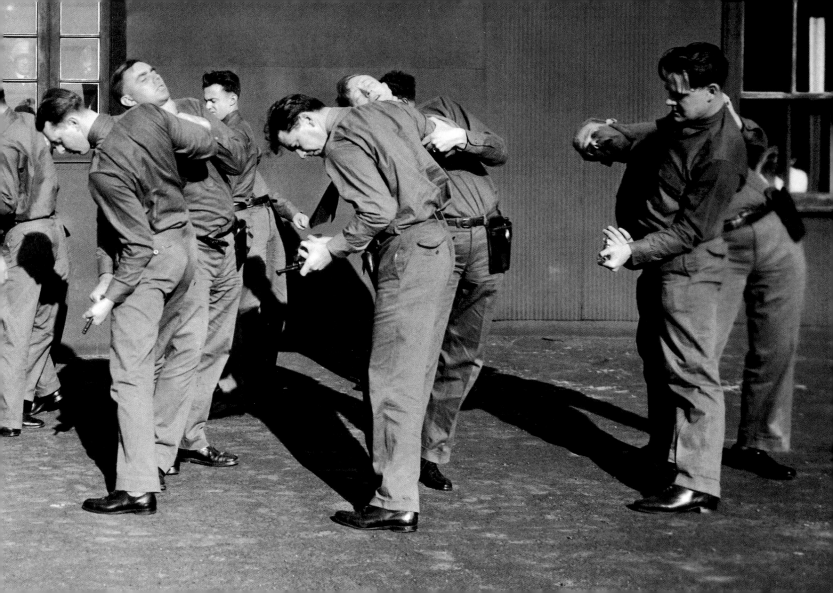

Bikers With Badges

Ten minutes to go two blocks: the police know how annoying after-theater traffic jams can be — they get stuck in them, too. When a plan to speed traffic through the theater district took effect in 1929, Police Commissioner Grover Whalen and three hundred officers were on hand with motorcycles that let them zip around the long lines of cars.

The New York Times Photo Archives

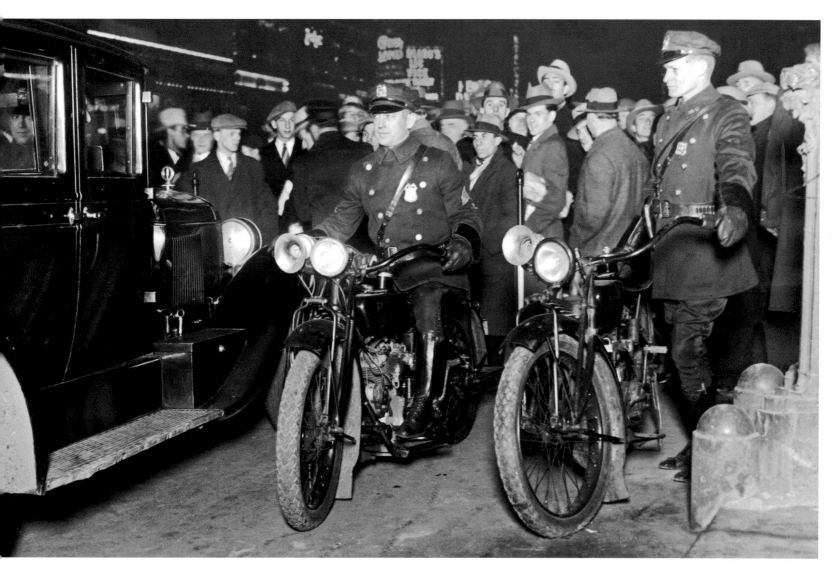

The "Mad Bomber" Was Here

When someone found what appeared to be a pipe bomb in a telephone booth in Grand Central Terminal, half an hour after a note signed the "Mad Bomber" had turned up in a different phone booth, the police department's bomb squad rushed in with a special steel-mesh container, just as it had time and time again in the 1950s. In all, the "Mad Bomber" planted twenty-two bombs that exploded, injuring fifteen people. Several others did not explode, among them this one. A few days later, the police arrested a disgruntled and disabled former electric company worker. He was sent to a hospital for the criminally insane after psychiatrists diagnosed paranoid schizophrenia.

Neal Boenzi/*The New York Times*

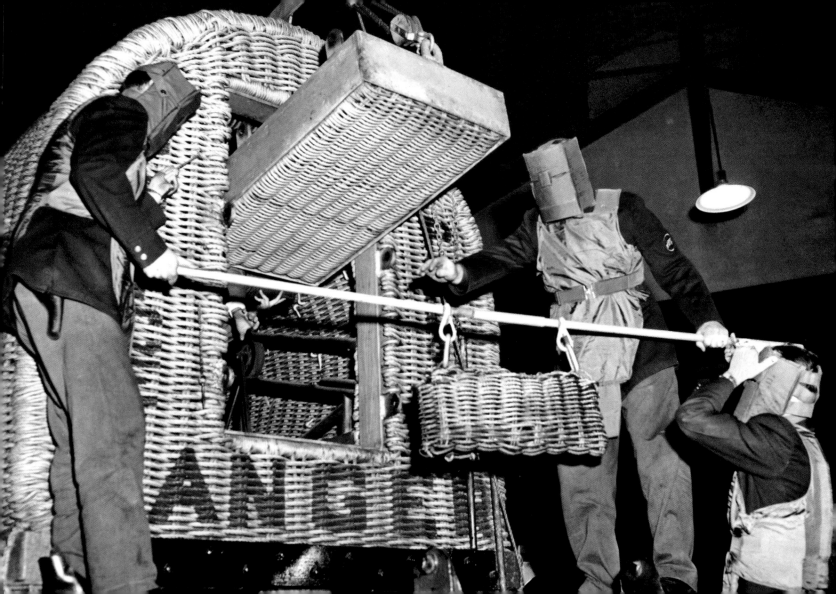

Infamously Reclusive

In their town house at Fifth Avenue and 128th Street, the reclusive Collyer brothers — Homer, a onetime concert pianist, and Langley, a lawyer who had been blind for years — lived amid mountains of books and newspapers, not to mention several pianos and a full-size automobile chassis. All this became known when someone called the police and reported that Homer was dead. Officers who broke through the barricaded door found Langley's body. According to the historian Jonathan Aspell, Langley had died of heart failure after setting off a booby trap, his idea of a burglar alarm. It took the officers longer to find Homer's body amid all the junk, and the newspapers had a field day until they did.

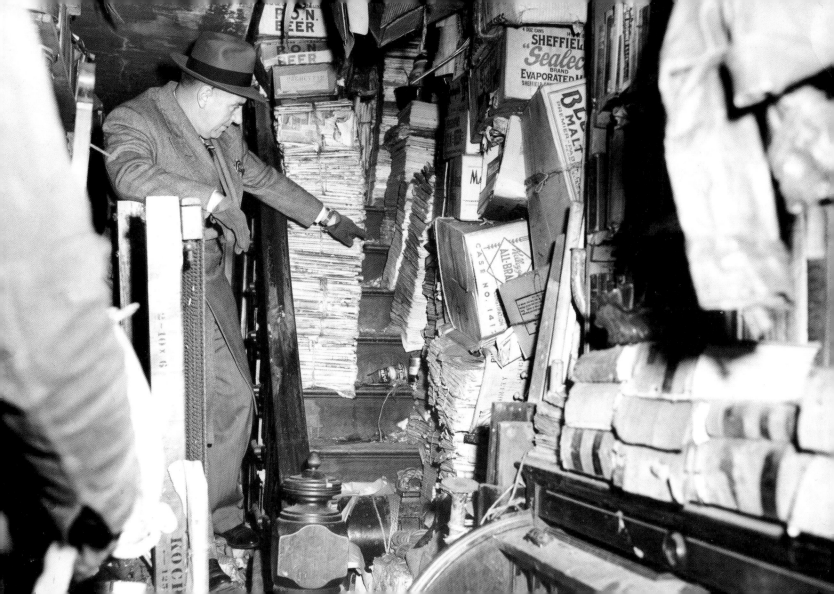

Interrogation

If not for the suits, uniforms, and haircuts, this interrogation scene in a Manhattan station house could have been ripped from last week's episode of *Law & Order*.

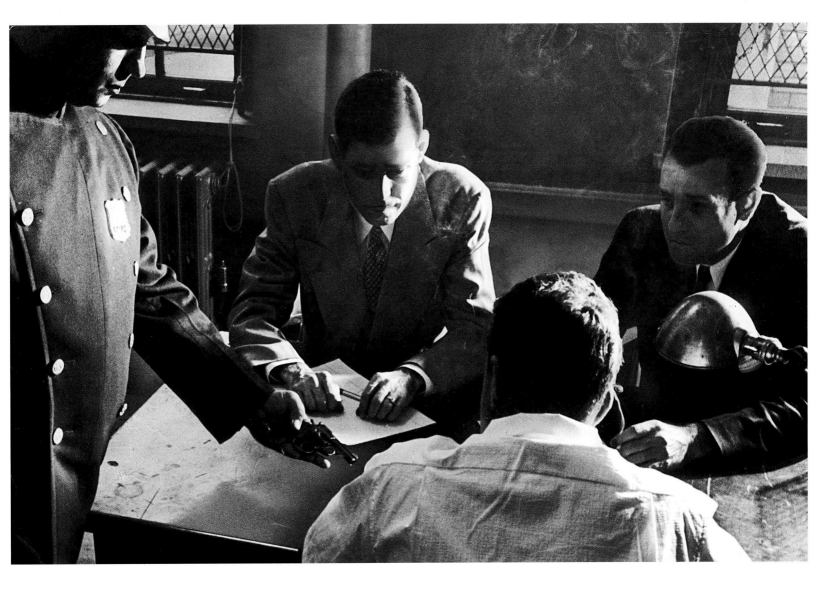

Manhunt

This officer was one of hundreds mobilized in the manhunt for a hit man named August Robles, whom *The Times* described as "5 feet 6 inches and 140 pounds of viciousness and guile." Robles had already escaped from custody twice, stealing three detectives' revolvers the second time. This officer could see into the East Harlem apartment in which Robles eventually died in a gun battle.

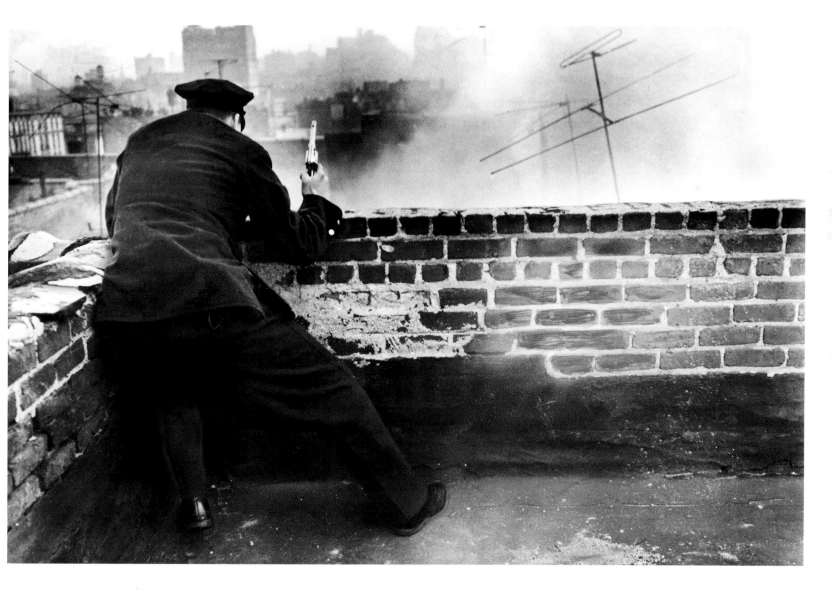

Just in Case
For this demonstration of bulletproof glass, Alvan Jacobson, whose nickname was "the human target," also wore a bulletproof vest, in case the gunman's aim was poor.

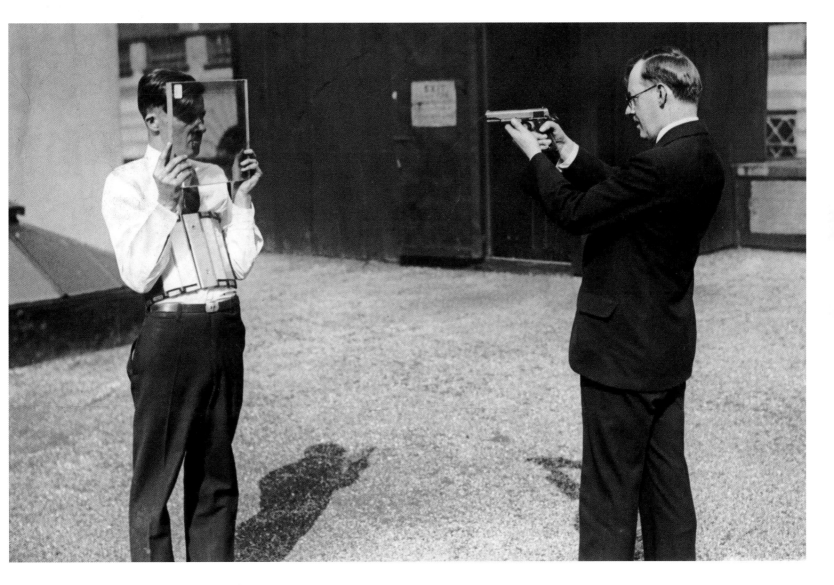

The Case of the Lingering Image

New York is no longer the nation's crime capital, if it ever really was. But it remains the headquarters for television crime shows, and the city and its actors are paid plenty for playing cops, robbers, judges, members of juries, prosecutors, witnesses, and victims. Here, Bobby Cannavale and Donnie Wahlberg (whose back is to the camera) appear in a scene for a pilot, a program that had been offered to NBC but ultimately did not make it onto the air. It was conceived by an officer-turned-producer, Sonny Grasso, who had been at the center of the famous "French Connection" drug-smuggling case.

James Estrin/*The New York Times*

DECEMBER 20, 1922

The Last of the Fire Horses

When the call came in, the firemen climbed aboard the fire engine, grabbed the reins, and galloped off. Out in front were the showiest workhorses anywhere, by order of a chief whose careful eye was trained on closely matching each fire company's team. Like a horse show judge, he paid passionate attention to size, coloring, and markings. But another chief, years earlier, had found a new way to answer an alarm, in something called a Locomobile that had pistons and cylinders and an appetite for gasoline, not oats.

Pacific & Atlantic Photo

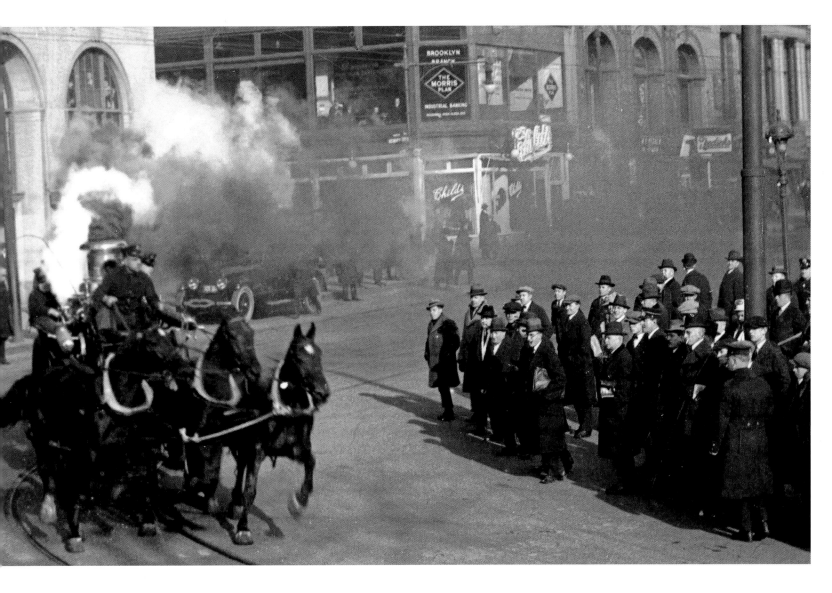

Opposite

Hats Off to the Fireboat

Hats off to the *H. Sylvia A. H. G. Wilks*! Hetty Sylvia Ann Howland Green Wilks was the widow of a great-grandson of John Jacob Astor and famously frugal: she ordered the family homestead torn down to save on taxes. As for the *H. Sylvia A. H. G. Wilks*, its five nozzles could pump eight thousand gallons of water an hour. It chased fires until it was decommissioned in 1972.

Eddie Hausner/*The New York Times*

Overleaf

Ladders Up

"Fire-fighting today is an engineering job and not just a matter of sprinkling water on a fire," Mayor Fiorello H. La Guardia declared when a dozen newly delivered hook-and-ladder trucks arrived at City Hall. Demonstrating them was an acrobatic job: when the ladders were raised, a fireman was perched on the top rungs of each one.

The New York Times Photo Archives

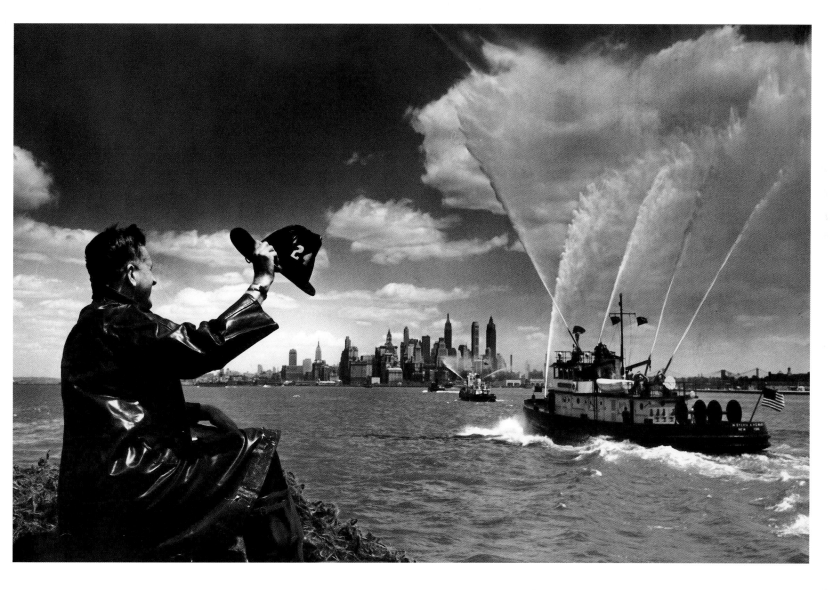

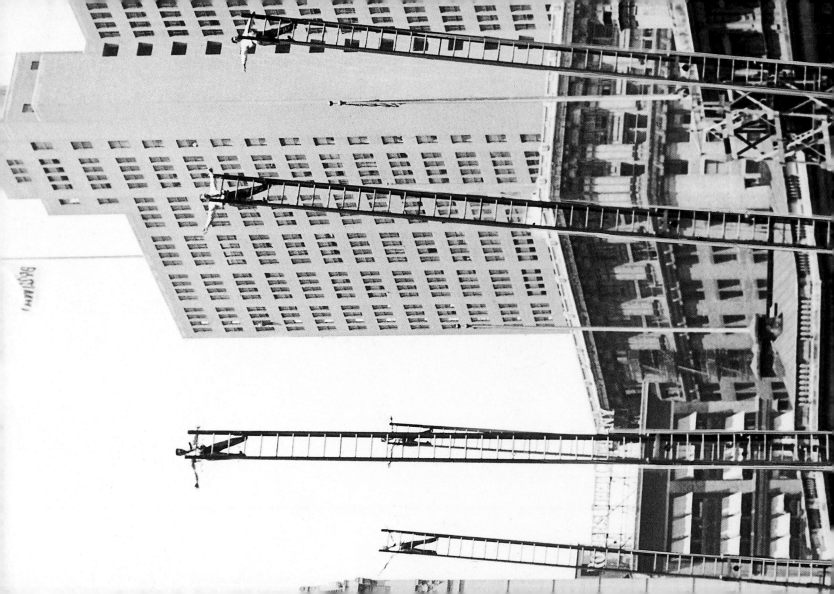

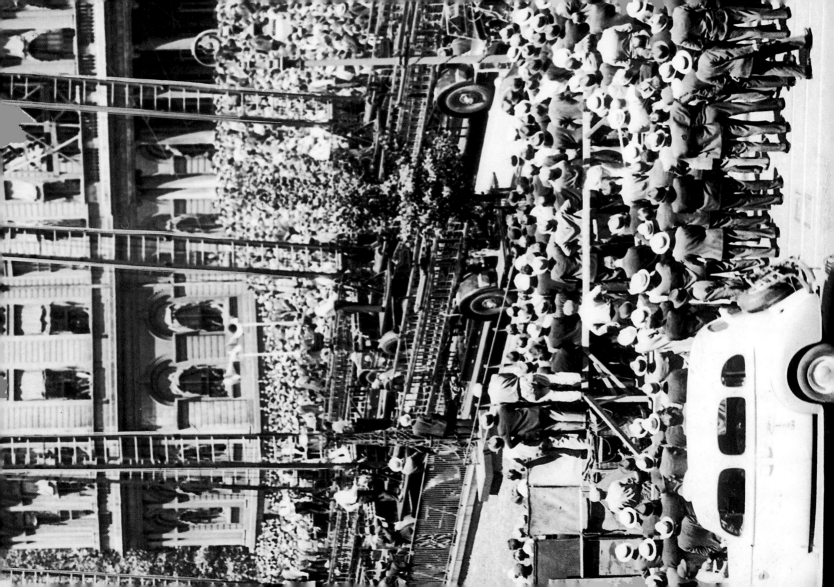

FEBRUARY 3, 1975

Shooting Hoops, Fighting Flames
These kids were so wrapped up in
shooting baskets that they seemed not
to notice the smoky blaze in the building
beyond their playground in East Harlem.

Paul Hosefros/*The New York Times*

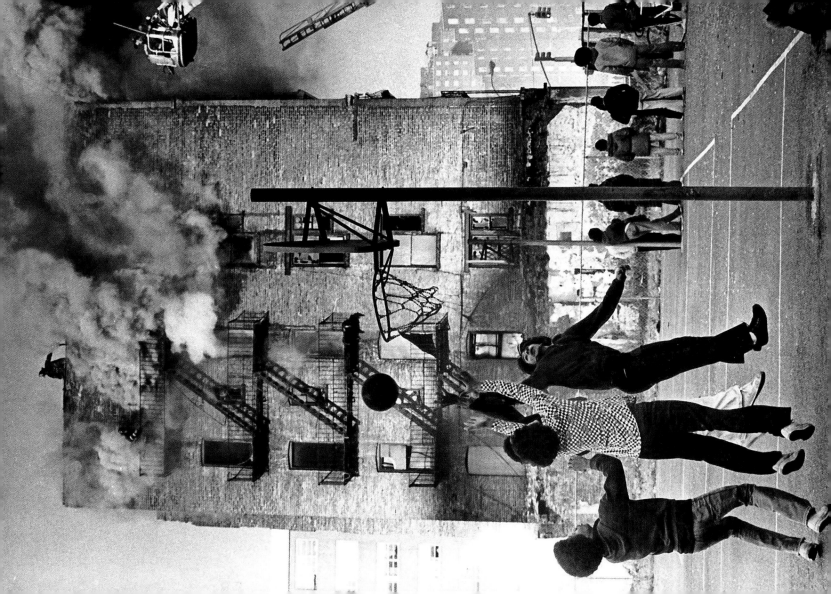

Opposite

Breathe Deep

When rubbish piled inside a long-shuttered subway station caught fire one afternoon, the tunnel filled with thick smoke. Some firefighters pulled hoses through the smoky tunnel while others used jackhammers to cut through the sidewalk so they could drop a ladder into the burning station. Five firefighters were overcome by heat and smoke.

John Orris/*The New York Times*

Overleaf

Reservoir, Forty-second Street Branch

What is now Midtown was still uptown when this team of horses clip-clopped along dusty Fifth Avenue. On one side are nearly new brownstones and stores; on the other, the fortress-like reservoir from which the city's drinking water was distributed. It was replaced a decade later by the New York Public Library.

The New York Times Photo Archives

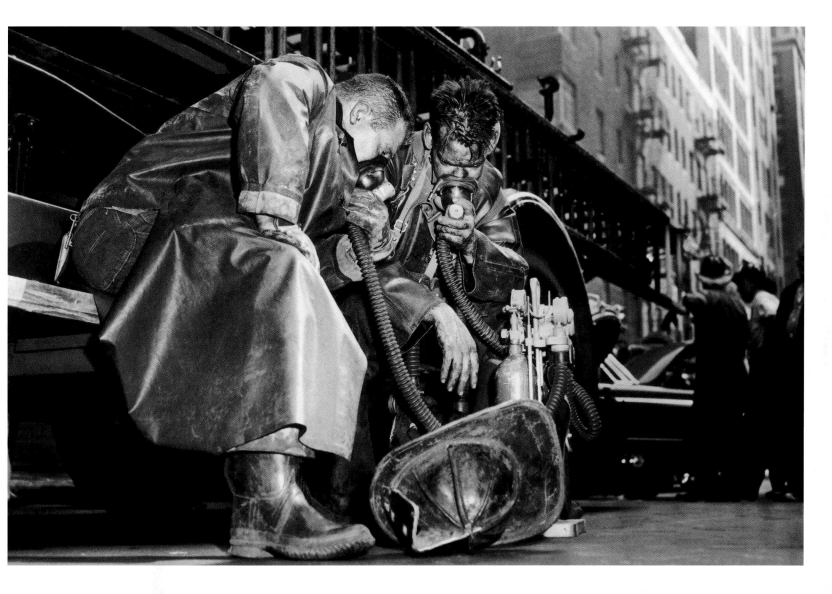

Under Construction

New Yorkers had plenty of time to decide whether they liked the New York Public Library's monumental building on Fifth Avenue at Forty-second Street: it took eleven years to build. It was three years from completion when these New Yorkers passed by, the men in the darkest of suits, the women in long skirts and hats with flowers, feathers, and veils.

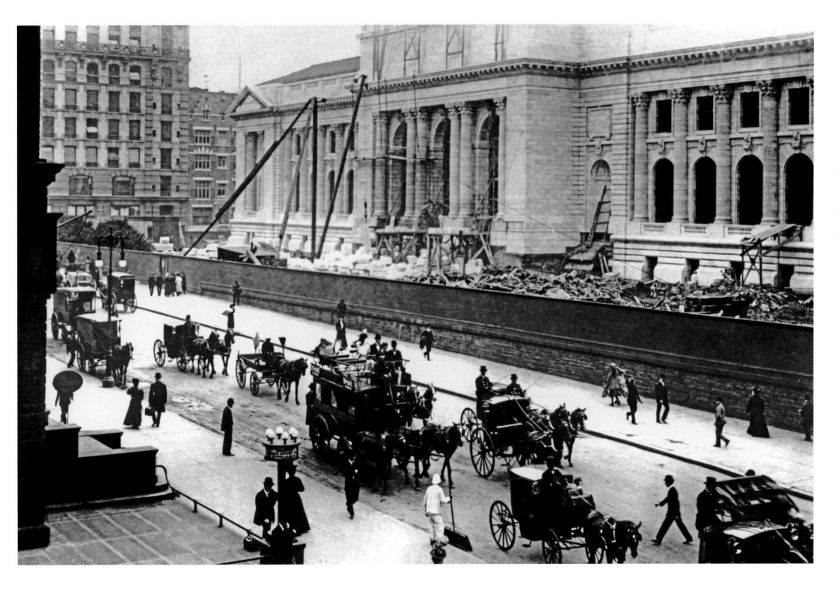

Main Reading Room

On its fiftieth anniversary, the New York Public Library said that it served more readers and researchers in more ways than any other library in the world. Many found their way to the main reading room. "With its cathedral-like ceilings, its wood panels, and its trompe l'oeil cloud covering," *The Times* observed years later, "this is the grandest of salons. And it is open to all."

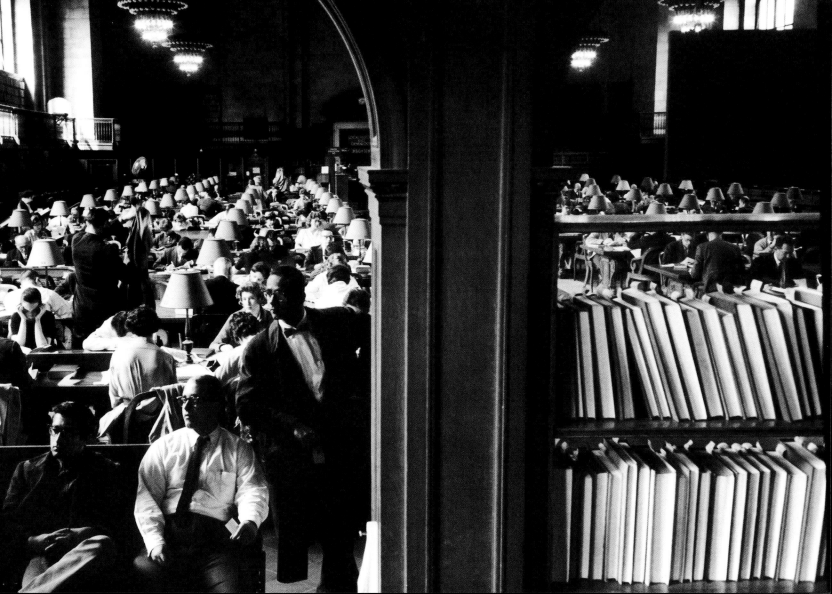

Saul Bellow, Underground

Sometimes celebrities ride the subway, unrecognized, and they do not even get a seat. Standing, facing the camera, ignored by the other passengers, is the author Saul Bellow. His novel *Humboldt's Gift* was a best seller at the time. Talk about life imitating art: that book, about a Pulitzer Prize-winning author, won Bellow a Pulitzer in 1976, the year in which he also won the Nobel Prize for Literature.

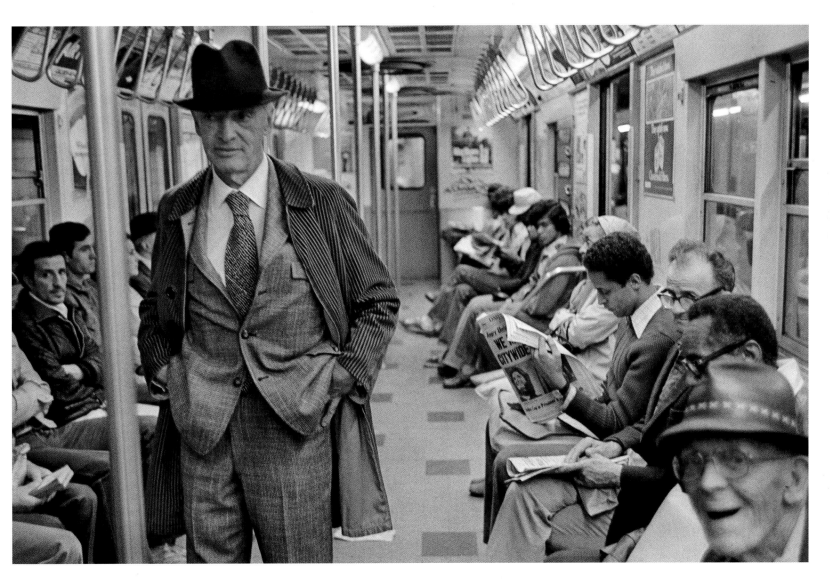

JULY 11, 1984

Through a Window

The photo shoot in the restaurant took maybe three minutes. The idea was to catch Norman Mailer's reflection in the window. But the woman in the Wimbledon T-shirt walked by, recognized Mailer, and started a conversation through the glass, using sign language. Having said her piece, she opened her newspaper, and the photo shoot resumed.

Fred R. Conrad/*The New York Times*

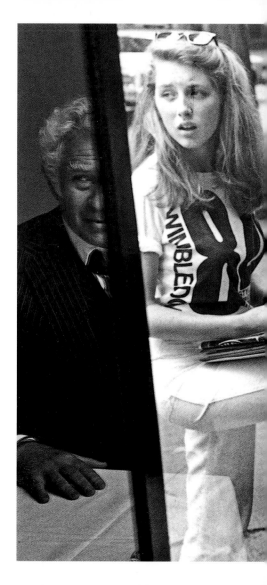

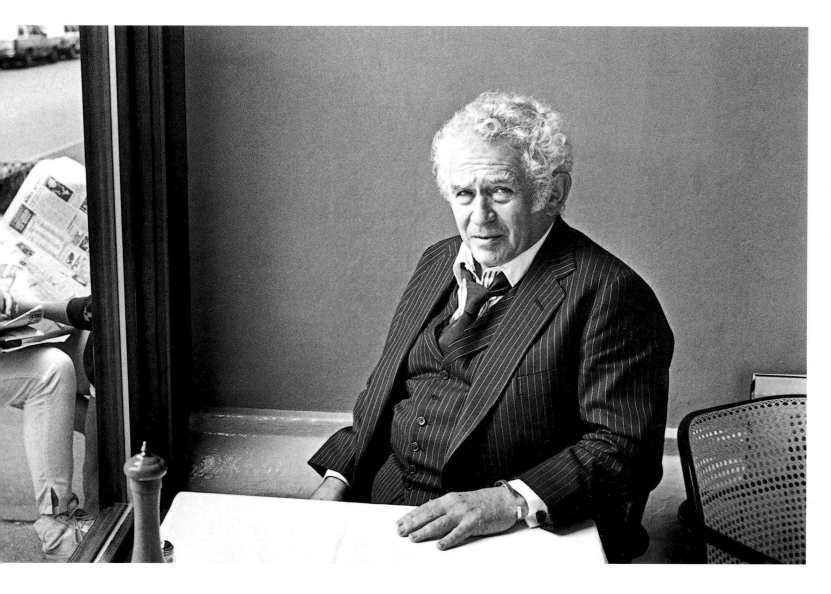

Masquerade

The author Truman Capote said he had paid thirty-nine cents at F.A.O. Schwarz for the mask he wore to his famed "Black and White Ball." His was not the only mask he bought: he had a stash for guests who arrived without one. His capital-S society crowd arrived in force, since being on his guest list was as important as being one of Mrs. Astor's four hundred had once been.

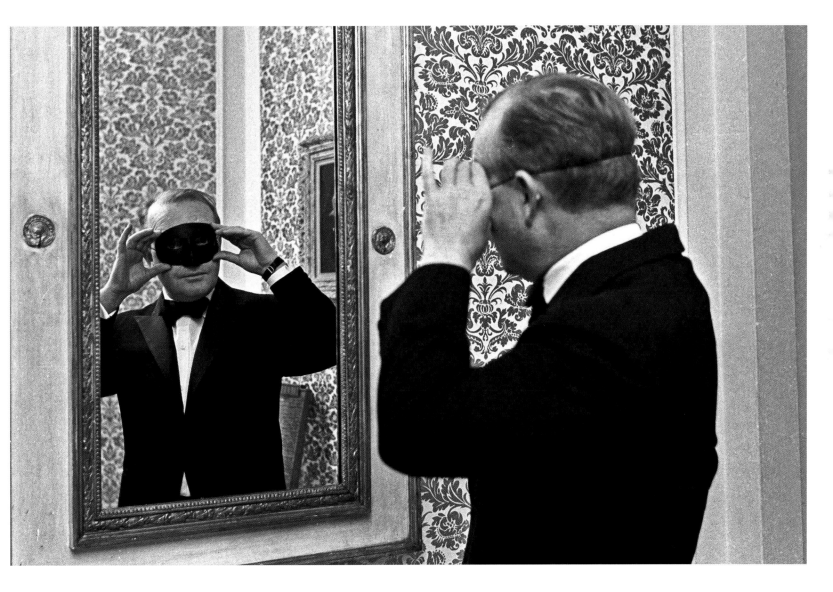

Café Society

P. J. Clarke's was the bar where Frank Sinatra had his own table, where Johnny Mercer wrote "One for My Baby," where Robert F. Kennedy waited in line with everybody else — and when everybody else was likely to include Yankee owner George M. Steinbrenner and crooner Tony Bennett. It was a checkered-tablecloth relic of a New York that disappeared with the Third Avenue Elevated train, an old pub that had been deep in shadow and now squinted at its new world.

Sam Falk/*The New York Times*

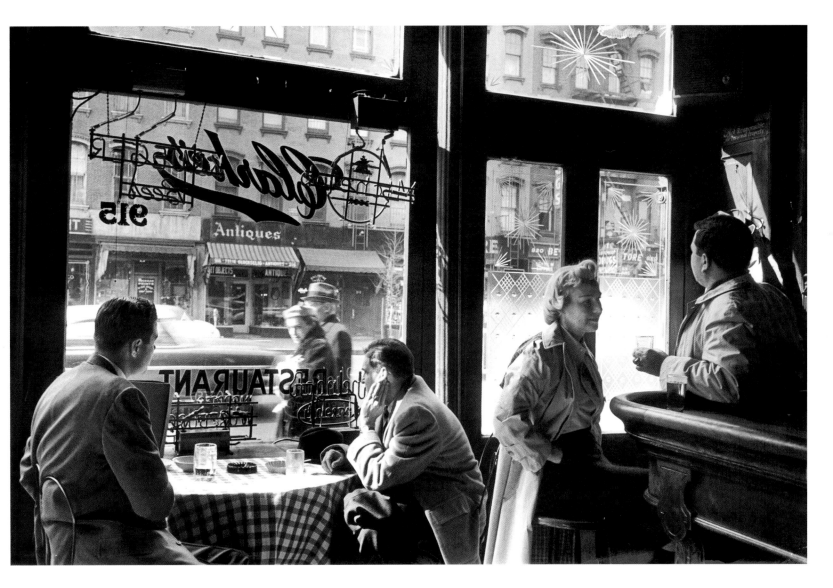

MARCH 1, 1964

Bohemian Rhapsody

At Café Figaro, on the corner of Bleecker and MacDougal Streets in the heart of Greenwich Village, cultural icons like Lenny Bruce and Larry Rivers dawdled over coffee, spouting poetry and talking late into the night. Bill Cosby would stop in and try out a comedy routine. Bob Dylan was a regular, too, until the Figaro's owner barred him for never picking up the tab.

Sam Falk/*The New York Times*

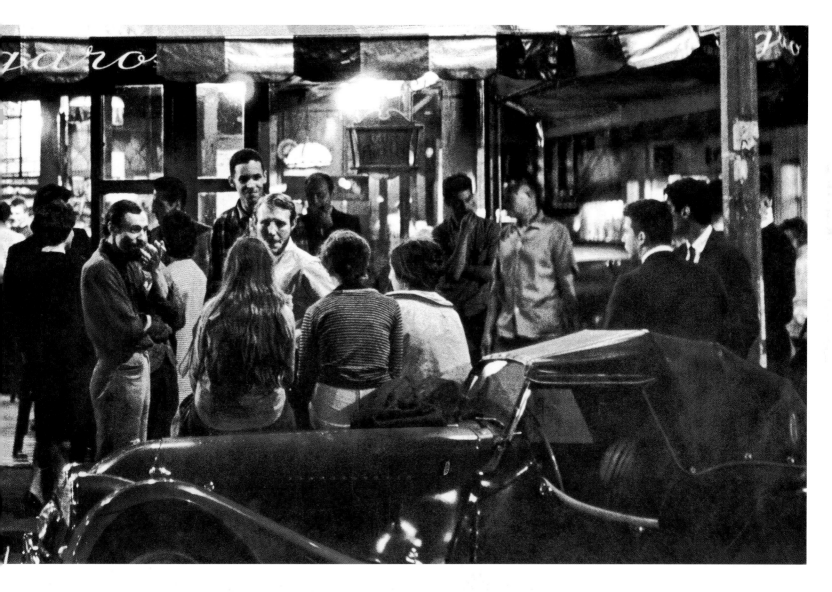

Saddle Up and Eat

Of the many lavish dinners during the Gilded Age, the one on horseback would be near the top of anyone's list. Cornelius Kingsley Garrison Billings, a gas company heir, celebrated the completion of his new trotting stable by inviting thirty-six guests and their mounts to Sherry's ballroom in midtown Manhattan. The diners, who ate from trays attached to their saddles, were served by waiters dressed as grooms. To make things seem somewhat authentic, there was a canvas backdrop of an English country scene. Plus turf on the floor, of course.

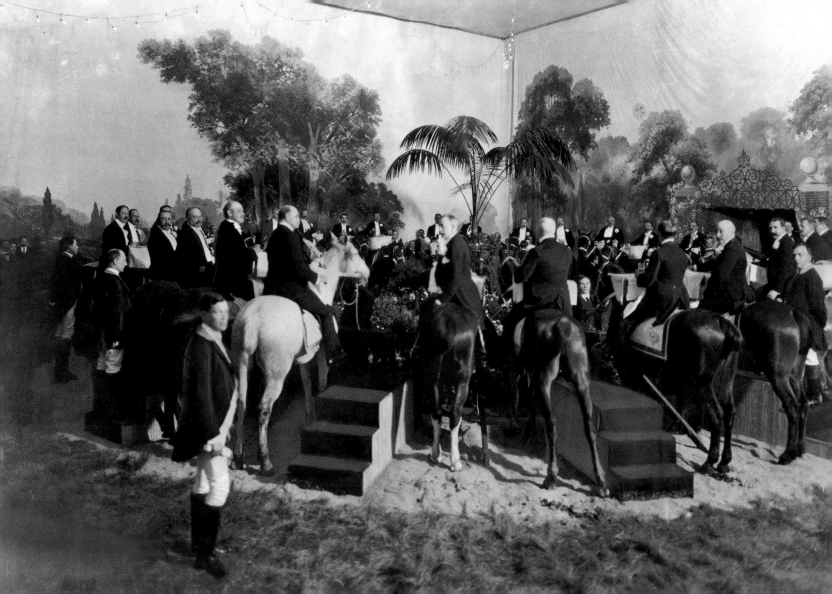

1974

Succulent Oysters of the Deep

The Oyster Bar in Grand Central Terminal is a throwback to the days when New York was, in the words of the historian Mark Kurlansky, "overtaken by oystermania." When it opened, in 1913, enormously rich oyster beds within easy reach of Manhattan were yielding tons of oysters every day.

Don Hogan Charles/*The New York Times*

Overleaf

SEPTEMBER 17, 1997

Windows on the World

Windows on the World, the restaurant atop 1 World Trade Center, "seemed suspended halfway between the earth and the moon," William Grimes noted in a restaurant review in *The Times*, adding that the bar had "a shiny, modern, go-ahead quality that suited the city's soul." The city's soul grieved on the bright morning in 2001 when Windows was destroyed with the rest of the trade center.

Fred R. Conrad/*The New York Times*

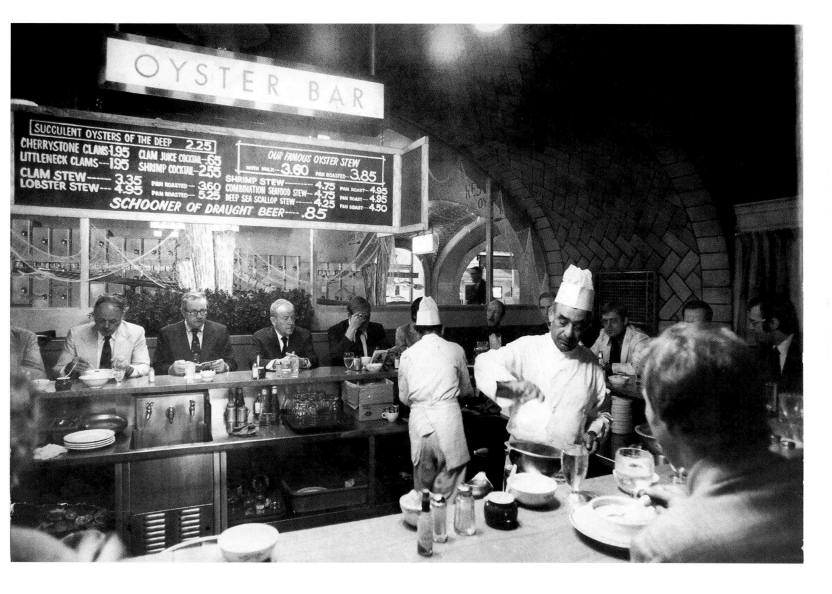

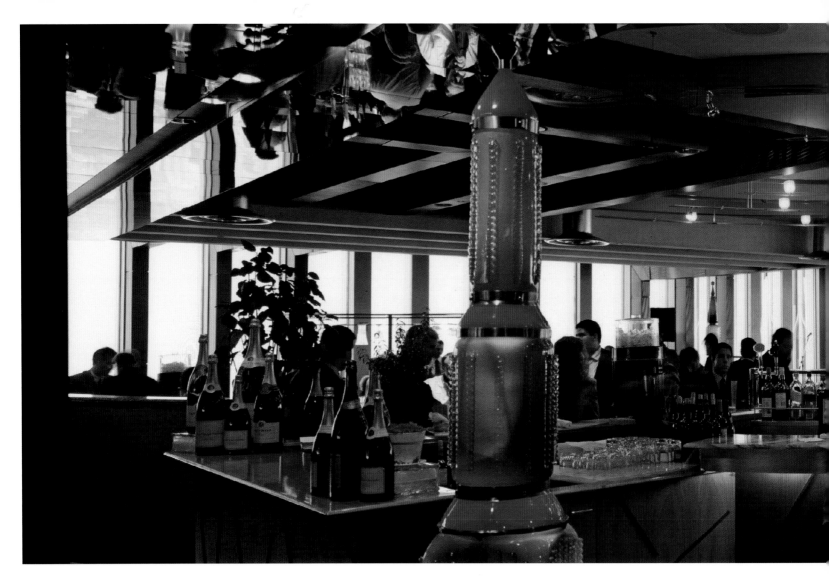

On the Roof

For New Yorkers who live in tall buildings, upward mobility is about accessibility, not status. In warm weather they clamber up the narrowest of stairs and the longest of fire escapes. They barge through the thickest of doors marked "Do Not Enter." There they enter the otherwordly universe of the rooftop. They drink, smoke, romance, sleep, raise pigeons, watch movies, and give parties.

Chang W. Lee/*The New York Times*

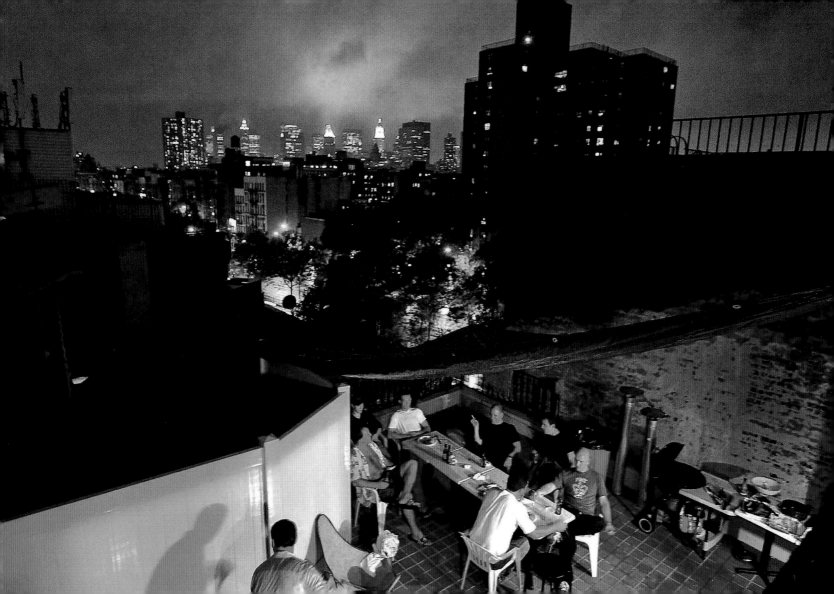

And This Is Only the Eighty-sixth Floor

King Kong's view of Midtown Manhattan, if he had bothered to look on his way to the top of the Empire State Building. The view is north, and that bright splash of light at the top of the frame is Times Square.

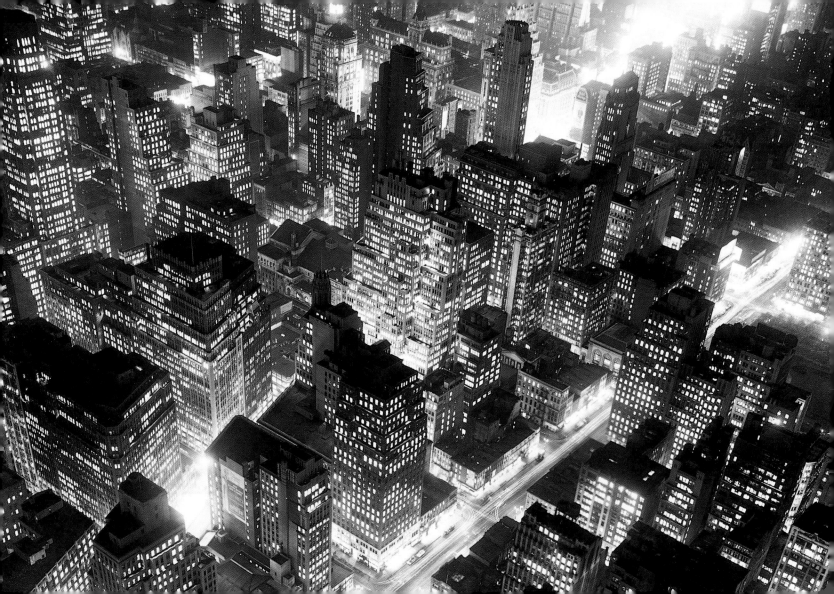

JUNE 17, 2003

Opposite

Biomorphic Benches

From high above, they look like little green amoebas and whatever it is that swims around little green amoebas in their grayish protozoan soup. Up close, it turns out, they are flower beds and the curving park benches in Federal Plaza in Lower Manhattan.

Vincent Laforet/*The New York Times*

JULY 2003

Overleaf

Billburg Artist

A painter on North Eighth Street in Williamsburg, Brooklyn, a neighborhood that became the city's self-proclaimed hipster capital in the mid-1990s. The artists who moved there, only to be followed by fledgling galleries and fashionable boutiques, called it "Billburg."

Nicole Bengiveno/*The New York Times*

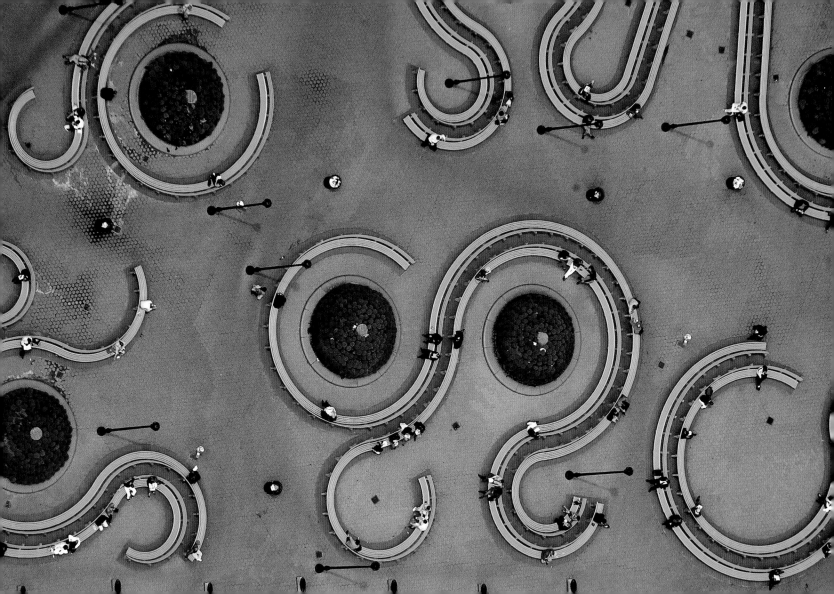

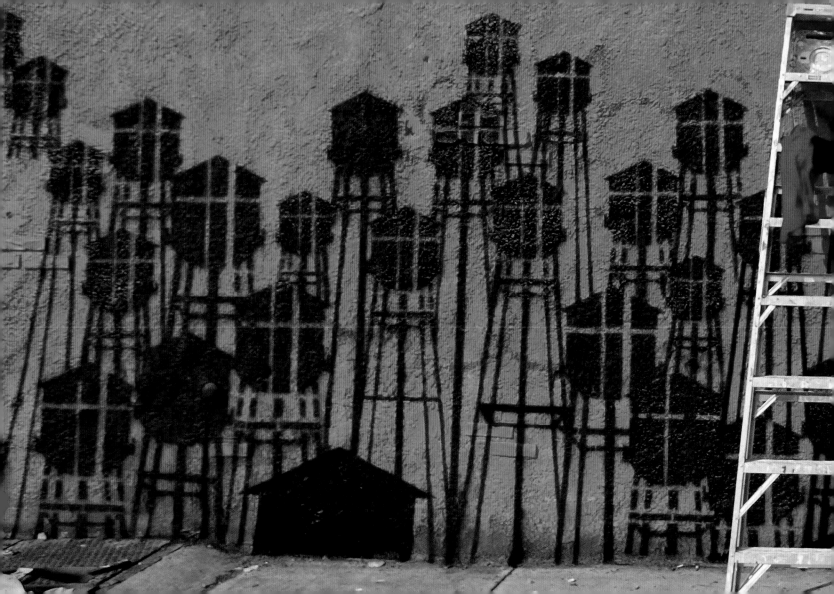

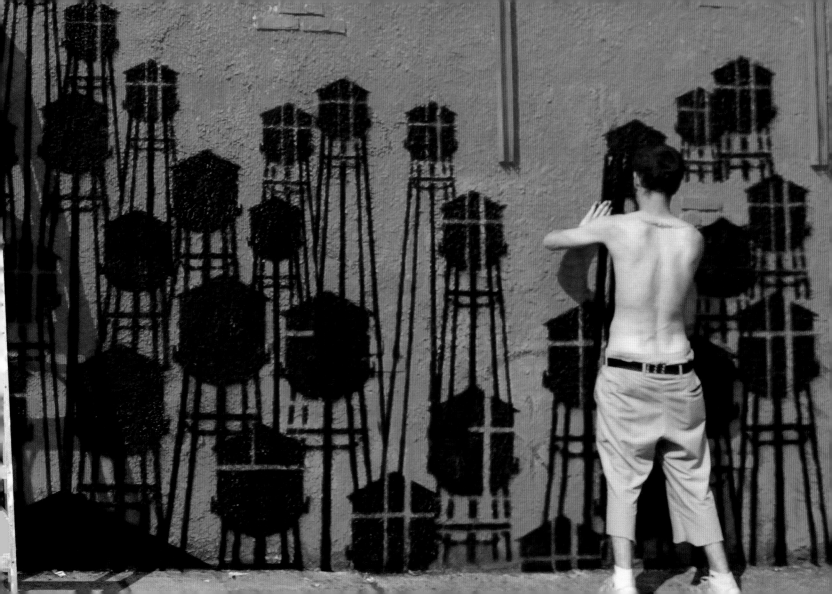

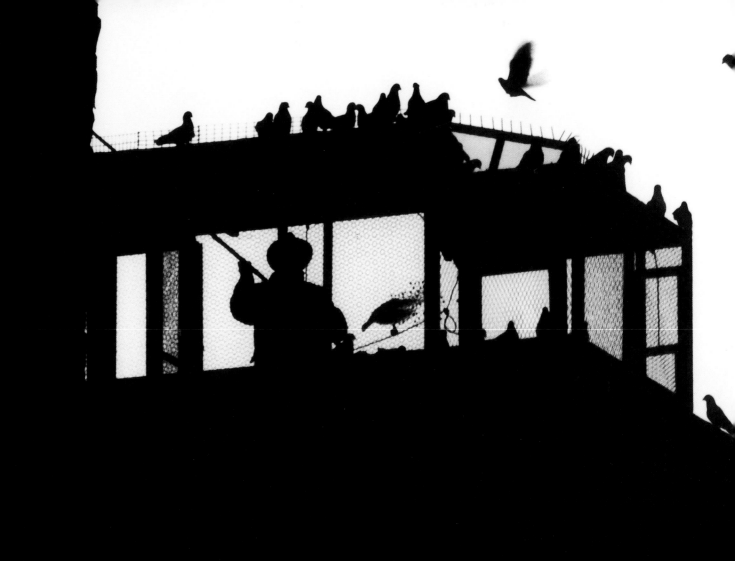

Previous

Big-City Pastoral

It looks like a scene from *On the Waterfront*: a pigeon fancier tending his flock, in this case on the Lower East Side.

Sam Falk/The New York Times

Opposite

A Pigeon's Best Friend

New York can be a tough place, even for pigeons. During a sleet storm in 1941, their wings iced up in midflight and they were "dropping like flies," reported *The Times*, employing an unfortunate metaphor. Animal rescue workers nursed twenty pigeons back to full strength, and later released them where they had been found — at the monument to the battleship *Maine* outside Columbus Circle. As *The Times* put it, "The significance of the locale is uncertain, unless it was a reminder to them to remember the rain."

The New York Times Photo Archives

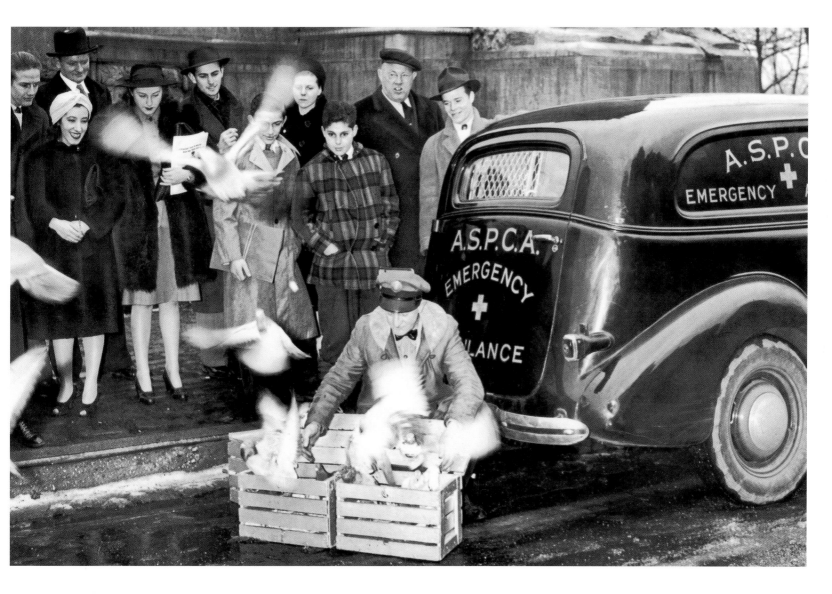

Cleaning the Flora and Fauna

That is not how it is done in the jungle or the zoo. But museum elephants need vacuum cleaners and feather dusters, not watering holes, mud baths, and the hot sun. The annual cleansing of animal, vegetable, and mineral exhibits at the American Museum of Natural History wore out 144 mops, ran through 150 cases of soap, and took about a month.

Ernie Sisto/*The New York Times*

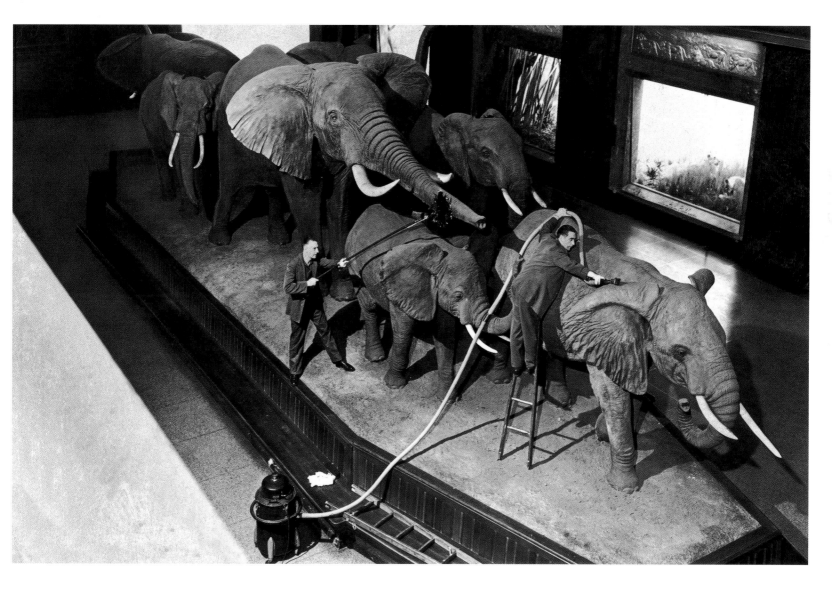

Ready for Winter

The thing about this photograph that makes you do a double take, looking at it through your twenty-first-century eyes, is not what it shows, but when it was taken. As late as 1941, delivery wagons moved at the one-horsepower speed of old Jimmy. What the photograph shows, by the way, is an official of the Humane Society handing out blankets to keep the horses warm as they make their rounds in winter.

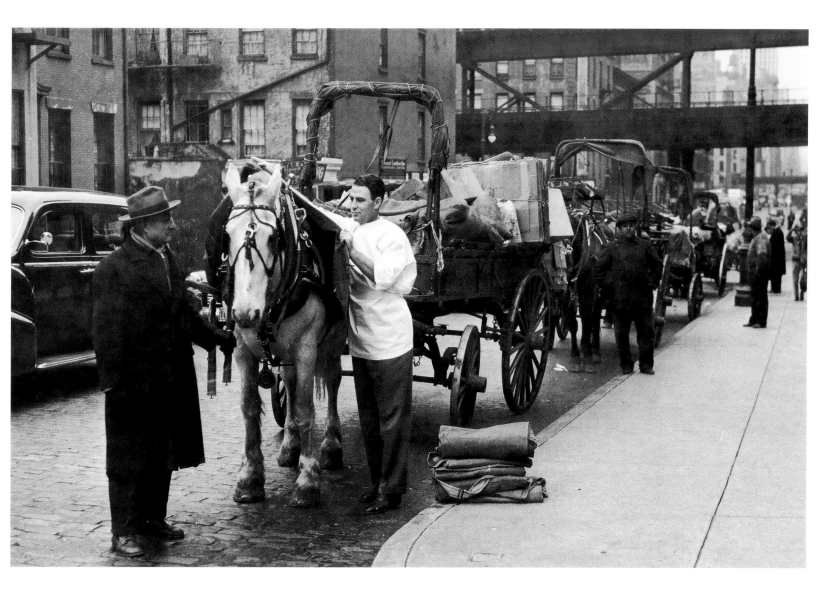

A Bronx Birthday Treat

One of these guys — Pete, the one with the big mouth and the two intimidating molars — is celebrating his forty-fourth birthday. The other guy knows that when Pete opens wide, he prefers a mouthful of hay and three heads of cabbage to cake and candles. Pete, the oldest tenant at the New York Zoological Garden, was forty-nine years, six months, and nineteen days old when he died in 1953, still the record age for a hippopotamus in captivity.

Arthur Brower/*The New York Times*

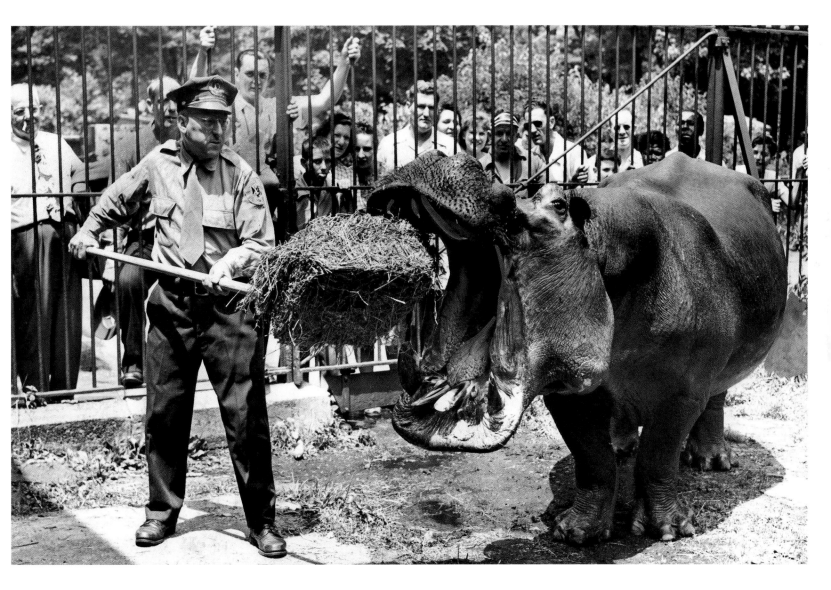

Why Eng Is All Alone

The Bronx Zoo had two snow leopards, Eng and Chang, until the night Chang got out of his cage after closing time. A watchman found Chang out in the open and did the only thing he could think to do: he pulled out his revolver and fired five quick shots. All five missed. The chase, joined by zookeepers who heard the shooting, went on for two hours until a police officer with a shotgun arrived and fired the shot that finally killed Chang. The zoo was left with Eng, who, *The Times* said, was "as evil and vicious as he can be."

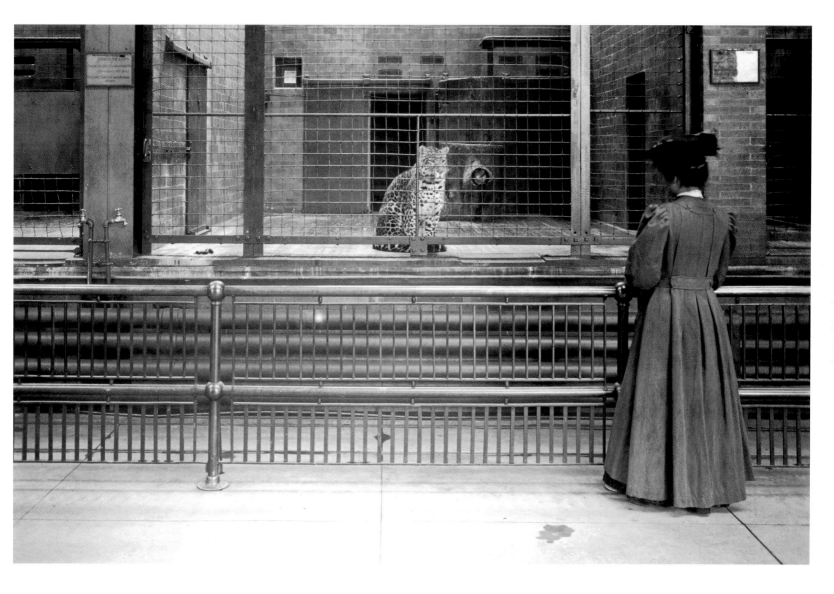

JUNE 29, 2001

Opposite

Up Close and Personal

A swimmer comes face to face with intrigued gawkers from the Ebenezer Preparatory School's summer camp program in Brooklyn. The walrus, one of four orphaned in Alaska, now lives at the New York Aquarium.

Ting-Li Wang/*The New York Times*

OCTOBER 15, 1963

Overleaf

Dinosaurs on the Hudson

When dinosaurs roamed the earth, they did not travel like this. These fiberglass beasts saw things that real dinosaurs would not have seen, like the Statue of Liberty, the Brooklyn Bridge, and the giant stainless steel Unisphere at their destination, the 1964 World's Fair. Their ancestors would not have heard the three-blast salute sounded by the cruise ship *Leonardo* as the dinosaurs' barge glided by.

John Orris/*The New York Times*

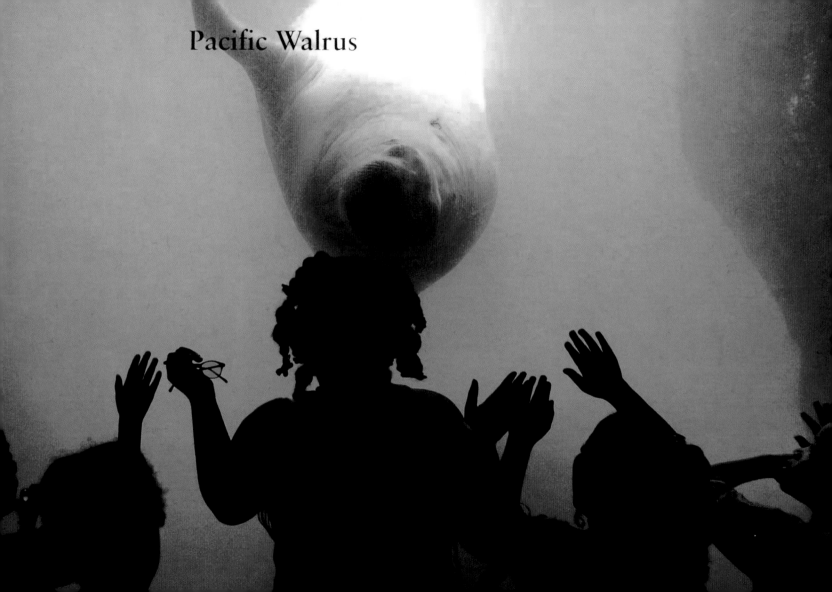

Pacific Walrus

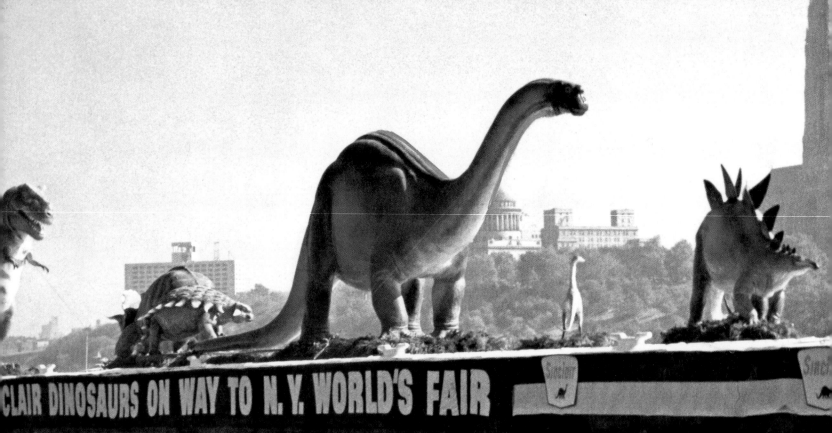

CLAIR DINOSAURS ON WAY TO N. Y. WORLD'S FAIR

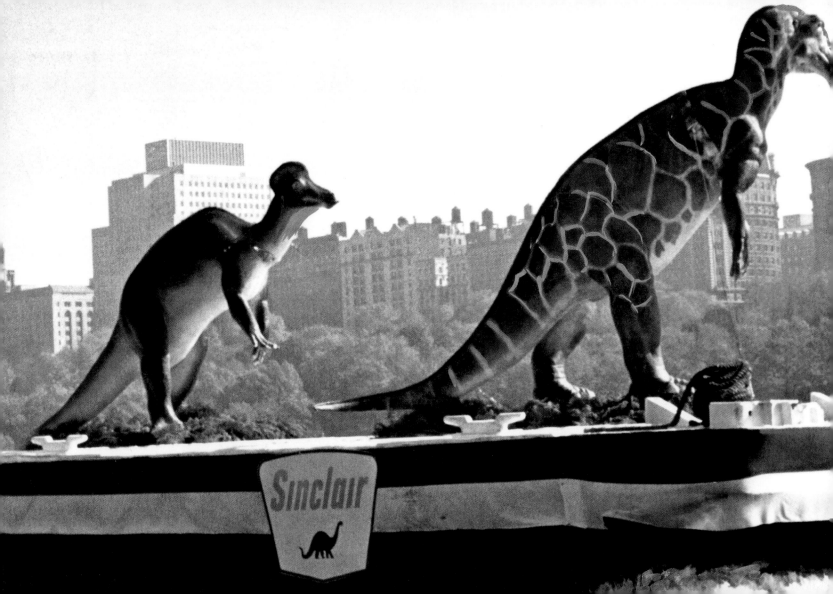

Opposite

APRIL 28, 1921

Elephants on Parade

Step right up, ladies and gentlemen, and see, right before your very eyes, the largest mammals in the world, or at least in show business, or certainly right here on Fifth Avenue! You'll marvel at their five-ton heft and their noble strides as they parade to their big-city big top, Madison Square Garden! This neighborhood hasn't heard such gloriously flamboyant hokum since the last election campaign!

The New York Times Photo Archives

Overleaf

APRIL 12, 1936

Pedaling in the Park

For years, signs had said that bicycles and roller skates were prohibited in Central Park. Now the signs were only half right: roller skating was still against the rules after the Parks Department announced bicycle-riding hours and inaugurated a "bicycle trail" with a parade.

The New York Times Photo Archives

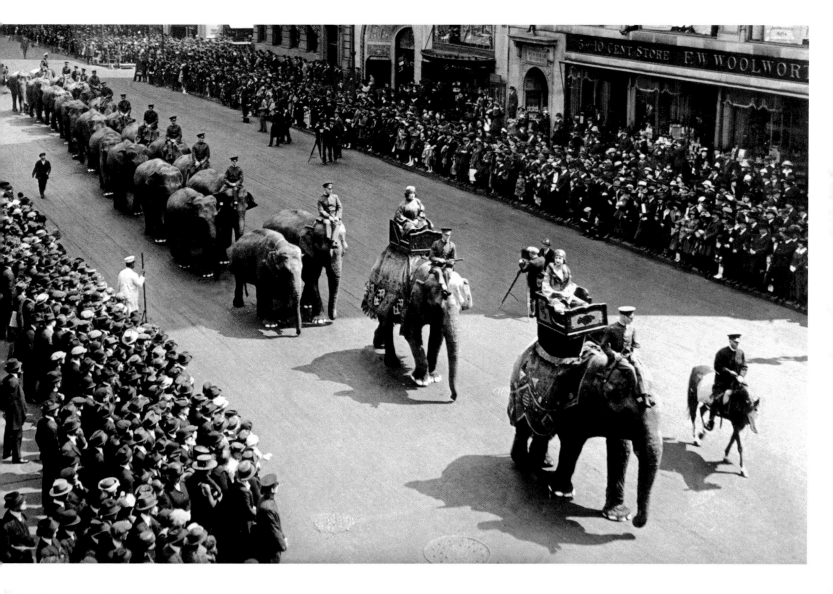

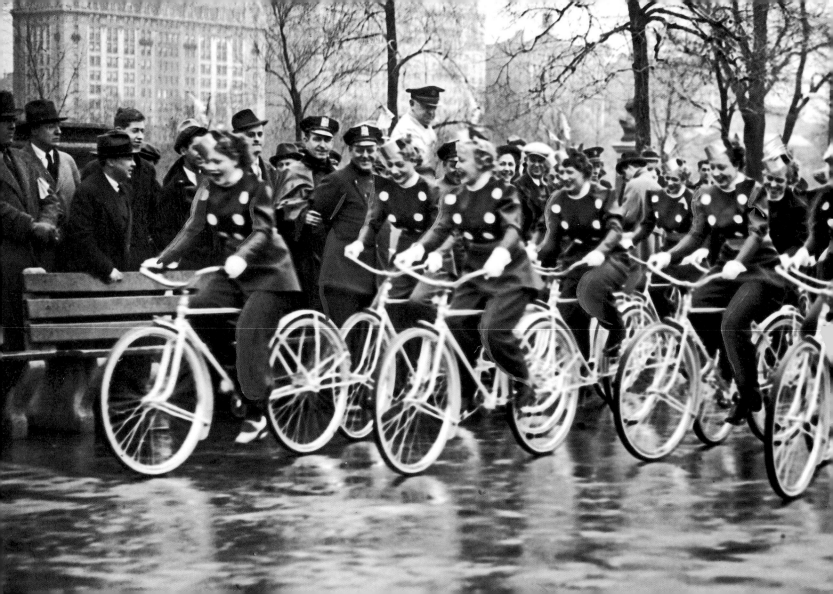

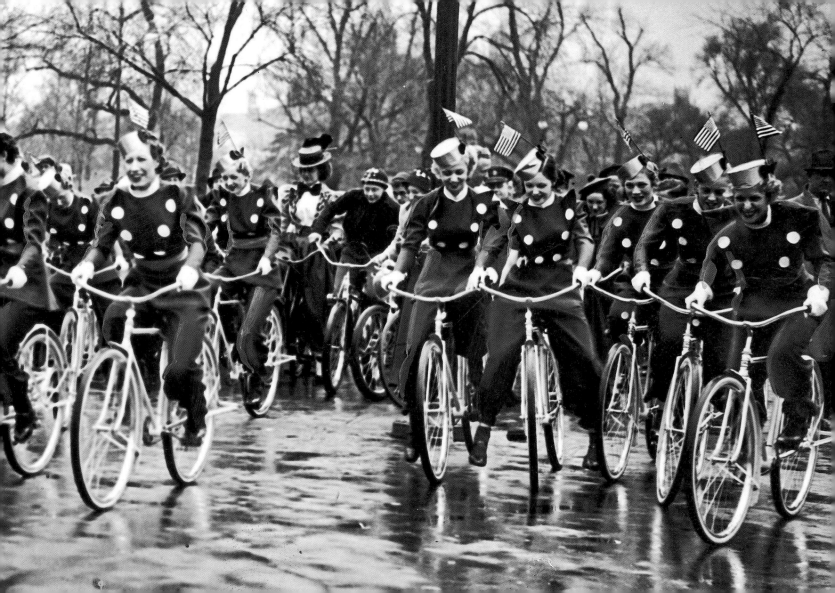

CIRCA 1913

Carefree Squirrels

The squirrels of Central Park are different from other squirrels, *The Times* declared at about the time this photographer captured a meal in progress. The park's squirrels are "pampered pets" who do not stow away food for the winter because they do not need to, *The Times* said. "Visitors toss them peanuts, bits of popcorn, and other delicacies, and they have come to expect this as their right."

The New York Times Photo Archives

APRIL 22, 1958

Overleaf

It's a Bird . . .

Birdwatchers have their own special vocabulary; someone in this Central Park group has "gripped off" — he or she has spotted a blue-gray gnatcatcher and mobilized the rest of the crowd in the search for that rare creature.

Sam Falk/*The New York Times*

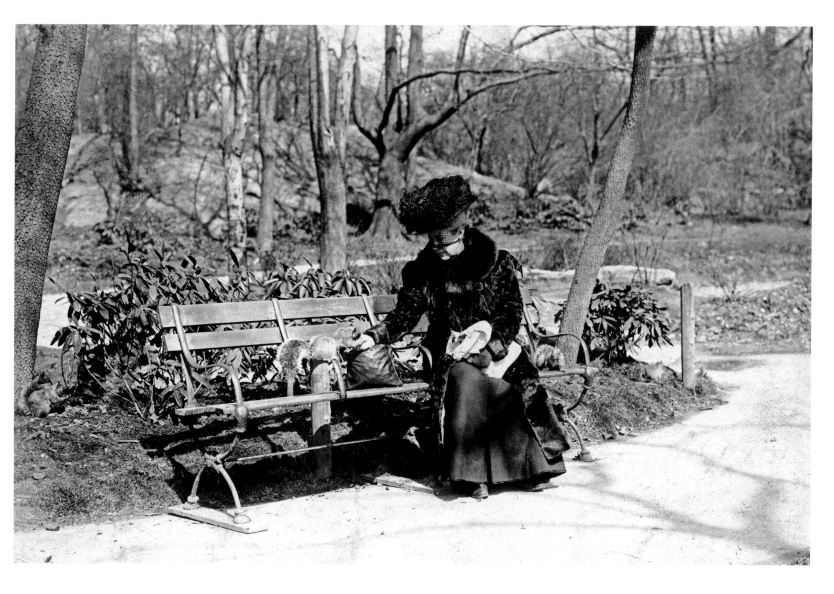

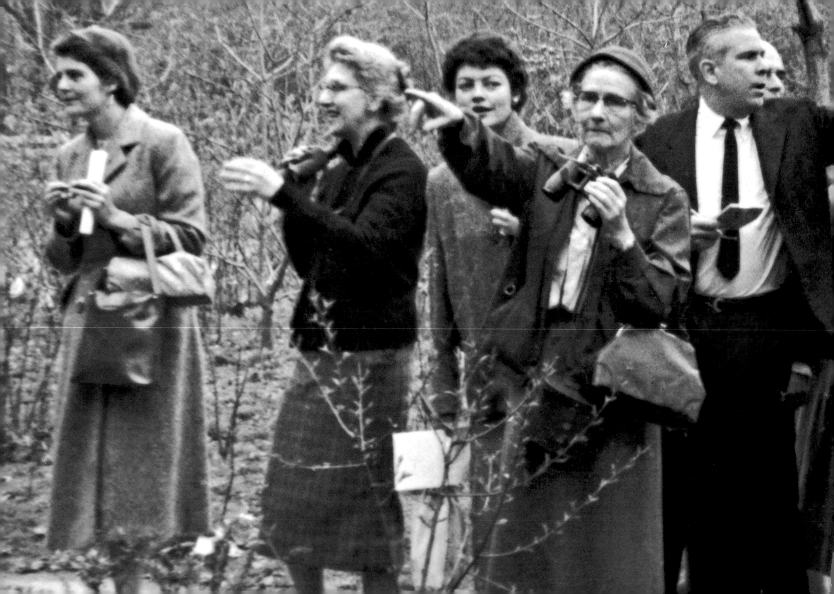

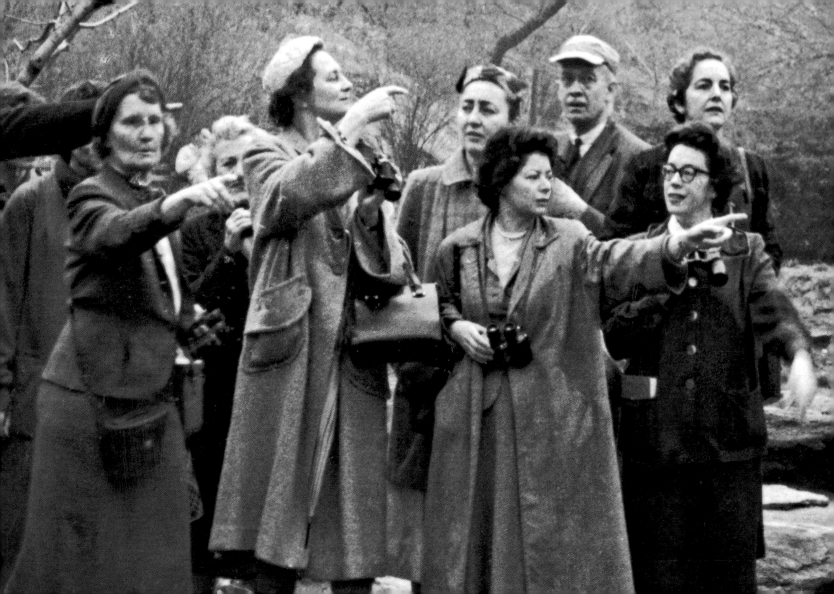

APRIL 16, 1942

Opposite

Blossom Time

In April, *The Times* wrote, "New Yorkers by the thousands stream into Central Park to revel in the full-throated glory of the new forsythia and cherry blossoms. There, they are again reminded that the park is the city's common ground, the democratic village green where people of all backgrounds and enthusiasms come to pursue their separate pleasures, for the most part congenially."

The New York Times Photo Archives

APRIL 29, 2003

Overleaf

Magnolia Season

Louisiana and Mississippi made them their state flowers, but magnolia blossoms also grow in the Bronx, at the New York Botanical Garden.

James Estrin/*The New York Times*

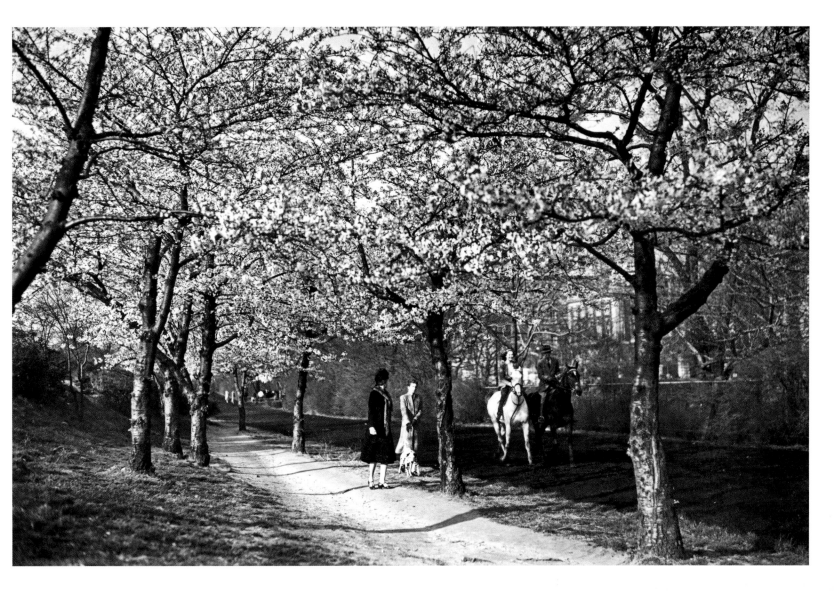

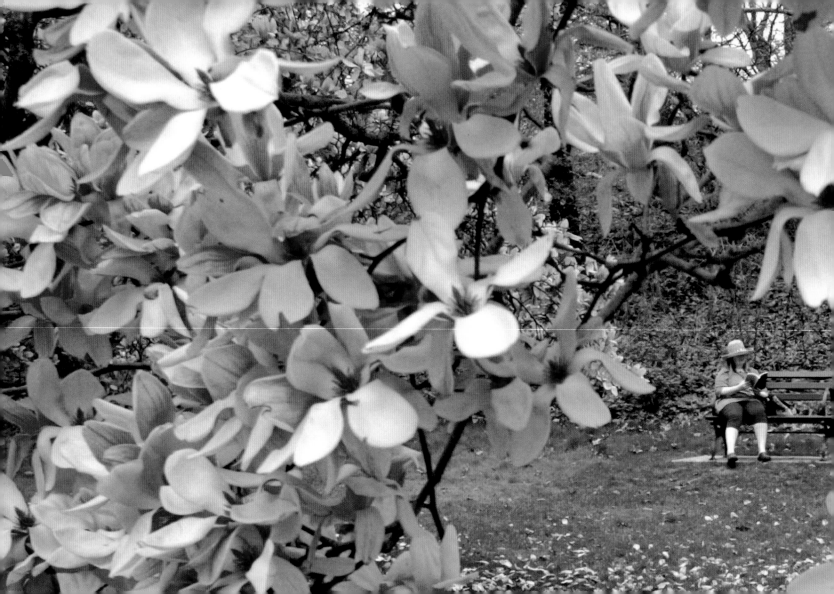

Chess Master in the Making

How to trap the other guy's bishop?
Topcoat weather cannot stop these chess
players in Central Park from pondering
the next move — and a crowd from
looking over their shoulders.

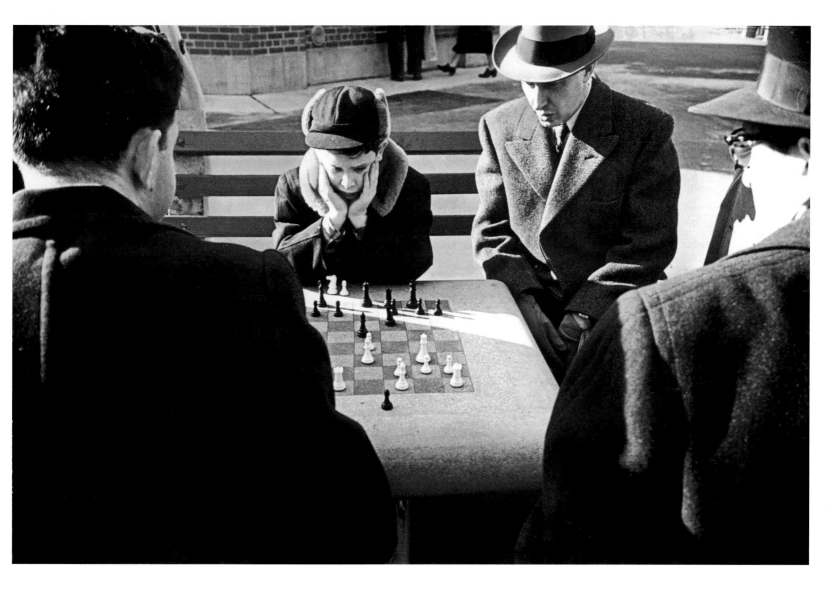

The Red Umbrella

Bobbing across Madison Square Park, an umbrella adds an unexpected dot of color to a snowy landscape.

JUNE 8, 1934

Pleasure Craft
The captains of these boats may be heading into deep water, but not because they lack naval know-how.

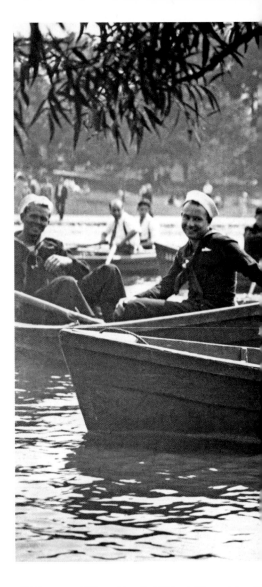

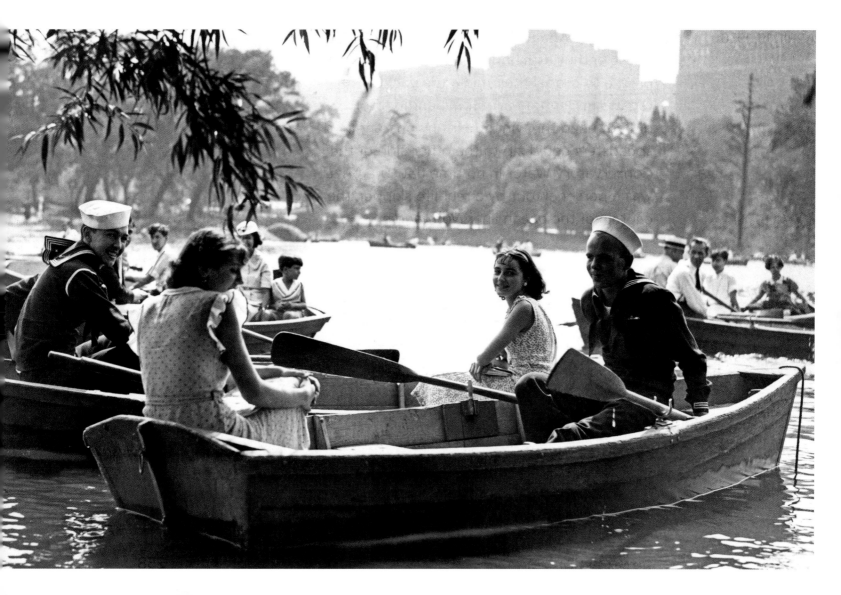

Full Speed Ahead

These enthusiasts hoped for a full-fledged breeze to propel their miniature yachts in a regatta in Central Park. Some competitors did not need the wind; their tiny gas-engined speedsters could zip to the other side of the Conservatory Water in no time flat. The prize was a personal tour by a real-life skipper, the captain of the ocean liner *Normandie*.

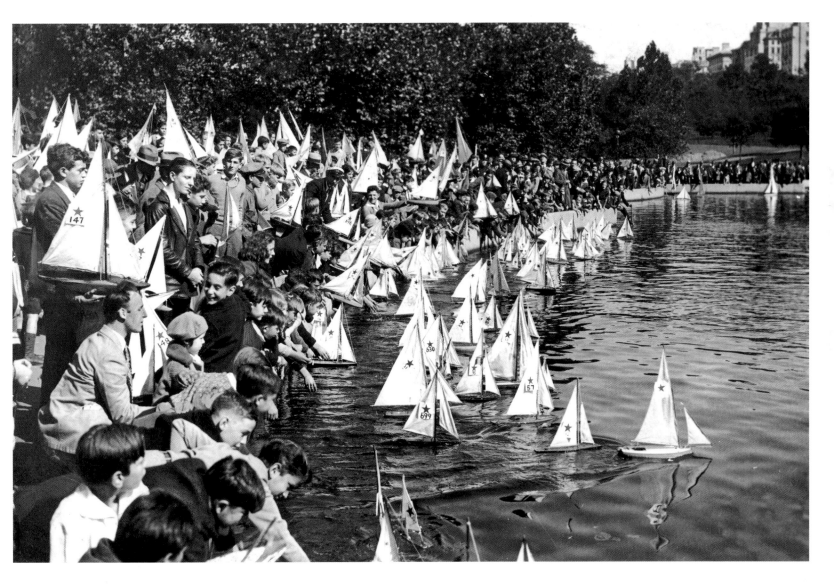

JUNE 13, 1927

Maritime Salute

Three weeks after his epochal solo flight from New York to Paris, Charles A. Lindbergh returned in triumph. *The Times* described the scene in the harbor when the hero of the air debarked from his seaplane. "Lindbergh was surrounded by 400 ships and 30,000 people aboard them who had become frantic with excitement. On the shores . . . 200,000 more shouted and waved, carried away with the emotion with which the very air of the bay seemed charged."

Fairchild Aerial Surveys

Overleaf

JUNE 23, 1952

Here Comes the *United States*

"The U.S. queen of the seas," *The New York Times* called the ocean liner *United States*. Surrounded by an entourage of smaller vessels and a fireboat shooting sprays of water, the *United States* made a decidedly regal entrance on her maiden voyage.

George H. Alexanderson/*The New York Times*

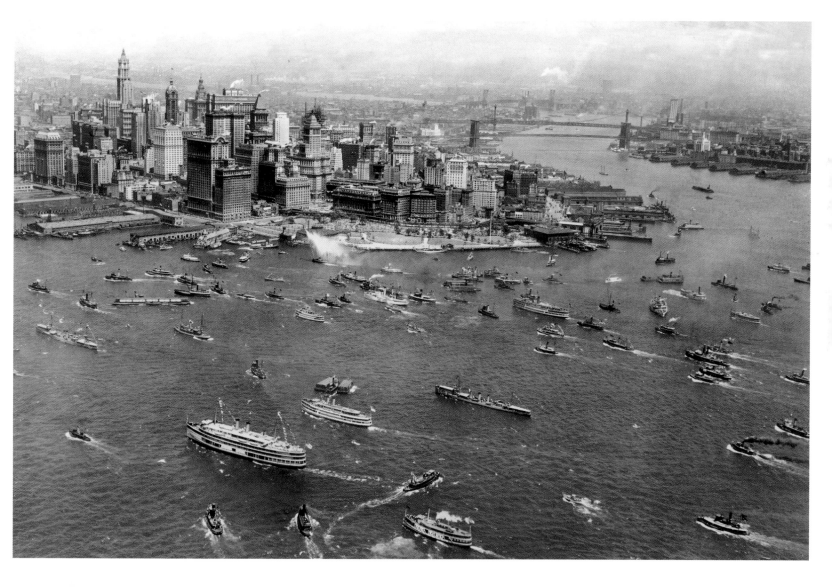

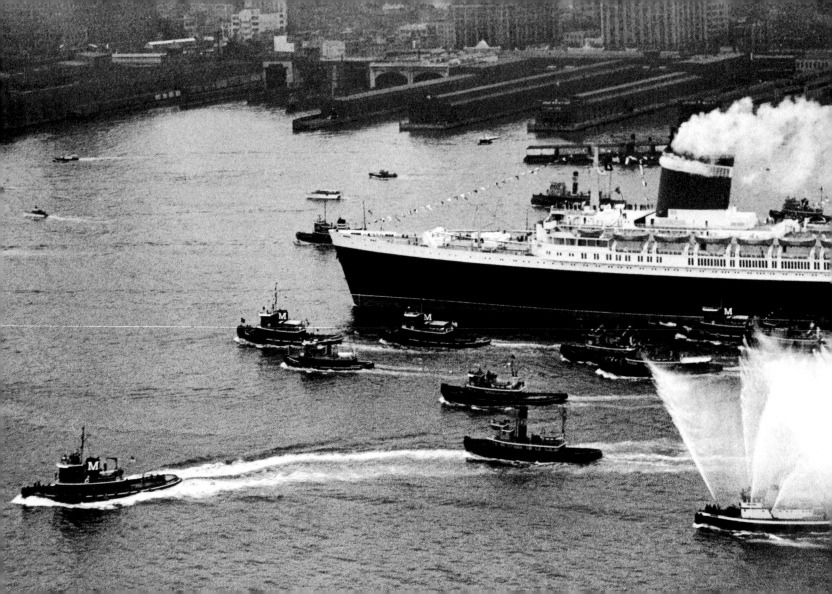

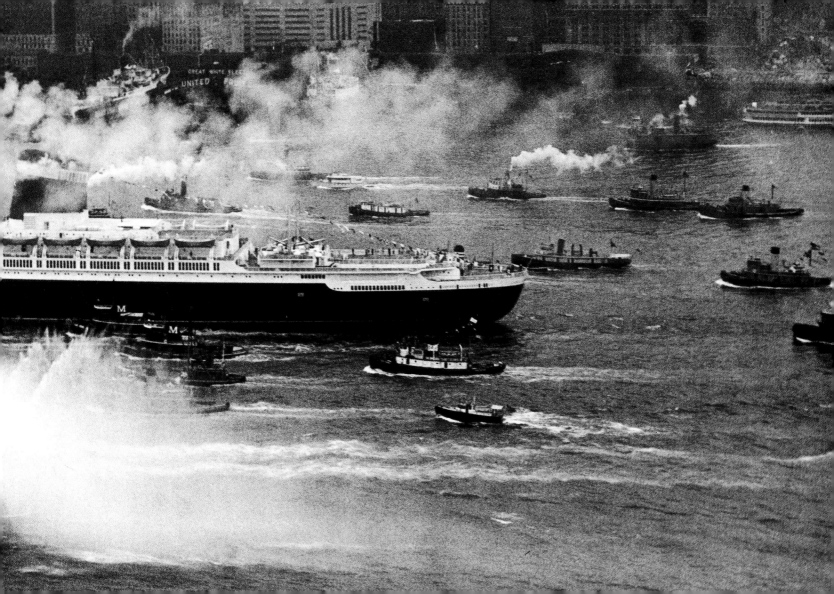

And That's Just the Bow

You had heard that it was longer than the Chrysler Building is tall. Then you looked down the street as the bow slithered by like the fin of a horror-movie monster. You could not get the heart-pounding theme from *Jaws* out of your head. And you decided that "big" is too small a word for the *Queen Mary 2*, seen through a Manhattan canyon.

Vincent Laforet/*The New York Times*

Portrait of a Longshoreman

As the government investigated organized crime and labor corruption on the New York waterfront in the early 1950s, the everyday business of hard labor on the docks continued.

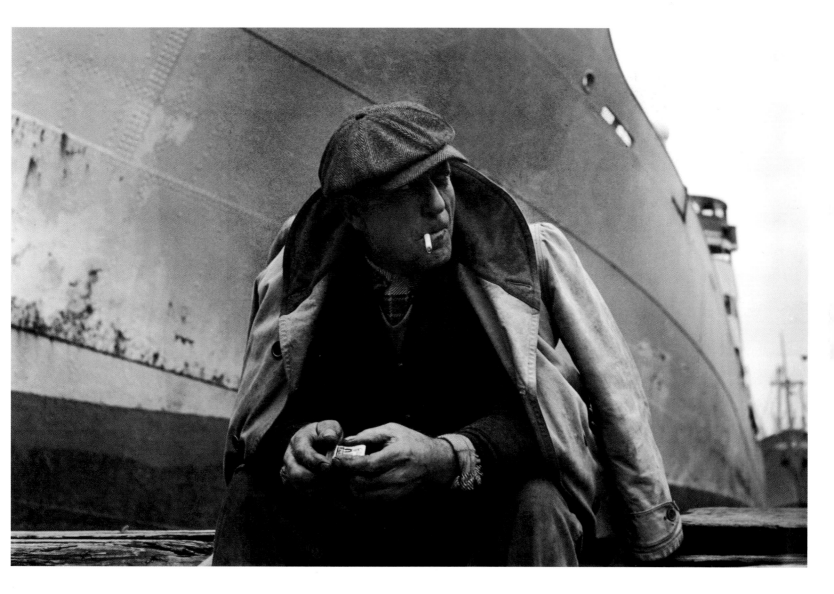

Rumrunner

Admiral Richard E. Byrd expected
the Antarctic to be a place that "God
had set aside as man's future," with
"an inexhaustible reservoir of natural
resources." But some resources had to be
carried along. Before he embarked on his
first expedition, these cases of whiskey
were loaded onto Admiral Byrd's ship,
The City of New York. The caption in *The
Times* said, "For medicinal purposes only."

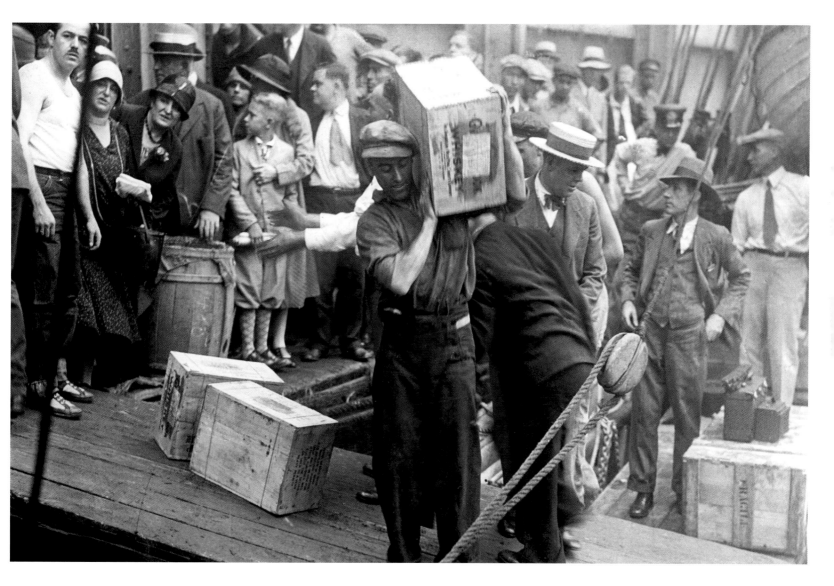

MAY 31, 1931

Majestic View
It is hard to say who had the better view: the passengers looking up from the deck of the S.S. *Majestic* as it turned smartly toward its pier, or the pilots in their cockpits as they flew confidently down the river in tight formation.

The New York Times Photo Archives

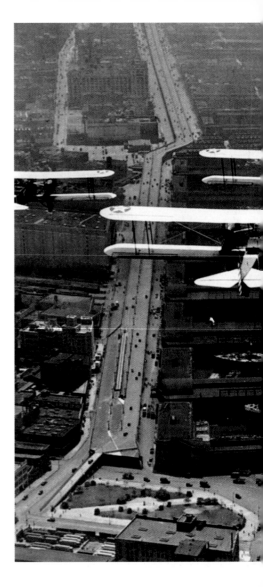

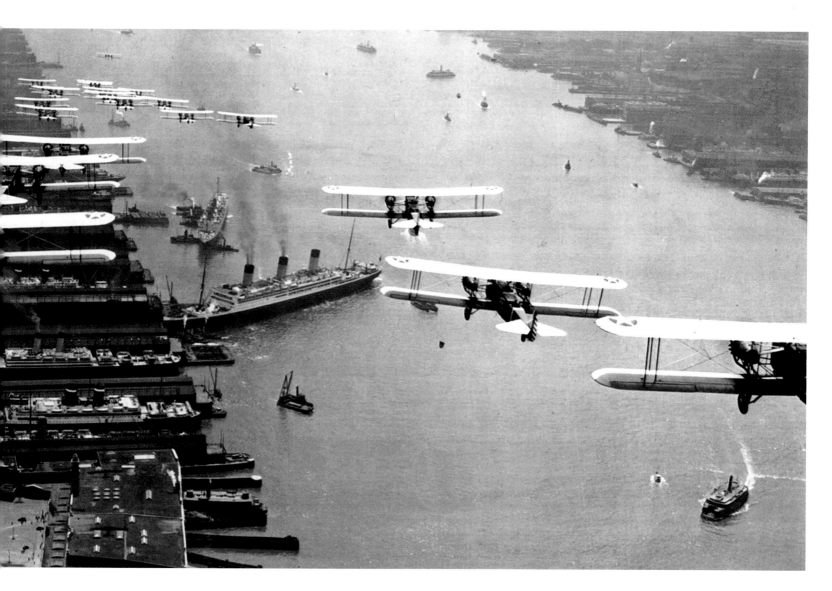

Lusitania's Last Voyage

The warnings were all over the papers about U-boats with torpedoes and orders to launch them. "It doesn't seem as if they scared many people from going on the ship, by the look of the pier and the passenger list," the captain declared as the *Lusitania* sailed, on May 1, 1915. Six days later, when the German torpedo hit, one passenger, Michael G. Byrne, looked back after he jumped into the open ocean. "The ship rose high in the air, and she slipped down as if she was gliding down a greased surface," he recalled. The 785-foot-long luxury liner was gone in less than half an hour. Byrne dog-paddled "through the lanes of dead bodies" for two hours before he was rescued. Nearly twelve hundred people died, among them the railroad heir Alfred Gwynne Vanderbilt. He had handed his life jacket to a woman and helped her into a lifeboat.

Brown Brothers

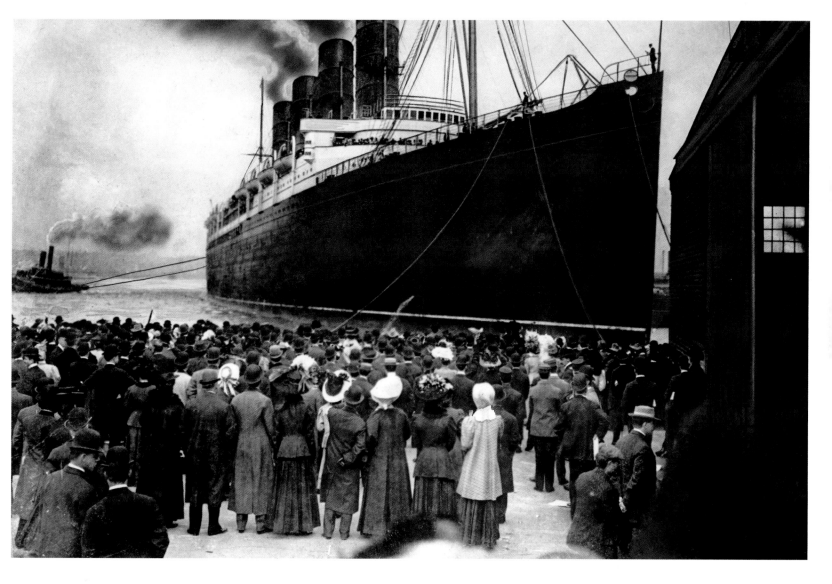

Scuttled

This was the inglorious end for the very elegant, very French ocean liner *Normandie*. Stranded at Pier 88 when the fighting broke out in Europe and stripped of the Art Deco decor and Lalique glass that had made it famous, the *Normandie* was being turned into a troop ship when a spark from an acetylene torch landed on something flammable — life jackets, many accounts say, although there was some talk about mattresses. Within hours, the ship snapped its moorings and rolled over on its side. It lay there for months before being sold for scrap.

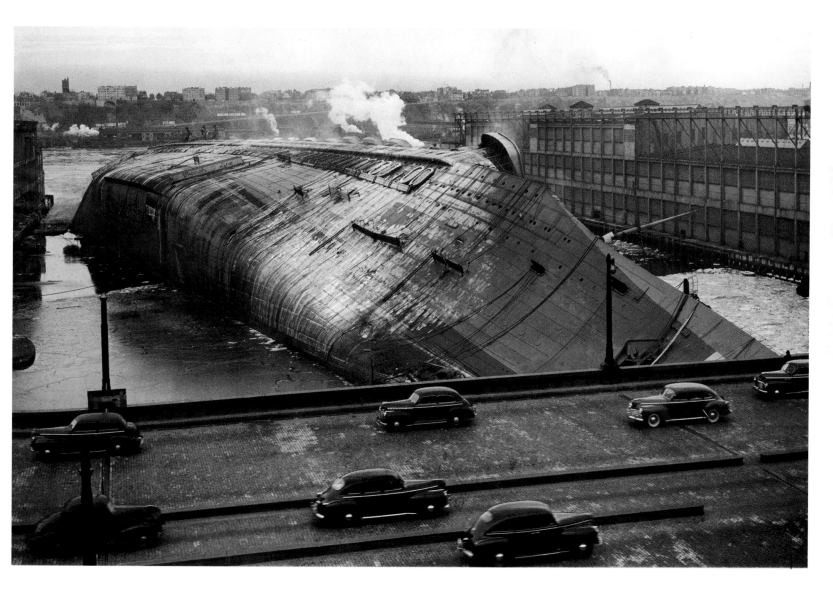

When Wreckage Rained Down

There was bad weather in the sky — freezing,
angry rain with snow flurries and hail — and
a horrifying scene on the ground: the tail
of an airplane that tumbled from the sky
and slammed into Park Slope, Brooklyn.
The United Airlines DC-8 had collided with
a smaller, slower T.W.A. Super Constellation
over New York Harbor. In all, 134 people
died that day; the next day, the death toll
rose by one with the death of the lone
survivor, a badly burned eleven-year-old boy.

Allyn Baum/*The New York Times*

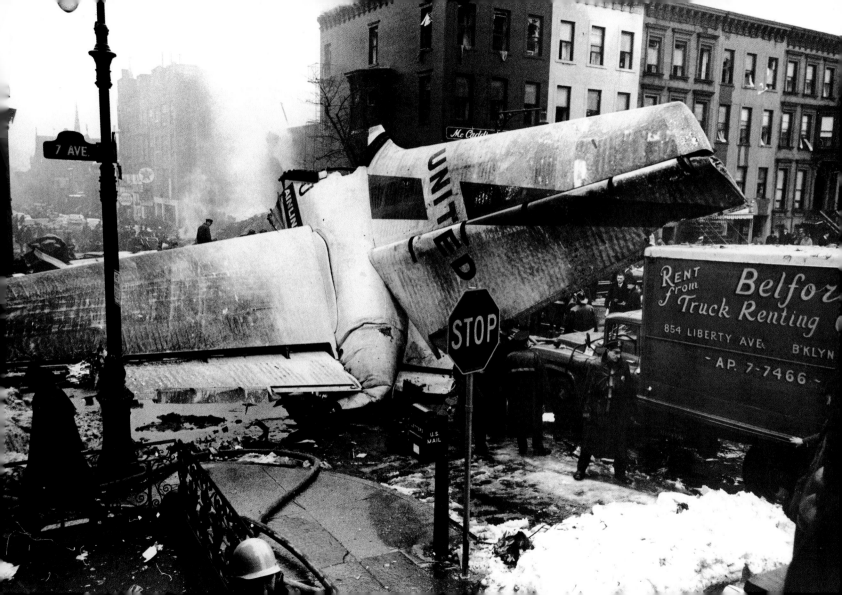

"Another Case of Man Failure"

Both subway trains were empty, the one that was parked on the track, waiting to go out on a rush-hour run, and the one that was roaring along at full speed. The crash in the Bronx was a blur of steel and sparks, of long, heavy cars splitting open and hurtling through the early morning sky, of glass and debris tumbling onto the street below the elevated tracks. The aftermath was a swarm of track workers puzzling over how to move the wreckage. "It was another case of man failure," the chairman of the Board of Transportation declared. The motorman, who had been involved in two earlier accidents and died in this one, had run a yellow signal.

Arthur Brower/*The New York Times*

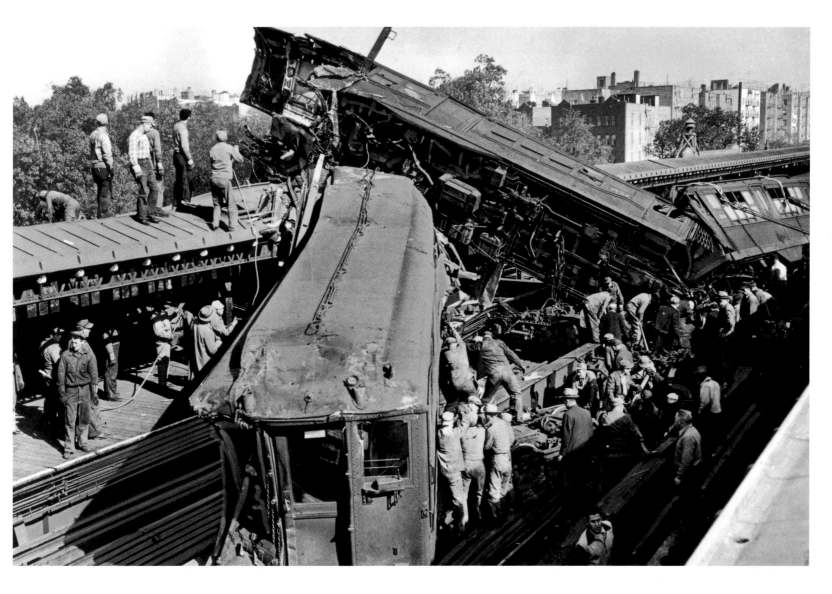

Waiting for Word

"Excited Crowds at White Star Office," the headline in *The Times* said. In that pre-television age, people went where they expected news to come from: the headquarters of the shipping line that owned the *Titanic*. "Throughout the day," *The Times* reported, "there had been reassurances that the *Titanic* was being towed to port." The mood turned to despair when White Star officials announced that the latest word from ships in the North Atlantic indicated that the dimensions of the disaster were far greater than they had thought.

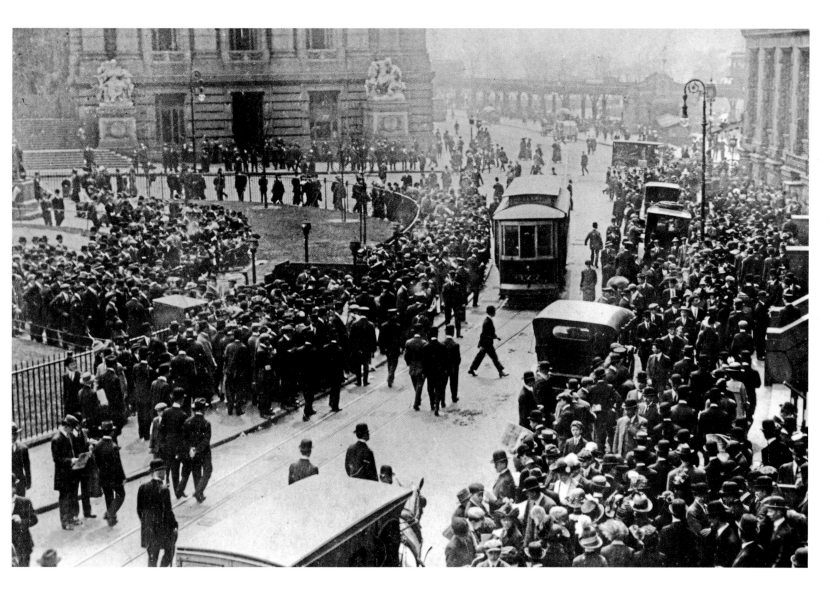

Survivors

They were crew members who had survived the unthinkable: the sinking of the unsinkable ship, the catastrophe that became a legend (and, in the 1990s, a legendarily profitable film), an iceberg seen too late, a steamer moving too fast, a collision too slight to be felt, a flood too big for the brand-new watertight compartments to contain. After being rescued and brought back to New York and given dry clothes at this sailors' home, they discovered that *Titanic* denoted not fame but infamy.

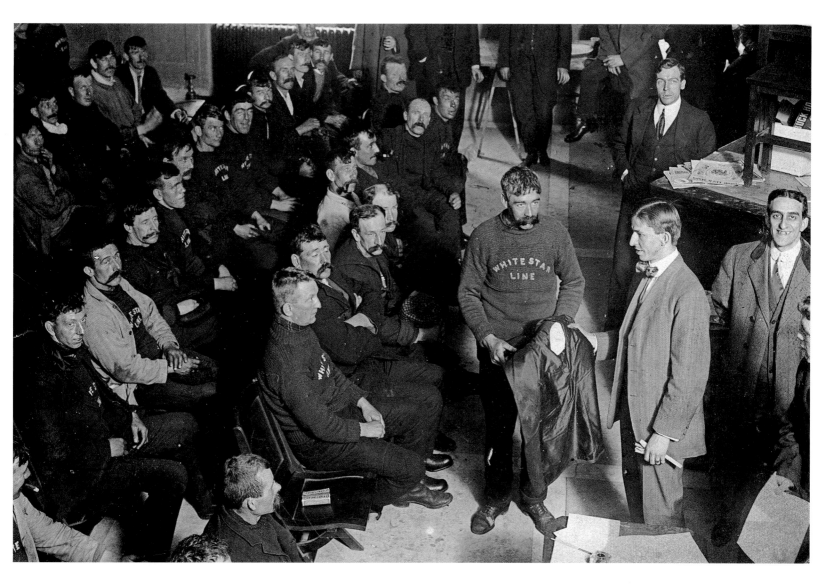

The Newest New Yorkers

New York was the gateway to America for these Russian immigrants and for more than twenty million other Europeans who arrived between 1880 and 1920. By the 1930s, immigration rules were tighter and border patrols more vigilant, and the commissioner general of immigration said that many were being turned away. "For every two aliens who manage to enter our gates," he wrote, "there are three shaking our dust from their shoes (some of them unwillingly enough) and returning to the land of their fathers."

Brown Brothers

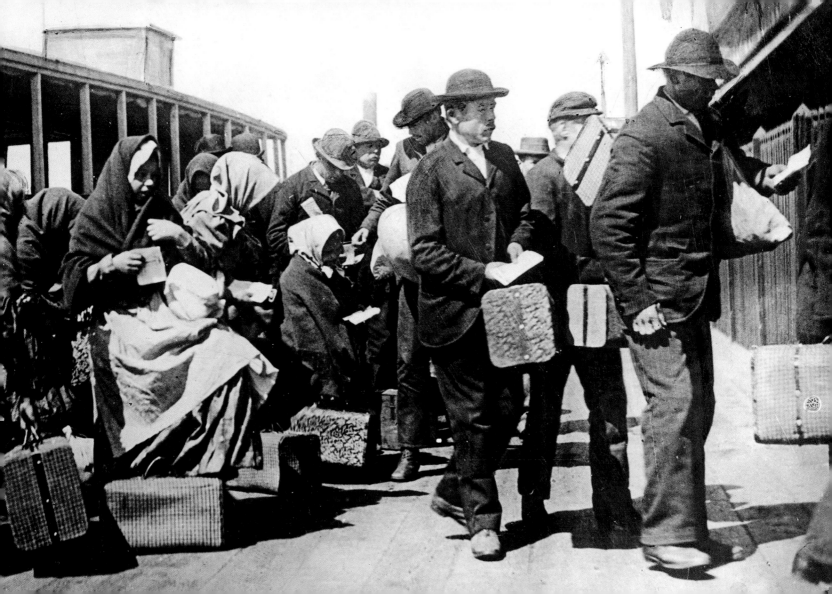

Arriving

Before too much longer, it would not matter where they had come from or what they had or had not accomplished there. The promise of New York was the promise of a new life.

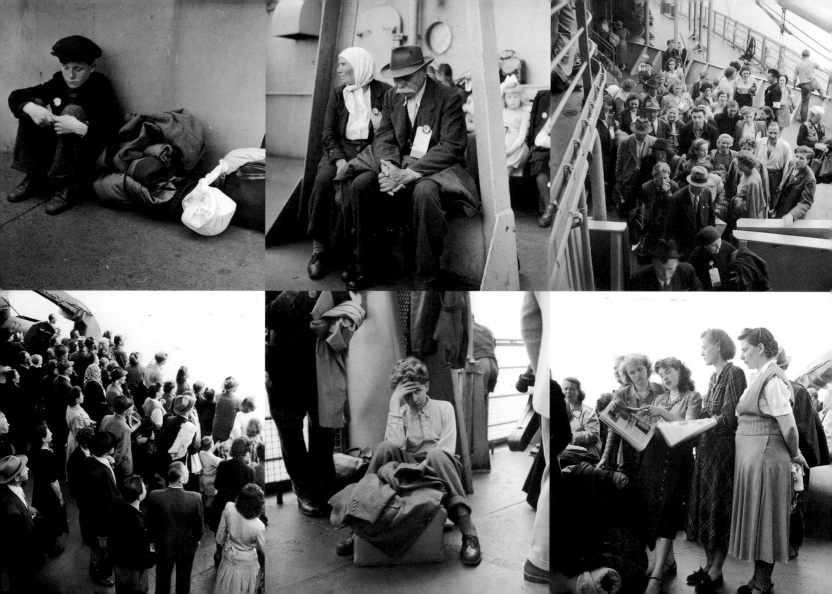

World of Our Fathers

The Lower East Side, the reformer William Dean Howells once wrote, was "from end to end a vast bazaar, where there was a great deal of selling, whether there was much buying or not." The peddlers conducted their business outside because there was no room in the buildings in which they lived. "The overflow from these tenements is enough to make a crowd anywhere," reformer Jacob Riis wrote, echoing a city report that said the "concentration and packing of a population has probably never been equaled in any city."

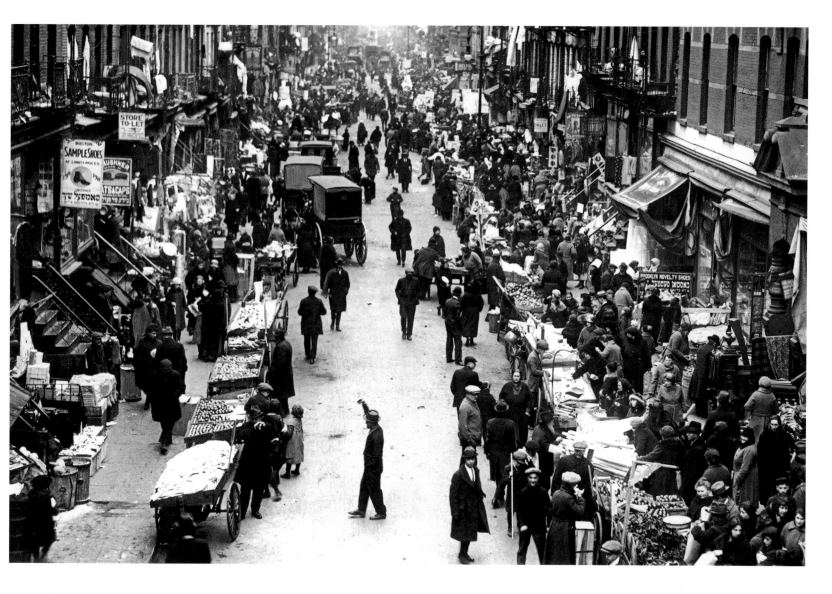

Happy Chinese New Year!

"In New York, there is always a New Year around the corner," *The Times* once observed on January 1. The new year that dawns in February — the Chinese New Year — is a time for exploding firecrackers, festive lion and dragon dancers, and costumed children like these.

Neal Boenzi/*The New York Times*

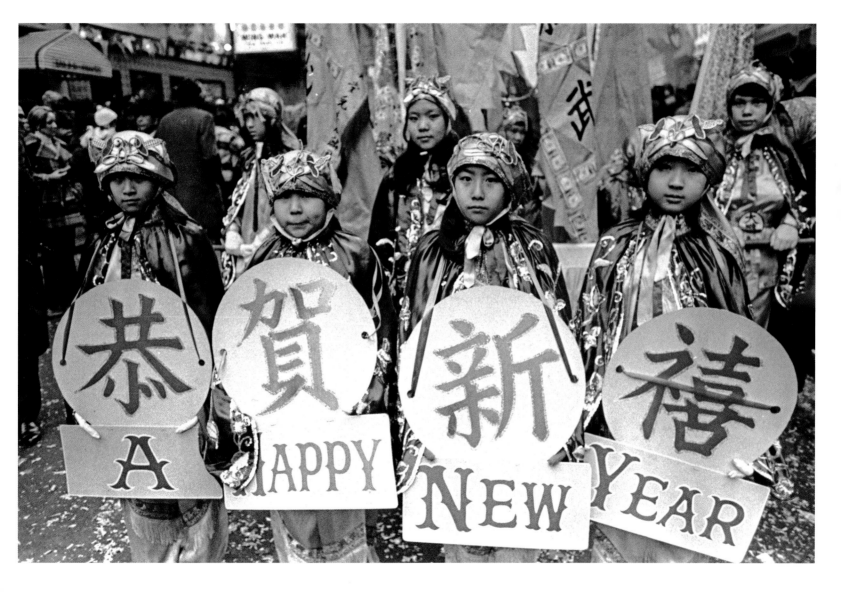

Traffic in Another Time

By the second decade of the twentieth century, thousands of rumbling, rattling automobiles still shared the streets, uneasily, with carriages powered by what Edith Wharton called the kind of "sturdy brougham-horse" that moved "as if he had been a Kentucky trotter."

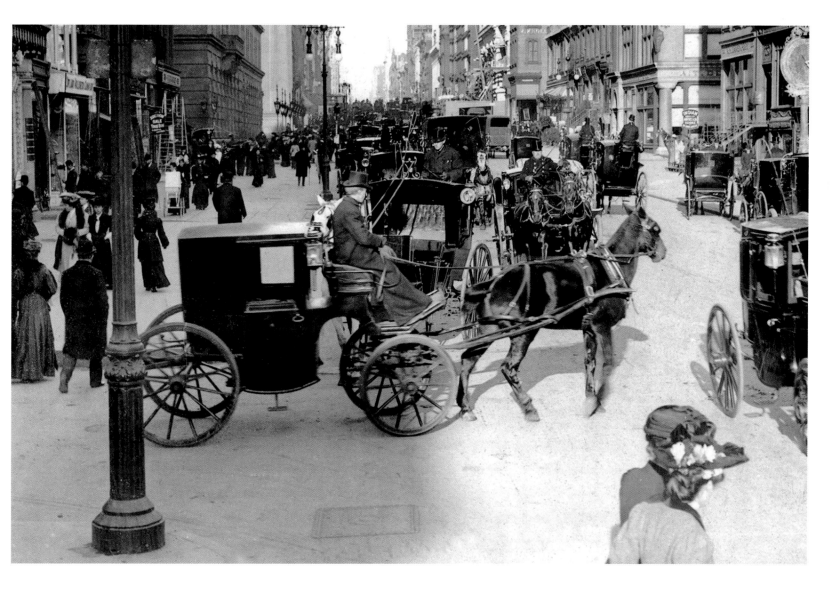

New York Has Smog, Too

Los Angeles is not the only city where smog emergencies make the headlines — and make it hard to see things in the distance. When a stagnant air mass parked itself over the city for four days in 1966, this glimpse south from the Empire State Building showed a city shrouded in acrid, sour-smelling air.

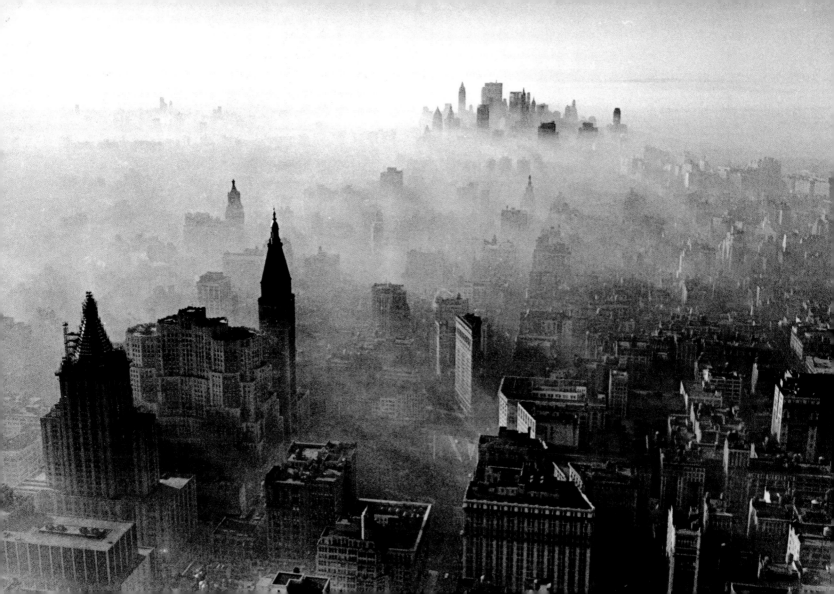

Yes, It Was That Warm

The calendar said November, but the thermometer said sixty-two degrees. Frieda Rose said it was the perfect day for a bathing suit, a mud pack from the Dead Sea, and a few hours of sun at the Russian and Turkish baths on the Lower East Side.

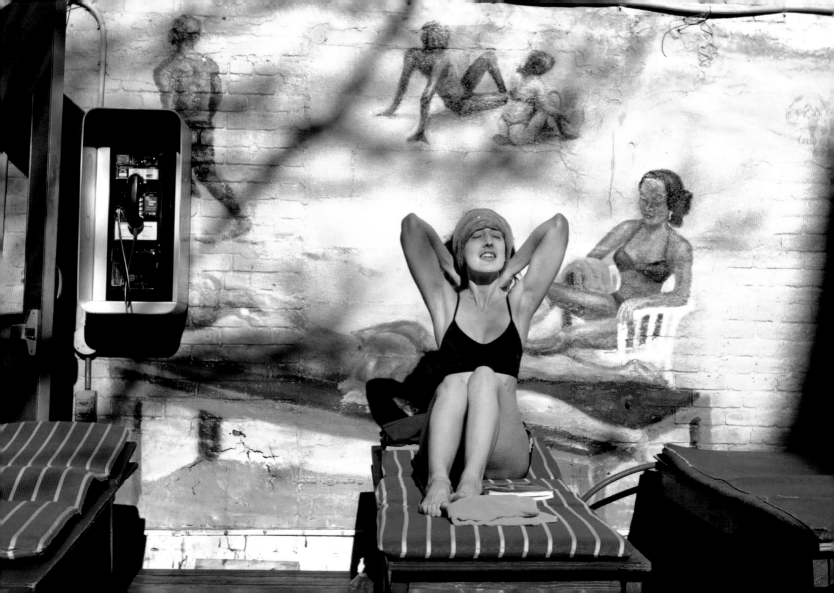

JULY 15, 1997

Pampered Pooch
Were the 1990s another Gilded Age?
Until the dot-com tide turned, there were
more millionaires than ever before, and
they spent their new wealth on things like
limousines for their dogs.

Andrea Mohin/*The New York Times*

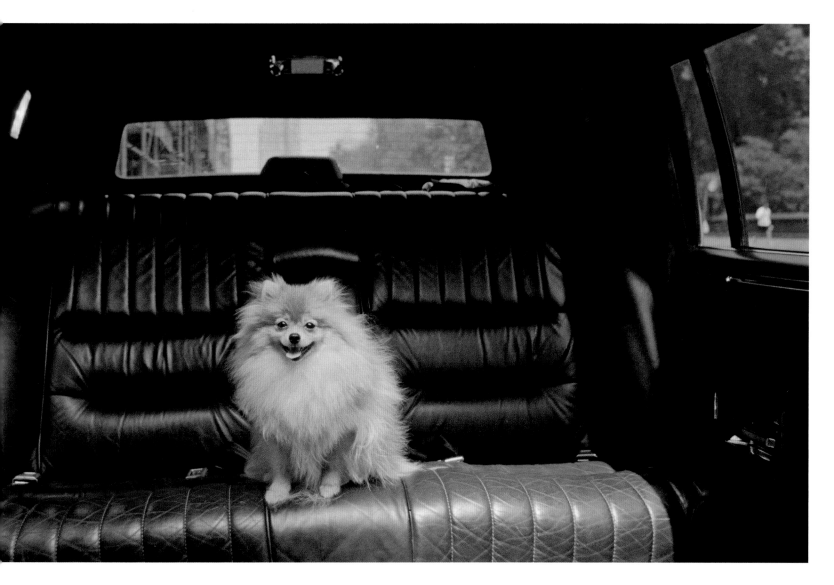

The Co-Op Life

This photograph illustrated an article about co-op apartment buildings that were "filled with gloom" because of inflation – 10.6 percent in 1979 – and steep price increases in the things co-ops buy, like heating oil. Economics probably was not on the minds of these youngsters, and a quarter of a century later, it is impossible not to wonder what the little girl in the hat and the little boy, lounging on the base of a solid column, remembered of life in this building on Central Park West.

Joyce Dopkeen/*The New York Times*

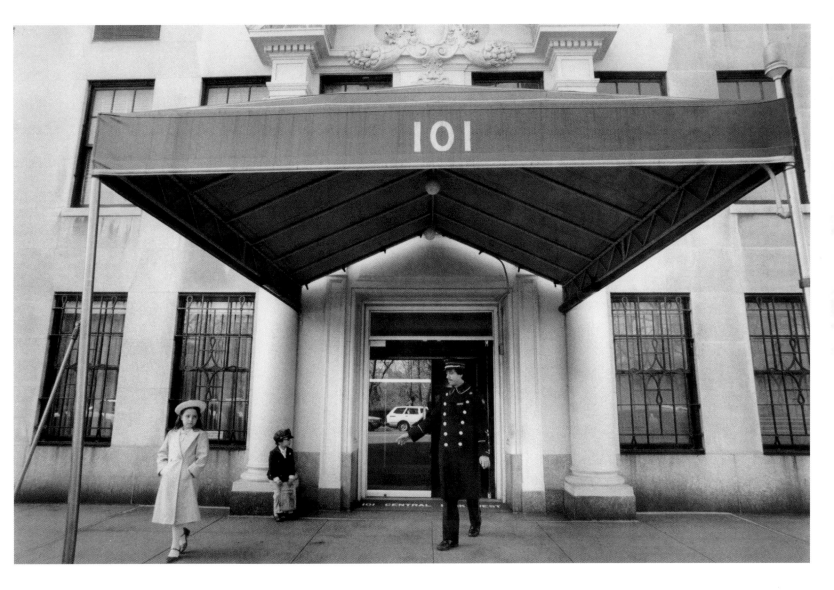

Certified Debutantes

The debutantes presented at this ball
at the Waldorf-Astoria included a
granddaughter and great-granddaughter
of presidents — Jennie Eisenhower, center,
the granddaughter of Richard M. Nixon
and the great-granddaughter of Dwight
D. Eisenhower.

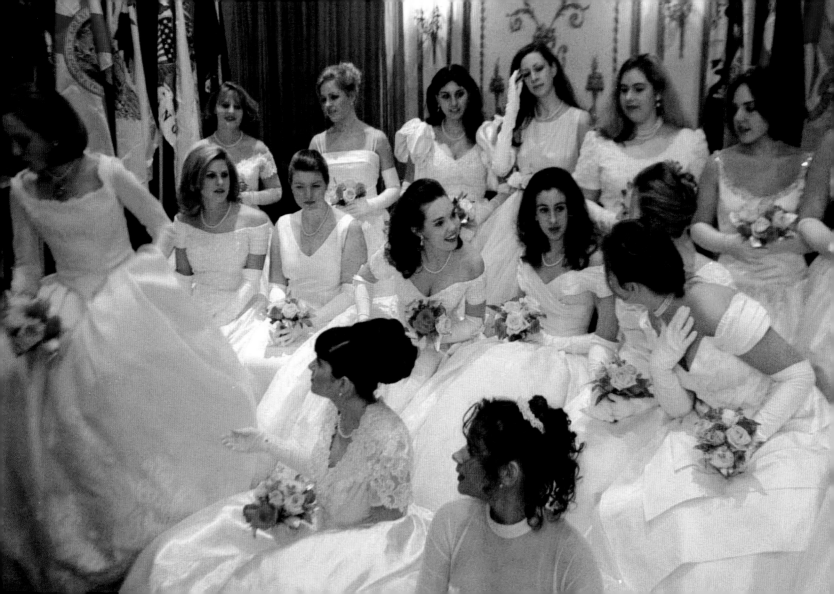

She Called Him "The Donald"

Ivana Trump and Donald J. Trump in the apartment they shared before he built Trump Tower (and they divorced). This apartment was a rental in a building where someone else was the landlord. "I would never live in a place I own," he said at the time. "The other tenants find out you're there and they telephone or come to the door at all hours."

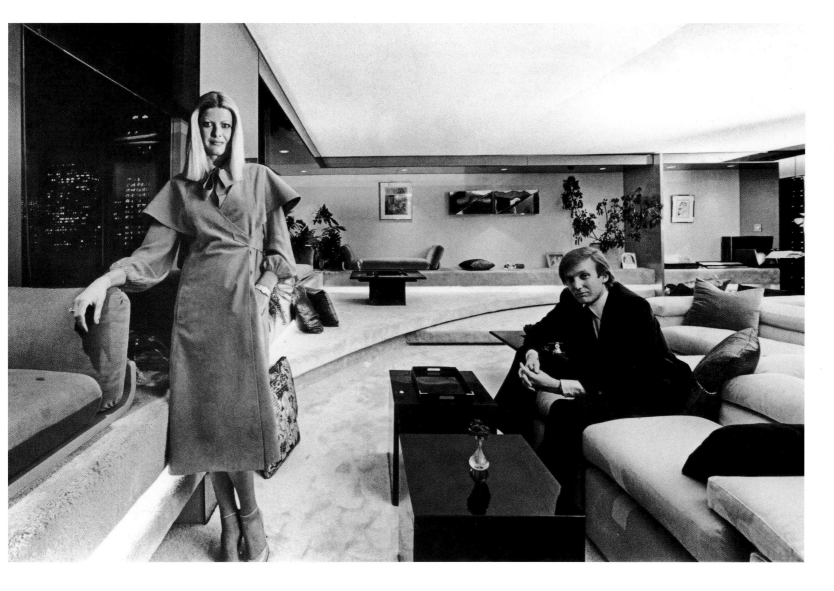

Rent Strike

World War I was over in Europe, but there was turmoil on the home front: tenants in scores of apartment houses staged rent strikes. They were angry at what they considered landlords' greed for doubling or tripling rents every few months. The city, working with the Democratic Party machine, eventually arranged arbitration, but not before Socialists gained a wide following among tenants. The landlord of this building at 1294 Park Avenue in Harlem accused the tenants of being "a Soviet committee."

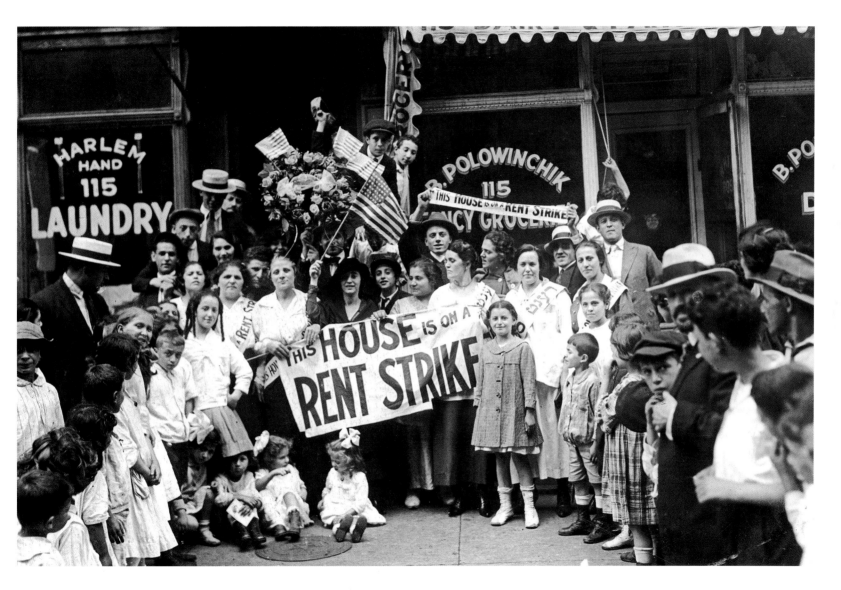

APRIL 17, 1968

Opposite

Helping Out

Inspired by her grown-up neighbors, who planned a pioneering cleanup campaign after a riot on their block of East 103rd Street in Harlem, Evelyn Custodio grabbed a broom and went to work.

Neal Boenzi/*The New York Times*

Overleaf

AUGUST 4, 1951

Broom Brigade

It was, *The Times* said, the "briskest scrubbing" that East 100th Street had ever had. Forty volunteers became street cleaners for a day. They attacked the block between First and Second Avenues but only after the briefest of photo ops — and after singing these lyrics to the tune of "Roll Out the Barrel":

> *Sweep, sweep East Harlem*
> *We've got the dirt on the run;*
> *Sweep, sweep East Harlem,*
> *Our job just has just begun.*

Arthur Brower/*The New York Times*

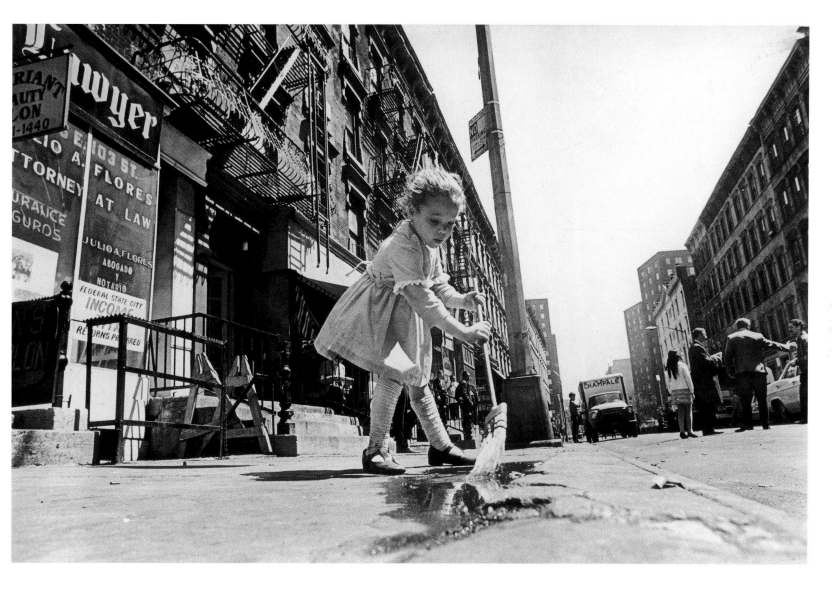

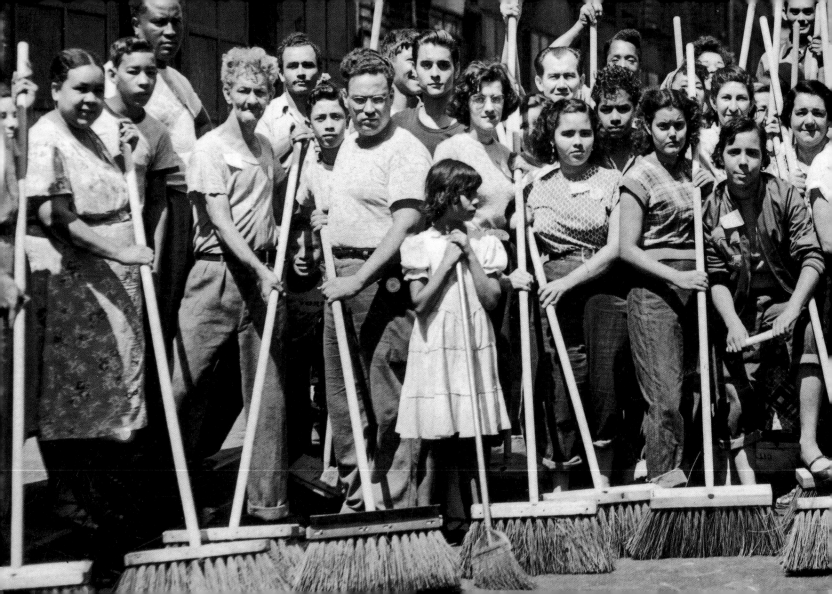

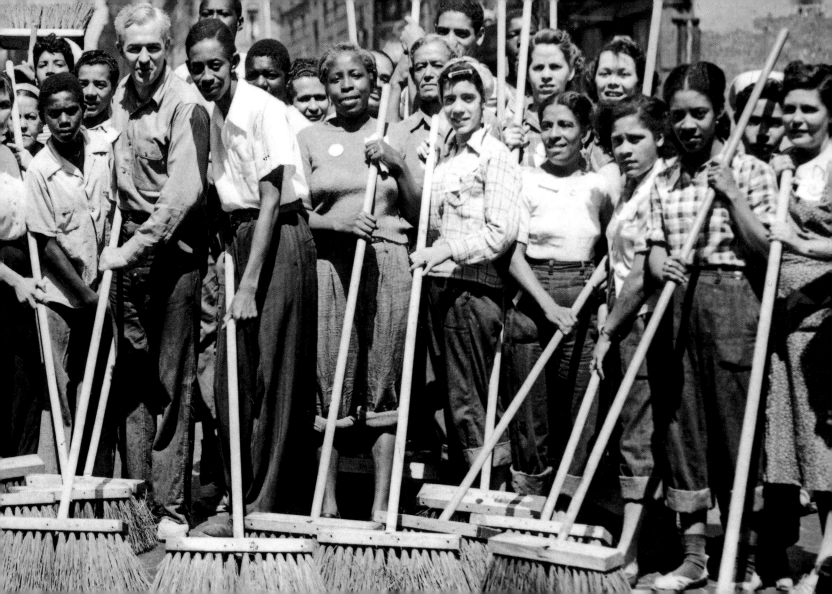

Home Front

In 1942, the battle on the home front was to keep morale high and foster solidarity with America's international allies. These spectators watched a "folk festival" featuring Polish, Russian, and American dances on the Lower East Side. *The Times* pointed out that the performance and speeches were almost drowned out by "strains of martial music . . . heard in the distance from a total of twenty-one neighborhood flag-raising ceremonies."

Sam Falk/*The New York Times*

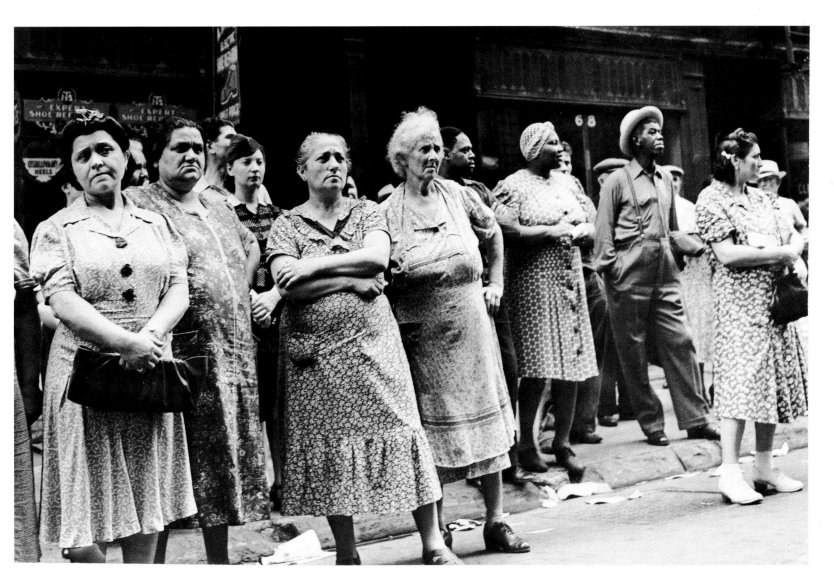

El Barrio, As It Was

East Harlem was mostly Italian until a wave of immigrants from Puerto Rico began moving there in the 1920s. After World War II more newcomers from elsewhere in Latin America arrived, and it remains today a center of Latino political, cultural, and religious activity.

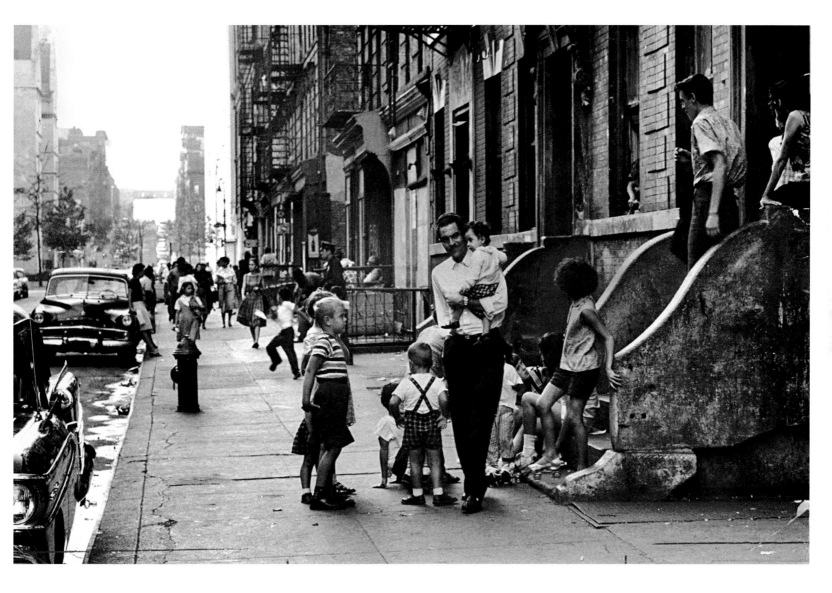

SEPTEMBER 19, 1951

A Feast in Little Italy

"The San Gennaro Feast has become one of the city's golden oldies — a sure-fire attraction that turns all comers into Italians in the same way the St. Patrick's Day parade creates instant Celts," *The Times* observed. The eleven-day festival honors a martyred bishop who was the patron saint of Naples.

Eddie Hausner/*The New York Times*

Overleaf

AUGUST 14, 2003

Blackout

It had been years since the skyline looked the way it did that night. The red eyes that usually blink at the very tops of the buildings were not red, and not blinking. Times Square lost its neon glow; Broadway marquees lost their incandescence. Only Forty-second Street still pulsed and blinked — white from headlights, red from taillights.

Vincent Laforet/*The New York Times*

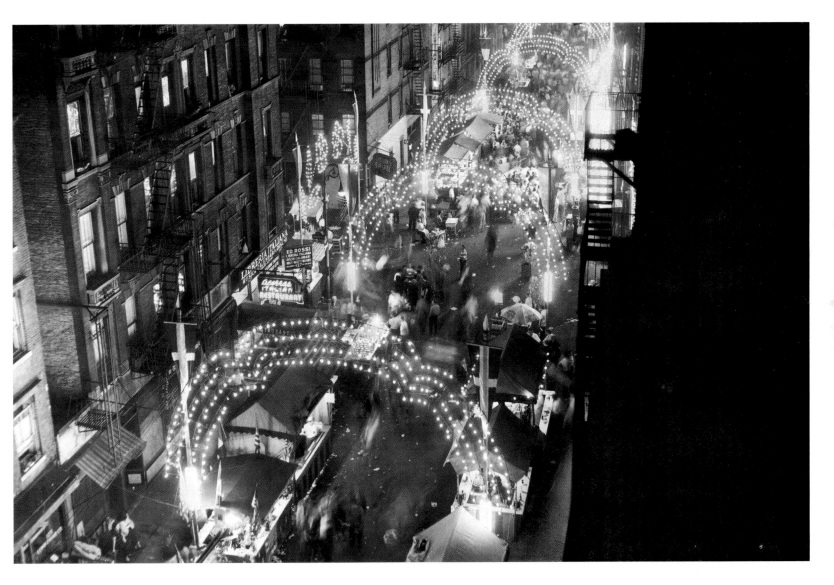

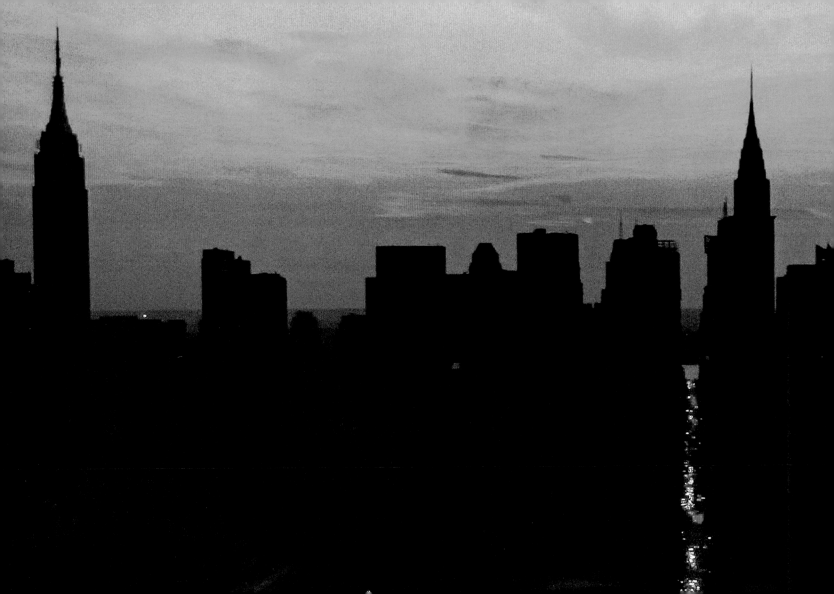

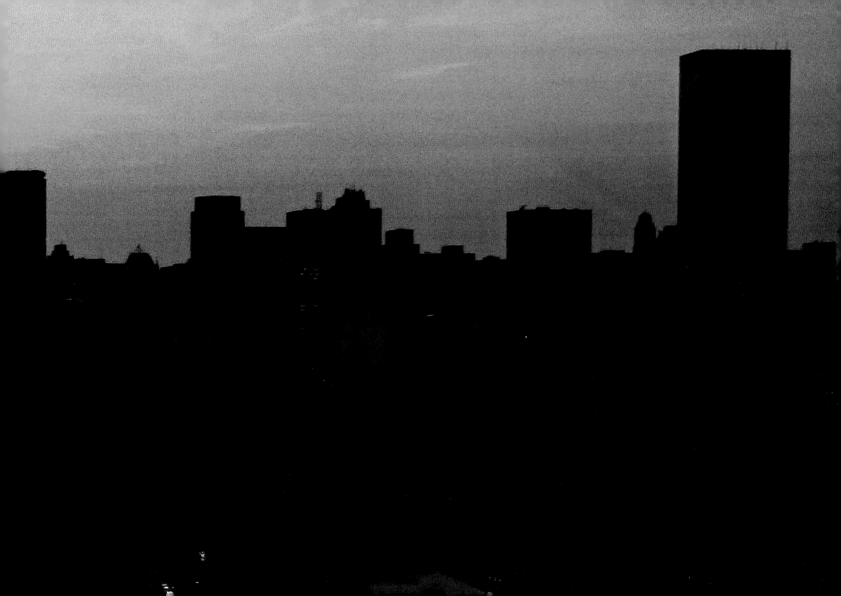

Coming Together

It started on a hot day somewhere in the Midwest when one power plant faltered. In minutes the power failures spread, domino-like, across the Northeast. Office workers watched their computer monitors blink off. Soon the police were evacuating people trapped in elevators and subways. For those who could not go home — whether home was twenty miles away in the suburbs or twenty stories up in a high-rise — the sidewalks of Manhattan turned into campsites as the largest blackout in the city's history continued through the night. Some people slept, some talked, some danced.

Vincent Laforet/*The New York Times*

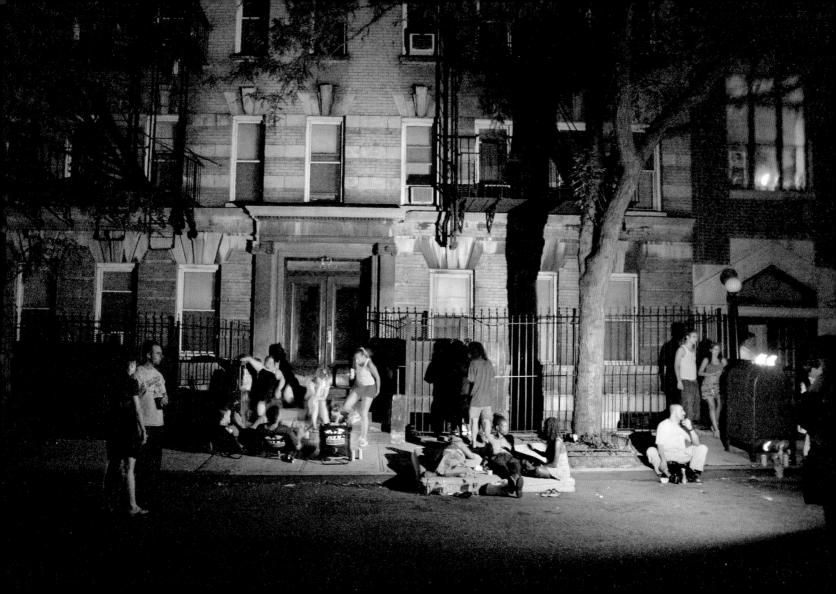

APRIL 6, 1944

A Prayer by Candlelight

Passover in 1944 came two months before the Normandy invasion and long before the details of the Nazi death camps became fully known. Next to this photograph of children in Washington Heights rehearsing a seder, *The Times* said that the mood at Passover tables would be "saddened by the sufferings of victims of Nazi persecution."

Ernie Sisto/*The New York Times*

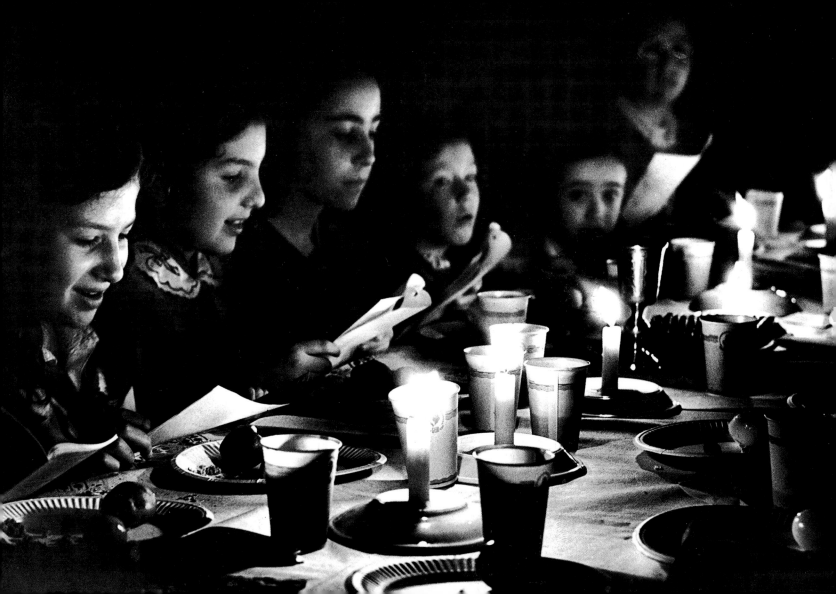

Mother's Day Portrait

He has learned all about f-stops and shutter speeds in workshops at the Photographic Center of Harlem. Now Jimmy Belfon puts what he has learned to the test as he takes a light reading before photographing three generations of a family for Mother's Day: from left, Maritta Best, with her mother, Edith Best, and Brian Dunn, a grandson of Mrs. Best.

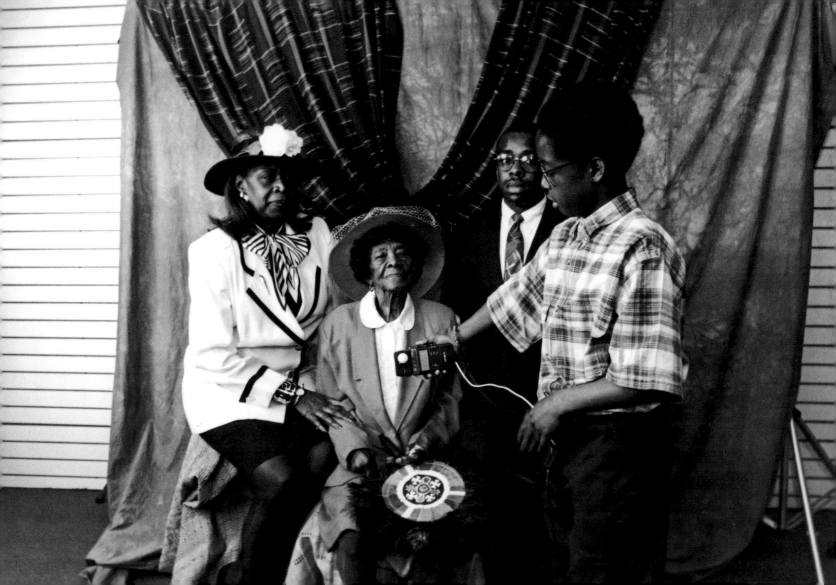

On the Avenue

"Oh, I could write a sonnet about your Easter bonnet with all the frills upon it," rhapsodized Irving Berlin. Surely he had hats like these in mind, and images like this: "On the avenue, Fifth Avenue, the photographers will snap us and you'll find that you're in the rotogravure . . ."

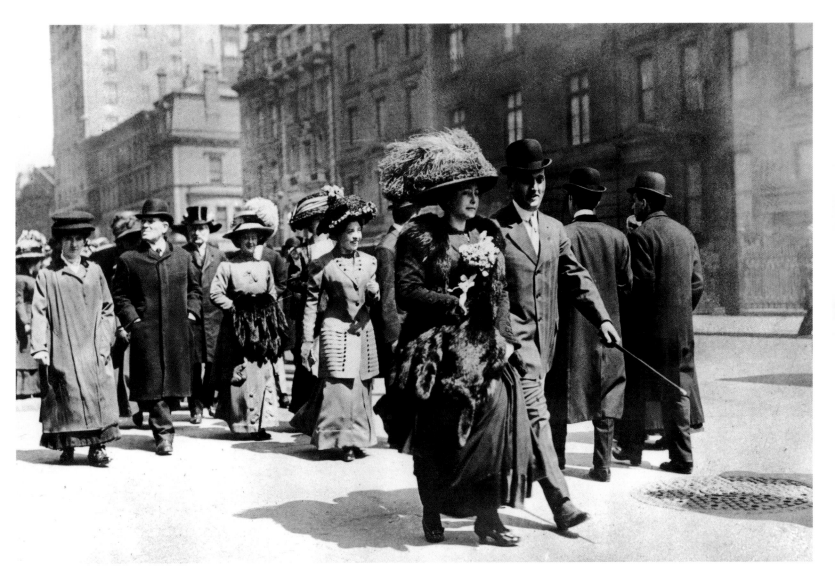

MARCH 31, 2002

Easter Finery and Bunny Ears, Too
Seven-year-old Kessie Brawner was all dressed up for Easter as she left her home in Brooklyn to go to services at Riverside Church in Manhattan.

Michelle V. Agins/*The New York Times*

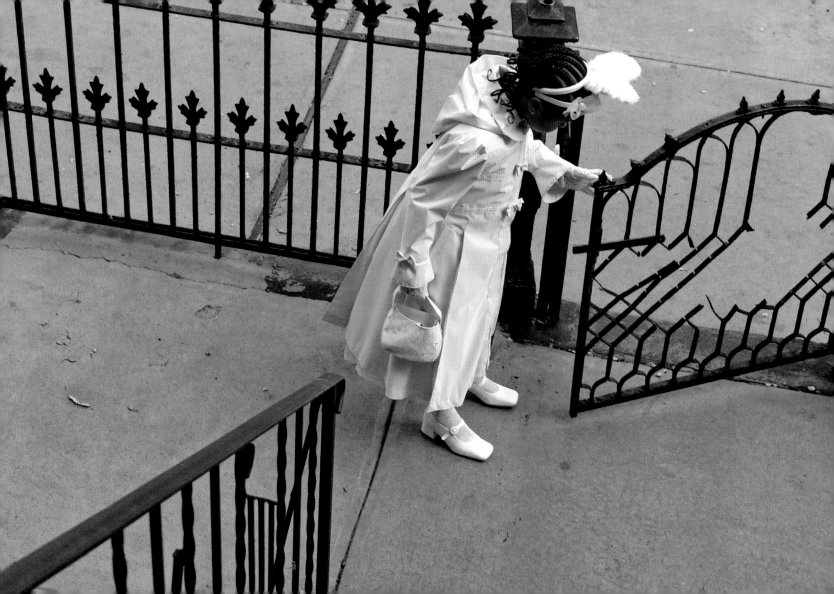

Evening Prayer

Ahnaf Bin Mahbubu, two, sat near his father during evening prayer at Masjid Nur Al-Islam, one of the city's 140 mosques.

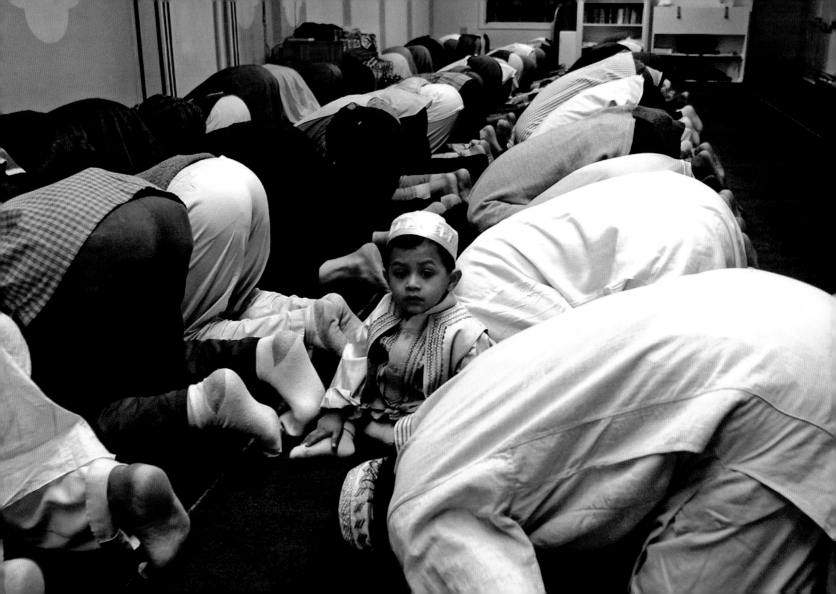

Festival of Thanks

The holiday after Yom Kippur on the Jewish calendar is Sukkoth, which commemorates forty years of wandering in the desert — hence the construction of the temporary shelter, the sukkah. The sukkah is usually brightly decorated, as Meir Lebowitz has done here for his mother in Kew Gardens, Queens.

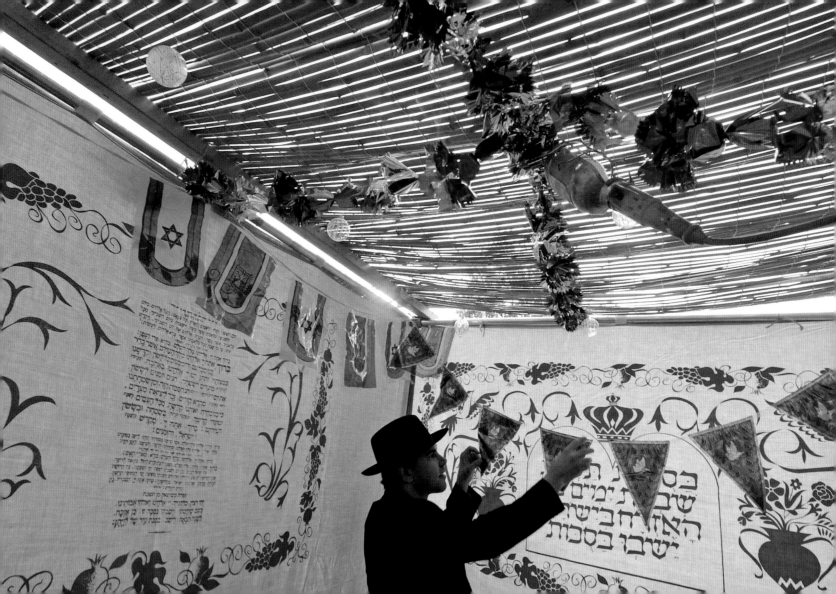

Opposite

JUNE 14, 2005

Awaiting Billy Graham

A "youth mobilization event" at the Korean American Presbyterian Church of Queens, before a crusade led by the Rev. Billy Graham. He said he was answering the call of pastors who wanted him to preach in New York one last time: "They just felt after 9/11 there was a search on the part of many people for the purpose and meaning in their lives."

James Estrin/The New York Times

Overleaf

MARCH 27, 1968

A Last Visit

Eight days before his assassination in Memphis, the Rev. Dr. Martin Luther King Jr. addressed members of the clergy in Queens, seeking support for his "poor people's campaign." "Nonviolence," he said, "is our most potent weapon."

John Orris/*The New York Times*

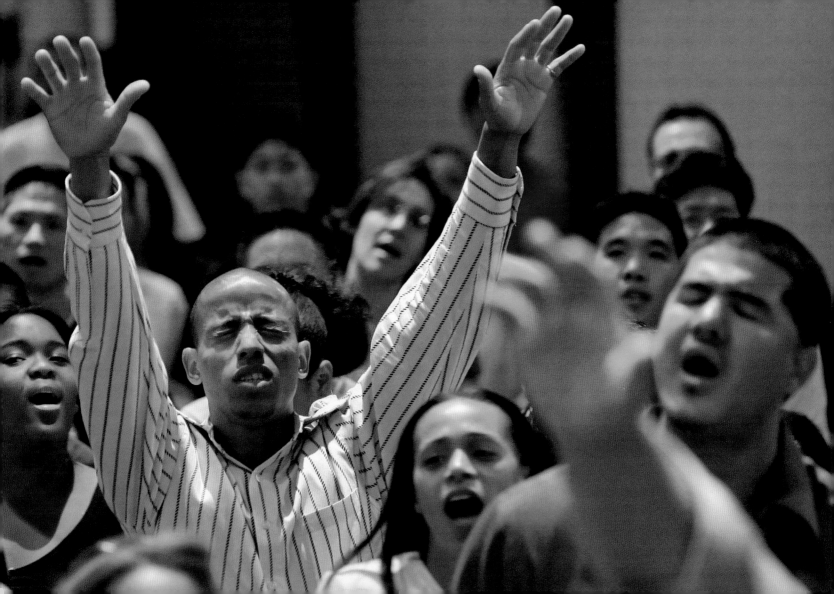

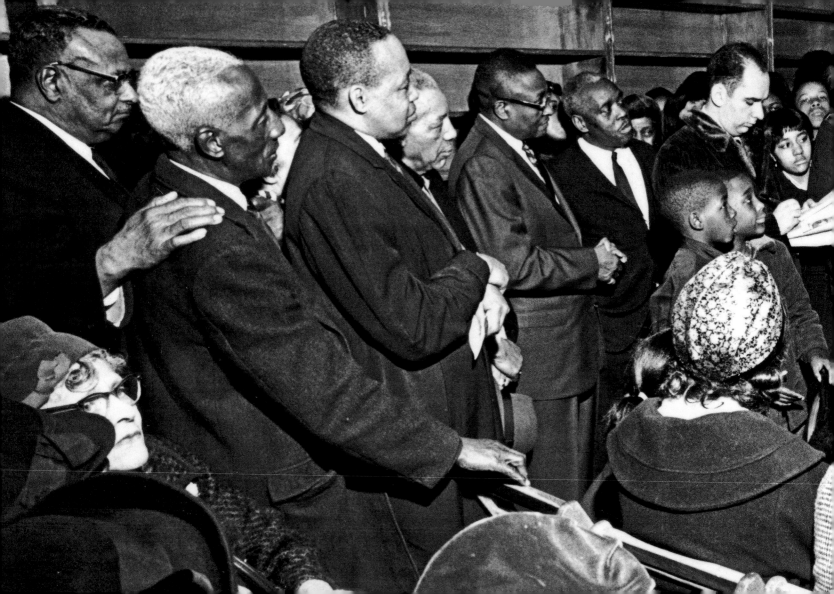

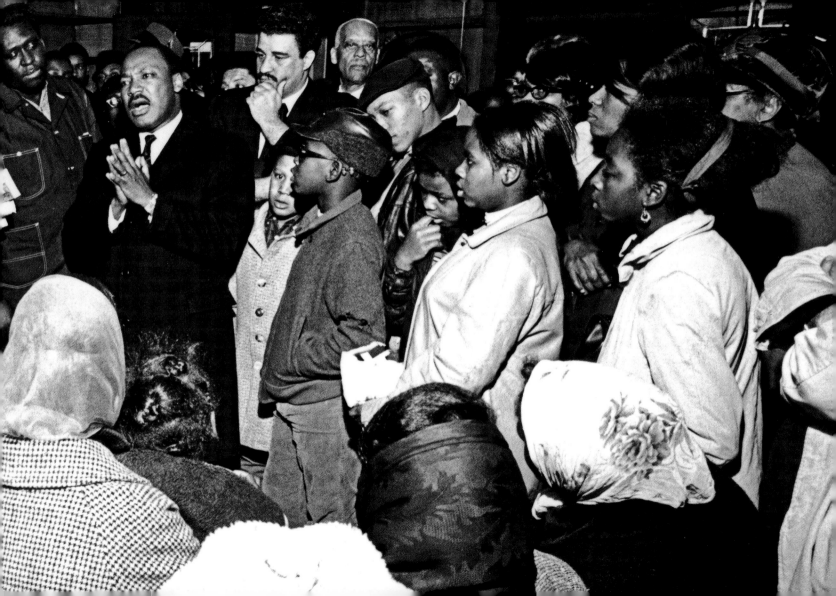

In Memoriam

Members of St. Paul Community Baptist
Church in East New York hugging on
the beach in Far Rockaway at a sunrise
service held in memory of the millions of
African slaves lost at sea on the way to
the Americas and to the Caribbean.

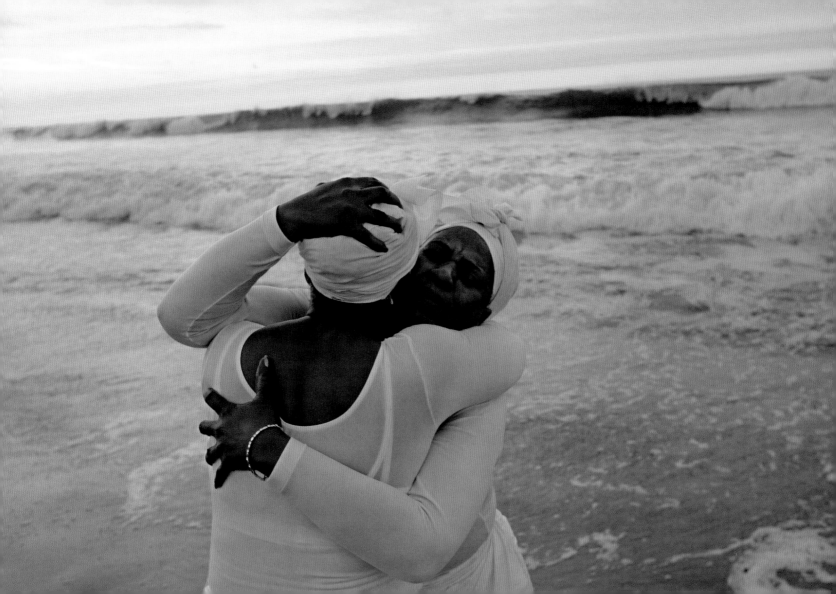

A Beginning

James H. Meredith, who had desegregated the University of Mississippi in 1962, walked along 125th Street on what he said was the first block of a 250-mile voter-registration drive. After passing a photographer who was perched, not too steadily, on a standpipe connector, Meredith stopped at thirty-three stores in a little more than two hours, collecting $70 in contributions and numerous promises of help in signing up new voters.

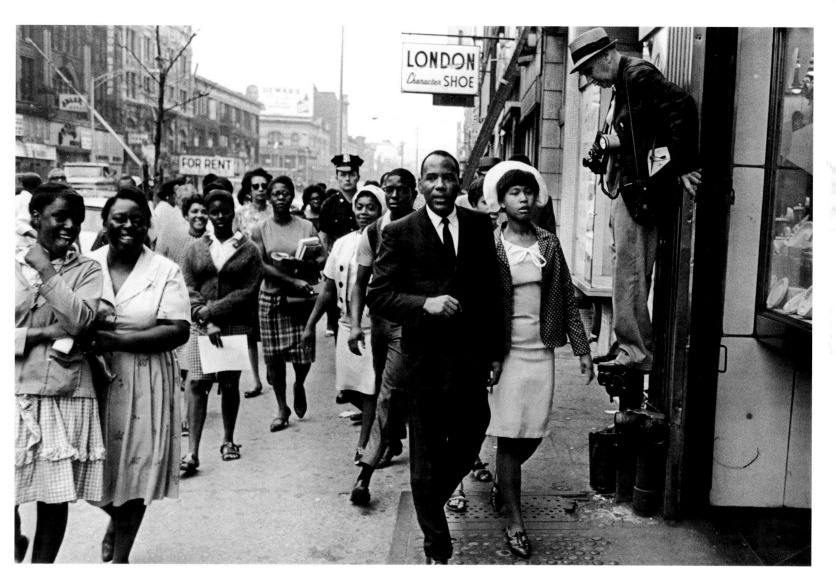

Rebellion

The Stonewall Inn was a gay bar on Christopher Street well before the word "gay" was associated with homosexuality. It was raided in June 1969, supposedly to check for liquor violations. The customers fought back, barricading the officers and liquor control agents inside. The standoff lasted three days, and was the beginning of the modern gay rights movement.

Larry C. Morris/*The New York Times*

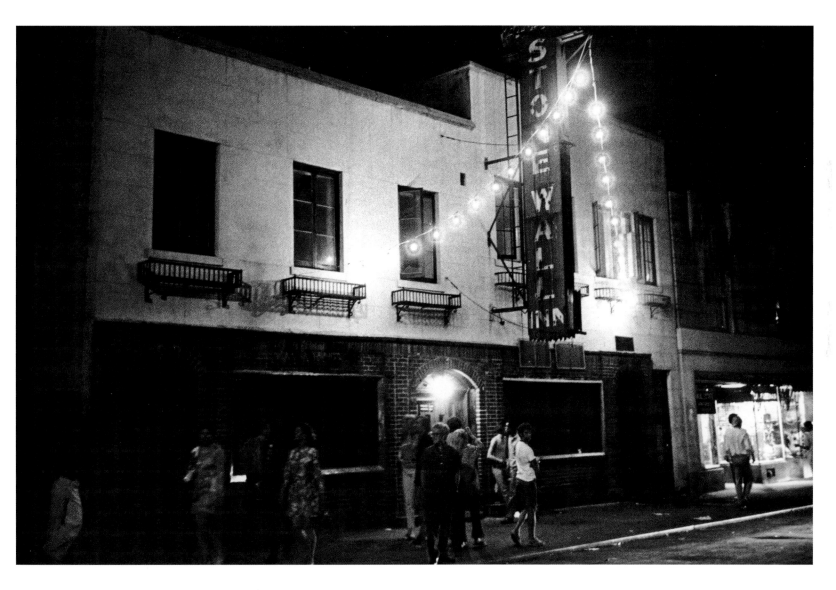

Marching for Rights

Thousands of gay men and lesbians marched from Greenwich Village to Central Park in this first gay rights parade. From Washington, Boston, and Cleveland, from Ivy League colleges, from Harlem, the East Side, and the suburbs, they gathered to protest laws that made homosexual acts between consenting adults illegal and social conditions that often made it impossible to display affection in public, maintain jobs, or rent apartments. The parade became a staple of the city's calendar, and by the 1990s, even the Empire State Building was lit up in lavender to take note of the event.

Michael Evans/*The New York Times*

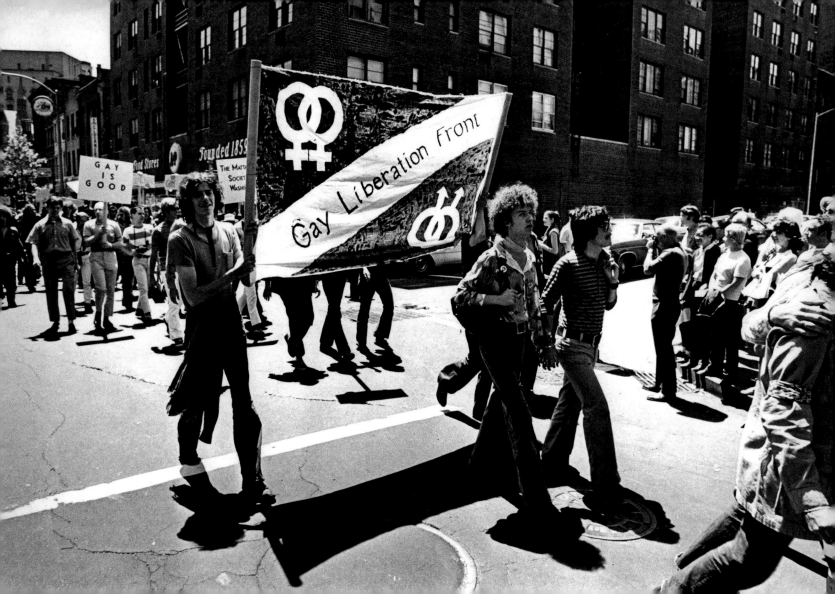

Police Action

After four weeks of demonstrations at
Columbia University, Mayor John V. Lindsay
sent the police to clear five buildings
that student protesters had taken over.
Demonstrators led by Mark Rudd of
the Columbia chapter of Students for
a Democratic Society had held a dean
hostage and staged a sit-in at the office of
the university president, Grayson L. Kirk.
In the emotionally charged debate over
the Vietnam War, the protests centered on
Columbia's ties to a consortium that did
research for the military and on plans for a
gymnasium in a nearby park. Kirk eventually
resigned; the gym was never built.

Larry C. Morris/*The New York Times*

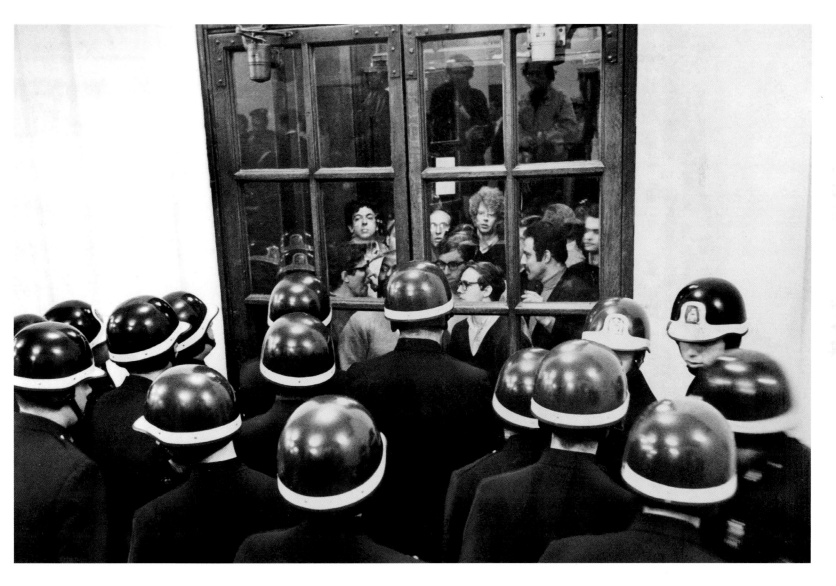

Jewel in a Glass Box

Forget, for a moment, that it is a pretty thing with the twinkly cityscape spread out behind it, and consider facts. The jewel-like sphere of the Hayden Planetarium is eighty-seven feet in diameter — wide enough to hold the other big blue object at the American Museum of Natural History on the Upper West Side, the blue whale. And the box? With 736 panes, it is in the record books as the largest suspended-glass curtain wall in the United States.

Sara Krulwich/*The New York Times*

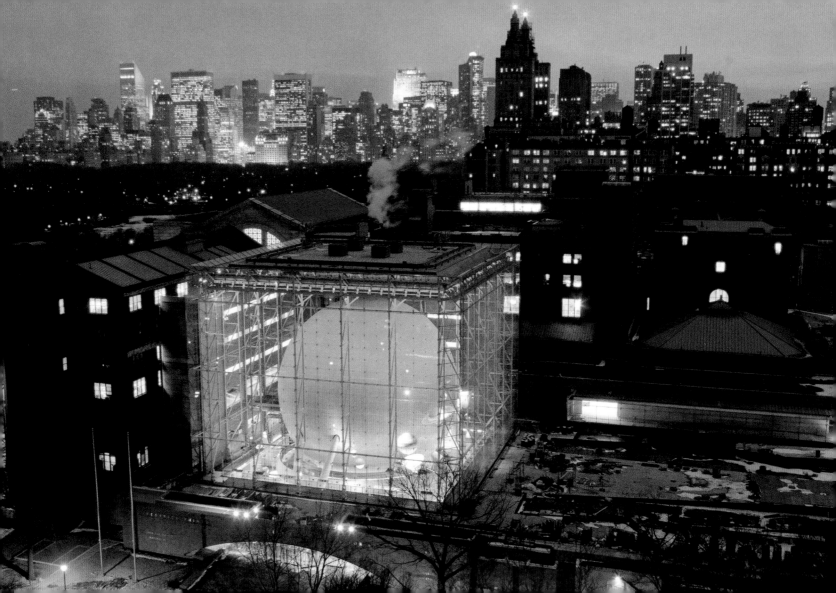

A Visitor From Outer Space

The Willamette Meteorite, the largest ever found in the United States, was so named because it was found in the Willamette Valley of Oregon. But it is believed to have landed in Canada and been carried south by a glacier. Later — much later — a steel company donated it to the American Museum of Natural History, where these boys climbed up and nestled in.

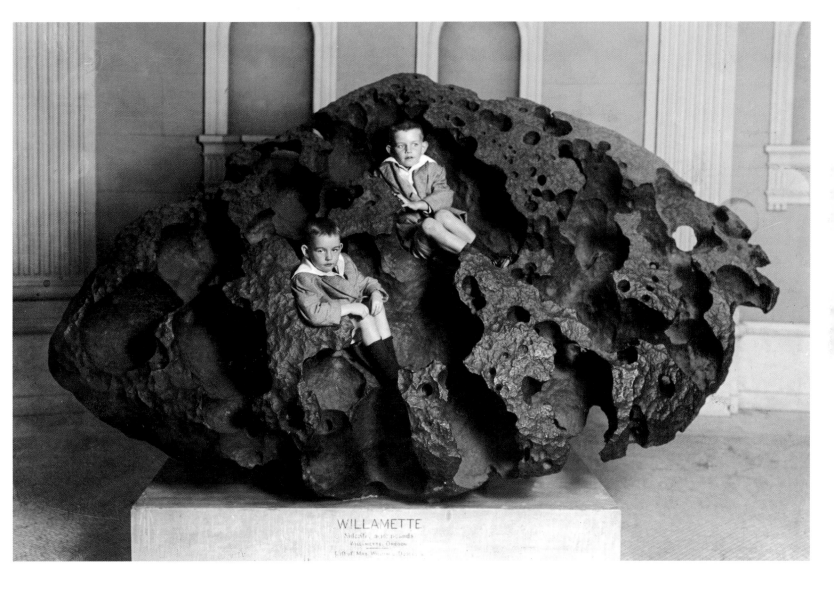

WILLAMETTE
Siderite, 14 15 pounds
Willamette, Oregon

Gift of Mrs. William E. Dodge

Opposite

JANUARY 15, 1934

Einstein Sets Type

Albert Einstein set the first type for the expanded *Jewish Daily Bulletin,* which was published in New York City starting in 1925. The journalist Daniel Schorr, who began his career there in the 1930s, says the *Bulletin*'s publisher hoped it "would appeal to people feeling increasingly Jewish with the rise of Hitler, but no longer reading Yiddish."

The New York Times Photo Archives

Overleaf

SEPTEMBER 12, 2001

Listening

The day after the 9/11 attacks, Secretary-General Kofi Annan took his place in the front of the chamber as the United Nations General Assembly began its 56th session on schedule. The U.N. was determined not to let the attacks keep it from going about its business, though it postponed the ceremonial opening of the General Assembly.

Ruth Fremson/*The New York Times*

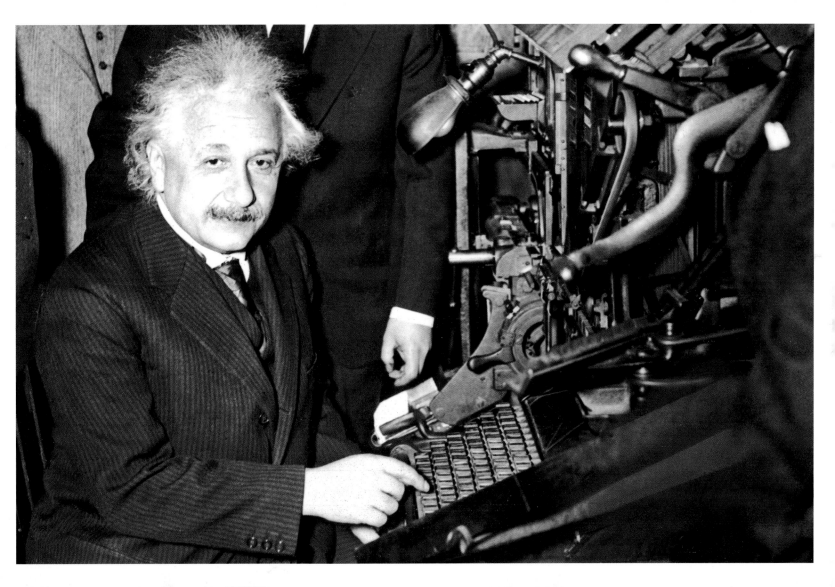

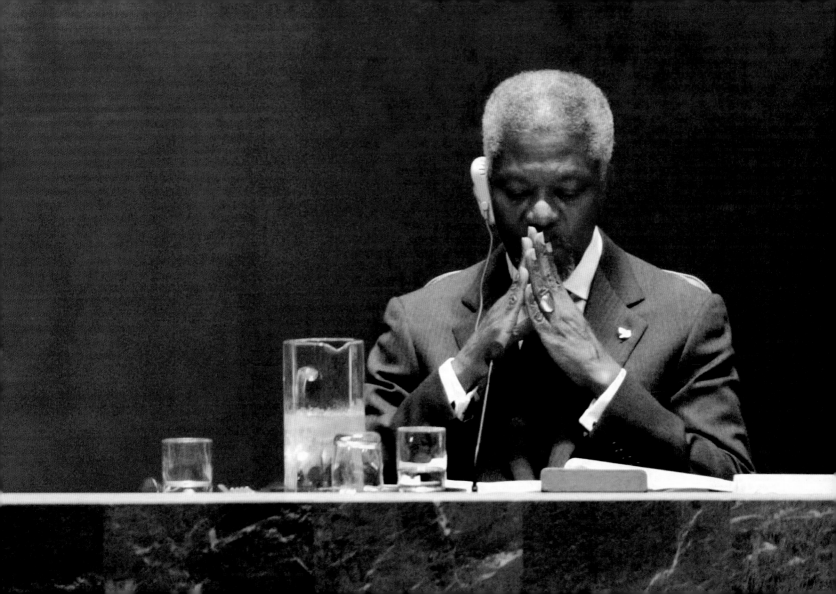

1918

Opposite

M*A*S*H

For surgeons heading to the front in World War I, an important stop was a demonstration hospital at the Rockefeller Institute for Medical Research. They concentrated on "the perfecting of war surgery and the study of 'shell shock,'" under conditions designed to mirror the field hospitals in France and England.

The New York Times Photo Archives

1927

Overleaf

The Press at Work

Photographers lined up outside the courthouse, waiting for Ruth Snyder, whom Damon Runyon called "a chilly-looking blonde with frosty eyes and one of those marble you-bet-you-will chins," and her lover, Judd Gray. They were charged with murdering her husband after taking out a double-indemnity life insurance policy. The verdict was guilty, the sentence death by electrocution.

The New York Times Photo Archives

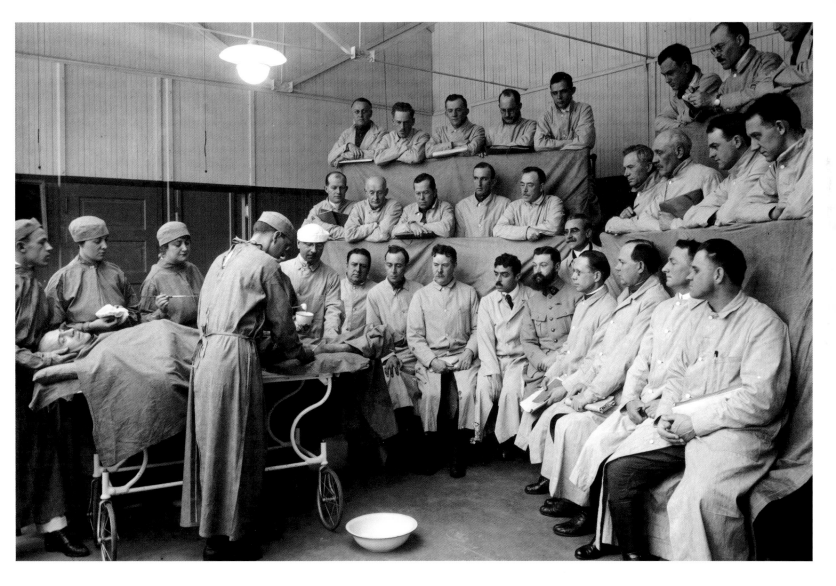

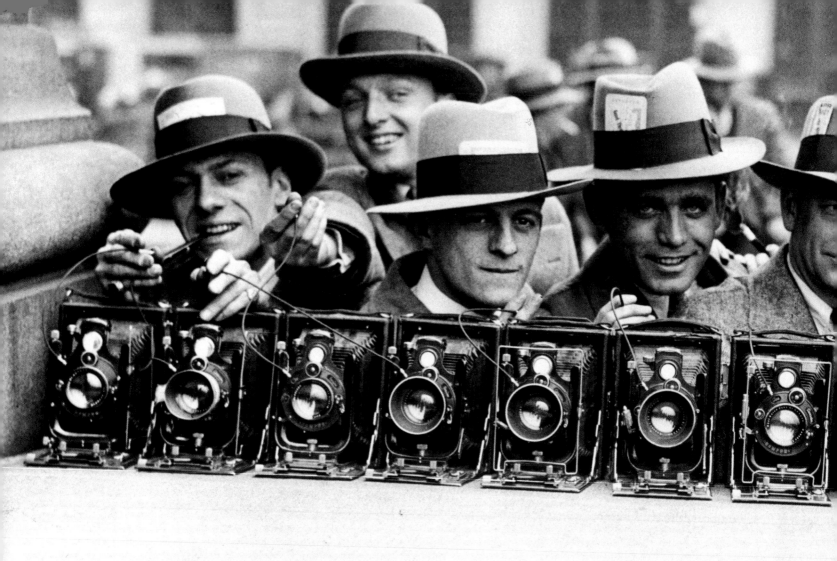

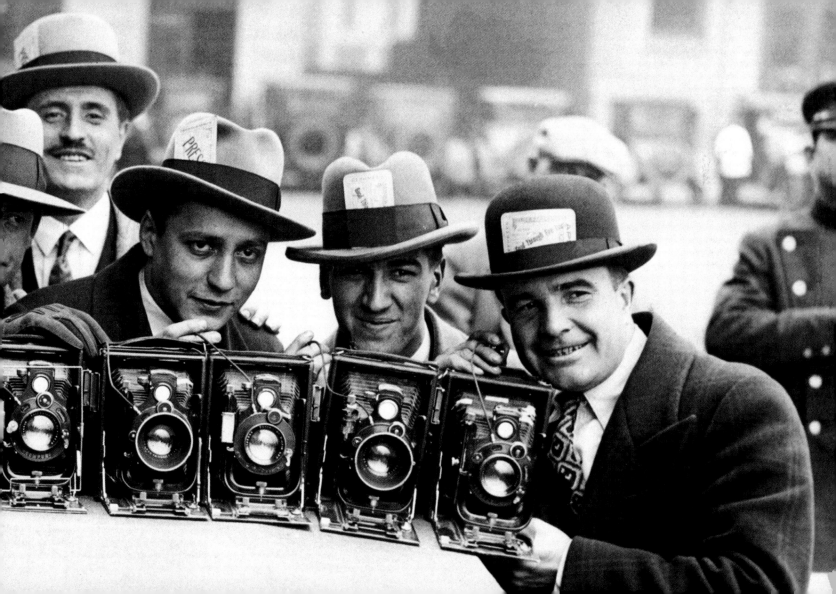

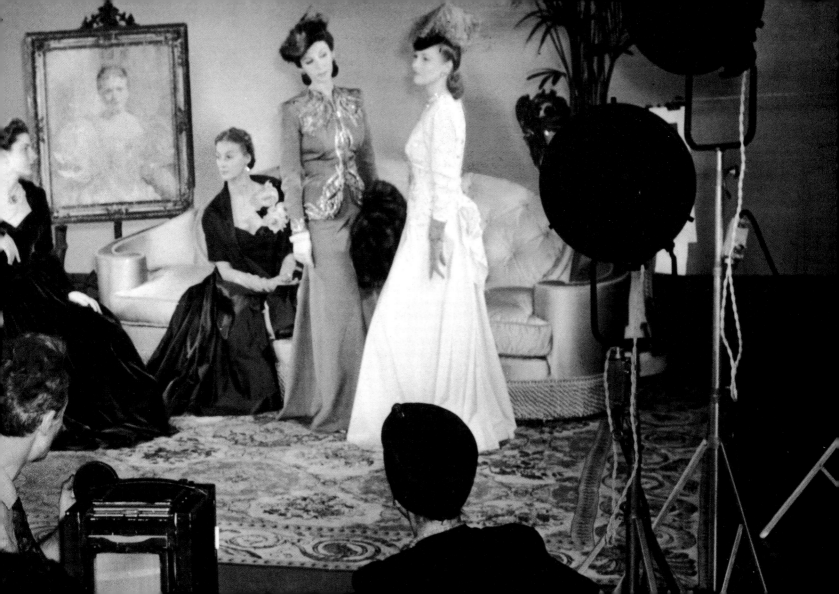

1940

Pre-Supermodel Models

"Hours under lights, endless sittings while photographers fiddle around trying to get just the effect they want; modeling fur coats in August and bathing suits outdoors in March are all part of the routine," *The Times* said in describing a model's life before World War II. Less-than-glamorous pay was also a fact of life. "There are quite a few girls in the business who won't work for less than $10 an hour," *The Times* said.

The New York Times Photo Archives

Opposite

SEPTEMBER 21, 1934

Booked

The kidnapping and killing of Charles A. Lindbergh's infant son made headlines from the day it happened, and bigger headlines after a carpenter named Bruno Richard Hauptmann was booked at police headquarters in New York. Executed in 1936, he claimed until the end that he was innocent.

The New York Times Photo Archives

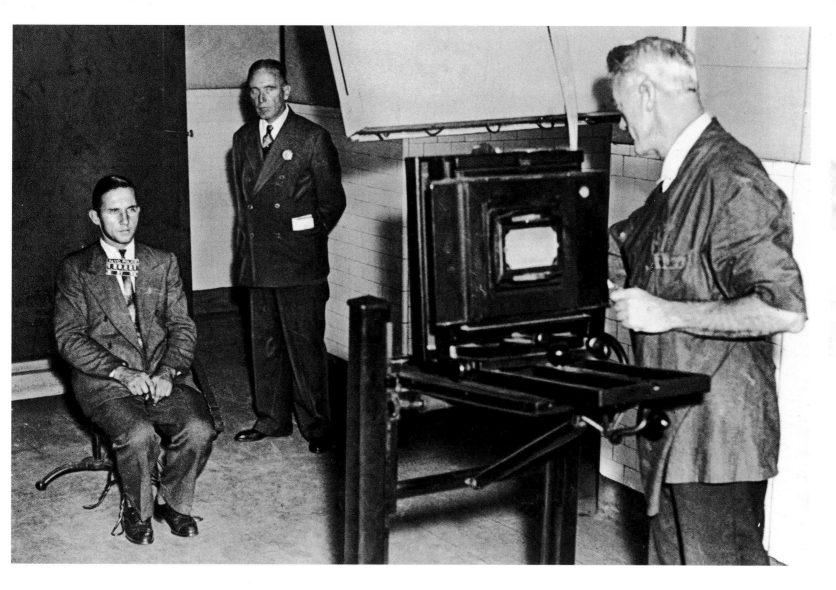

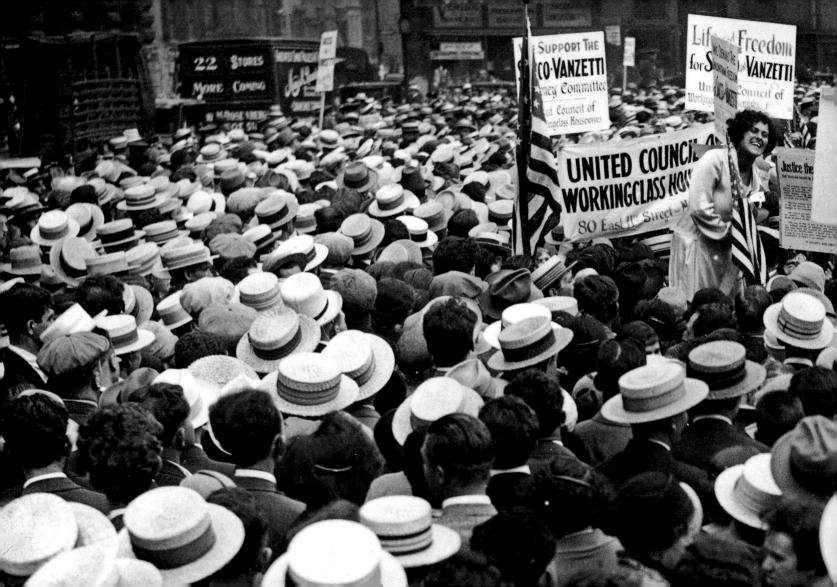

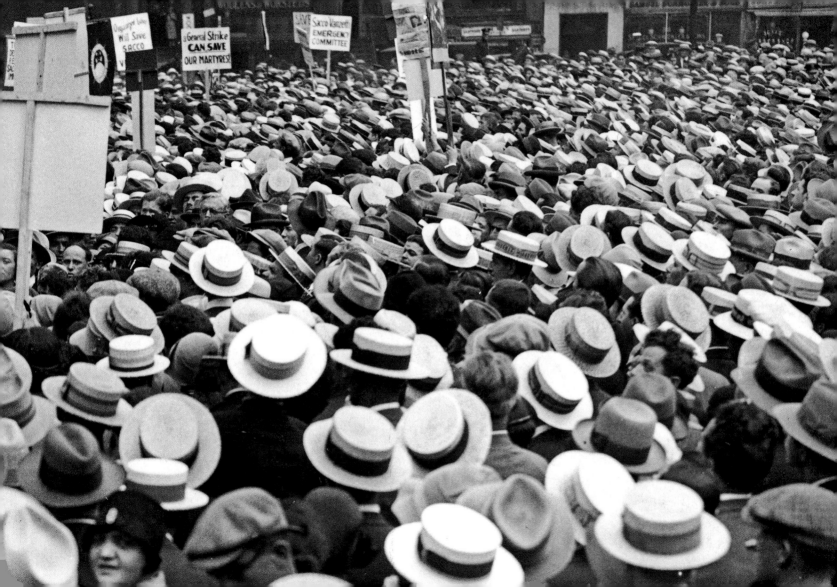

AUGUST 9, 1927

Pleading for Sacco and Vanzetti

This crowd gathered in Union Square to protest the scheduled execution of Nicola Sacco and Bartomoleo Vanzetti, obscure anarchists convicted of robbing a bank in Braintree, Massachusetts, and fatally shooting the paymaster and a guard. Their defenders charged that they were framed and the trial was essentially a political prosecution.

The New York Times Photo Archives

Opposite

MARCH 27, 1921

Suffragettes and a Saint

A year after women won full voting rights, these women joined in the St. Patrick's Day parade on Fifth Avenue. For all the jockeying that goes on at the parade — whether among spectators elbowing for unobstructed views or among would-be grand marshals campaigning to lead the parade — the first female grand marshal didn't appear until 1989.

Paul Thompson

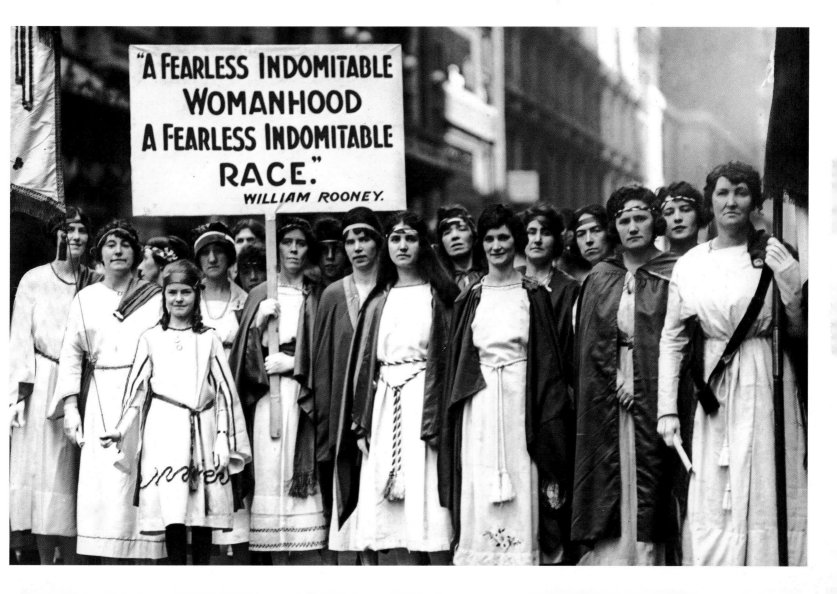

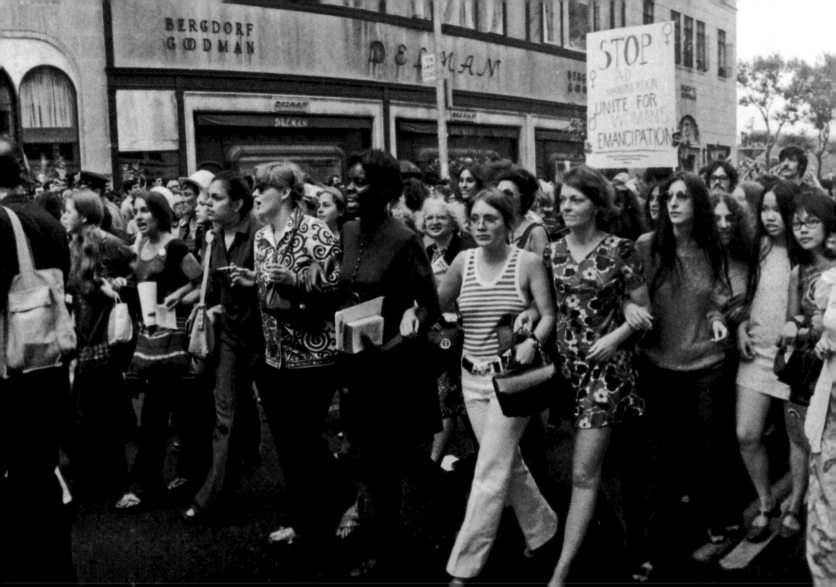

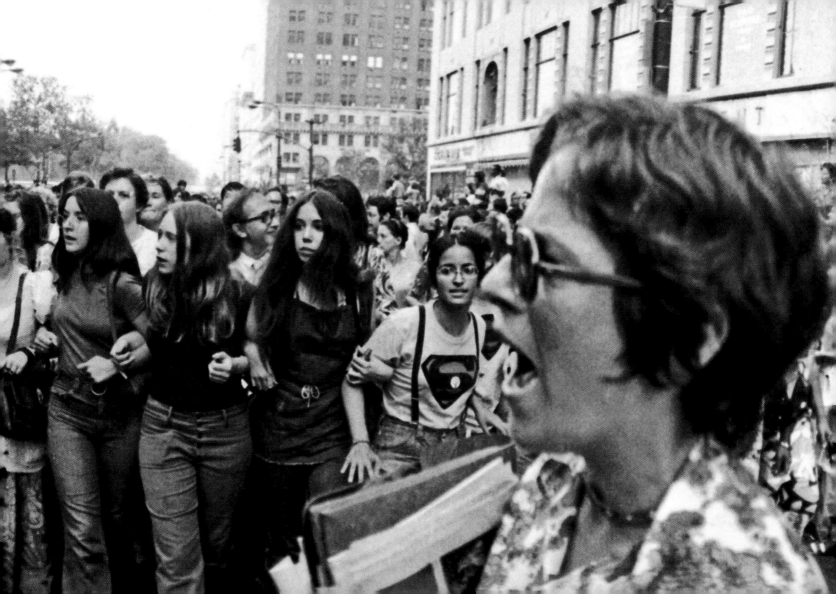

AUGUST 26, 1970

Women Being Heard

"From the radical left to the Establishment middle," the feminist writer Susan Brownmiller declared before this march filled Fifth Avenue from curb to curb, "the women's movement has become a fact of life." Billed as the "Women's Strike for Equality," the march was a celebration of the fiftieth anniversary of American women's right to vote and the beginning of a crusade for new rights.

William E. Sauro/*The New York Times*

Opposite

JUNE 12, 2005

Puerto Rican Colors

It's all about national pride when Fifth Avenue rocks to a Puerto Rican beat and flag-waving, salsa-bopping crowds line the sidewalks. The Puerto Rican Day parade ranks second in size to the St. Patrick's Day parade. This is Port Authority Sgt. Michelle Serrano.

Tyler Hicks/*The New York Times*

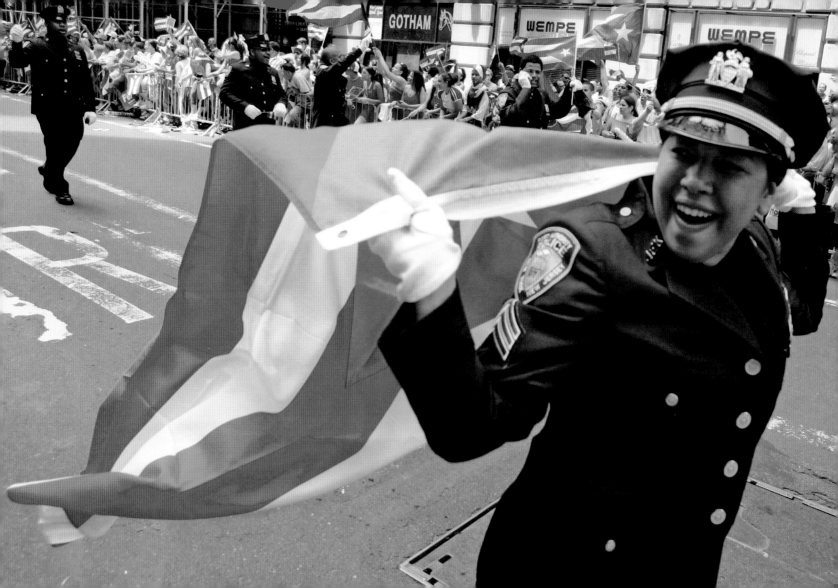

The Year of the Tiger

The Chinese Year of the Tiger — Lao Hu Nian — danced in, borne by dragons and by marchers bundled up against the midwinter cold. As dictated by tradition, Chinatown was decked out in red and gold, colors that signify good fortune and prosperity, and firecrackers exploded on every block.

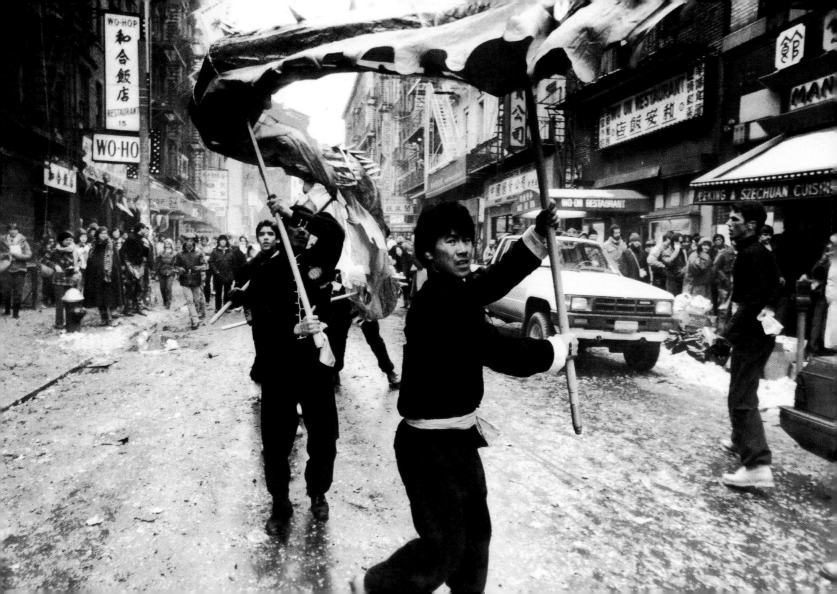

APRIL 28, 1919

Back From Over There

New York City's Sixty-ninth Regiment returned from World War I to great fanfare, marching up Fifth Avenue "amid the acclaims of unnumbered thousands of friends and admirers," according to *The Times*. The backdrop here is the Metropolitan Museum of Art, site of the reviewing stand, where Governor Alfred E. Smith and Mayor John F. Hylan welcomed the troops home.

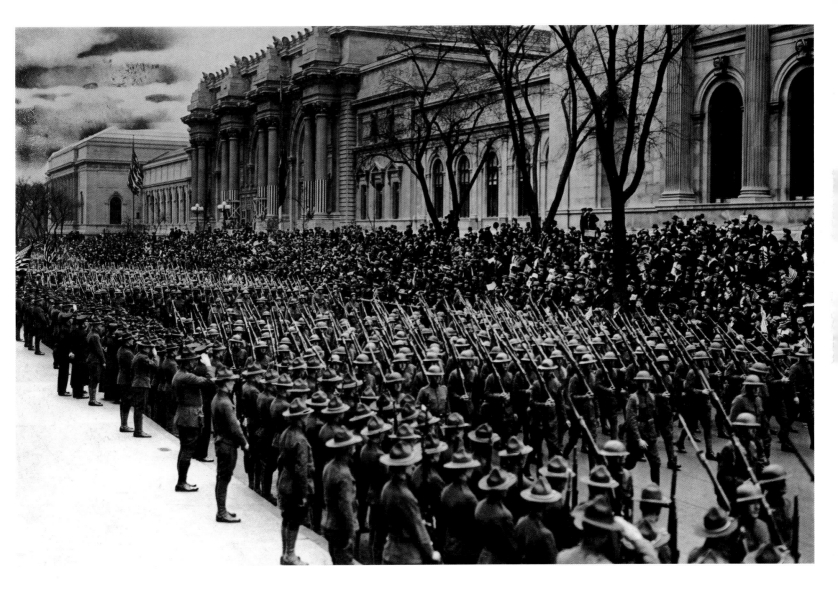

Remembering the Doughboys

It began as Armistice Day when the war to end all wars ended, and was later rechristened "Veterans Day" to honor the American dead of all wars. By 1997, the marchers in the annual parade in Manhattan included men dressed like the doughboys their grandfathers had been.

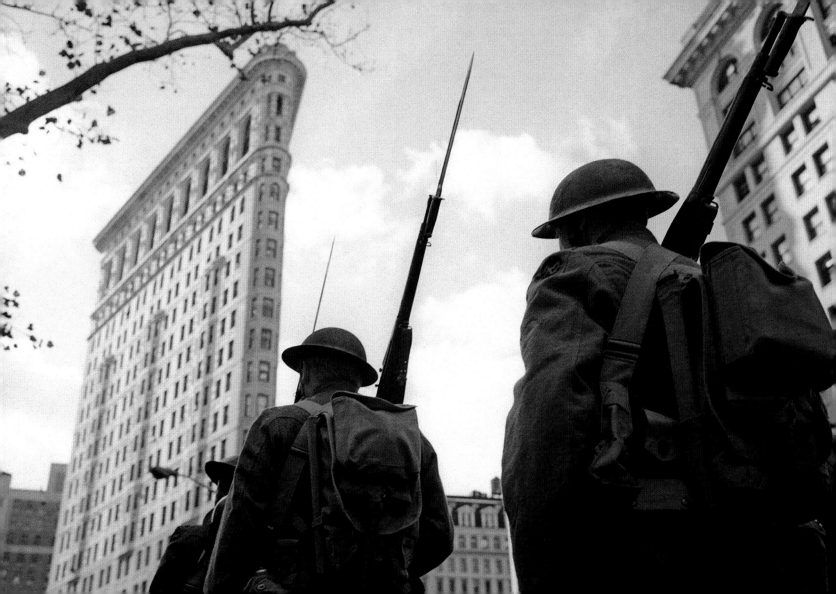

Pyramids on Park Avenue

As the doughboys prepared to come home from World War I, two pyramids of captured German helmets were stacked along what was named "Victory Way," the stretch of Park Avenue between Forty-fifth and Fiftieth Streets. Nearly ten thousand people attended the dedication of this esplanade, created to raise money to pay for the war that had officially ended with the signing of the armistice in November 1918.

Underwood & Underwood

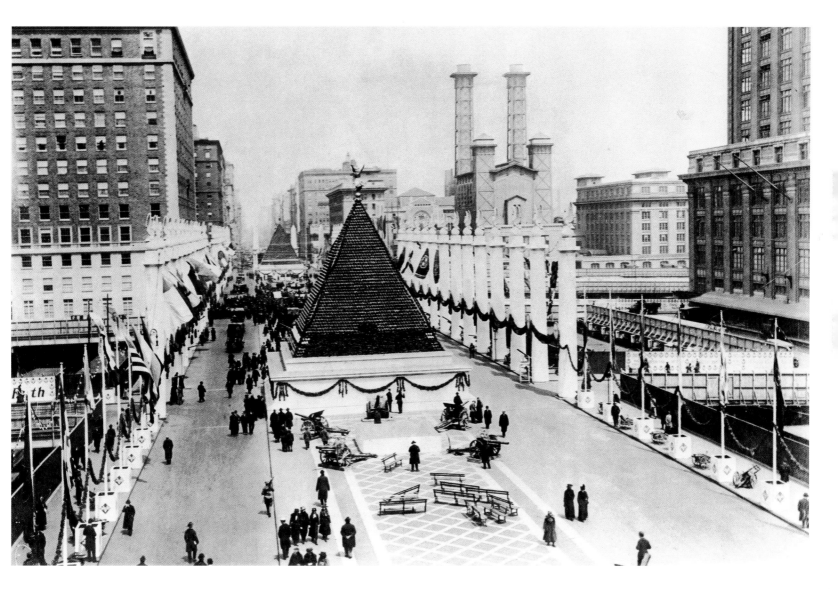

Everyone Is Irish

Veteran *Times* reporter Richard F. Shepard observed that it's puzzling the way New York becomes Irish on St. Patrick's Day. Puzzling, because in the city that was the original melting pot, the Irish somehow get everyone to celebrate their saint, their homeland, their day. Maybe it's the green beer. The St. Patrick's Day parade has been a New York ritual since at least the eighteenth century, and even though the Irish hold on government and politics in New York is far less than it once was, the parade seems to draw more would-be Irish — more marchers, more bands, and more crowds — every year.

Vincent Laforet/*The New York Times*

380

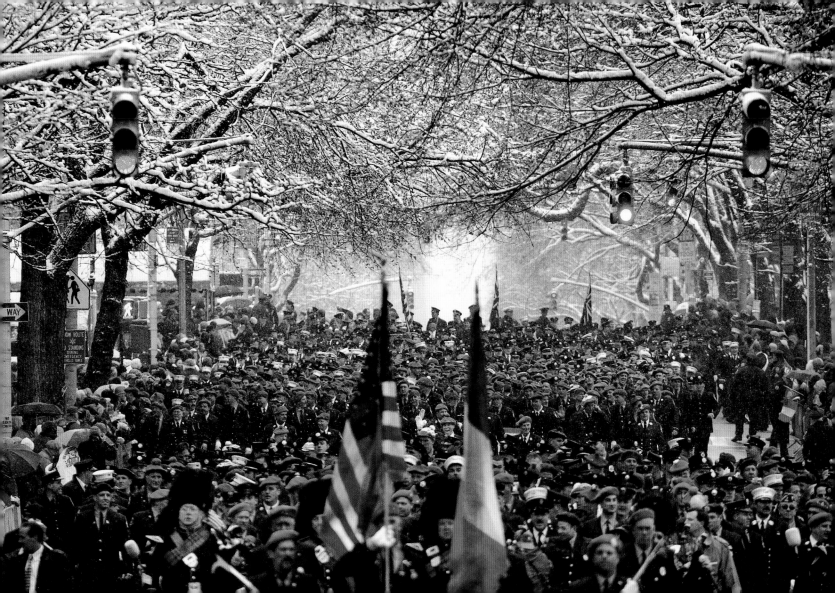

Mirror, Mirror, in the Air

These two men did not have to yell "down in front" to see the marching bands at an American Legion parade. They attached shaving mirrors to walking sticks and used them as periscopes to look over the heads of other spectators.

Thanksgiving on Broadway

Giant cartoon-character balloons float
by. Crowds ooh and ahh. The Macy's
Thanksgiving Day parade is always
comfortably predictable and yet
somehow always fresh. But didn't Mickey
Mouse look a bit thinner then?

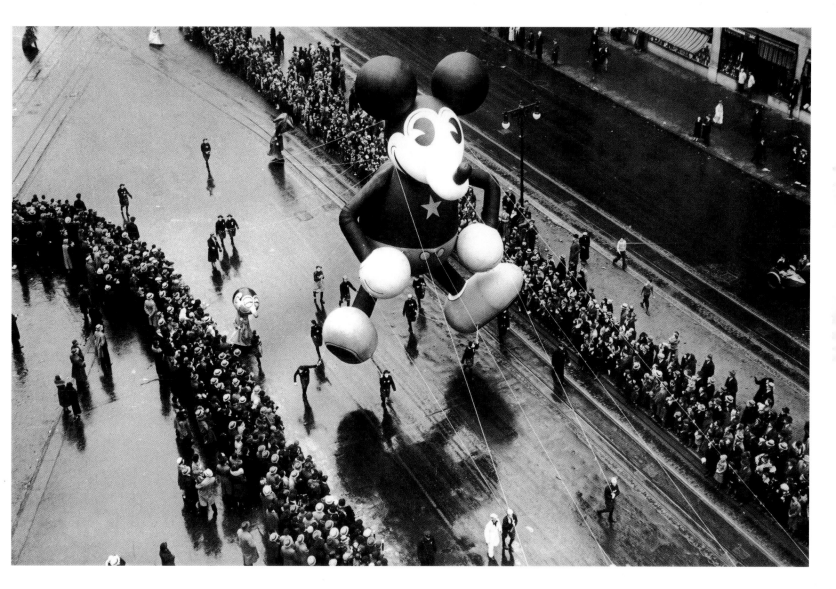

Breathing Life Into Kermit

Before the long, meandering convoy of floats and trumpet-blaring marching bands got moving, volunteers pumped life into the Kermit the Frog balloon as they prepared for the Macy's Thanksgiving Day parade.

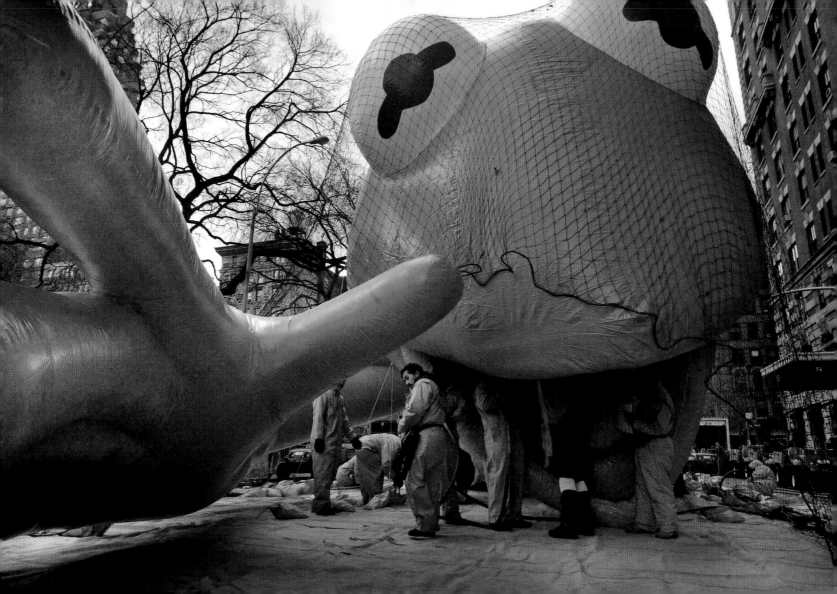

1927

Nineteen Gals, a Guy, and a Publicity Stunt

If these women had let go of their trampoline-like net, *Honeymoon Lane*, a musical that had been running at the Knickerbocker Theater for nine months, would have lost its playwright, lyricist, and leading man, Eddie Dowling.

The New York Times Photo Archives

Overleaf

1939

"The Road of Tomorrow"

RCA introduced television at the 1939 World's Fair. General Motors built its Futurama. And Ford's "Road of Tomorrow" had a cork-and-rubber surface and ramps that were stacked like platters of spinning records. It led to a building in which Ford displayed Henry Ford's very first car and two of the company's newest models, a Lincoln Zephyr and a Ford convertible with a rumble seat.

The New York Times Photo Archives

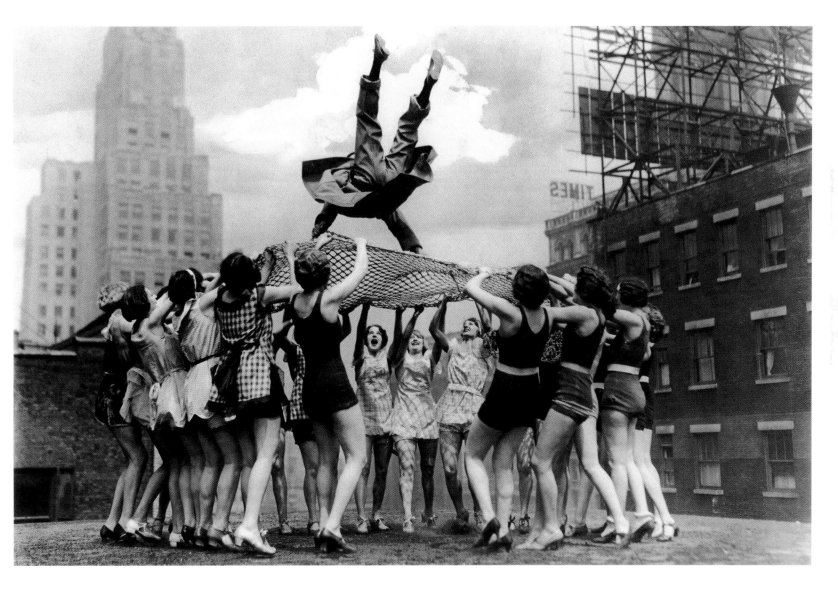

Isn't That Bruce Wayne?

It had Henry Ford's grandson at the wheel, a mouthful of chrome teeth, eyebrows over its headlights, and a leaner, lower-to-the-ground look that was decidedly different from the round hoods and fenders of its high-riding neighbors in Times Square. Somehow, though, this experimental Lincoln Futura did not become the car of the future. What it did become, twelve years later, was the Batmobile on television. But that's another story.

Fred J. Sass/*The New York Times*

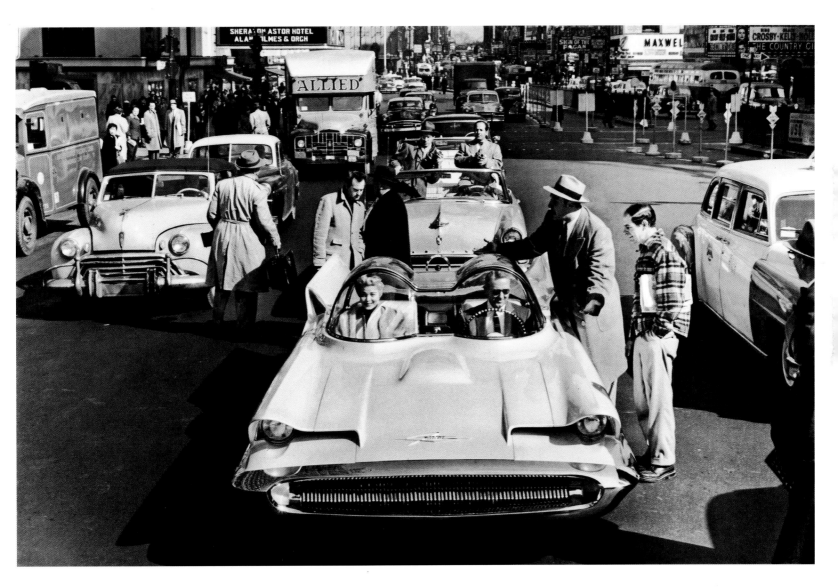

At the First Auto Show

Years before Henry Ford's first Model T rolled off the assembly line or Chevrolet's first Classic Six roared down the road, there was the annual parade of vehicles known as the New York Auto Show. When the first one was held in Madison Square Garden, these newfangled vehicles were often referred to as "horseless carriages."

Brown Brothers

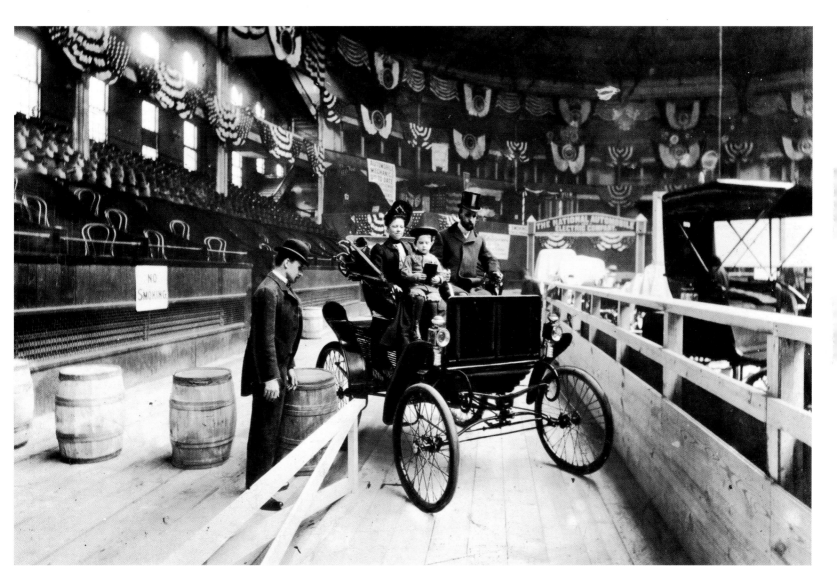

Hog Heaven

Manhattan isn't exactly the open road, but that fact did not get in the way of an exhibition of more than one hundred classic choppers at the Solomon R. Guggenheim Museum. "The Art of the Motorcycle," with shiny stainless steel panels designed by the architect Frank O. Gehry, was a big hit, attracting more than five thousand people a day on weekends.

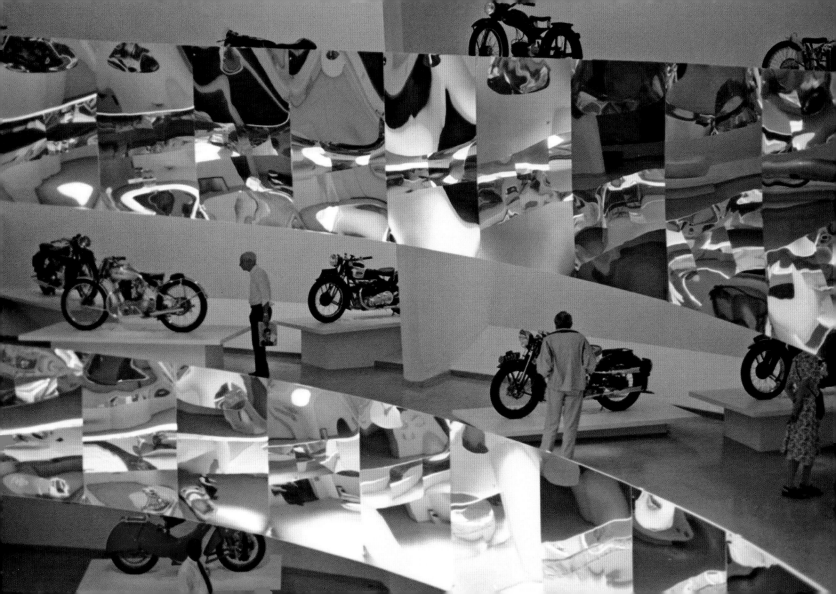

Gadget Inspector

It's a tough job, but someone has to do it. William H. Olsen was a city inspector of elevators in cold weather, and amusement-park rides at Coney Island the rest of the year. He was the first passenger in the new Satellite Jet, pictured here, but only after some preliminary tests. First he loaded the twelve sidecars with 450 pounds of sand and ran the Satellite Jet through its usual gravity-defying cycle of soaring and twisting and turning. Then he took the sand out of half the cars and pushed the "go" button again. Then, finally, he climbed in.

Neal Boenzi/*The New York Times*

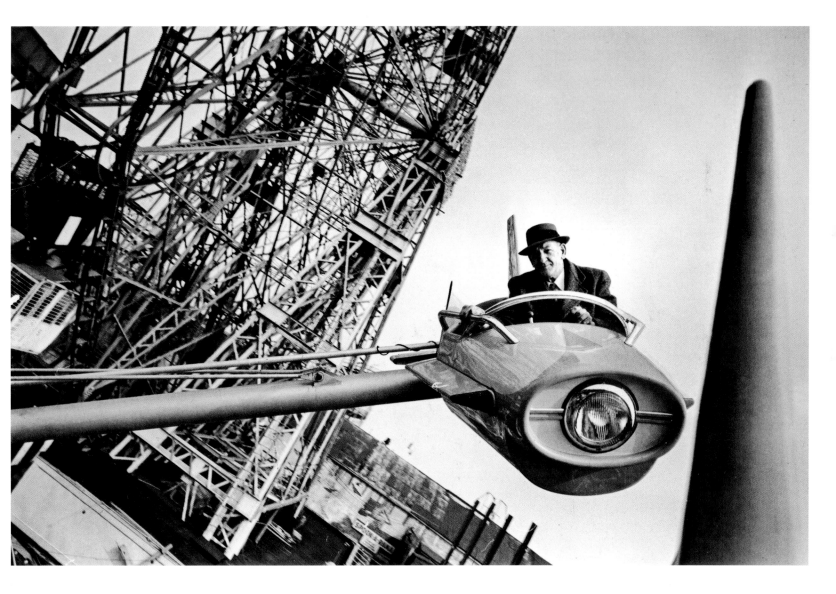

The Popeye Diet

Spinach, *The Times* observed during World War II, was "a rarity in the produce market nowadays." Wartime rationing had curbed the availability of such staples as butter, meat, sugar, and coffee, and shipments of vegetables like spinach arrived only occasionally. This grocer is inspecting spinach on sale at the old Washington Market in Lower Manhattan, where generations of grocers bought their produce until it was demolished to make way for the World Trade Center.

Take It Away

In the days of flappers and bathtub gin and Model As and trucks with peculiar-looking tires, the agency that took away New Yorkers' trash was called the Department of Street Cleaning. Today, the Department of Sanitation has twenty-two hundred trucks that collect twelve thousand tons of trash for disposal and recycling every day.

Paddy's Market, R.I.P.

From just after the Civil War until just after the Depression, it was a fixture in Hell's Kitchen: an open-air bazaar that everyone called "Paddy's Market." Never mind that no one remembered who Paddy was: this stretch of Ninth Avenue in the West Forties was where New Yorkers could buy anything from bedroom slippers to bedroom furniture, and all kinds of fruits and vegetables. *The Times* reported in 1937 that Paddy's was "doomed" by the construction of the Lincoln Tunnel. Paddy's was ordered moved to a vacant lot nearby. Business was never the same, and by the time the Ninth Avenue El (at left) went out of service in 1958, Paddy's had gone too.

Where Everyone Sells Everything

In New York, even the most exotic foods are always for sale. This vegetable-stand owner from Turkey specialized in produce from the West Indies: plantains, dasheens, yams, and coconuts.

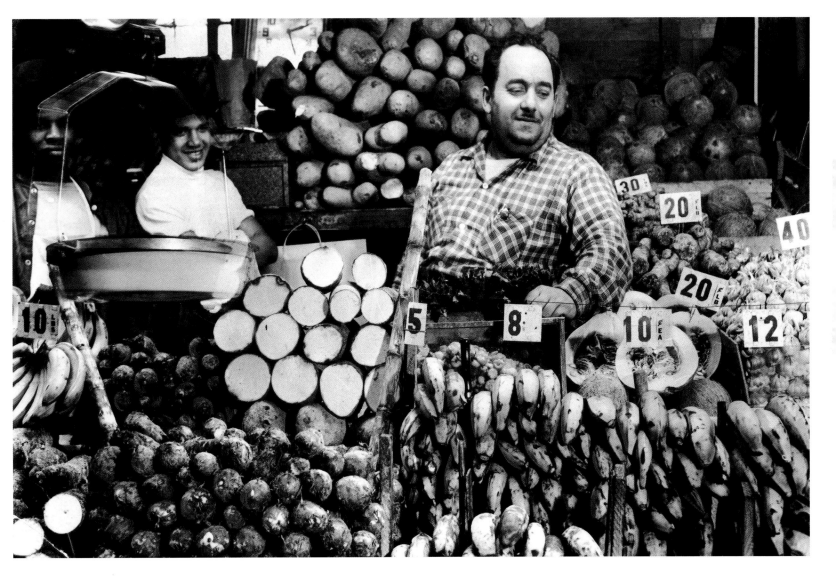

Opposite

Taste-Tester

Little sister Mychael Wingate, two, samples a peach as big sister Nia Roach, seven, fills a bag to take home from a farmers' market on 125th Street in Manhattan.

Tyler Hicks/*The New York Times*

Overleaf

Laundry Room

At the Plaza Hotel — where F. Scott and Zelda Fitzgerald pranced in the fountain and Eloise burbled "Ooooooooh, I absolutely love the Plaza" as she pranced through the corridors — sheets and towels were meticulously laundered from the day the first guest arrived in 1907. That first guest was accustomed to being fussed over: he was a Vanderbilt.

Drucker & Company

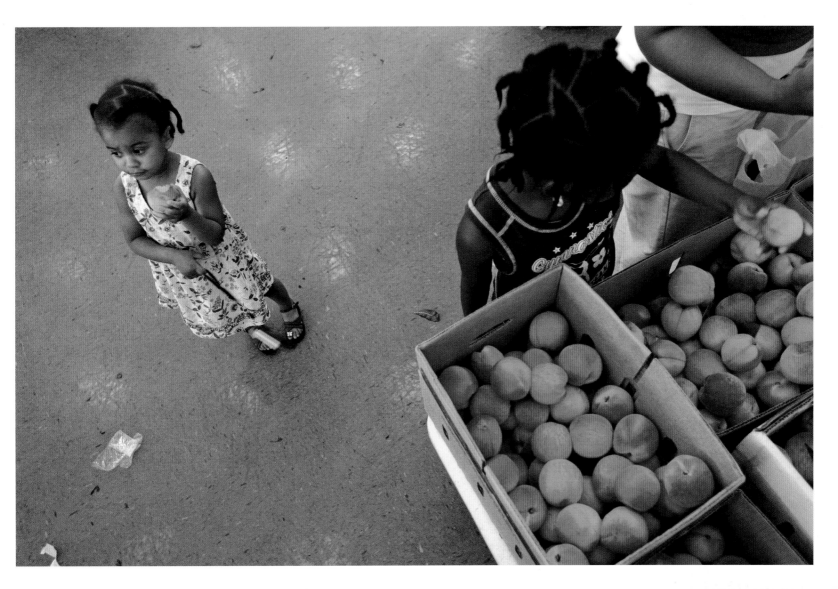

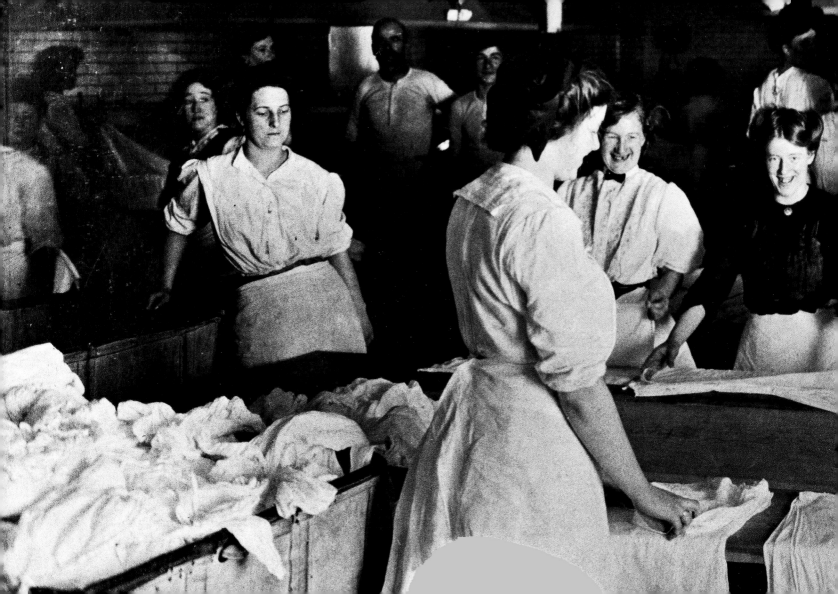

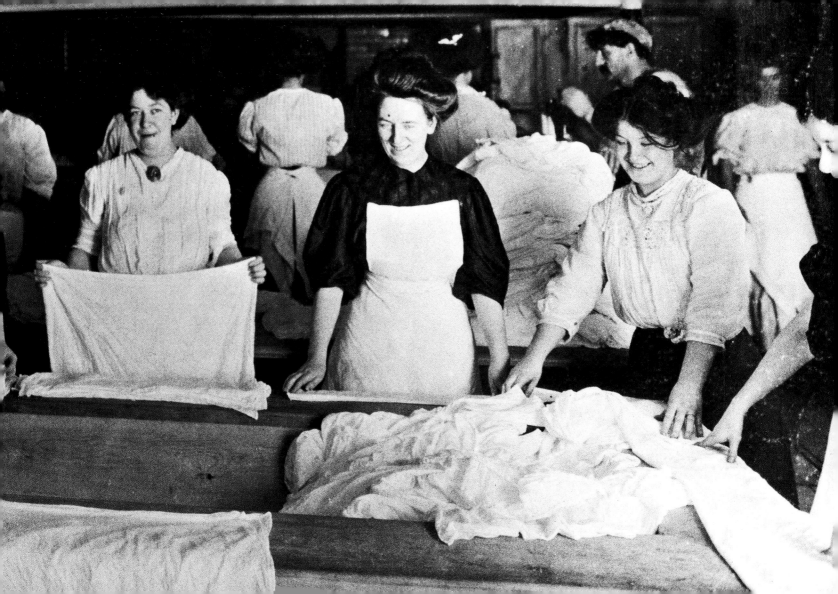

FEBRUARY 19, 1945

Opposite

Over-the-Counter Cigarettes

There used to be smoke shops on every block in Manhattan, it seemed, and with the loosening of rations toward the end of World War II, they could take down their "one pack per customer" signs. There were plenty of "legal" cigarettes again and, in a bid to thwart the black market that had developed during the war, the government wanted them displayed openly.

The New York Times Photo Archives

FEBRUARY 22, 1954

Overleaf

Ten Thousand Hunters and Gatherers

Lured to Hearn's (and other Fourteenth Street department stores) by ten- and twelve-inch television sets at $6.95 each and vacuum cleaners at $2.95, hordes of bargain hunters responded to the city's first widely advertised Washington's Birthday sale.

The New York Times Photo Archives

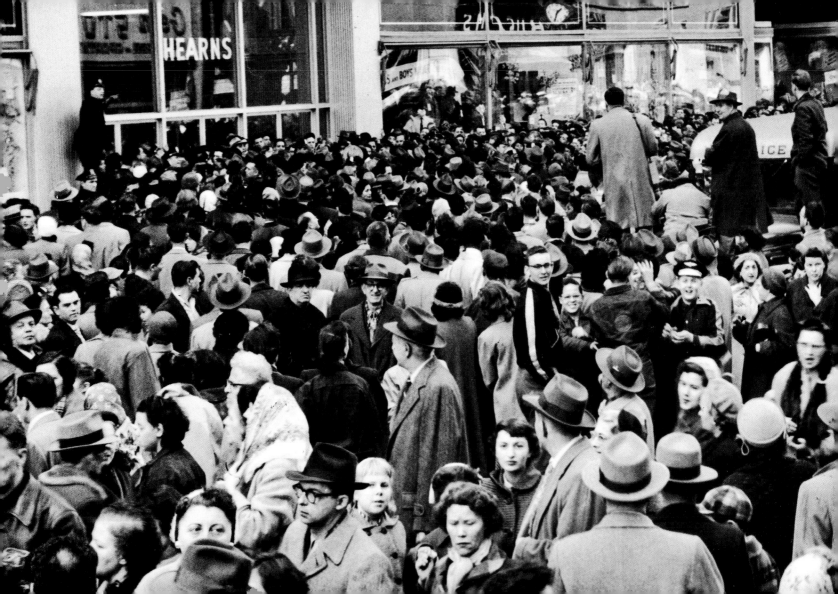

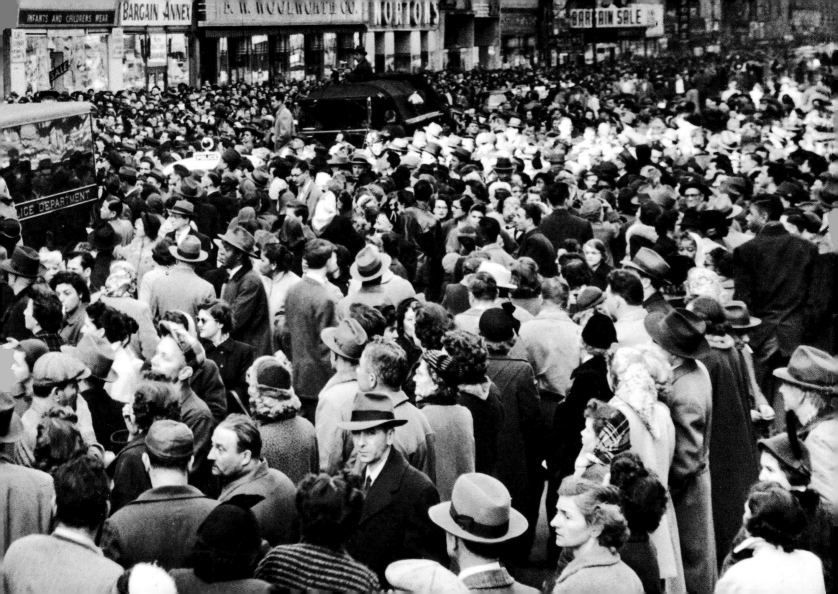

Shirts, Shirts, Shirts

At S. Klein On-the-Square, the pioneering discount department store, a big sale meant choosing as many shirts as you could carry and waiting in a long line at the cash register.

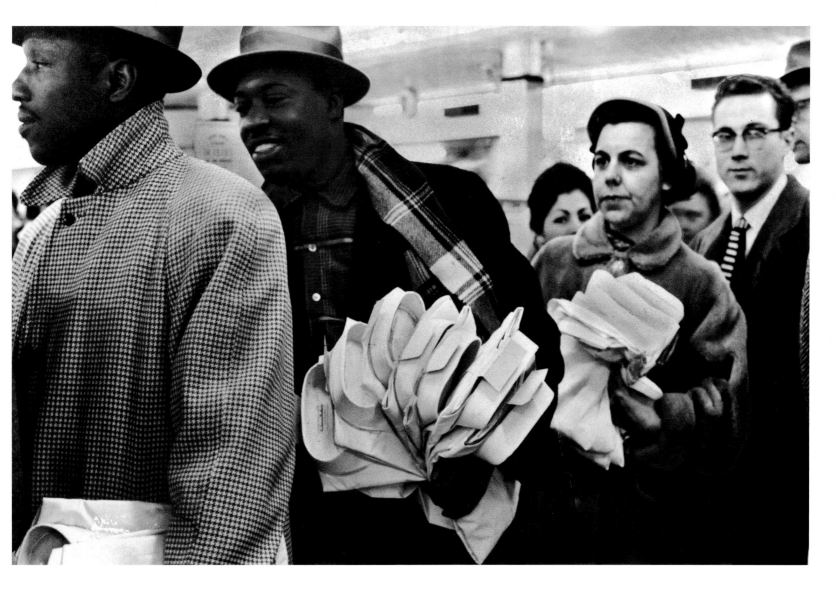

Stripping for Relief

These members of Advertising Post 209 of the American Legion were not playing strip poker to beat the heat. The clothes of the losers — every last stitch — were given to the jobless in the Depression.

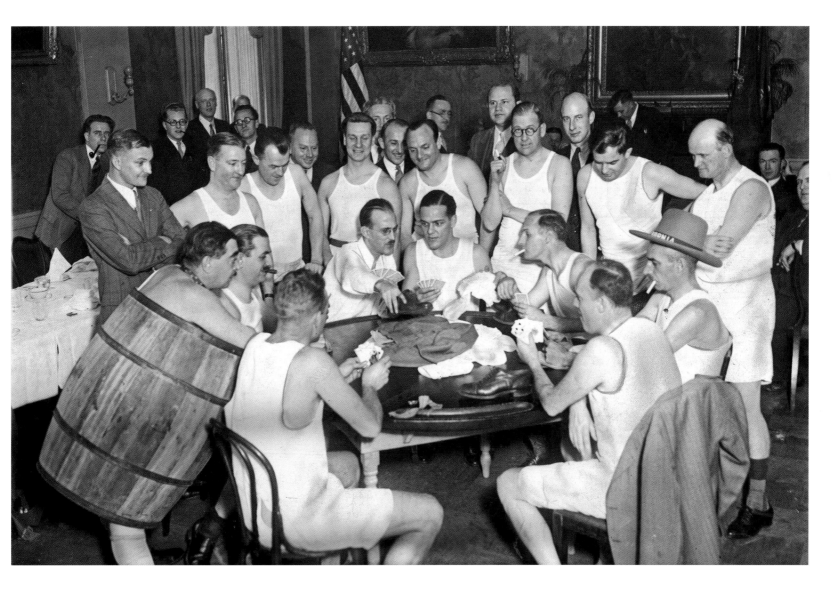

APRIL 8, 1960

Opposite

Sidewalk Slalom

In 1910, 70 percent of women's clothes sold in the United States were made in New York City. Fifty years later, the percentage had fallen dramatically, but tell that to the pedestrians dodging racks of dresses on the sidewalks of Seventh Avenue. The Garment District was (and still is) the nerve center of the nation's fashion business.

Neal Boenzi/*The New York Times*

MARCH 8, 1952

Overleaf

Clogged Arteries

A modern-day driver's reaction to this photograph will probably be something like "'Twas ever thus," or maybe "Some things never change." *The Times* published the photo to show how delivery trucks parked on both sides of the street — in this case, West Thirty-seventh Street in Midtown, with Eighth Avenue in the foreground — left only one lane open to crosstown traffic.

Neal Boenzi/*The New York Times*

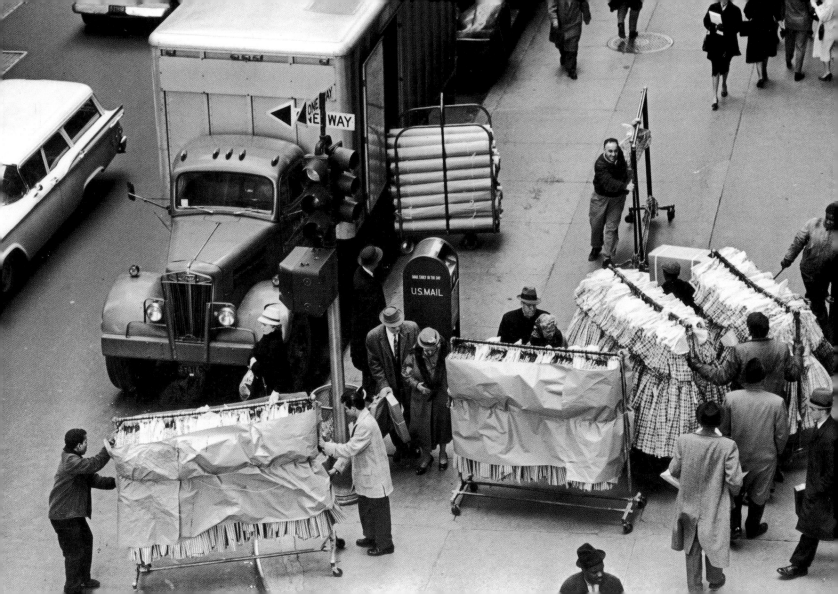

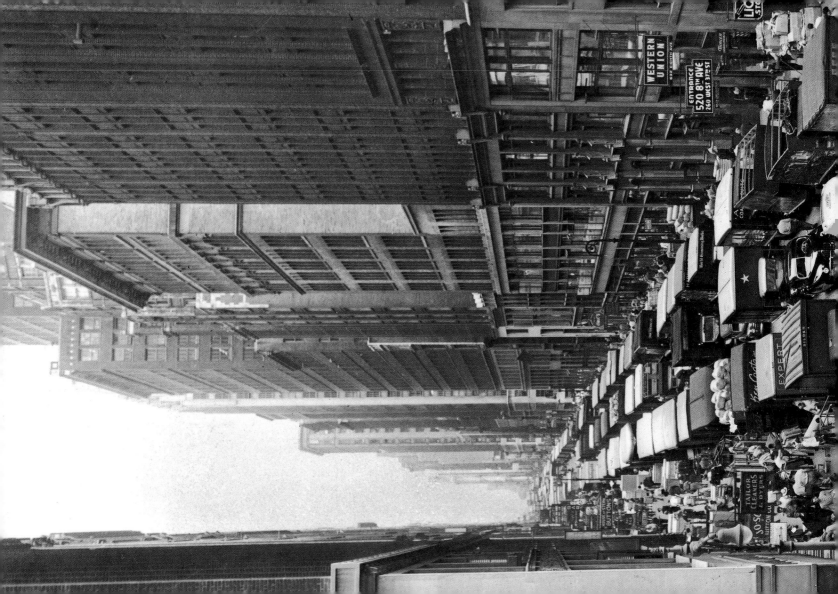

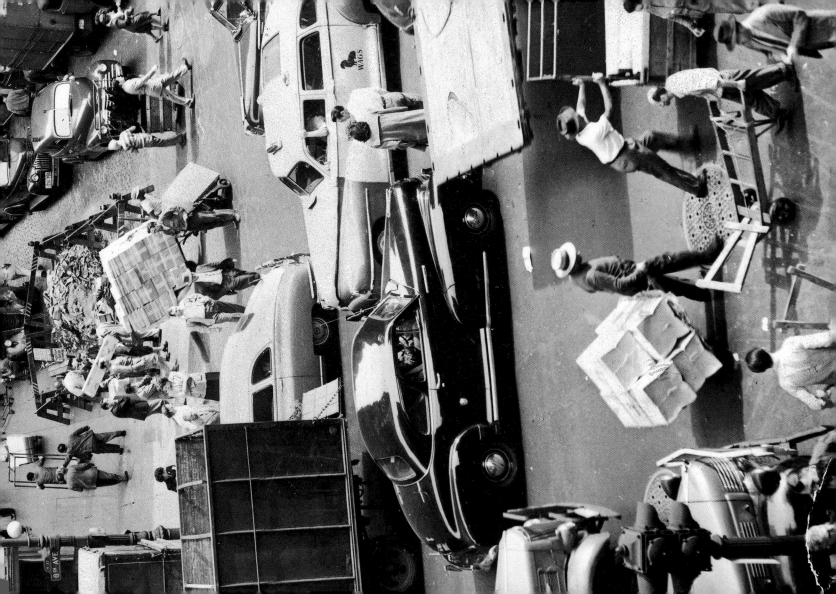

Asleep at the Wheel

In the days when long-distance freight arrived on ships, not on trucks or airplanes, it had to be unloaded at the Hudson River piers and hauled to its destination. The handwritten caption on the back of this photograph explained why deliveries seemed to take so long: "Truck drivers often fall into a snooze while waiting for traffic to move in the congested lower end of Manhattan."

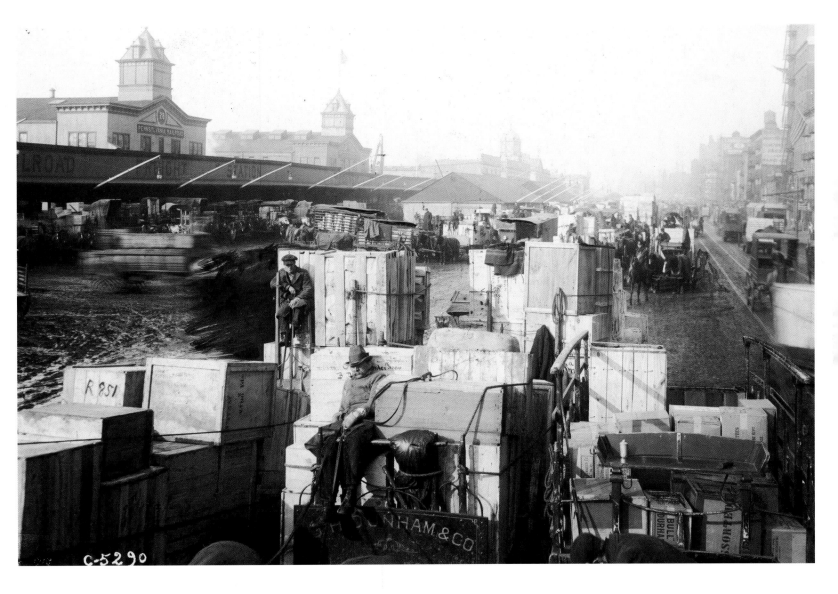

What Morse Hath Wrought, and Bell, Too

When the wired world grew to include telephone as well as telegraph lines, there was only one thing to do: build taller poles to hold the ever more complicated ganglia of modern life. These wires ran along Broadway in Lower Manhattan.

The New York Times Photo Archives

Opposite

DECEMBER 5, 1983

Copper and Steel

What she was accustomed to seeing, off to her left, were those two tall, boxy buildings rising into the sky. She was curves and folds and a crown; they were straight lines. She glowed at them; they shimmered and winked back. One night in September 2001, after a day that was unthinkable, what she saw off to her left, for the first time in years, was emptiness.

Fred R. Conrad/*The New York Times*

Overleaf

OCTOBER 19, 1970

The Tallest

When this four-ton piece of steel framework was lowered into place on the north tower of the World Trade Center, it made the Empire State Building the second tallest building in the world, by four feet, and the construction crews still had eight stories to build.

William E. Sauro/*The New York Times*

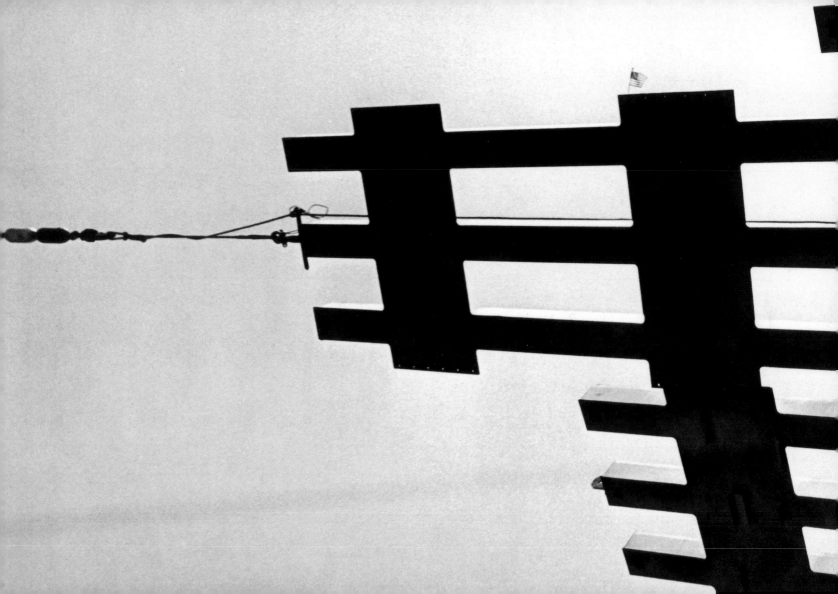

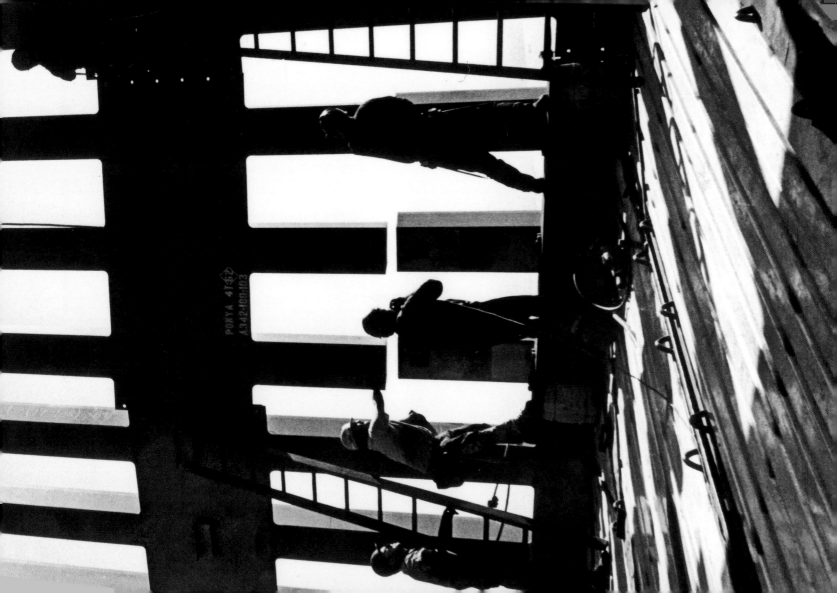

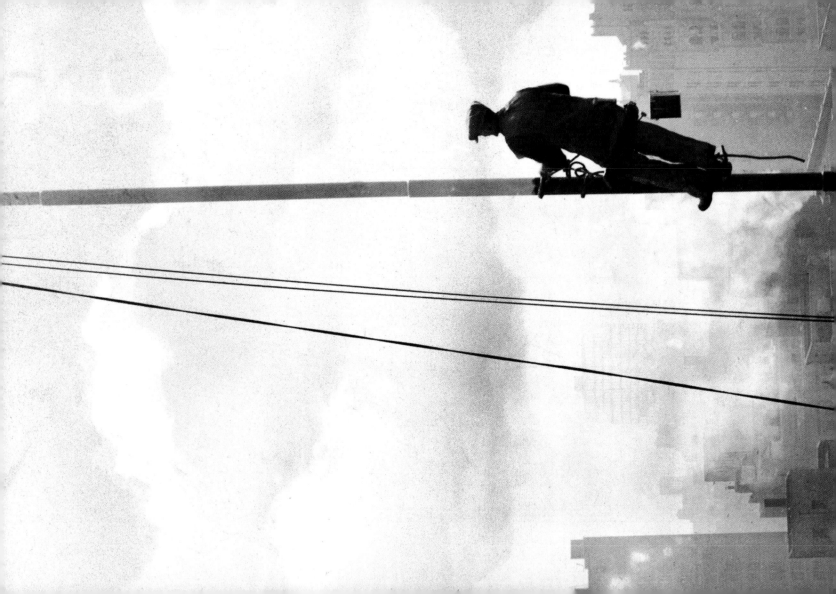

Previous

1925

A Steeplejack's-Eye View of New York

Like the Sistine Chapel ceiling, a flagpole has to be painted. This Manhattan Michelangelo worked his way down from the top, brushstroke by careful brushstroke. The flagpole was attached to the twenty-third story of a building in the Garment District.

The New York Times Photo Archives

Opposite

1925

Lunch Hour With Harmonicas

How would these ironworkers have serenaded Manhattan from twenty-two floors up on the Murray Hill Building if they had played guitars or drums?

The New York Times Photo Archives

Overleaf

SEPTEMBER 19, 1942

New Look in the Navy Yard

After their first day of work at the Brooklyn Navy Yard, women apprentices head for home.

The New York Times Photo Archives

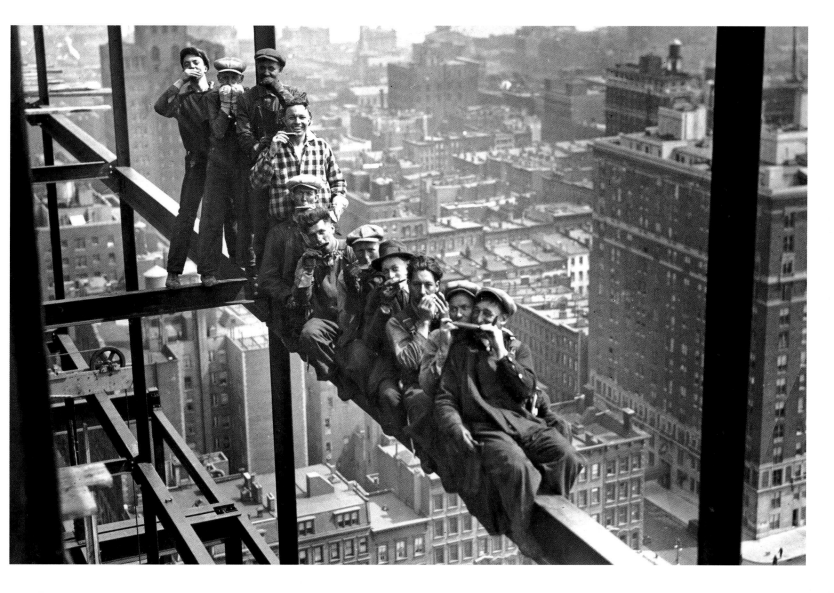

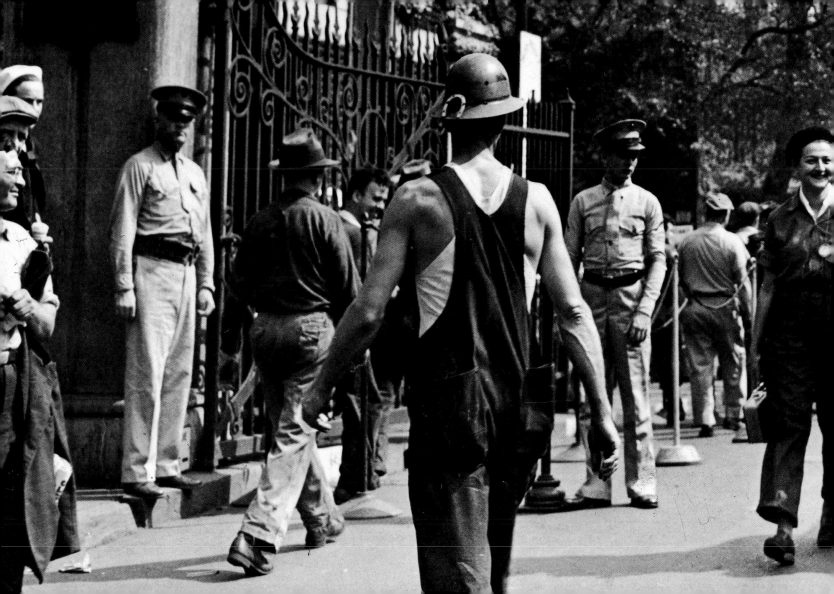

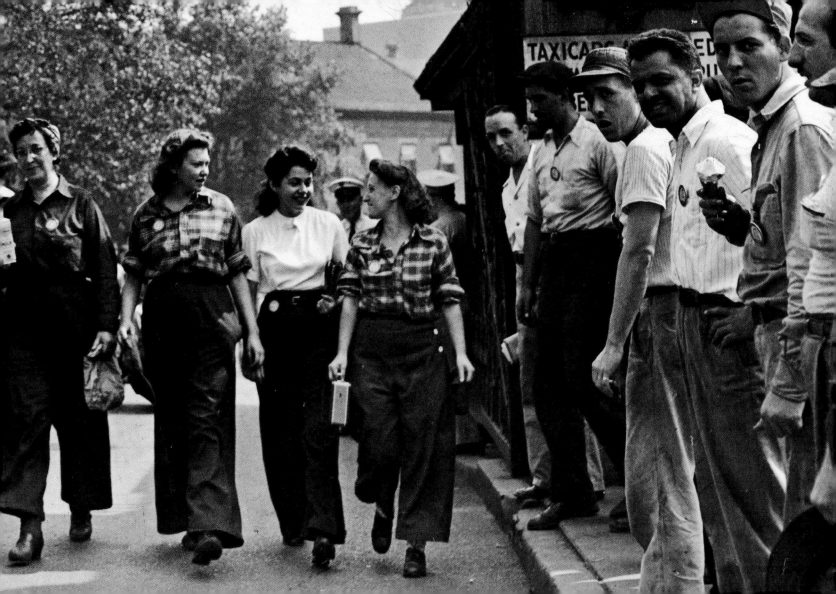

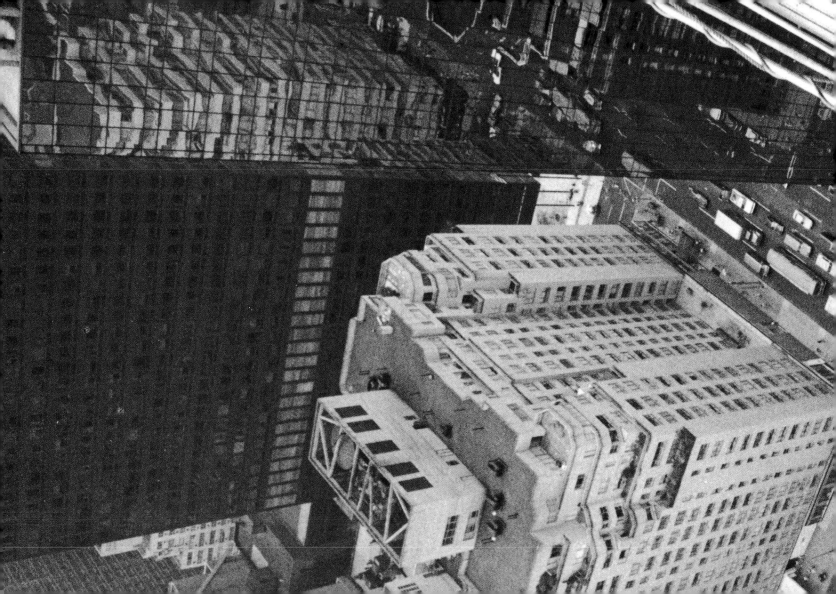

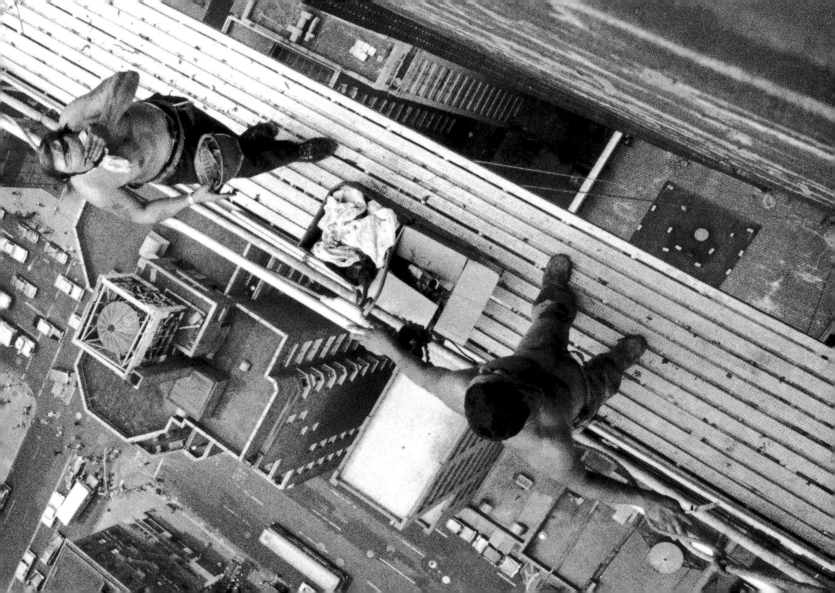

Previous

JUNE 11, 1976

High, and Trying to Keep Dry

A construction worker, caulking a building on Third Avenue near Fifty-ninth Street, pauses on a thirty-eighth-story scaffold. The breezes at altitude gave little relief from the ninety-degree heat.

D. Gorton/*The New York Times*

Opposite

SEPTEMBER 29, 1982

Philippe Petit on a Tightrope

"Anything that is giant and manmade," Philippe Petit once said, "calls me." The twin towers of the World Trade Center, the twin towers of Notre Dame — they called. In 1982, the Cathedral of St. John the Divine called with a job offer. As construction resumed after a forty-one-year hiatus, cathedral officials named him an artist in residence and assigned him an office high above the nave. On this weekday, he was just walking to work.

Fred R. Conrad/*The New York Times*

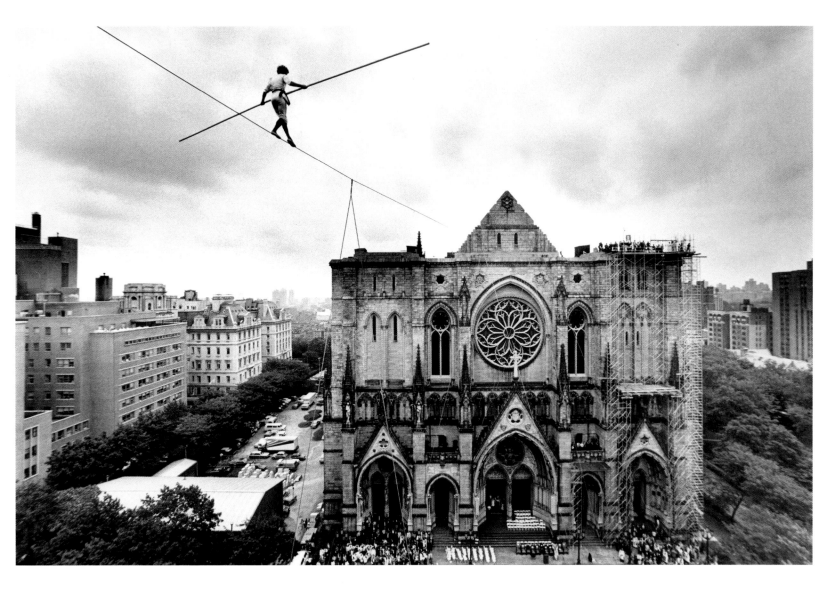

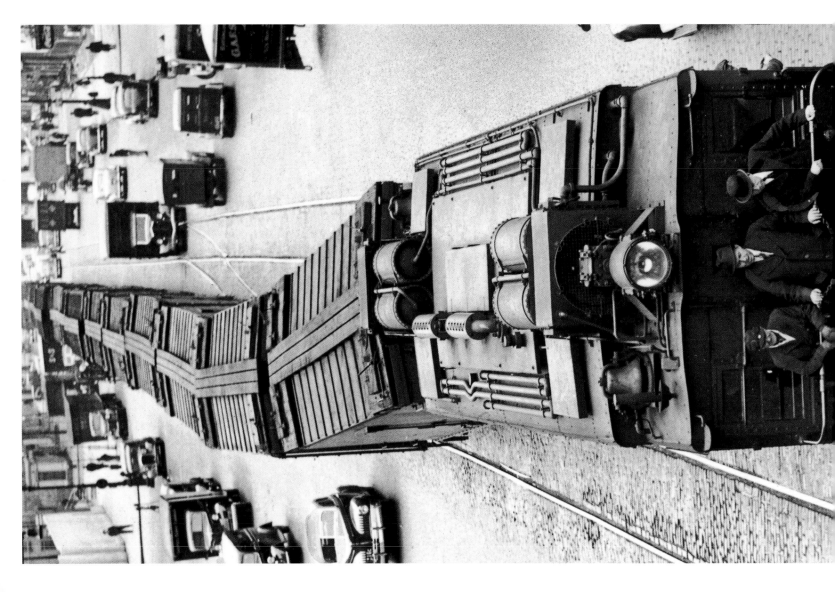

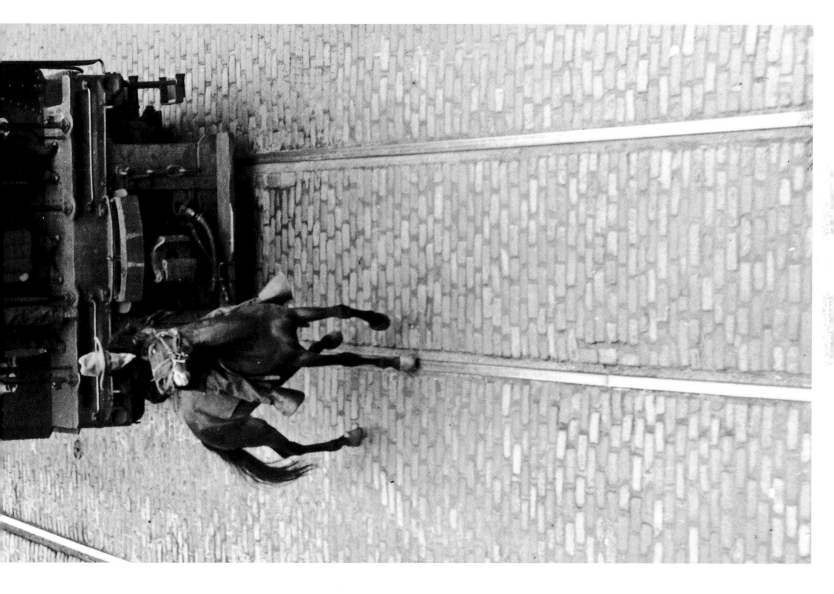

MARCH 29, 1941

An Urban Cowboy's Last Ride

For ninety years, "Tenth Avenue cowboys" ambled ahead of slow-moving freight trains that snaked through city streets. An ordinance required railroads to "employ a proper person to precede the trains on horseback, to give the necessary warning." The last of those was George Hayde, pictured here. He put away his ten-gallon hat when the trains switched to the elevated tracks that became known as the "high line."

The New York Times Photo Archives

Opposite

1952

Last Days of a Legend

The Third Avenue El, or elevated railway, was once thought to be "the crowning achievement in solving the problems of rapid transit," according to Moses King's 1893 *Handbook of New York City.* By the 1950s it had become an eyesore and a traffic hazard, and it made its last run in 1954.

Sam Falk/*The New York Times*

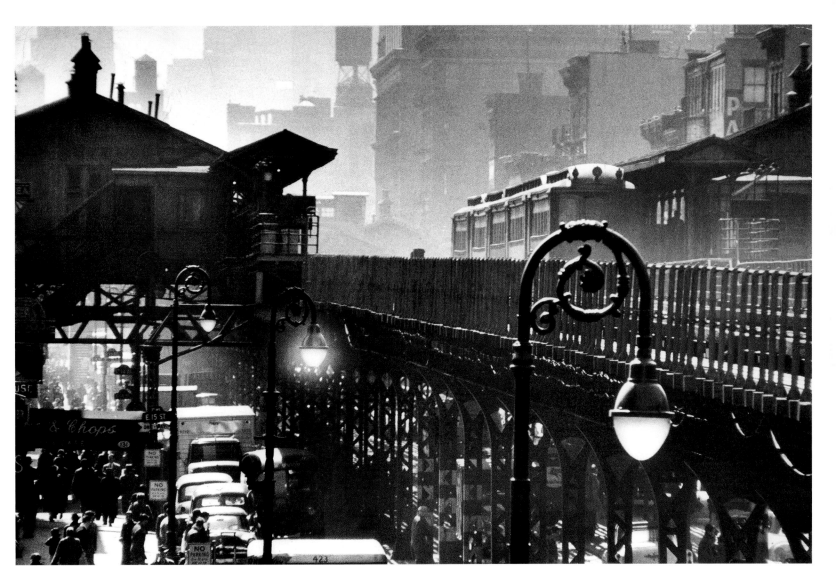

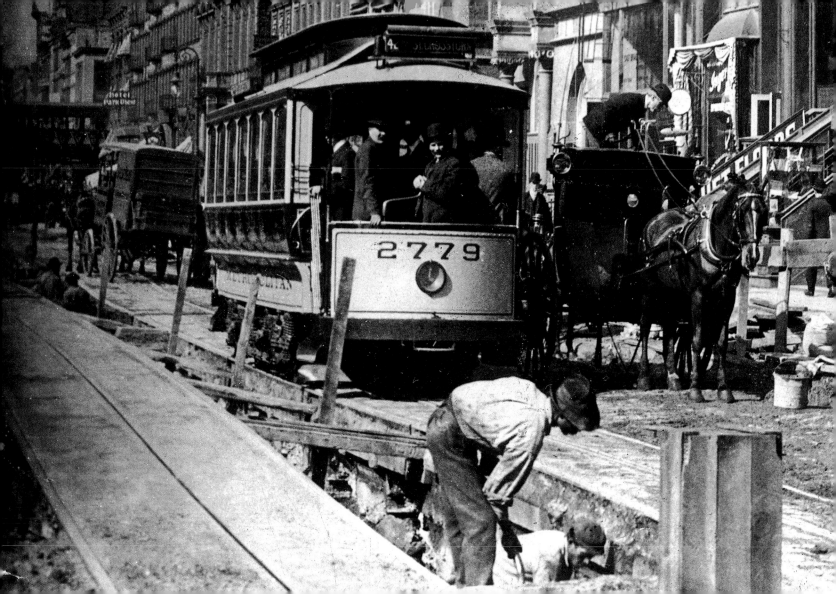

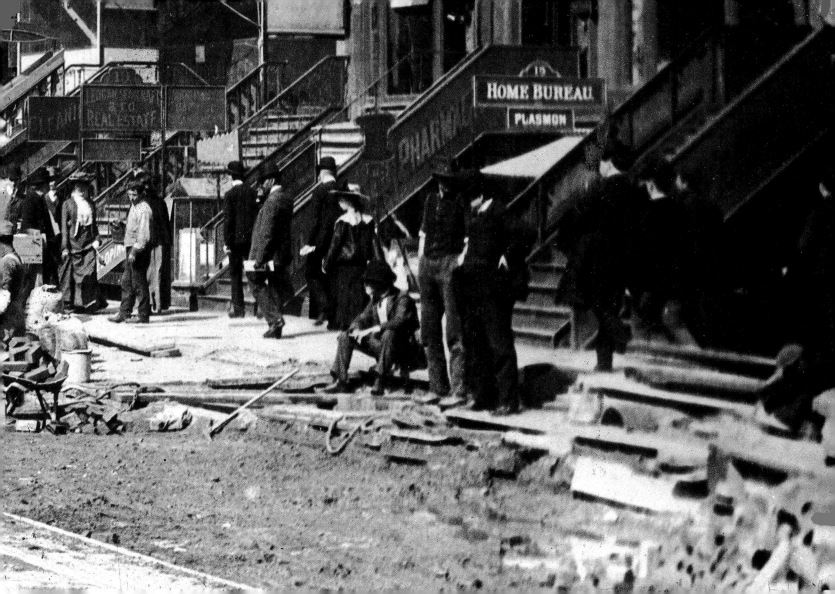

1898

The Forty-second Street Crosstown Trolley

As the twentieth century approached, New York was feverishly building bridges, skyscrapers, and subways, and paving major thoroughfares like Forty-second Street. The work crews slowed the streetcars and the horse-drawn carriages and gave pedestrians something to watch on the way to wherever they were going.

Seidman Photo Service

CIRCA 1900

Opposite

Digging Deep

"Sandhogs" burrowing out the subway under Manhattan earned their $1.50 daily wage the hard way. In four years, using pack mules that were lowered into the tunnels when construction began in 1900 and not brought out until just before the first train rumbled to life four years later, they dug more than nine miles.

Brown Brothers

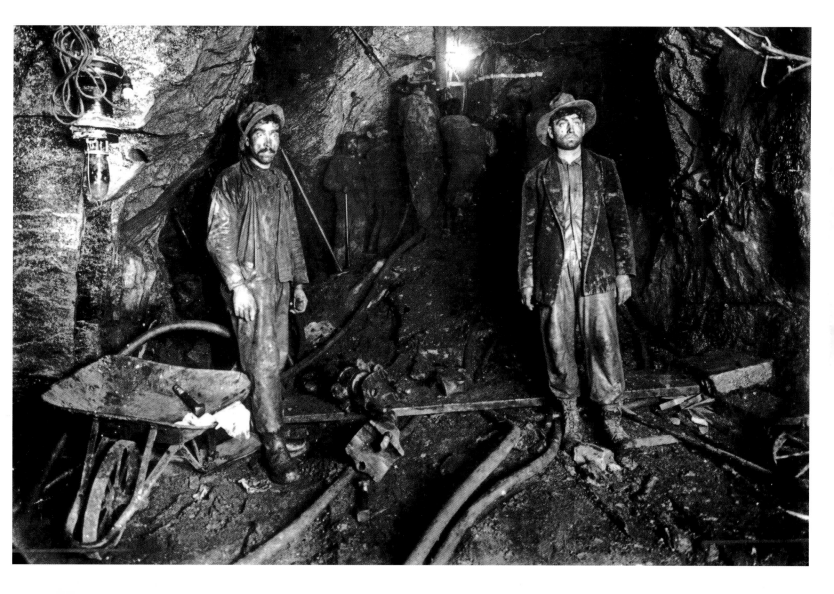

Waiting Out the War

The Brooklyn-Battery Tunnel had to wait out World War II unfinished when supplies and manpower dwindled and construction all but stopped. After D-day, with Germany's surrender just a matter of time, New York sought permission from the government to buy 790 tons of bolts, washers, and nuts to finish the 9,117-foot-long tunnel. The government, which controlled such things during the war, granted the request; work resumed in 1945, and the tunnel finally opened in 1950.

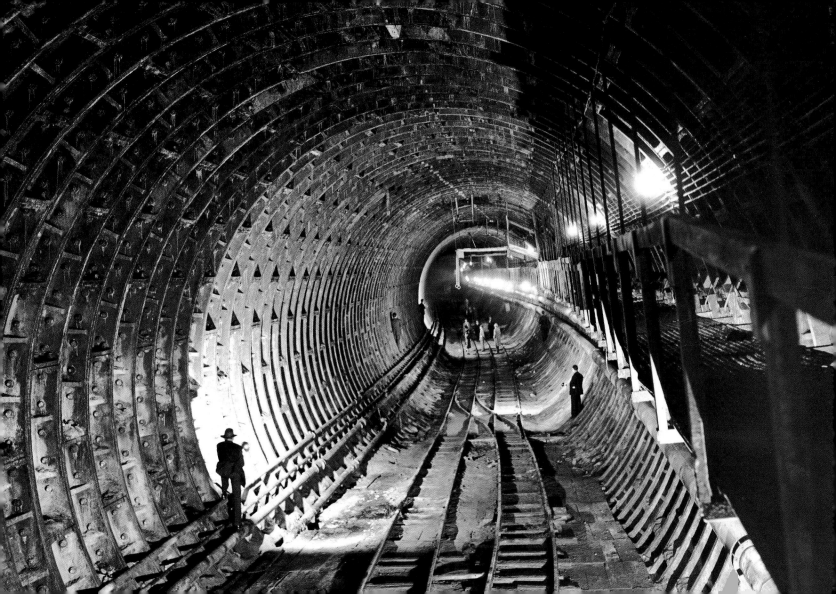

Circling a Statue

If not for a software maker's name on the fuselage of this stunt pilot's biplane, this photograph could have been taken in the early days of flying; Wilbur Wright himself had famously buzzed Lady Liberty in 1909. Daredevil pilots barnstormed landmarks like the Statue of Liberty, blue exhaust trailing from their single-engine aircraft, as they rocked the wings and gunned the throttle and headed into impossibly steep climbs.

Vincent Laforet/*The New York Times*

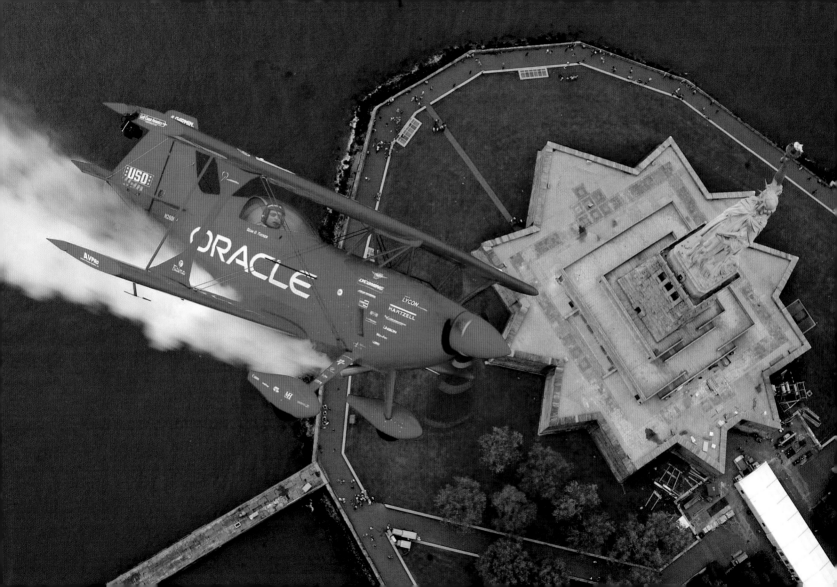

JULY 1939

Opposite
Fixing the Crown
She was middle-aged by then, some fifty years after President Grover Cleveland presided at her dedication, and her dress, made of copper three-sixteenths of an inch thick, was worn at the seams — so worn that rain poured through. Workers did wardrobe repairs outside, installed a new stairway inside, rebuilt the spikes of her crown, and re-electrified her from torch to toe.

The New York Times Photo Archives

SEPTEMBER 1, 1980

Overleaf
Campaign Stop
It was so hot at a Labor Day stop at Liberty State Park in Jersey City that the candidate slipped out of his coat, pulled off his tie and unbuttoned his shirt. That was another sign of the California confidence that Ronald Reagan — former B-movie star and former governor — brought to the campaign and, later, to the White House.

Vic DeLucia/*The New York Times*

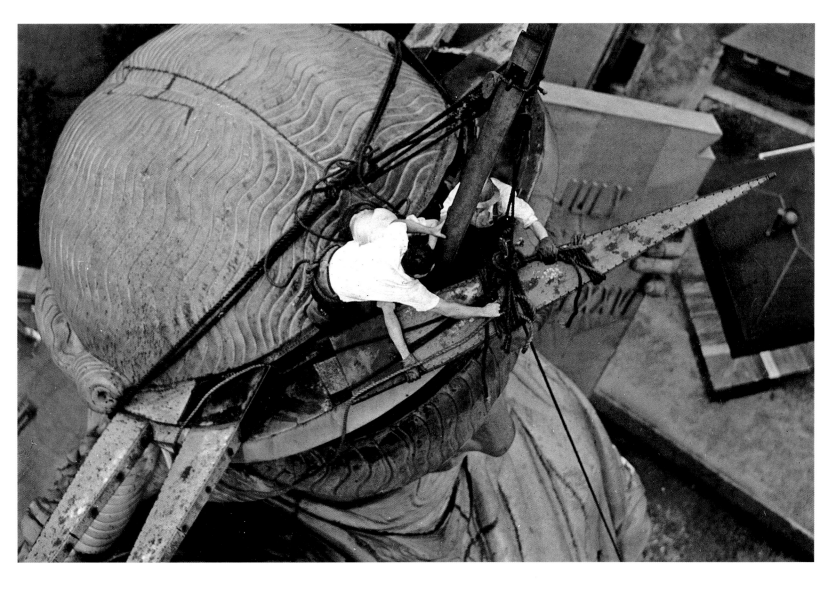

NOVEMBER 3, 1961

Opposite

J.F.K. Visits N.Y.C.

The shortest of visits began with the longest of motorcades. President John F. Kennedy spent only four-and-a-half hours in New York on the Friday before Election Day to campaign for Mayor Robert F. Wagner, but his motorcade had thirty cars and was escorted by sixty-five police officers on motorcycles.

Allyn Baum/*The New York Times*

MARCH 1, 1962

Overleaf

In New York's Orbit

John Glenn did what no one had done before — he orbited the Earth. Then he did what celebrities and winning sports teams had long done — he rode through the so-called Canyon of Heroes in Lower Manhattan in a shower of ticker tape, confetti, and smiles. With him were his wife, Annie, and Vice President Lyndon B. Johnson.

Carl T. Gossett Jr./*The New York Times*

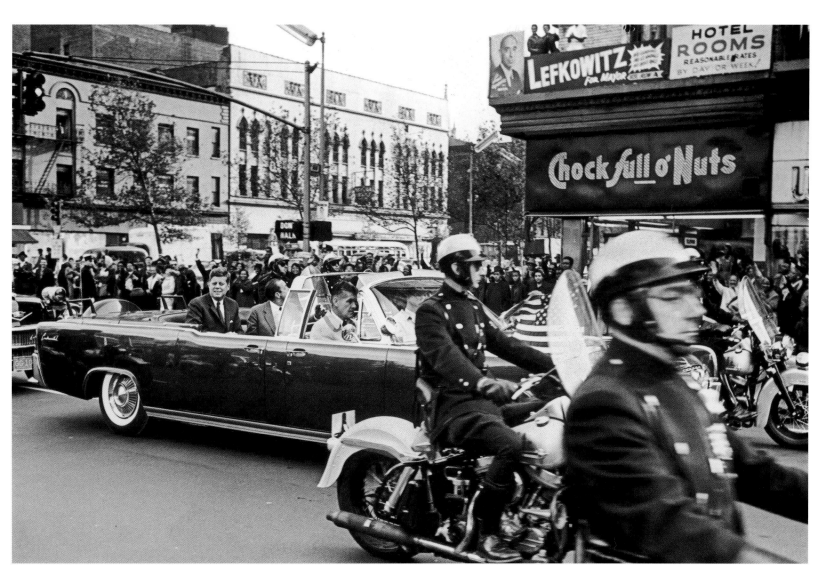

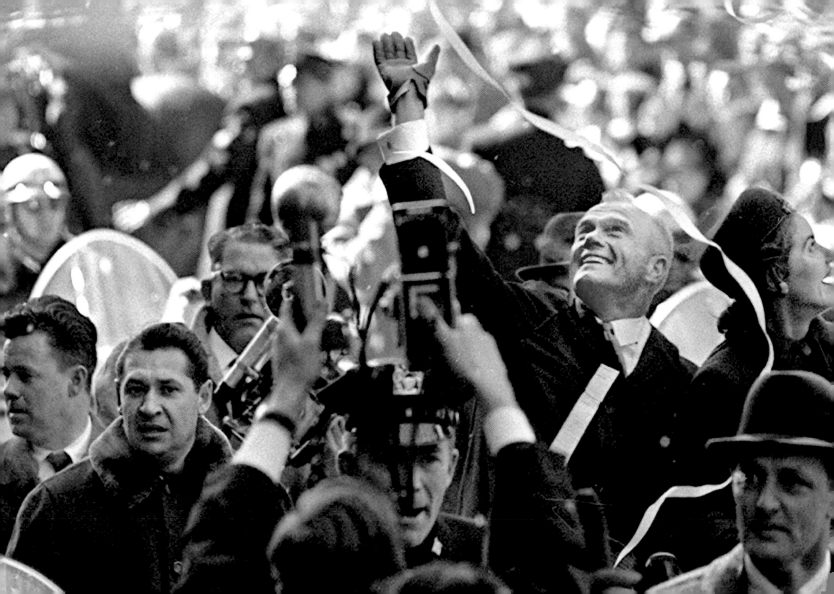

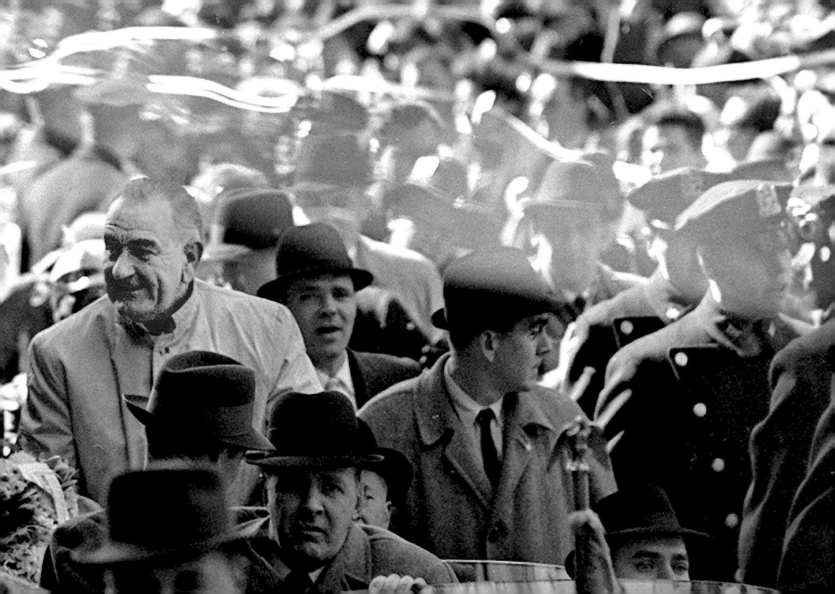

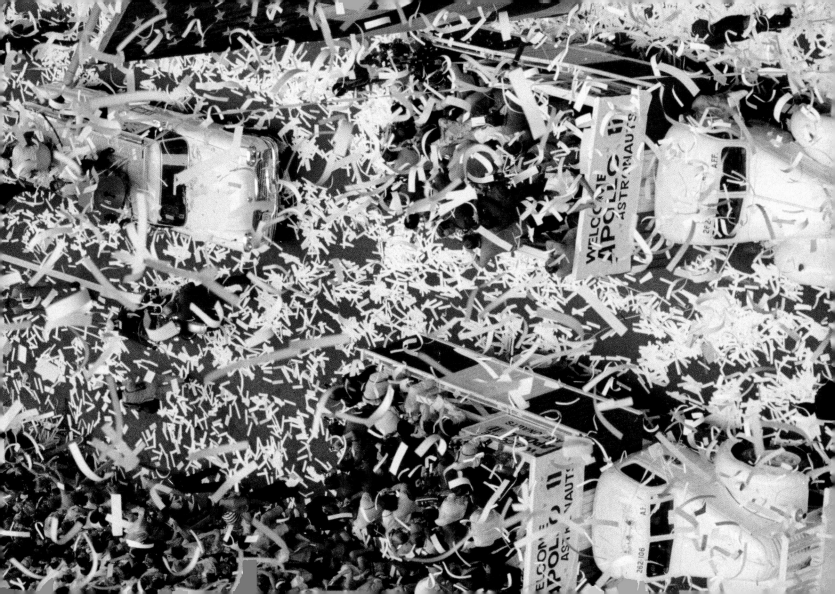

August 13, 1969

Previous

One Small Step, and One Giant Parade

The *Apollo 11* astronauts rode to the moon, and then they rode up Broadway, where, thanks to Earth's gravitational pull, tons of ticker tape floated down on them.

Jack Manning/The New York Times

JULY 4, 1928

Opposite

One of Tammany's Own

The man at the center of attention is the 1928 Democratic candidate for president, Alfred E. Smith. He was a happy warrior for Tammany Hall, having risen through the ranks of that notorious political machine. Smith did not see Tammany as notorious. "How can anything live in this country for 139 years that is not all right?" he asked in his speech. But all was not right: soon, a corruption investigation forced the resignation of Tammany's man in City Hall, Mayor James J. Walker.

The New York Times Photo Archives

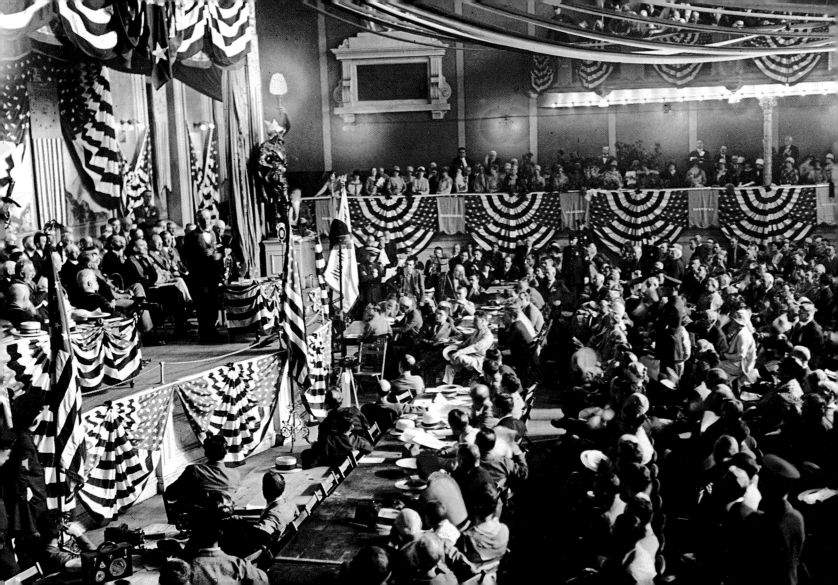

Opposite

Campaign Collection

After the last polling place has closed, campaign buttons become collectibles, and Ben Kaplan collected them for this memorabilia shop in Manhattan. Going into the 1964 campaign and President Lyndon B. Johnson's landslide defeat of Barry Goldwater, he had ten thousand or so on hand. The rarest read "I'm for Wilson," as in Woodrow.

Jack Manning/The New York Times

1909

Overleaf

Honoring an Explorer

Frederick A. Cook may or may not have discovered the North Pole and may or may not have been the first to climb Mount McKinley — even now his name stirs controversy. But at this meeting in 1909, the city's Board of Aldermen granted Cook the Freedom of the City, a ceremonial honor like the modern-day key.

The New York Times Photo Archives

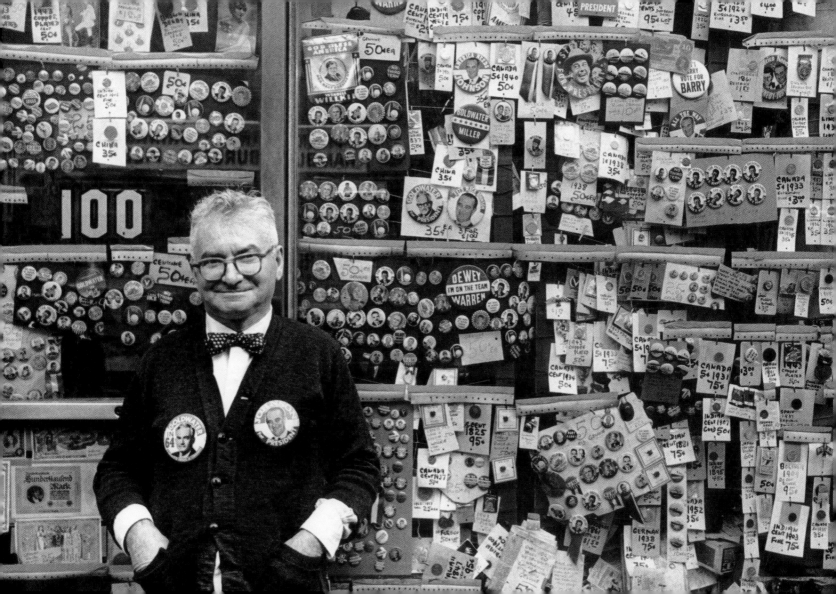

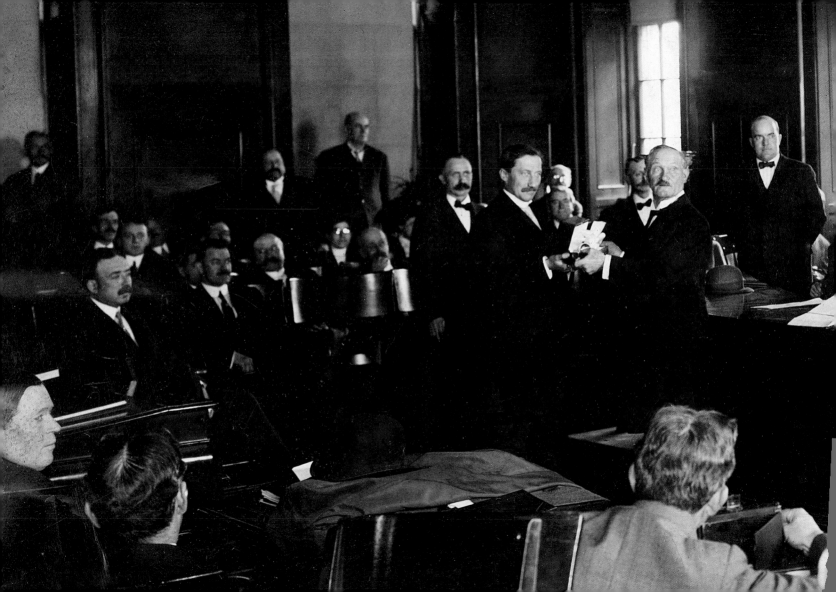

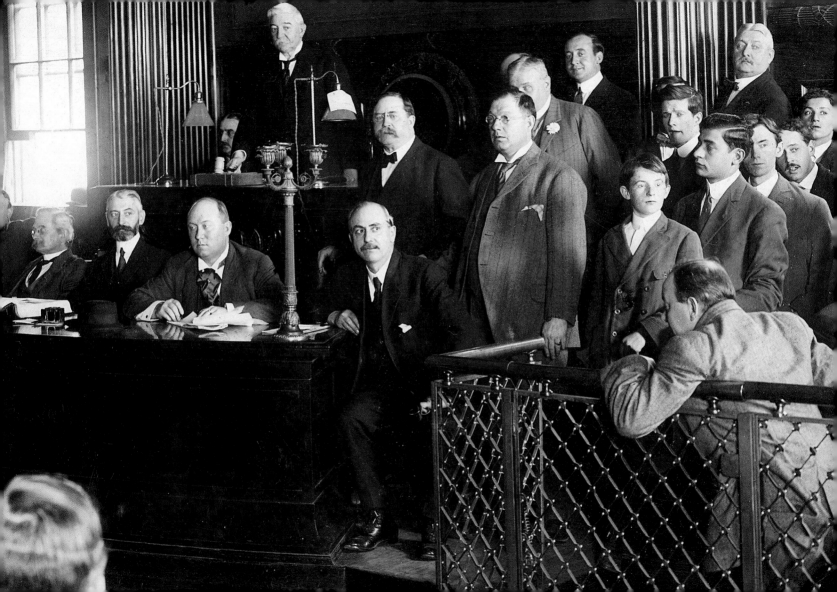

The First Ride Is Free

Officials and notables rode a flatcar with white sheeting covering the wooden front railing as the city's first subway riders boarded the IRT — for Interborough Rapid Transit — at the City Hall station. Mayor George B. McClellan (son of the Civil War general who was dismissed by Lincoln) is in the first row on the far right.

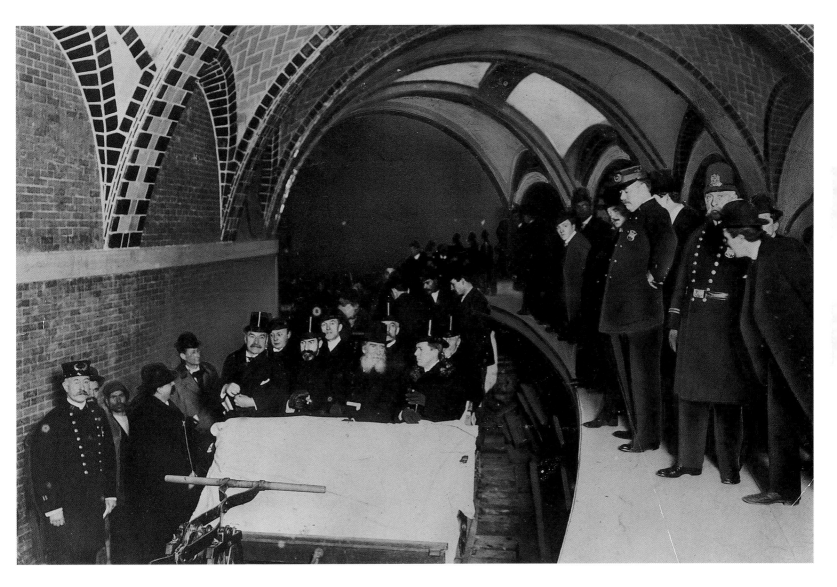

Political Pitch, Aimed at the Head

An unexpected interruption in the closing moments of a televised Democratic primary debate startled everyone, particularly Abraham D. Beame: a heckler hurled an apple pie at his head. The mayor saw the pie coming, and his reflexes were good. He managed to cover his face with his hand. Seated next to him is Congresswoman Bella Abzug, one of the nine mayoral candidates who were present.

With Relish

On the way to a landslide re-election, Mayor Robert F. Wagner (foreground) stopped for a quintessential campaign snack: a hot dog at Coney Island.

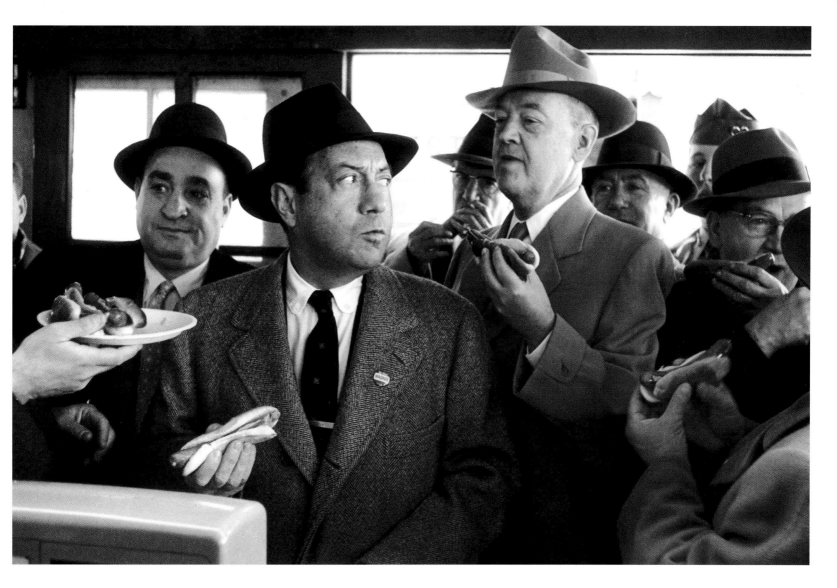

AUGUST 22, 1991

Seeking Common Ground

After a week of rioting by blacks angry with Hasidic Jews in the Crown Heights section of Brooklyn, Mayor David W. Dinkins (center) appealed to both sides for peace. "I alone cannot do it," the mayor said. With blacks and Hasidim, he said, "there's far more that we have in common than divides us, because, simply put, each group has been oppressed over time."

John Sotomayor/*The New York Times*

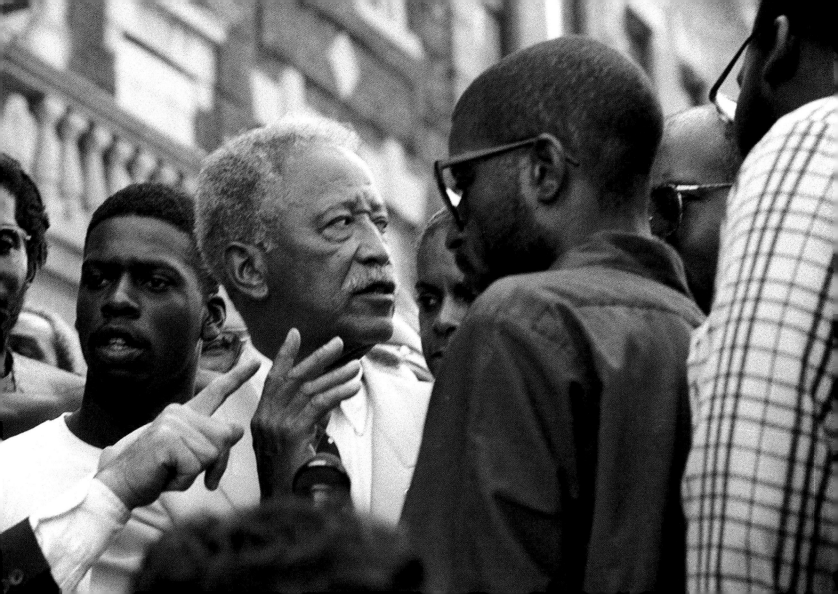

The Morning After

It had been a long night in this Queens household. Now, on the morning after he lost a runoff for the Democratic nomination for mayor, Mario M. Cuomo held his sleepy-headed son, Chris, and announced plans to run as the Liberal Party candidate against Edward I. Koch; in the background is his daughter, Madeline. The outcome in the November election was the same; Koch, not Cuomo, was sworn in as the new mayor. Cuomo won his next election in 1978 and became New York's lieutenant governor. He went on to three terms as governor, serving from 1983 to 1995.

Barton Silverman/*The New York Times*

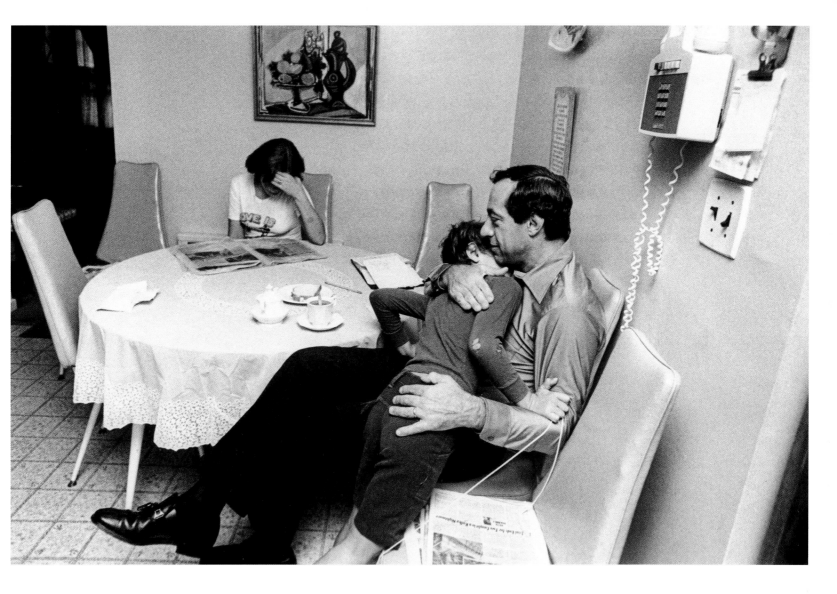

Hizzoner

He asked people "How'm I doin'?" but
the sign on Edward I. Koch's desk said
something else. As slogans go, "the best is
yet to be" had the bounce of a Sinatra lyric
and the only-way-to-go-is-up optimism
of a tireless cheerleader for a city that
had survived a brush with bankruptcy a
decade earlier. Koch established himself as
a combative and opinionated mayor who
could outtalk anybody, and do so in the
authentic voice of New York.

Neal Boenzi/*The New York Times*

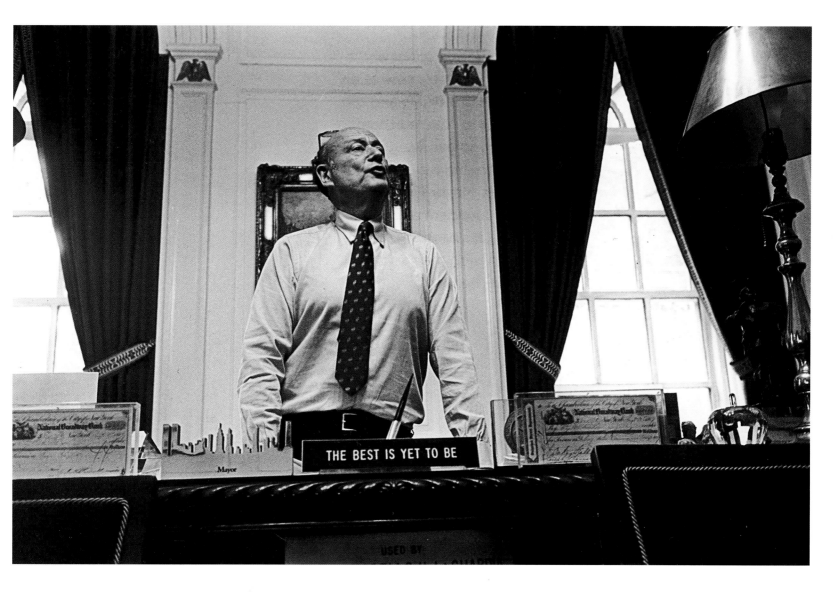

The Big Race

There is a fine line between a sprint and a stampede. During the Fat Men's race at an annual picnic for City Hall officials and the newspaper reporters who covered them, there were, apparently, no overweight reporters, so this supersized run was strictly for city officials. Mayor Fiorello H. La Guardia was so confident about his speed — or the excess baggage of his rivals — that he ran with a cigar in his mouth. And, of course, he won.

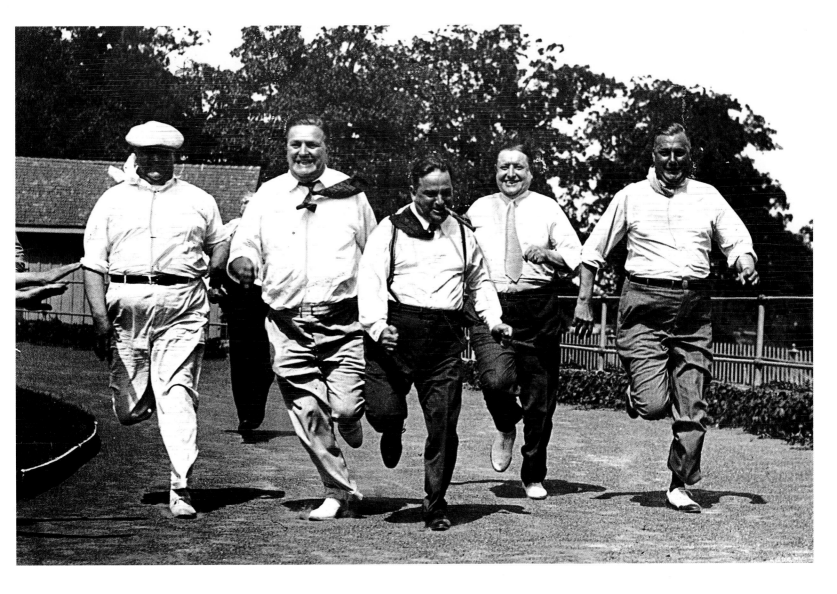

Bare-Chested Campaigner

John V. Lindsay, who was running for mayor on the Republican-Liberal ticket, got the kind of exposure every politician enjoys — a tour among voters and a swim in the ocean off the Rockaways on a crowded holiday weekend.

Allyn Baum/*The New York Times*

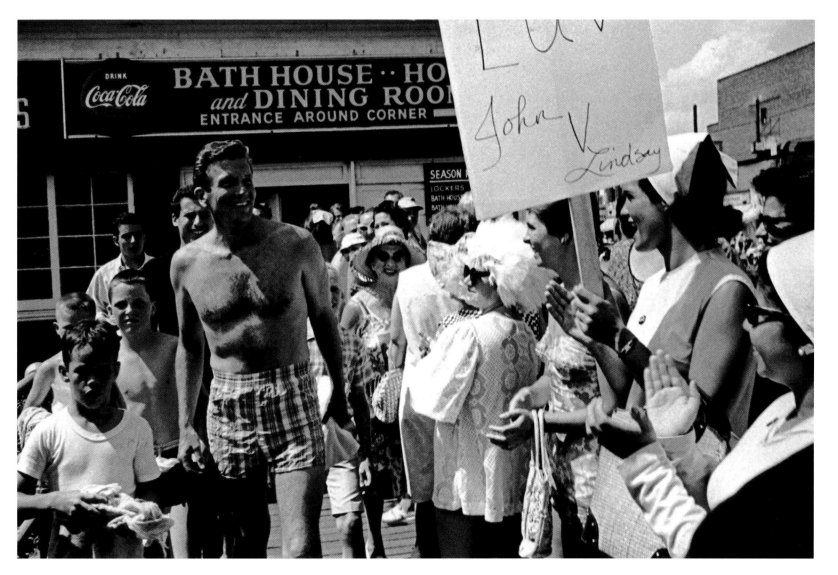

Mayor Upstaged

Andrew Giuliani, seven, did not say a word that the audience could hear during the inaugural speech of his father, Mayor Rudolph W. Giuliani. But as Andrew pounded the air and tried to lip-synch, he stole the show.

Andrea Mohin/*The New York Times*

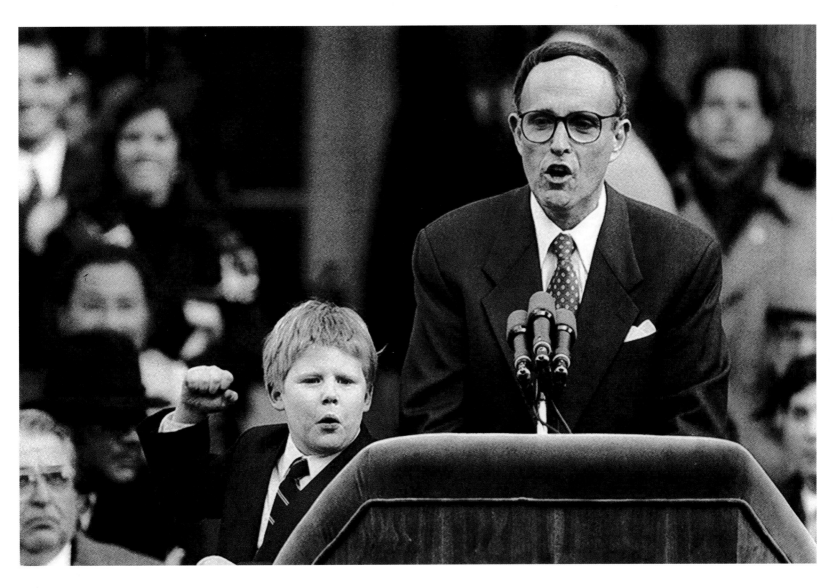

APRIL 20, 1927

Opposite

Home Team Opener

The Honorable James J. Walker, a dapper bon vivant and Mayor of New York, throws out the first ball on Opening Day at the Polo Grounds before 50,000 fans. His pitch was high and hard into the waiting glove of pitcher Freddy Fitzsimmons, who led the Giants to a 5-1 victory against the Philadelphia Phillies.

The New York Times Photo Archives

JUNE 9, 1968

Overleaf

Bats for Everyone

"The giveaway promotion has come to major league baseball — and may be its biggest drawing card since Babe Ruth," *The Times* reported in 1968. Taking a page from the bottom-of-the-league Mets, who drew their biggest crowds on days when they handed out Little League paraphernalia, the Yankees distributed more than thirty-six thousand bats on Bat Day.

Ernie Sisto/The New York Times

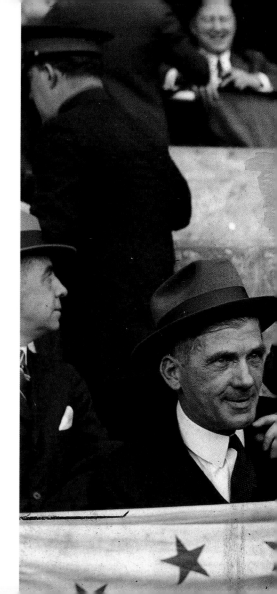

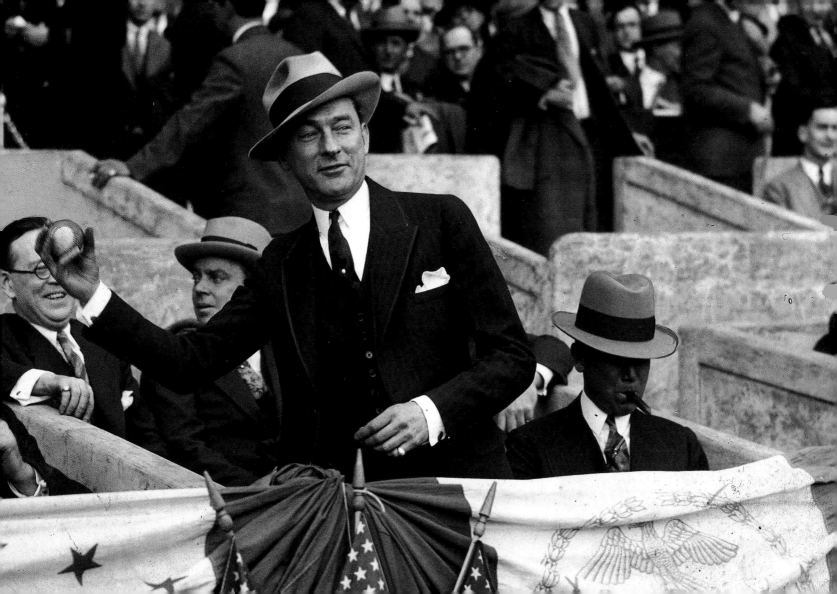

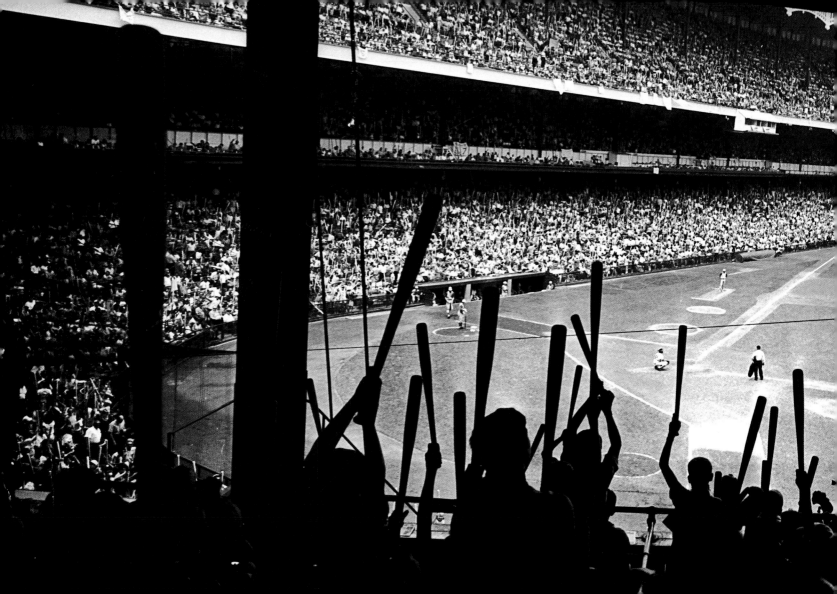

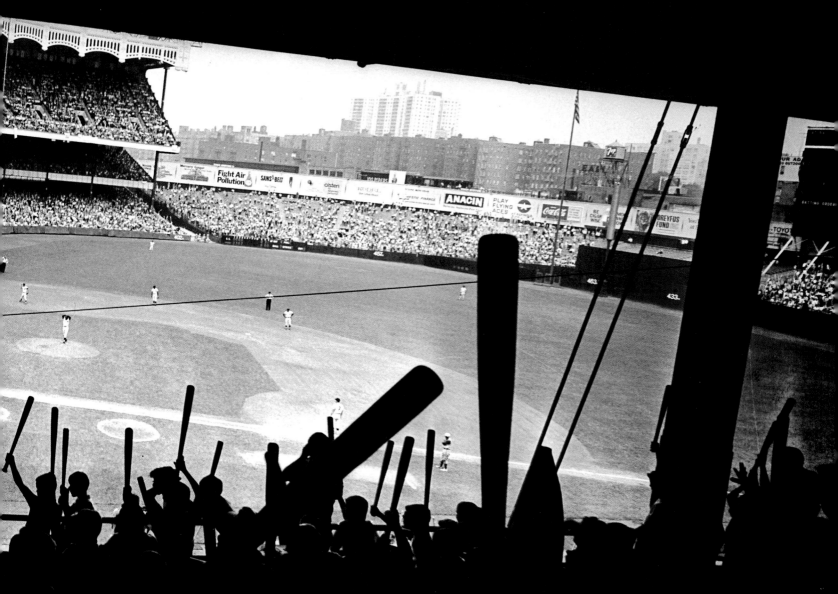

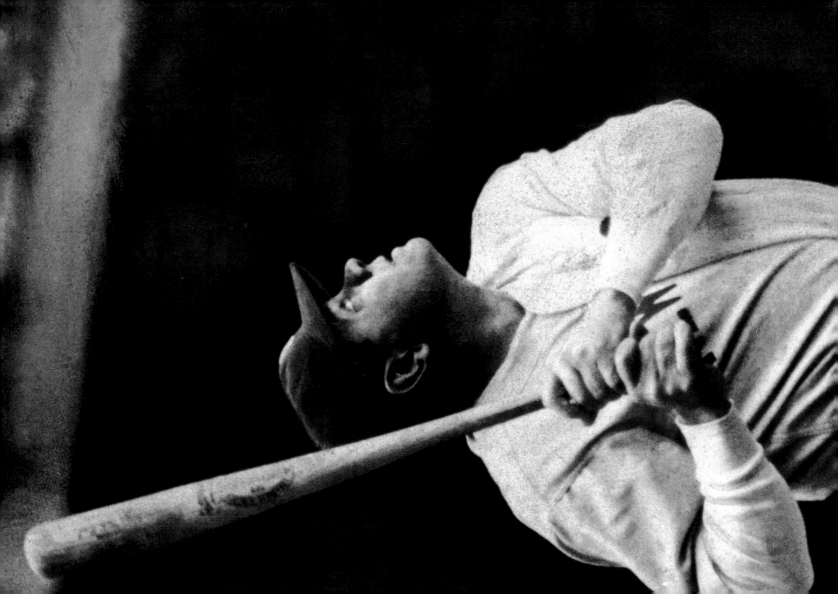

CIRCA 1928

The Babe

He was the Babe, the Bambino, the Sultan of Swat. The legendary Yankee slugger George Herman Ruth had a personality and appetite as big as his home runs. "I swing big, with everything I've got," said the man who, by himself, hit more homers in the 1920 season (fifty-four) than any one team. "I hit big or I miss big. I like to live as big as I can."

The New York Times Photo Archives

Opposite

AUGUST 16, 1948

Remembering Ruth

Members of the Harlem River baseball team share a moment of silence for Babe Ruth before the start of the Junior Olympics in Brooklyn. Ruth, fifty-three, died that day at Memorial Hospital in Manhattan. His body lay at the entrance of Yankee Stadium, where thousands of mourners paid their respects.

Meyer Liebowitz/*The New York Times*

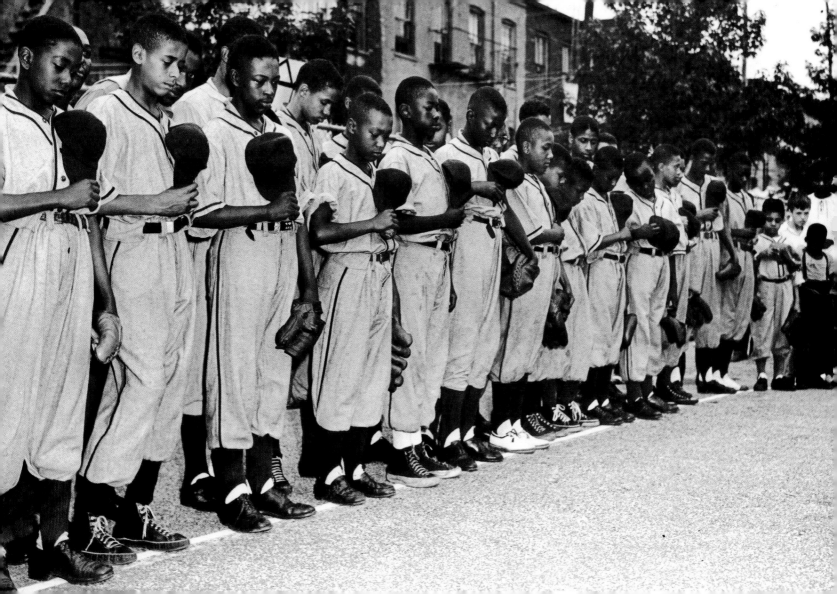

Eighth-Inning Stretch

When Rocky Colavito of the Cleveland Indians slammed a foul ball into the seats in the eighth inning of the first game of a doubleheader at Yankee Stadium, fans flew into action, trying to make the catch.

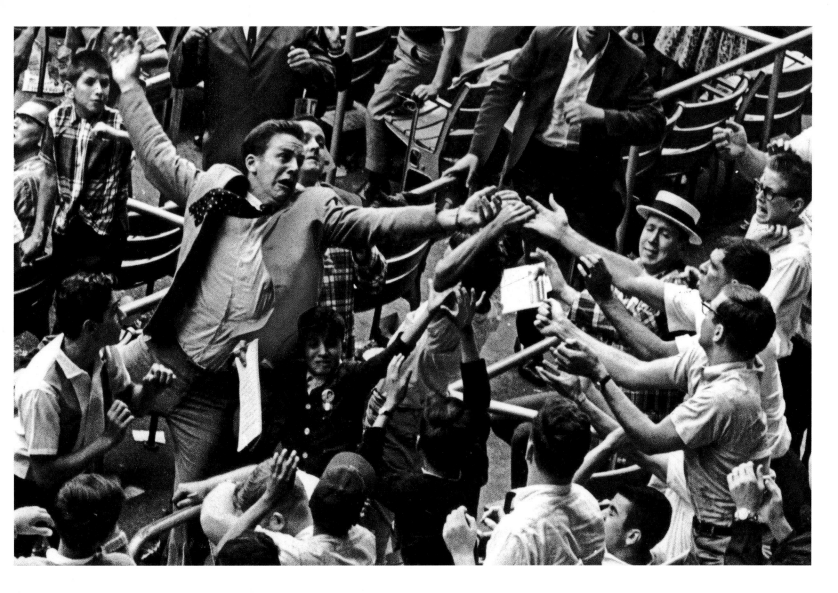

Stealing the Spotlight

Jackie Robinson, who stole home an electrifying nineteen times during his career, made a cap-losing slide in this game against the Chicago Cubs at Ebbets Field. Robinson caught a corner of the plate with his right foot before the catcher, John Pramesa, could tag him. The umpire is Augie Guglielmo and the man with the bat is Preacher Roe, the Dodger pitcher.

P.S. Roe stepped back to the plate and made his first hit of the season.

Fred J. Sass/*The New York Times*

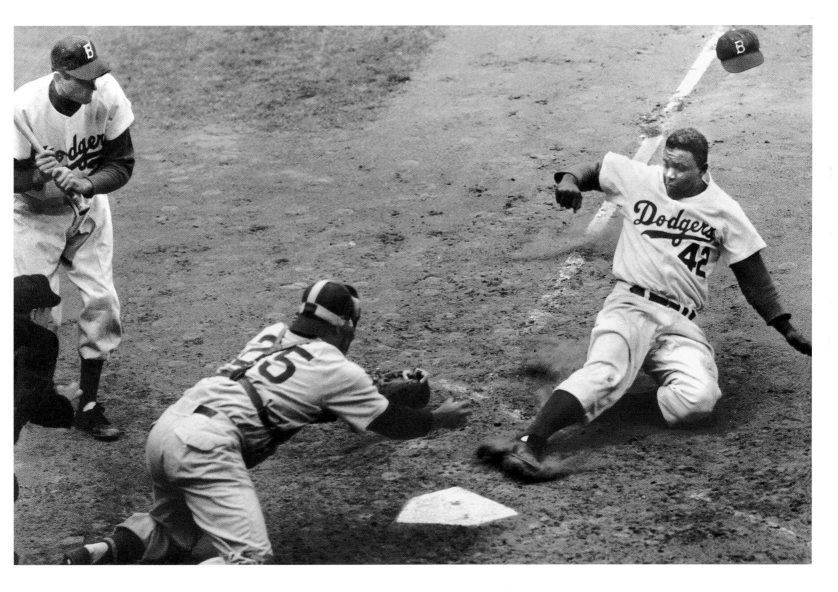

OCTOBER 3, 1952

Safe!
Umpire Art Pasarella makes the call,
Yankee Gil McDougald gets the bad news,
and Dodger Pee Wee Reese keeps his
foot firmly planted on third base — all in
a cloud of dust. Reese stole the base in
the ninth inning of World Series Game 3,
which the Dodgers won, 5–3. But in the
end, the Yankees won the Series.

Ernie Sisto/*The New York Times*

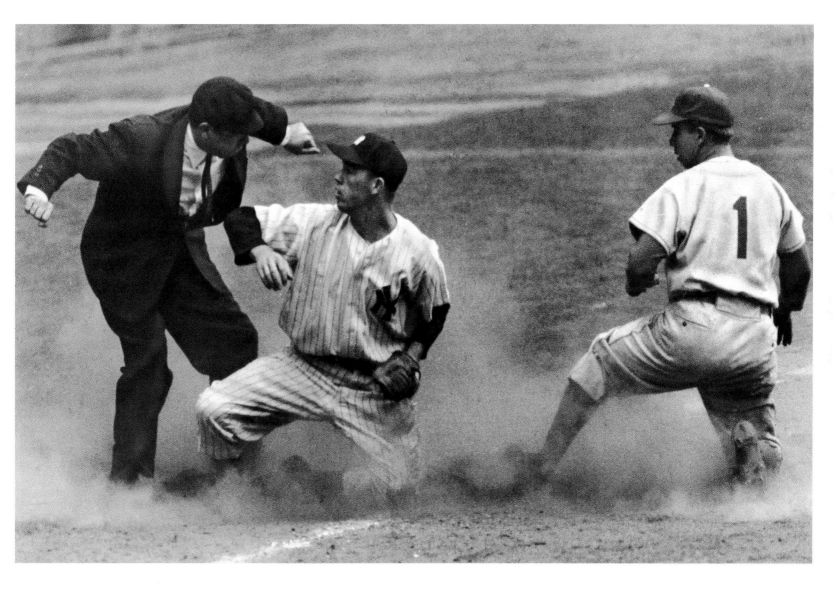

Mantle and Maris

If you mentioned the "M & M boys" in 1961, baseball fans knew exactly who you meant: Mickey Mantle (left) and Roger Maris. The two Yankees teammates were locked in a home run race for the ages, both chasing Babe Ruth's record of sixty in a season. The Mick dropped out late in the season because of an abscess in his right hip and finished with fifty-four home runs. Maris hit sixty-one, a record that stood for thirty-seven years — even longer than the Babe's.

Patrick A. Burns/*The New York Times*

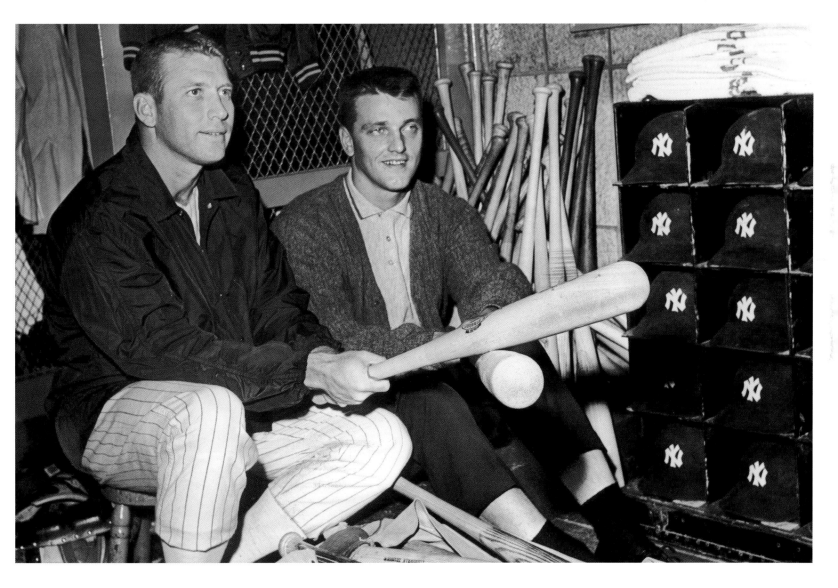

CIRCA 1910

Birthplace of a Dynasty

Hilltop Park existed only eleven years, but its roots live on. From 1903 to 1912, the wood stadium had a playing field with almost no grass and was the first home of the New York Yankees, then known as the Highlanders. Located at Broadway and 168th Street, the highest point in Manhattan, the park sat sixteen thousand fans at ten cents a head and afforded a great view of ships plying the Hudson. It was demolished in 1914, and the site is now occupied by Columbia-Presbyterian Hospital.

The New York Times Photo Archives

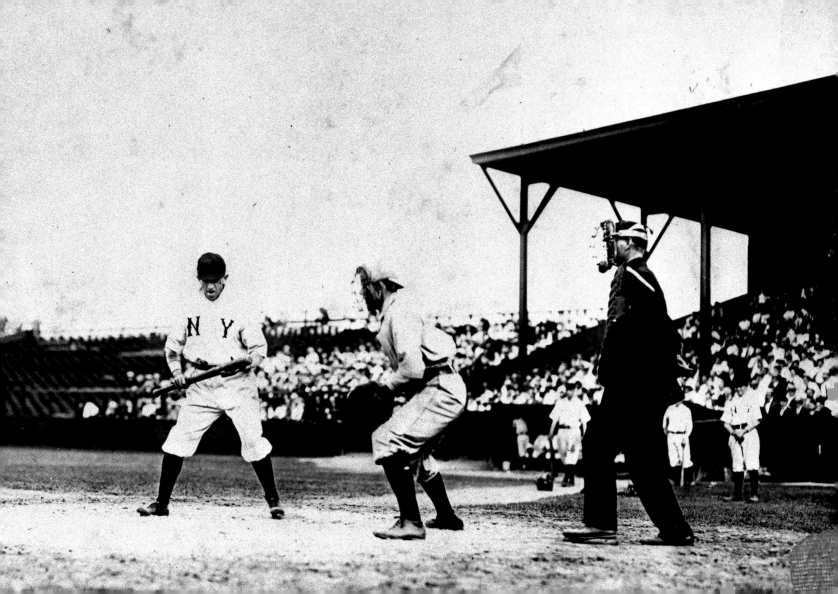

SEPTEMBER 17, 1986

Opposite

Time to Rejoice, and Rake

As the Mets celebrated their division-clinching victory, a groundskeeper went about his business at Shea Stadium. The Mets had defeated the Chicago Cubs for their first division title in thirteen years. A few weeks later, they won the World Series.

Keith Meyers/*The New York Times*

OCTOBER 22, 2000

Overleaf

The Crack of the Bat

As if a Subway Series were not enough drama, Yankee pitcher Roger Clemens added to it in Game 2 by nearly inciting a brawl. Clemens hurled the barrel of a shattered bat into foul territory, barely missing hitter Mike Piazza of the Mets as he raced toward first base. Piazza headed toward the mound, and both teams' benches emptied. Clemens was fined $50,000, but got it back in winnings when the Yanks took the Series.

Barton Silverman/*The New York Times*

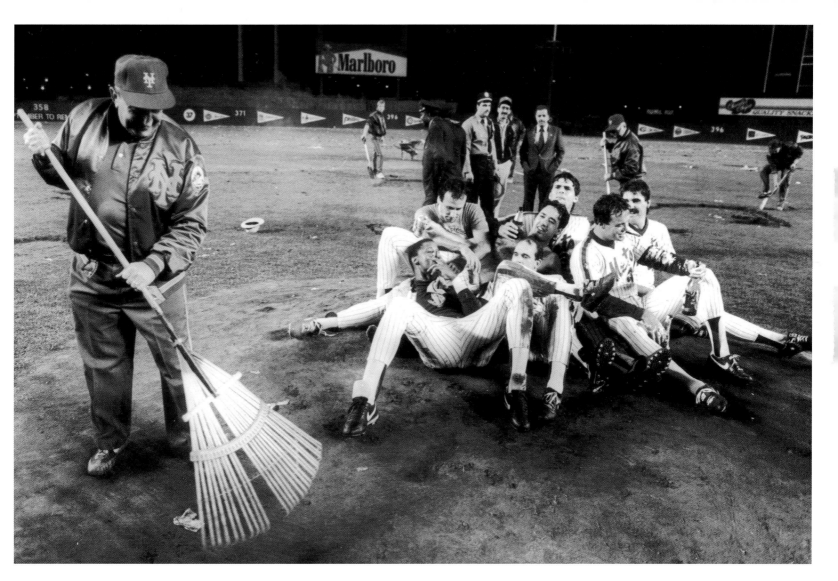

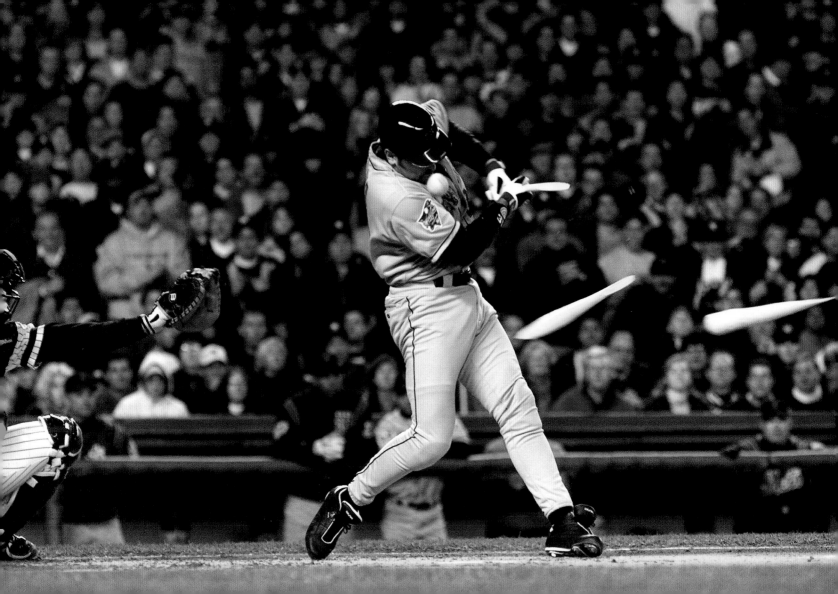

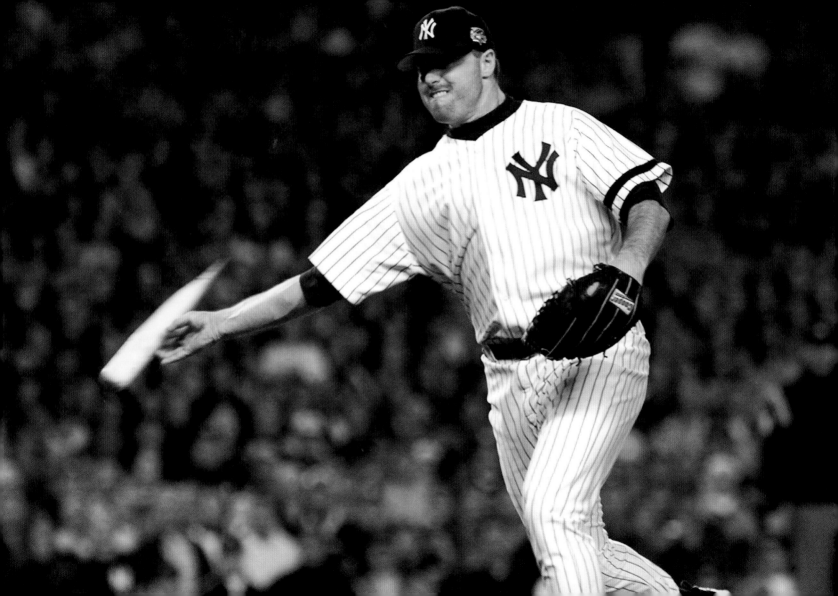

Covering All the Bases

Derek Jeter is the captain of the Yankees, the heart-throb of teenage girls and the frequent subject of baseball highlight reels. Here the star shortstop turned a double play, vaulting over David Segui of the Toronto Blue Jays. "You've got to be confident," Jeter explained after the Yankees won, 3-1.

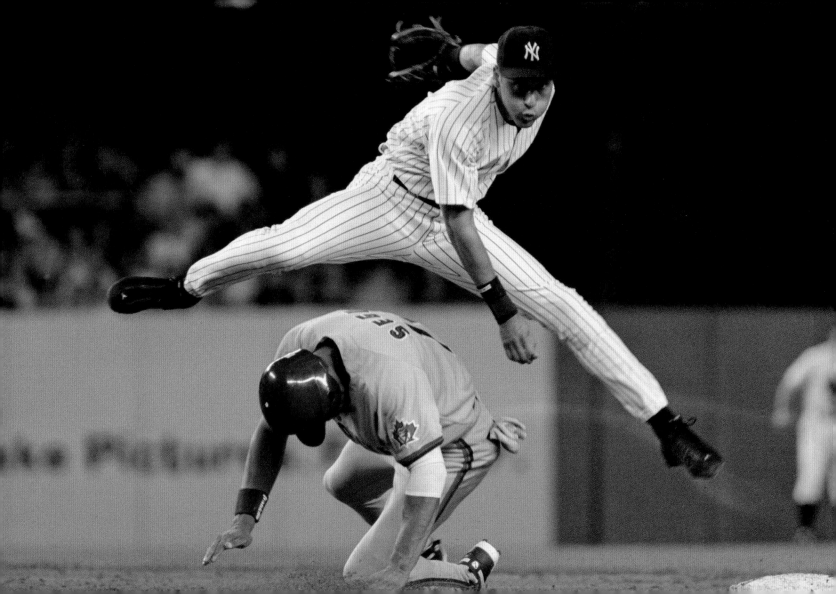

MARCH 20, 1964

Opposite

A Face in the Crowd

Before a fight at Madison Square Garden, the heavyweight champion of the world declined to be introduced when the management would not present him as Muhammad Ali, his newly adopted name. It was several years before sportswriters and broadcasters referred to him as Muhammad Ali and not something like "Cassius Clay, or as he prefers to be called, Muhammad Ali."

John Orris/*The New York Times*

MARCH 24, 1962

Overleaf

Deadly Bout

Boxing fans still wince at the bout between Emil Griffith (black trunks) and Benny "Kid" Paret for the welterweight championship at Madison Square Garden. Paret was pummeled in the twelfth round, knocked unconscious, and taken to a hospital for brain surgery. Ten days later, Paret died.

John Muravcki/*The New York Times*

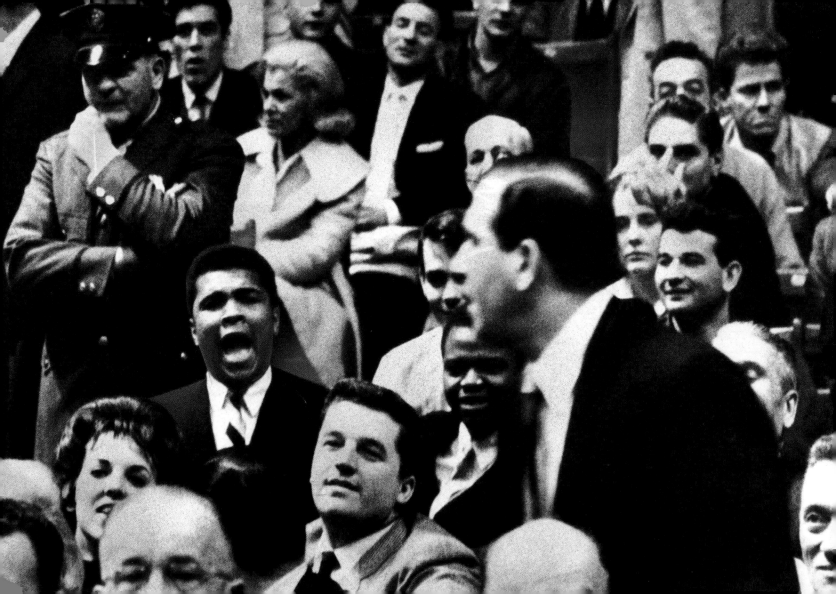

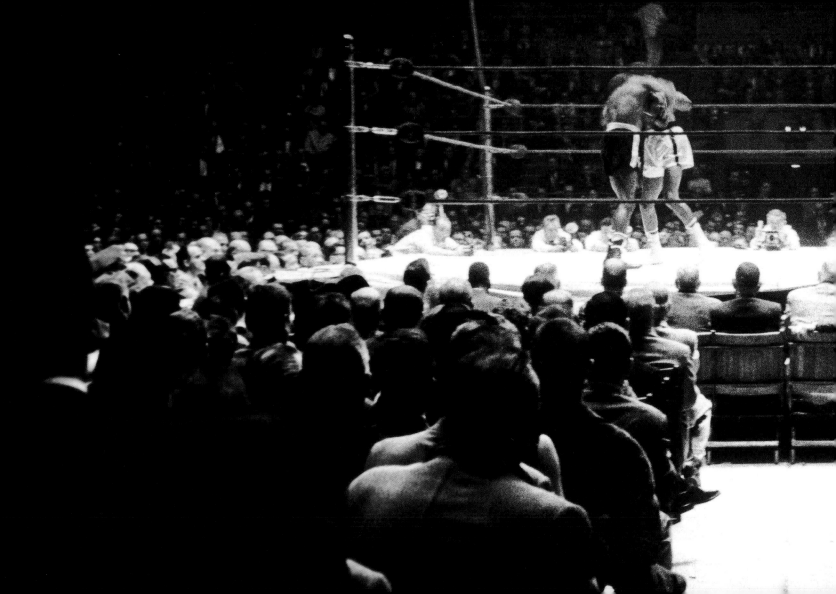

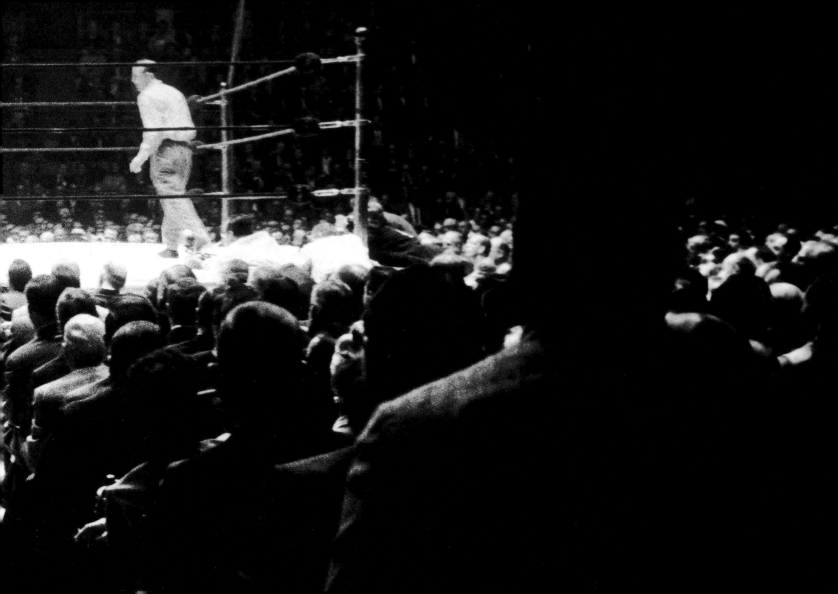

Opposite

A Ring in Times Square

There was a new show on Broadway, for one day anyway: boxing. To drum up ticket sales for their heavyweight bout, Joe Frazier and Jerry Quarry sparred in Times Square. Quarry (right) traded leather with Charlie "Emperor" Harris. Quarry fared worse at Madison Square Garden, when Frazier stopped him in the seventh round.

William E. Sauro/*The New York Times*

1965

Overleaf

A Rising Superstar

Stopping 7-foot-1-inch Lew Alcindor was always a challenge, even at Power Memorial High School in Manhattan. Alcindor (later Kareem Abdul-Jabbar) led Power Memorial to a seventy-one-game winning streak and three city championships. He went on to be a star at UCLA and in the NBA, where his trademark "sky-hook" made him basketball's all-time leading scorer.

The New York Times Photo Archives

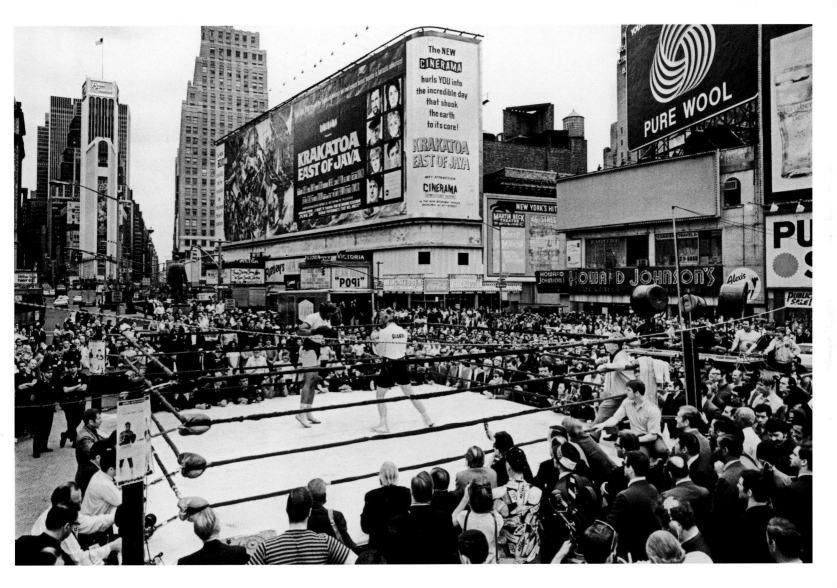

Another Opening, Another Show

Dave DeBusschere, then wearing number 22 for the Detroit Pistons, scored the first field goal during the first basketball game played at the new Madison Square Garden. The Pistons played the Boston Celtics in an NBA double-header that pitted the New York Knicks and San Diego Rockets in the second game.

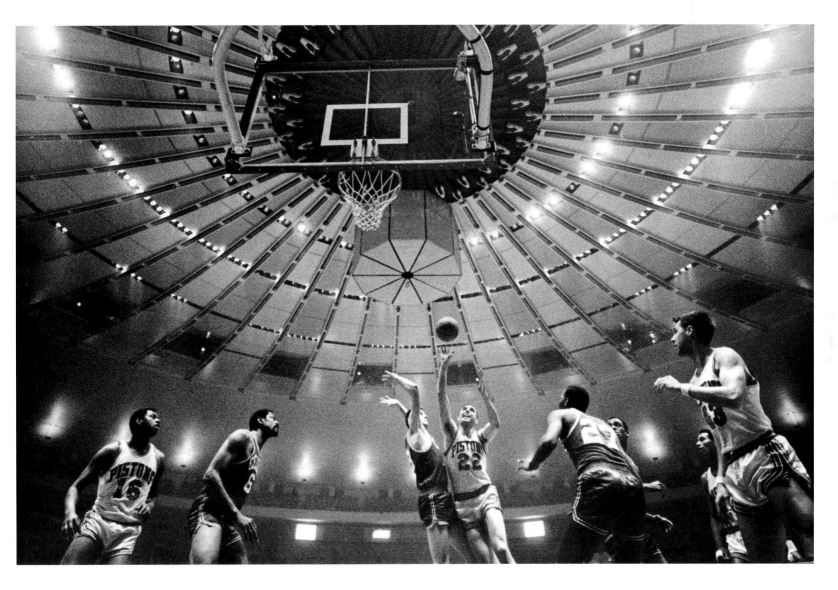

MAY 8, 1973

Opposite

Chamberlain and Bradley

Every eye in Madison Square Garden was on Los Angeles Laker Wilt Chamberlain (left) and New York Knick Bill Bradley. The Knicks won the NBA Finals two days later — and haven't won a championship since.

Larry C. Morris/*The New York Times*

SEPTEMBER 8, 1949

Overleaf

At the Brooklyn Green

It gave a grassy square of Manhattan the name Bowling Green, but by the time these champions gathered in Prospect Park, lawn bowling had been eclipsed by newer games. Not that the bowlers cared. "The players," *The Times* said, "act in much the same way as the little men who were found by Rip van Winkle playing nine-pins in the Catskill Mountains. Rip said, 'The folks were evidently amusing themselves, yet maintained the gravest faces.'"

Ernie Sisto/*The New York Times*

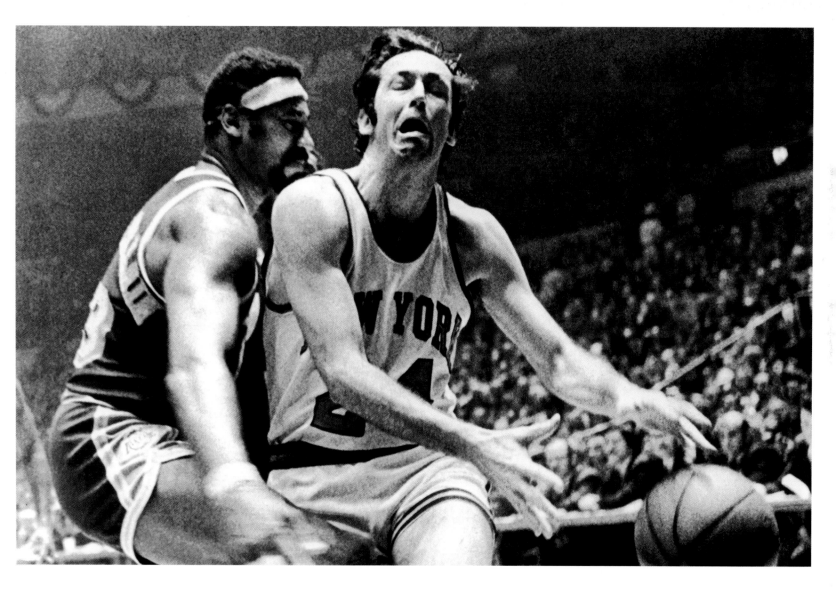

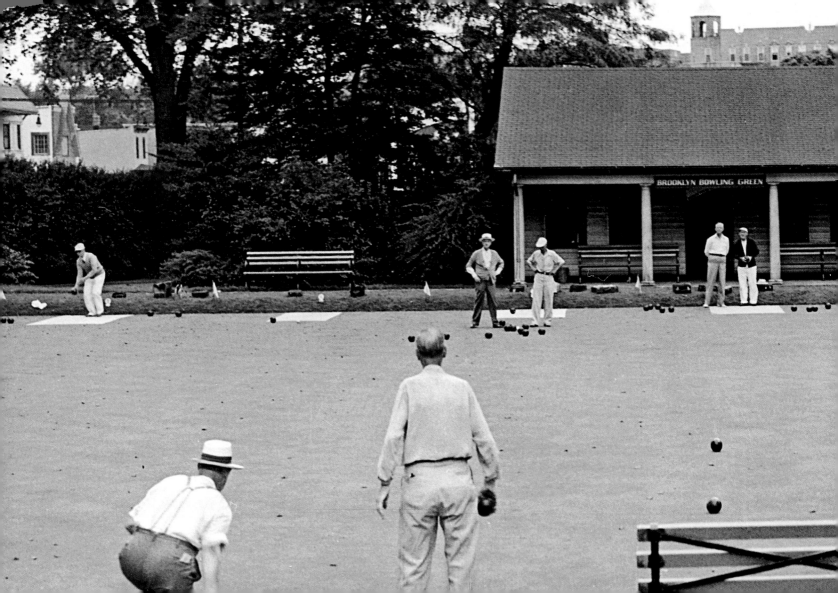

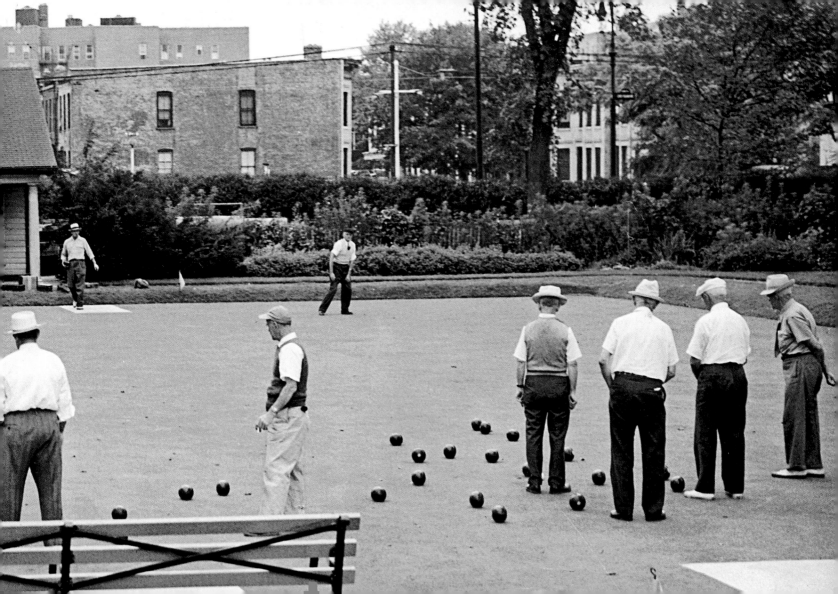

1964

Dressage

As it had since the nineteenth century, the horse show brought elaborate pageantry to the people's palace, Madison Square Garden. While the horses pranced and paraded, these men in top hats and tails promenaded like ambassadors from a gentler, more genteel generation.

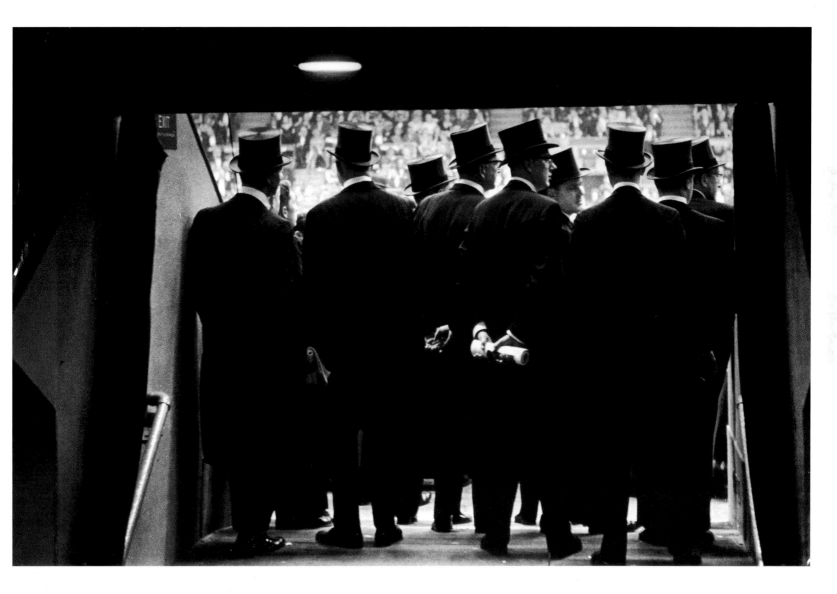

"We Own the Cup"

Basking — and baking — in an eighty-nine-degree celebration of a sport played on ice, the New York Rangers, a team that had been jinxed for generations, reigned as the best in the National Hockey League. Long-suffering fans accustomed to whining about missed goals or blind referees changed their chant. "We want the cup" became "We own the cup."

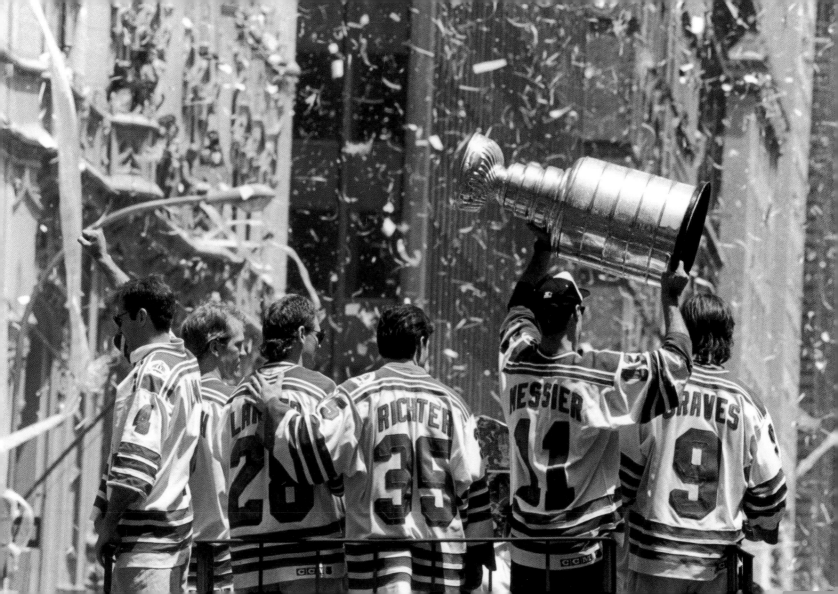

Opposite

1935

Ouch, With a Smile

Anyone who has skated too fast over a
rut in the ice or come out of a curve off
balance knows this split-second sequence:
oops, down, down, ouch. These skaters
were practicing for a race in Central Park.

The New York Times Photo Archives

Overleaf

FEBRUARY 14, 1985

A Vertical Course

Who said a marathon has to be run
outdoors? Not these sprinters, heading for
the stairwell in the Empire State Building
and the 1,575 steps they had to climb
on the way to the finish line, eighty-six
floors up. Al Waquie of Jemez Pueblo,
New Mexico, took the lead on the fiftieth
floor and completed the course in eleven
minutes and forty-three seconds.

Marilynn K. Yee/*The New York Times*

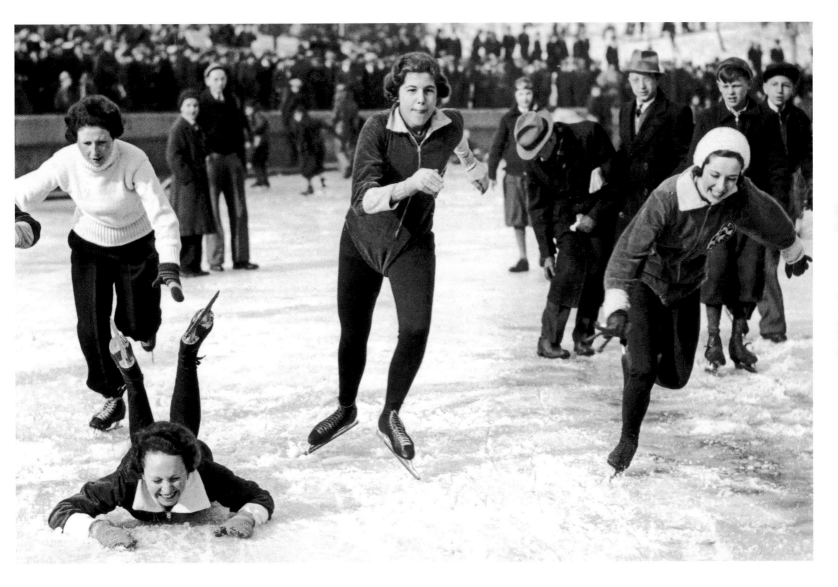

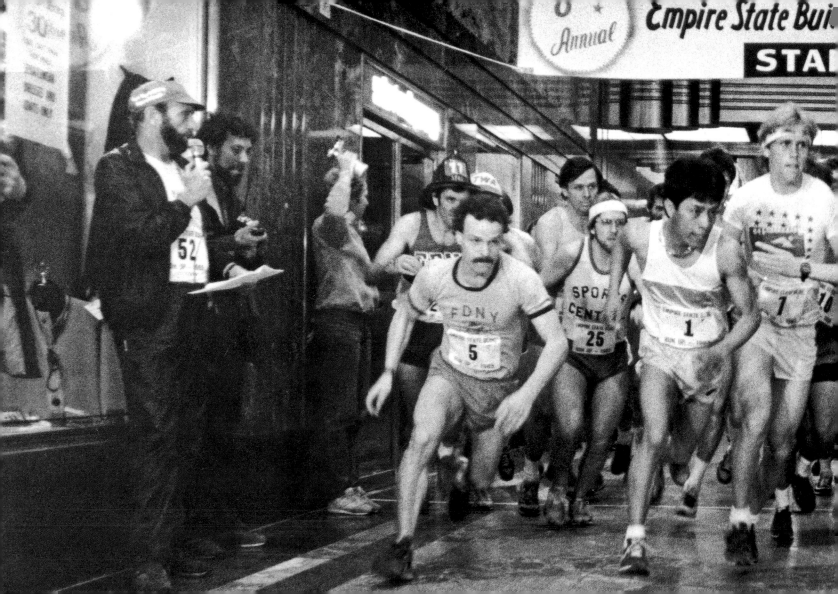

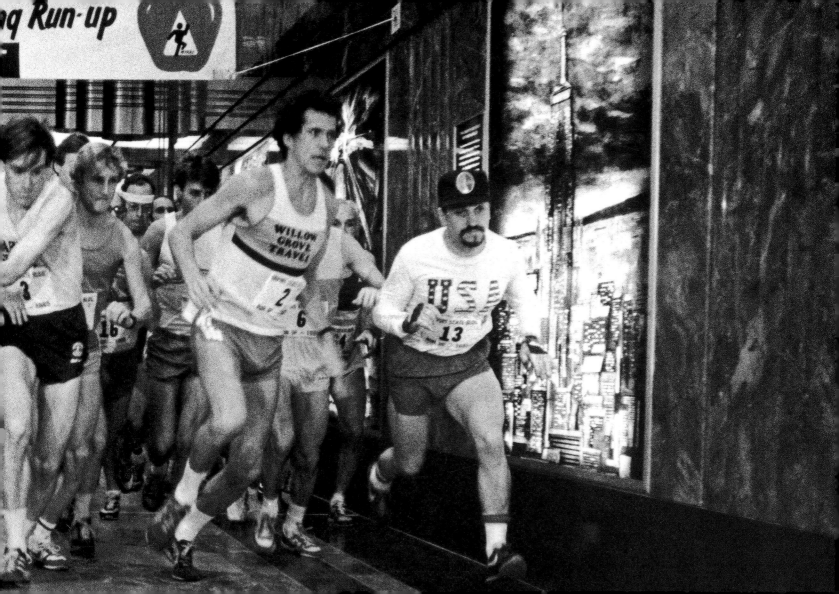

NOVEMBER 6, 2005

Opposite

Photographer at Work

Cell phones with cameras brought a
new immediacy to photography. Now
there was no film to drop off, no prints
to pick up. He would know — in seconds
— whether this shot of runners in the
New York Marathon was any good. If it
was, he could send it — again, in seconds
— anywhere he wanted.

James Estrin/*The New York Times*

NOVEMBER 7, 2004

Overleaf

Onward

The runners were bound for Brooklyn and,
eventually, the finish line of the New York
Marathon in Central Park in Manhattan.
The cargo ship was bound for a more
distant destination. The Verrazano-
Narrows Bridge, wide enough for the
marathoners and tall enough for the ship,
accommodated them all.

Vincent Laforet/*The New York Times*

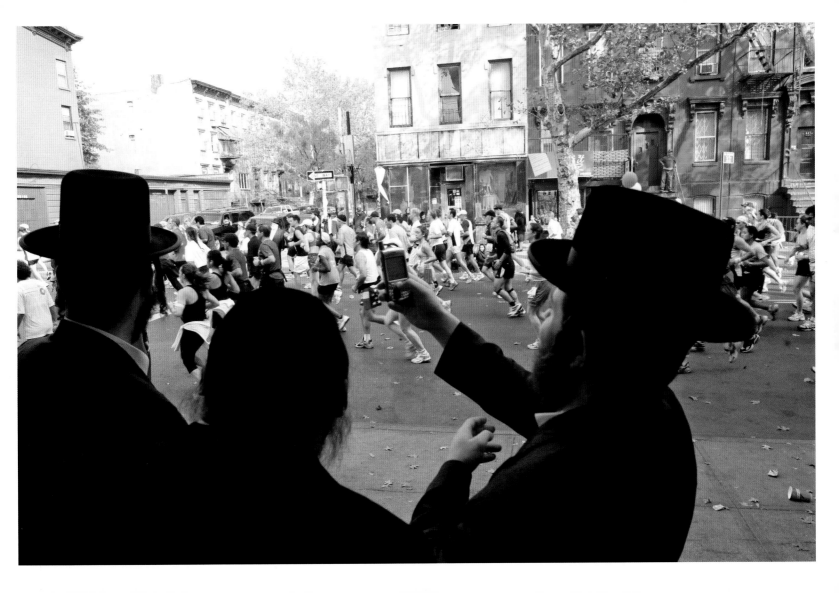

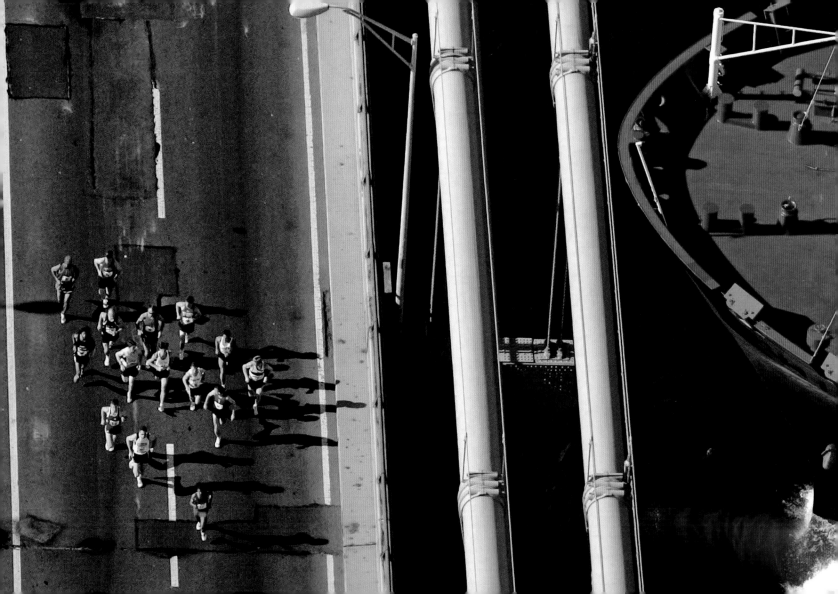

AUGUST 30, 1945

Opposite

On Your Mark . . .

The "anything on wheels" derby gets under way with much seriousness. Among the sixty-eight entries were homemade carts, roller skates, even doll carriages.

The New York Times Photo Archives

AUGUST 18, 1918

Overleaf

Speed Demons

New York has always had its car-phobic neighborhoods — think most of Manhattan — and its car-friendly ones — think Sheepshead Bay, Brooklyn. Here, Ralph De Palma, a familiar figure in his twelve-cylinder Packard wherever there were checkered flags and stopwatches, roars past the finish line at 111 miles an hour and into the record books with the fastest time on a ten-mile course.

The New York Times Photo Archives

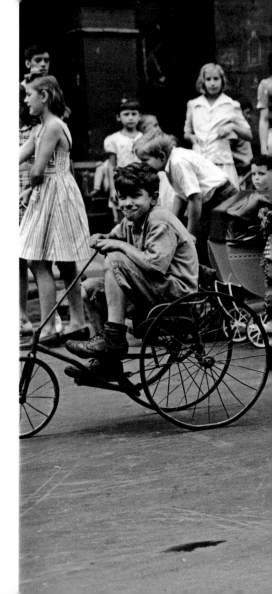

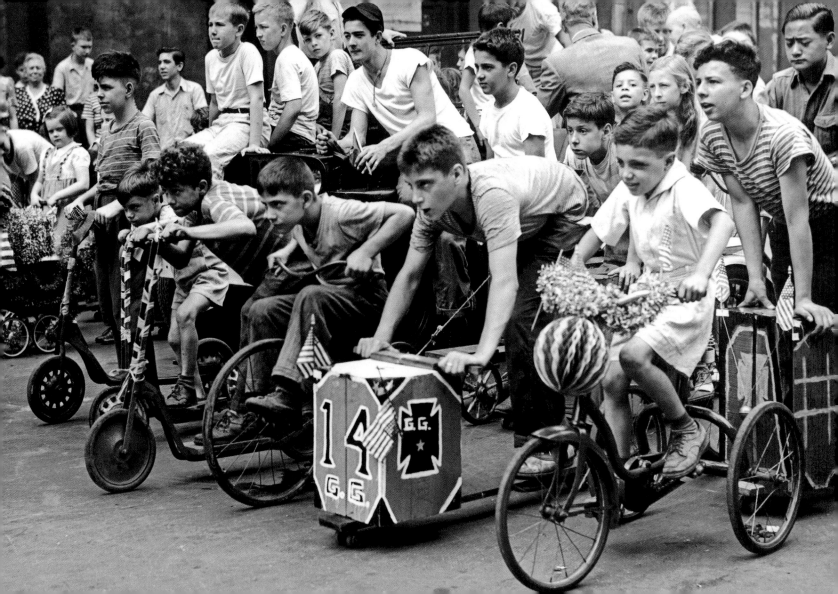

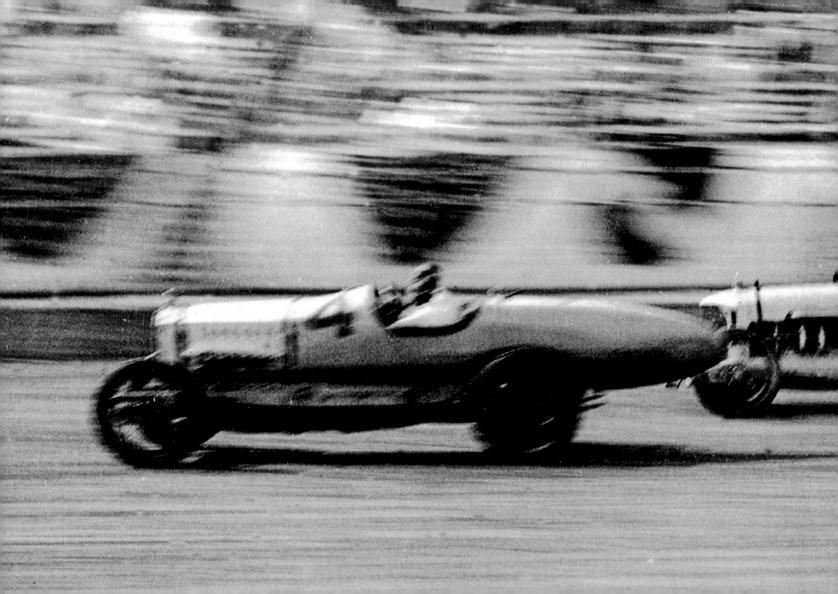

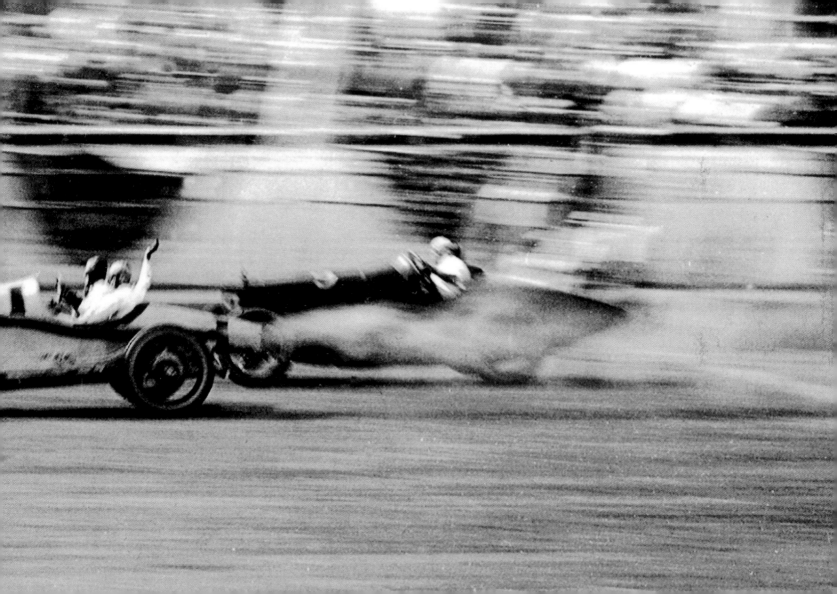

The Williams Era

In what George Vecsey of *The Times* called an "all-Williams, all-the-time" final at the United States Open, Serena Williams cruised to a straight-sets victory over her sister, Venus. Here, Serena returns a shot against Lindsay Davenport during the women's semifinals at Arthur Ashe Stadium in Queens.

Chang W. Lee/*The New York Times*

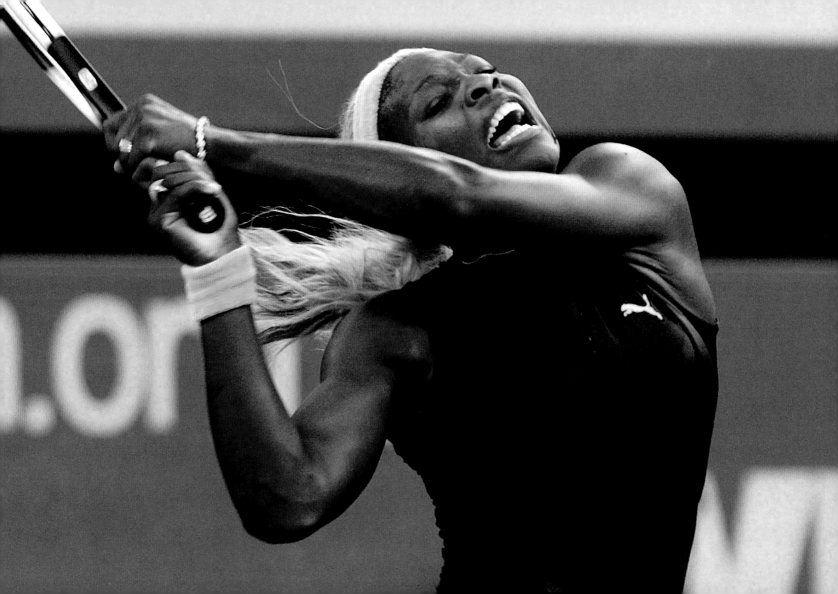

Opposite

Y. A. Tittle's Last Game

Seventeen years of pro football caught up with Giant quarterback Y. A. Tittle as he sat on the bench throughout the second half of his final game, a 52–20 loss to the Cleveland Browns at Yankee Stadium. Fans remember "YAT" for leading the team to Eastern Division titles in 1961, 1962, and 1963. A few even remember what his initials stand for: Yelberton Abraham.

Carl T. Gossett Jr./*The New York Times*

Overleaf

Football Foes

This was a game within the game: who would end up with better statistics, the Giants' star linebacker, Sam Huff (70), or the Cleveland Browns' great running back, Jim Brown (32)? Brown won that day, rushing for 110 yards on fourteen carries and helping the Browns win, 48-34.

Ernie Sisto/*The New York Times*

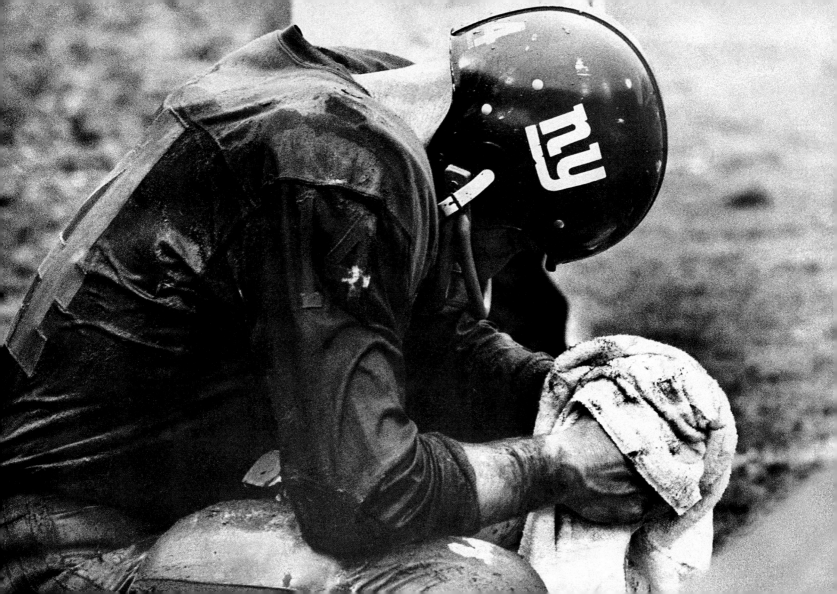

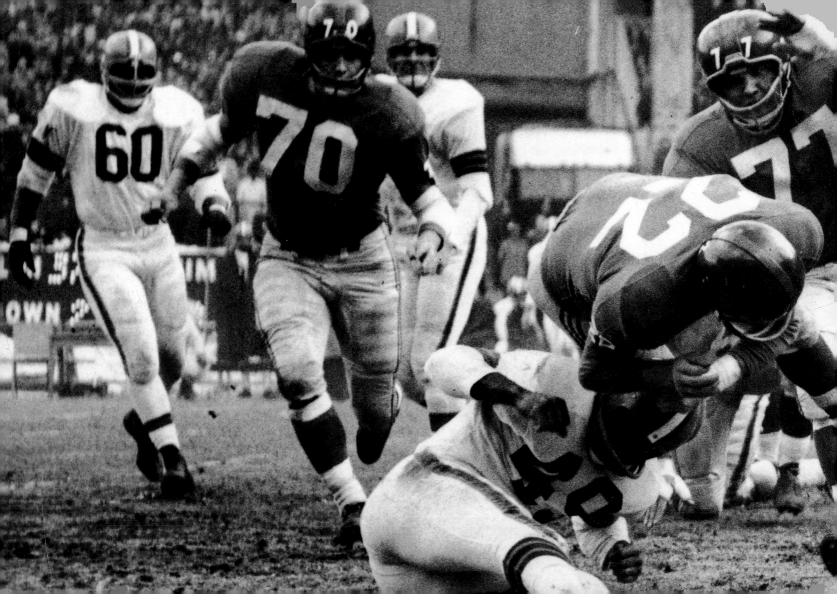

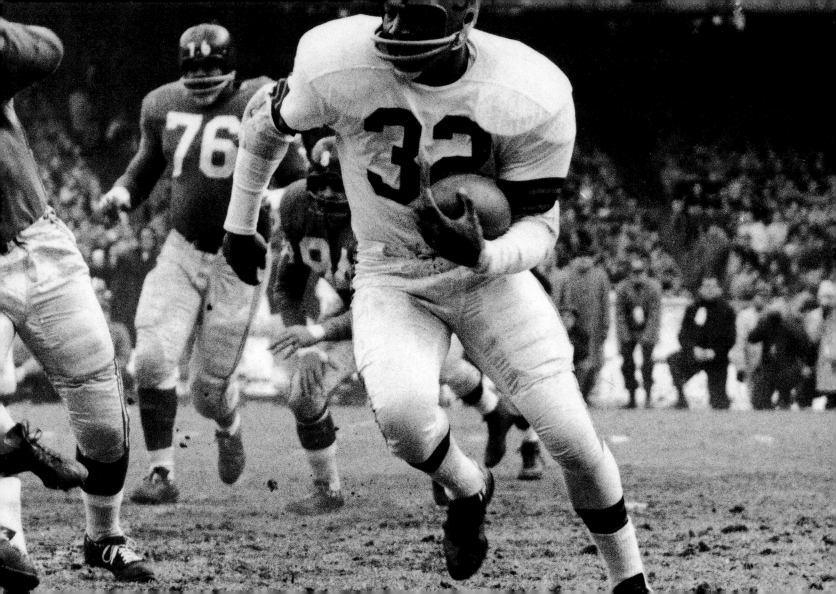

MAY 12, 1957

And the Kick Is . . . Great

The dress and the high heels were not the regulation uniform. But Marilyn Monroe managed to make the first kick at this all-star soccer game, between Israel Hapoel and the American Soccer League All-Stars, at Ebbets Field in Brooklyn.

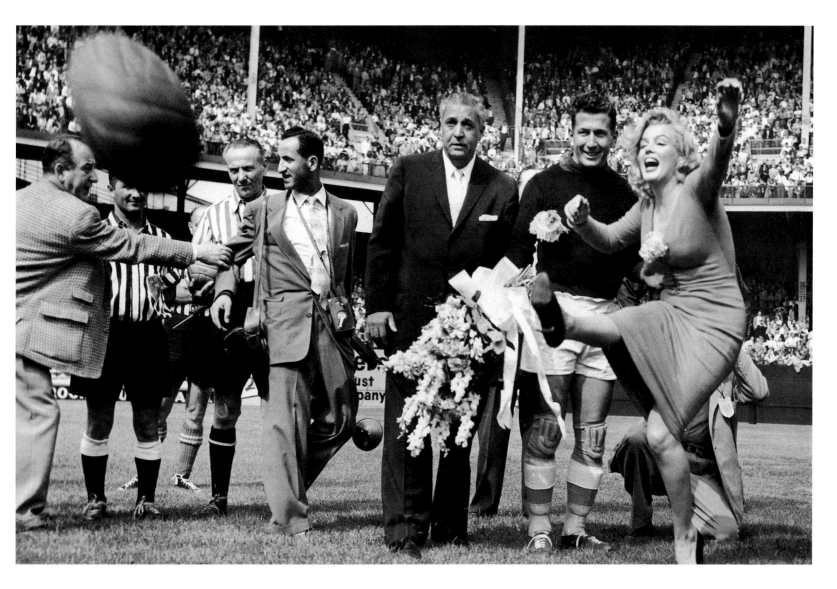

MAY 12, 1957

Opposite

"Broadway Joe" in Action . . .

New York Jets quarterback Joe Namath had a surefire passing arm and delivered under pressure, as when he launched this pass against the Houston Oilers in 1966 at Shea Stadium. He also had bravado, as when he promised a victory over the Baltimore Colts in Super Bowl III in 1969. The Jets won, 16–7.

Barton Silverman/*The New York Times*

JUNE 6, 1969

Overleaf

. . . and Meeting the Press

Living up to his nickname, "Broadway Joe" Namath said he was retiring from professional football rather than comply with an NFL order to sell his half interest in an East Side bar. Several weeks later, he returned to the Jets and sold his share of the watering hole. At the press conference were, from left, Kyle Rote, Howard Cosell, and Harry Walsh.

Neal Boenzi/*The New York Times*

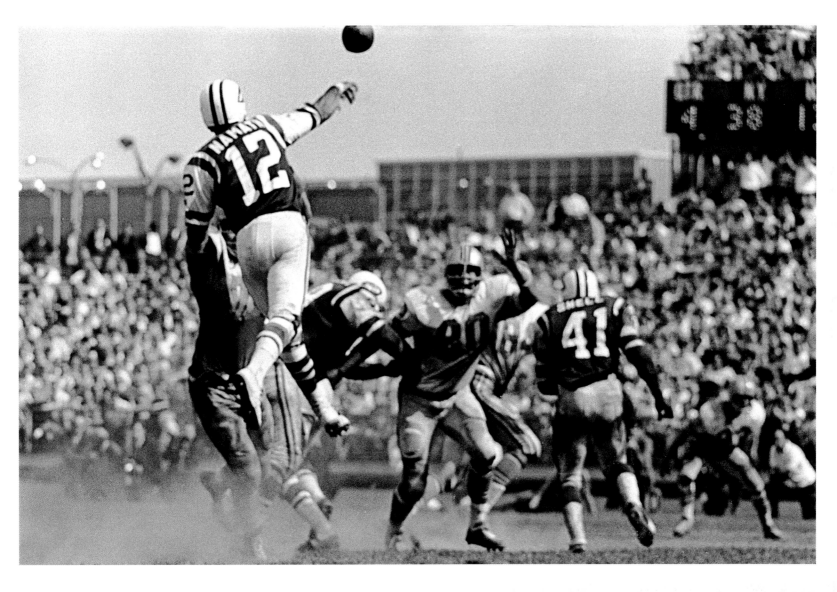

NOVEMBER 12, 1918

Opposite

1918 Armistice: The Real Thing

The end of World War I on November 11, 1918, touched off a second round of parades and parties. New York had begun celebrating the week before, when a wire service had sent out a dispatch incorrectly announcing the peace. This time around, *The Times* declared that "the glooms who said that New York had exhausted its reserves of enthusiasm . . . were wrong."

The New York Times Photo Archives

APRIL 27, 1952

Overleaf

Sightseers

On a rainy afternoon, the Korean war-era soldiers on this bus accomplished two things: they saw the city, and they kept their uniforms dry.

The New York Times Photo Archives

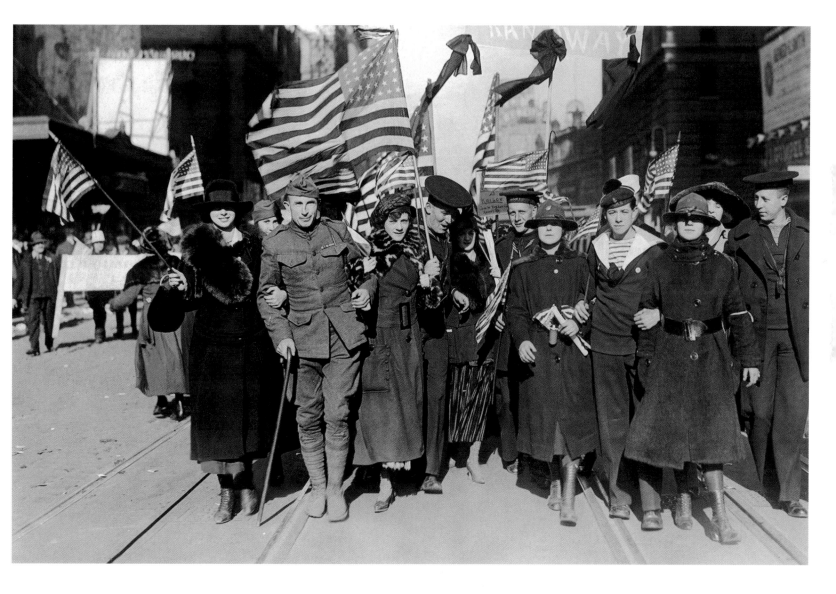

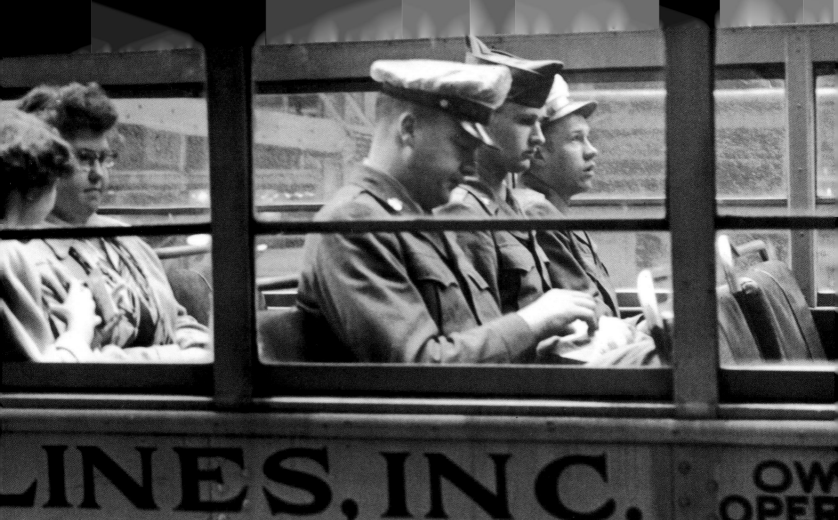

LINES, INC. OW
OPER

Here's Looking at You
She is on a billboard, going nowhere.
But she sees everyone who has been
everywhere and looked at everything,
like this summertime crowd on a double-
decker tour bus.

Librado Romero/*The New York Times*

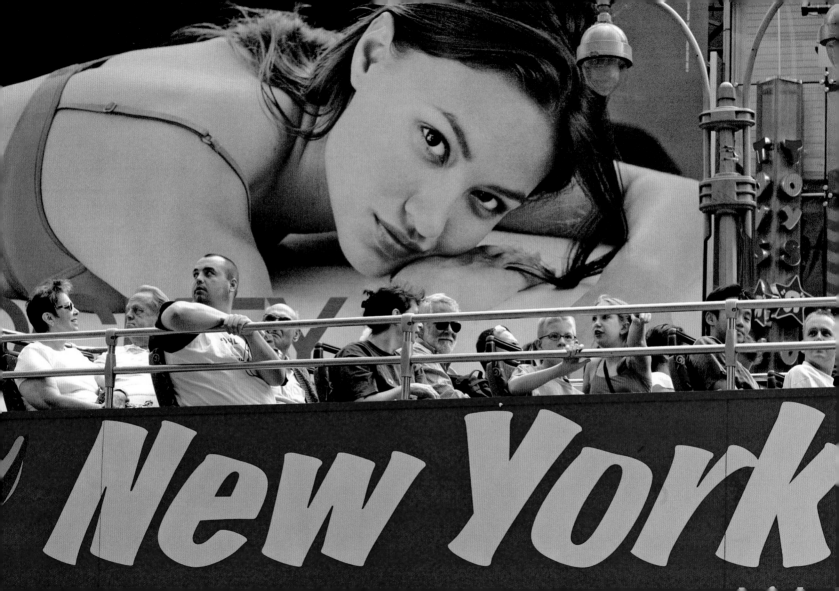

And Over There . . .
The driver of a one-horsepower cab pointed out sights in Central Park on a balmy afternoon in what was, according to the calendar if not the sixty-two-degree reading on the thermometer, officially still winter.

Neal Boenzi/The New York Times

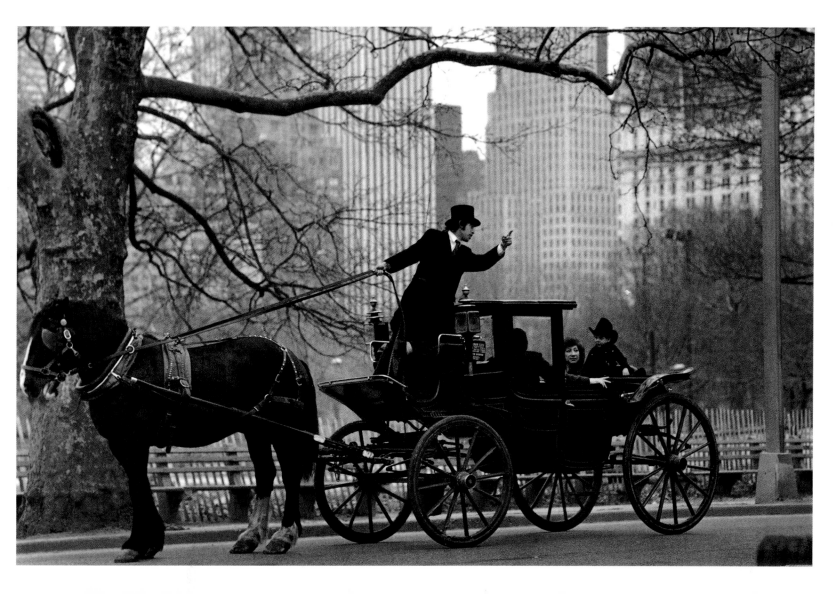

Loining Noo Yawk Cabbies ta Tawk Good

Jerry Cammarata, a speech teacher, tried ta loin Noo Yawk cabbies ta tawk in standard American. Presiding over a class organized by a taxi owners' association, he explained "auditory acuity," "synergistic motor movement of the buccal cavity," and something that sounded like "kinesthetic proprioseptic feedback," *The Times* said. "What we're going to do is to omit from our vocabulary 'toity-toid and toid.'" "Uf caws," said Cal Miller, a taxi driver in the back row.

THE PARTS OF THE MOUTH
RESPONSIBLE for ARTICULATION

1. Lips
2. Teeth
3. Gum Ridge
4. Hard Palate
5. Soft Palate
6. Tongue
7. Nose

THE X (APPLE) SOUND

FEBRUARY 1, 1994

Flying Nun

The nuns of the Fraternité Notre Dame turned to martial arts as a diversion from their ministry to the poor. Sister Marie Chantal tries a mid-air move as Sister Marie Francesca appears poised to strike. The two practiced at a Ninth Avenue tae kwon do academy, taking a break from the soup kitchen they ran in Harlem.

Jack Manning/*The New York Times*

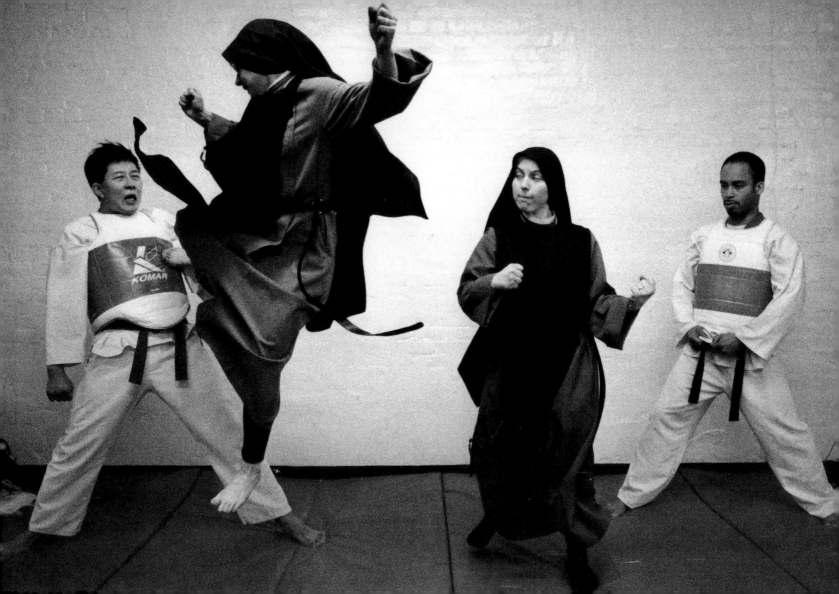

Opposite

Tanks, and Goodbye

The world's largest natural-gas storage tanks, in Greenpoint, Brooklyn, stood four hundred feet tall and could hold enough gas to keep 160,000 homes going for a month. By the twenty-first century, though, newer pipelines could do the job, and the tanks were demolished.

Chang W. Lee/*The New York Times*

1953

Overleaf

A Touch-up for the Whitestone

The Bronx Whitestone Bridge was — in the words of the urban planning czar Robert Moses — "the finest suspension bridge of them all, without comparison in cleanliness and simplicity of design." But even it needed an occasional touch-up. The top of this photo received some paint, too, from a photo retoucher, whose work was commonly practiced at newspapers decades ago.

Ernie Sisto/*The New York Times*

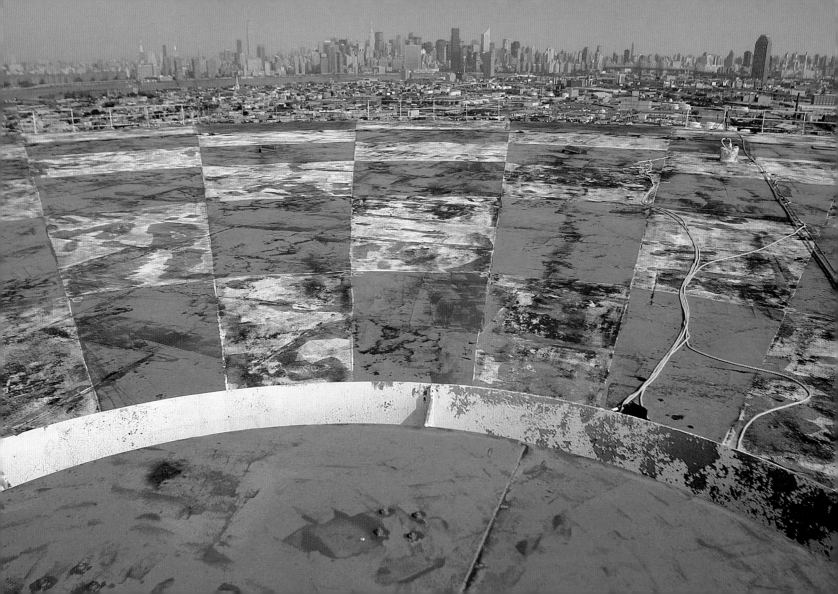

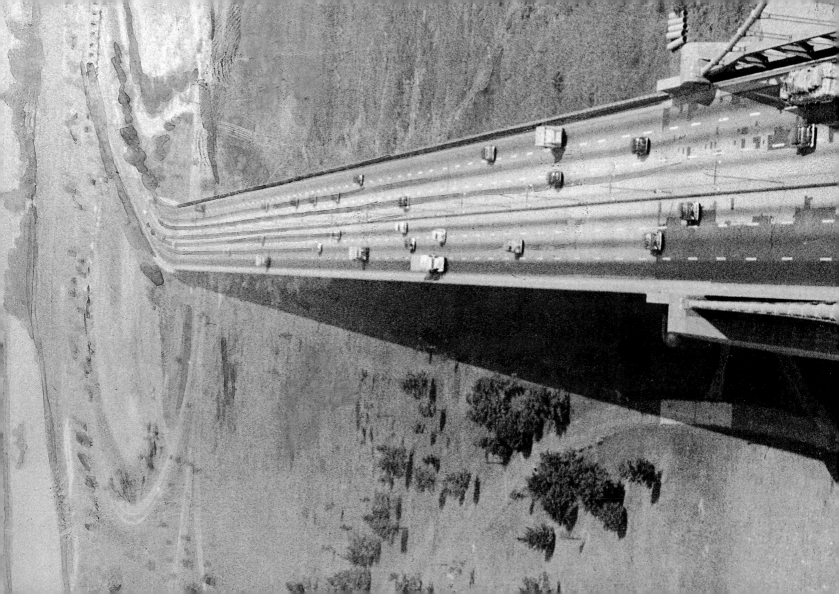

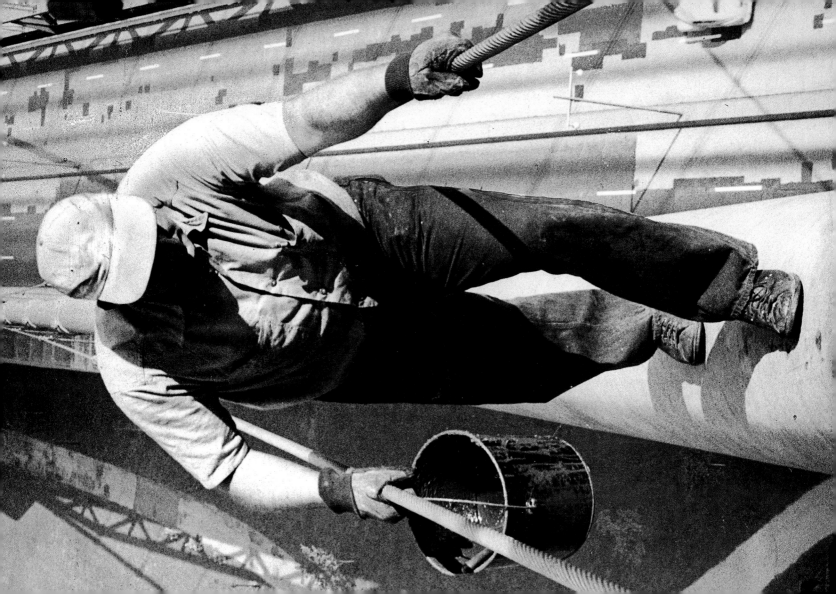

OCTOBER 24, 1931

Day One for the George

First came the soldiers on parade, followed by the rush-hour headaches, and finally the first-name familiarity. On opening day, military units and marching bands high-stepped their way from New York to New Jersey and back again, celebrating an engineering achievement that measured 4,760 feet from end to end and was finished eight months ahead of schedule. "The George," as commuters came to call it, was then the world's longest suspension bridge. "Martha," as the lower level was nicknamed, was completed in 1962.

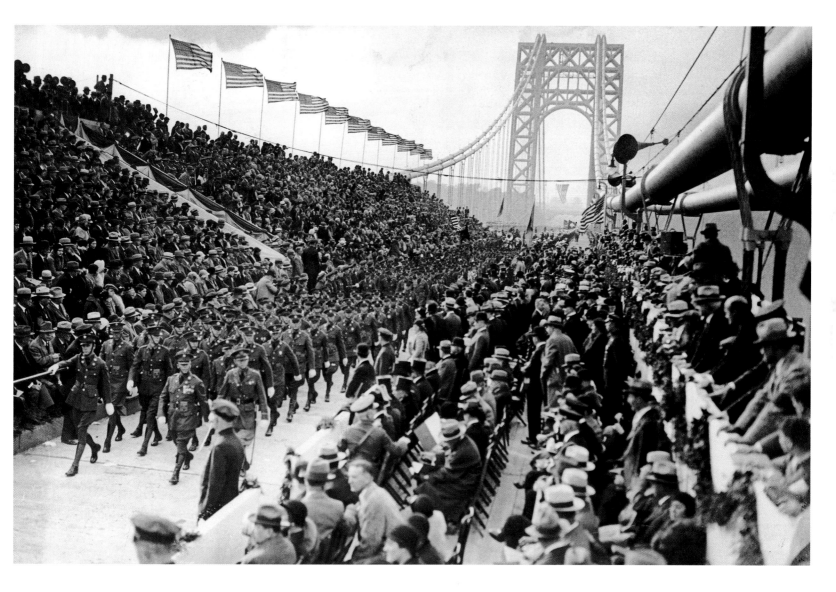

Building the Monumental Bridge

1878

John A. Roebling's Brooklyn Bridge was still unfinished when these men posed — the engineers and foremen on one side, the top-hatted financial and political types on the other. They had a few years to go before the job was done and the poet Walt Whitman declared that New York had something that fulfilled Christopher Columbus's mission.

The New York Times Photo Archives

Overleaf

At Sunset

NOVEMBER 16, 1987

"The Brooklyn Bridge," *The Times* once noted, "was the first monument to seize the American imagination as Chartres Cathedral or the Eiffel Tower seized the French." Imagination-seizing monuments must be kept up, which is probably why the maintenance worker suspended on the cables was still on the job as the sun went down on a November afternoon.

Chester Higgins Jr./*The New York Times*

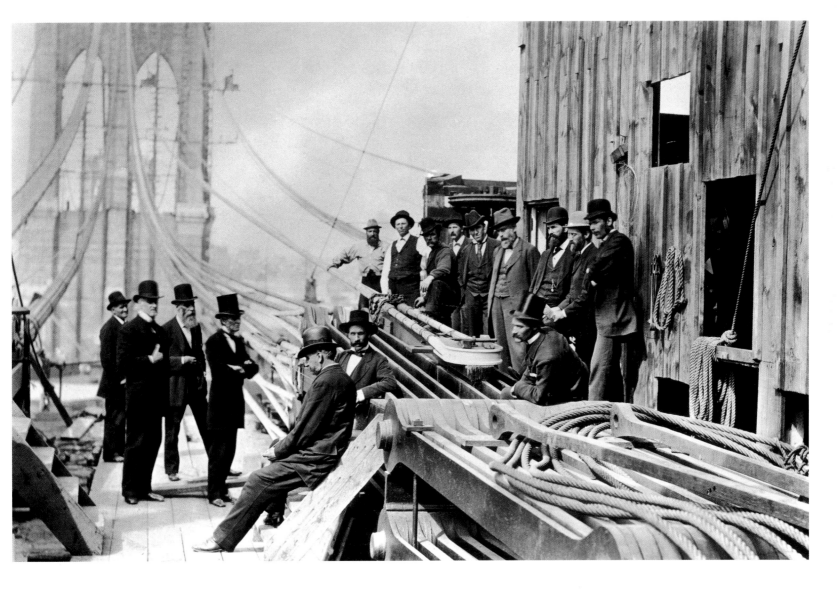

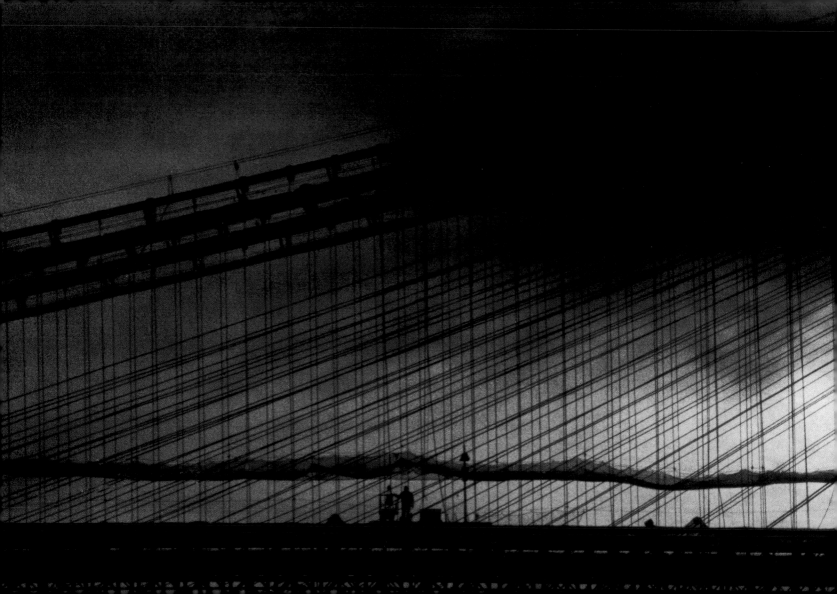

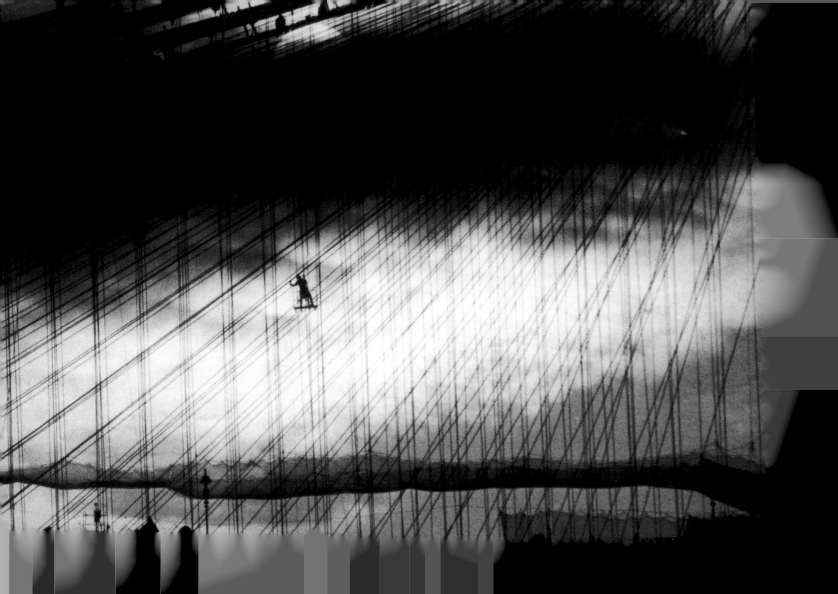

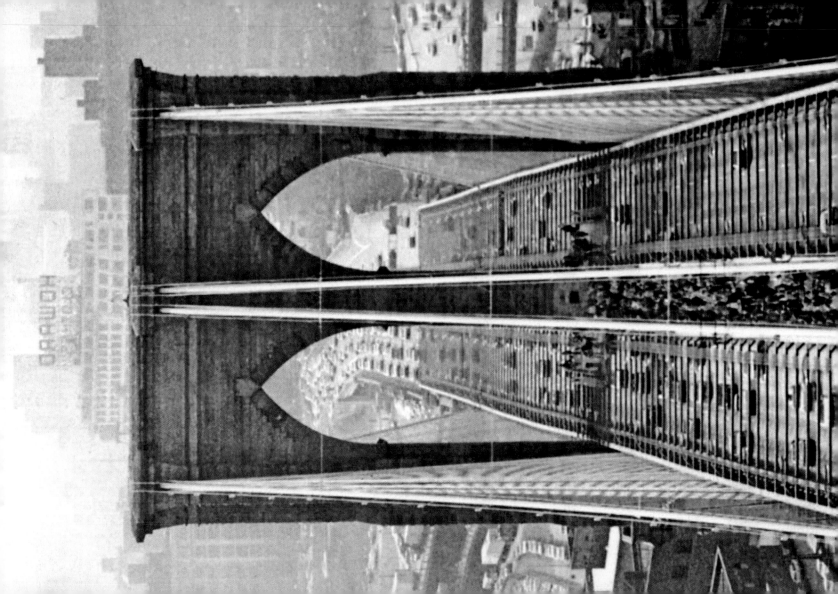

APRIL 7, 1980

Previous

Walking to Work

That ribbon of people streaming across
the Brooklyn Bridge was going to work
the hard way. The easy way, the usual way,
had been preempted by a transit strike.
They trudged back and forth until the
walkout ended eleven days later.

Fred R. Conrad/*The New York Times*

NOVEMBER 25, 1974

Opposite

Another Time of Transition

Battery Park City and the World Financial
Center would come to occupy that space
just west of the twin towers, on the very
land that was created by the construction
of the World Trade Center. Once again
the face of the city was changing and,
for another twenty-seven years, those
spires would dramatically punctuate the
Manhattan skyline.

Neal Boenzi/*The New York Times*

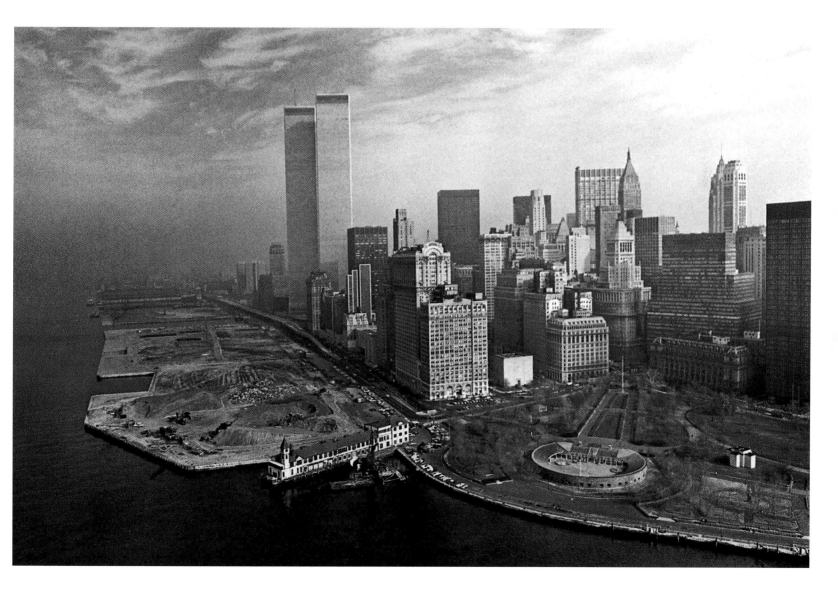

9/11

It was a moment when everything changed on a morning when everything changed: one of the twin pillars of the World Trade Center collapsed in an angry cloud of fire, smoke and debris. On that clear, bright day of death, the buildings were gone less than two hours after they were struck by jetliners hijacked by terrorists, and 2,749 people were dead. The families lived with profound and sometimes prolonged grief; President Bush promised to fight a war on terror "until every terrorist group of global reach has been found, stopped, and defeated."

Chang W. Lee/*The New York Times*

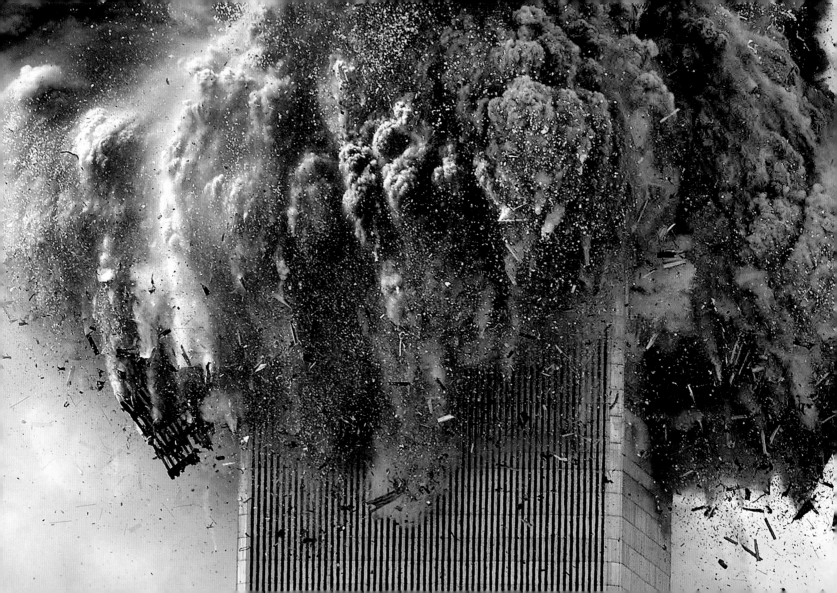

SEPTEMBER 11, 2001

Exodus

As the quarter-mile-high towers of the World Trade Center exploded in fire, people fled Lower Manhattan the only way they could — on foot. They ran at first, then slowed to a walk as they crossed the Brooklyn Bridge, covered in ash.

Andrea Mohin/*The New York Times*

SEPTEMBER 11, 2001

Aftermath

The debris was so thick it blocked out the sun. Firefighters had to hose down rubble in the streets near ground zero — rubble that included fire trucks and ambulances that had been driven there by firefighters and paramedics who died inside the burning towers.

Angel Franco/*The New York Times*

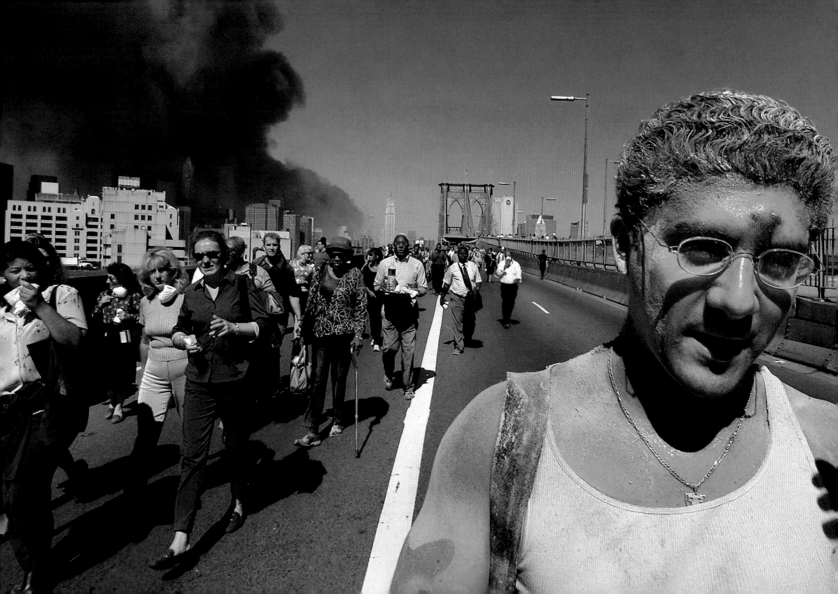

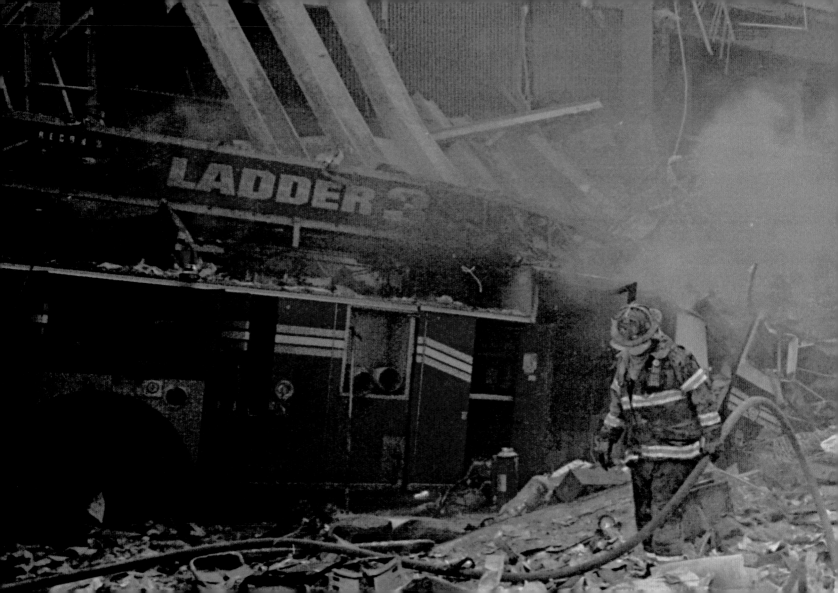

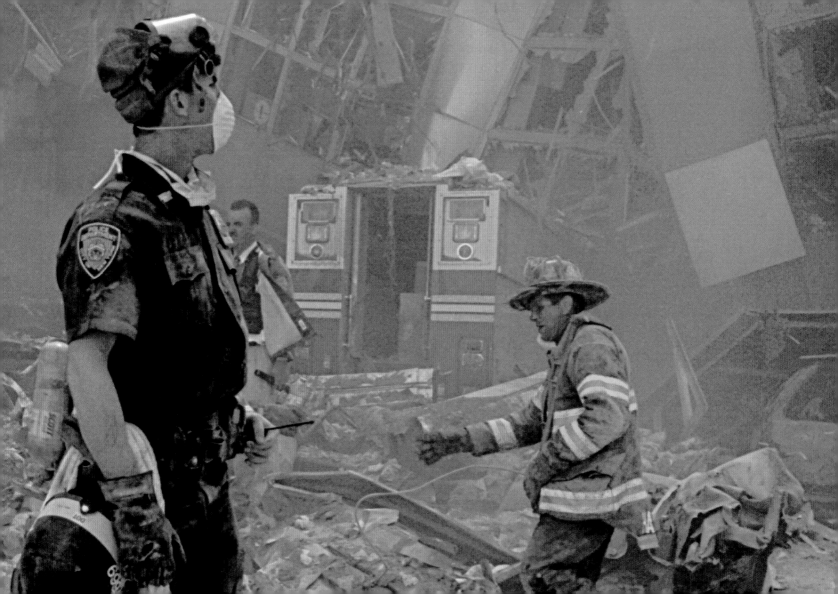

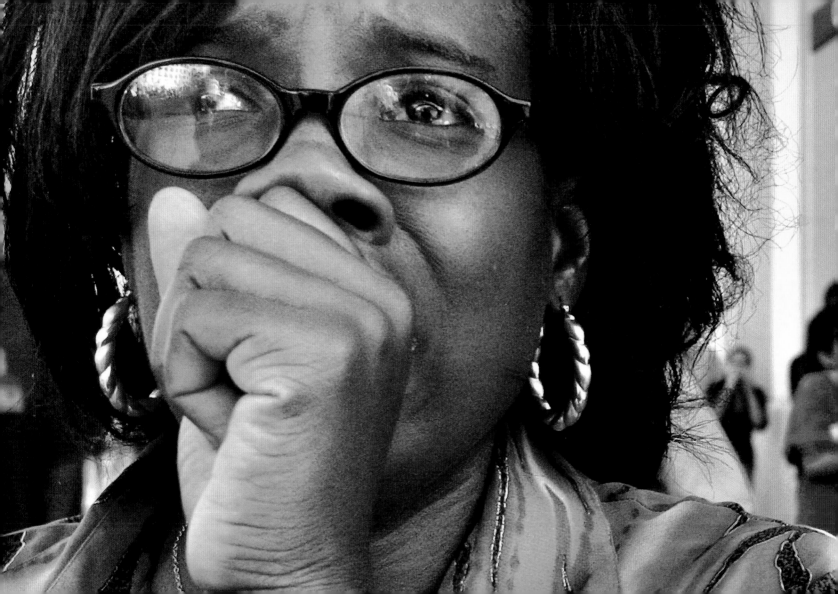

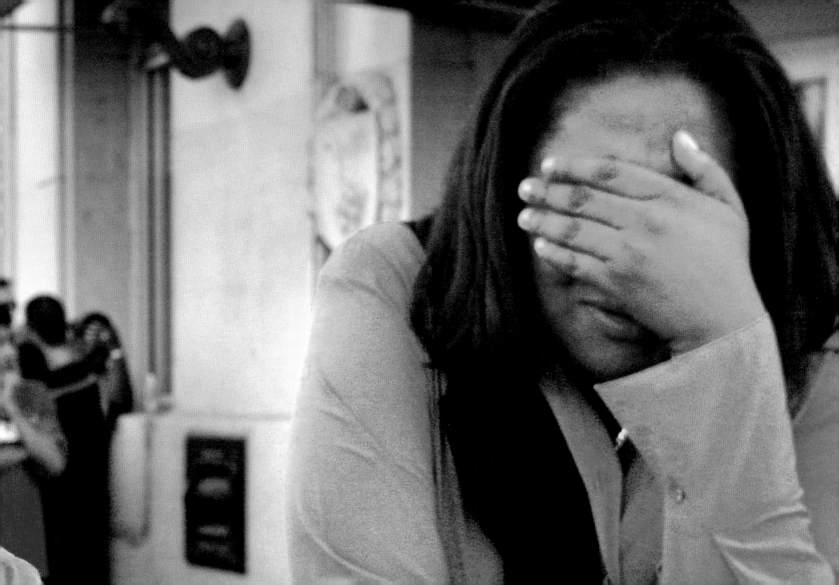

Previous

Unbelievable

When the south tower of the World Trade Center crumbled to the ground, the disbelief and horror showed in the reactions of these onlookers on a Manhattan sidewalk.

Angel Franco/*The New York Times*

Opposite

Residue

"Fallout" took on new meaning near ground zero. Many homes were debris-encrusted, and so were the things inside, like this tea set in an apartment just across the street from where the World Trade Center had been.

Edward Keating/*The New York Times*

Only Rubble

The place where two of the world's tallest buildings had stood for more than a generation had a new name, "ground zero." The twin towers of the World Trade Center had been reduced to rubble in a matter of hours, and on the morning after, rescuers were dwarfed by what remained recognizable — the giant ragged honeycombs of one tower wall — and overwhelmed by debris that would yield the dead.

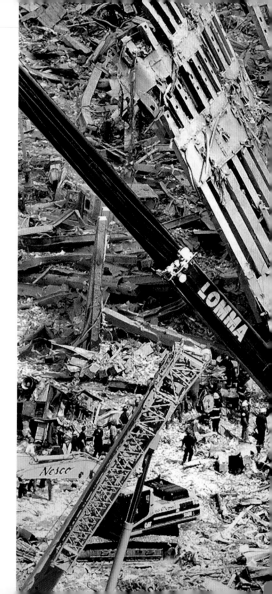

Ruth Fremson/*The New York Times*

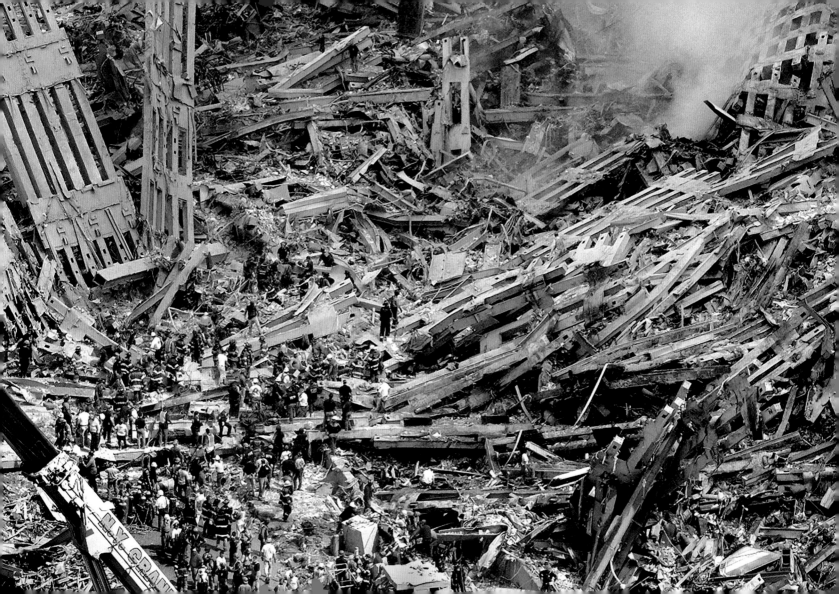

SEPTEMBER 11, 2002

Silence and Dust

The nation paused a year later to remember the 3,016 victims who did not come home on the day terrorists turned commercial jetliners into missiles and flew three into the World Trade Center and the Pentagon, and crashed one in a field in Pennsylvania. Here, a gust of wind swirled across ground zero, engulfing a commemorative service in dust.

James Estrin/*The New York Times*

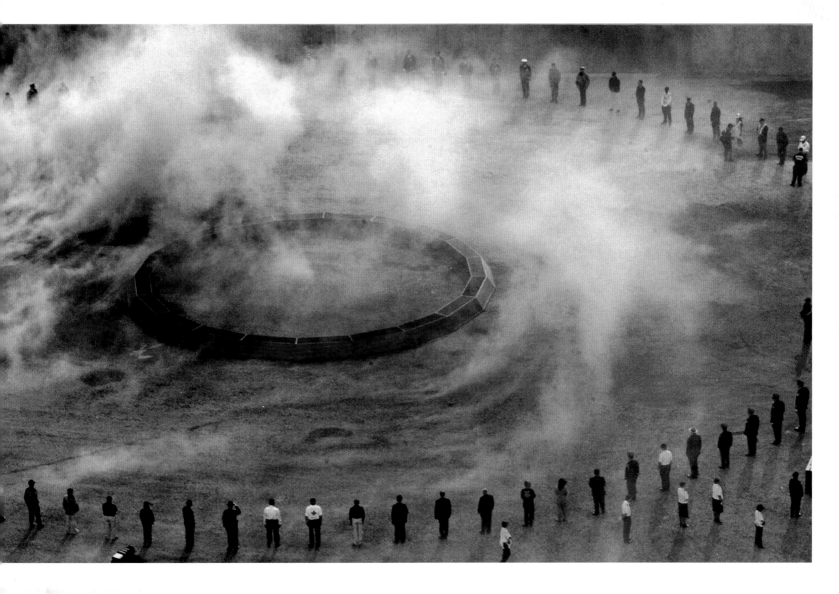

Memorial Mural

In the months following 9/11, scores of
memorials found their way onto walls
in New York City as artists and average
citizens sought relief from shock and grief
through artistic expression.

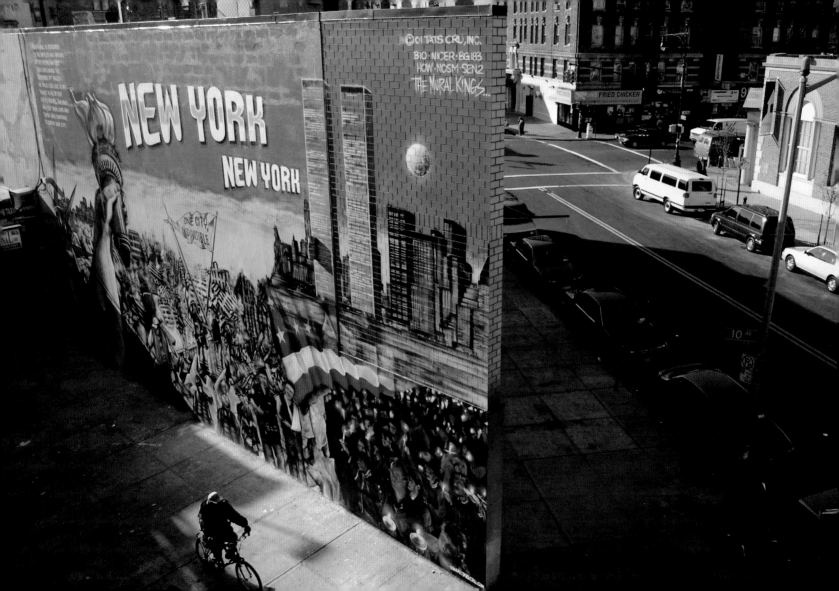

MARCH 11, 2002

Towers of Light

Six months after the 9/11 attacks two
soaring towers of light beyond The Empire
State Building commemorated what had
not been forgotten.

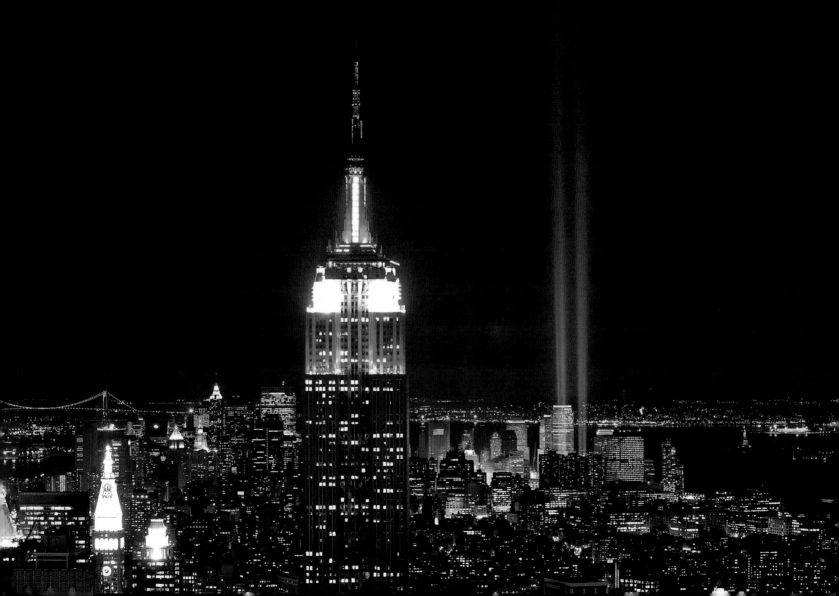

JULY 18, 1933

Vantage Point

These visitors breezed by the Prometheus statue that someone once called "a great brooch pinned to the bottom" and past lobby murals commissioned by John D. Rockefeller Jr. It was opening day at the RCA Building, the centerpiece of the city-within-a-city that is Rockefeller Center, and from seventy floors up, the city seemed so far away — except for that other building, the record-breaking Empire State Building that was thirty stories taller.

The New York Times Photo Archives

DECEMBER 12, 2002

Quintessential Symbol

The architecture critic Paul Goldberger summed it up: "The profile of the Empire State Building, with graceful setbacks set in perfect balance to sheer rise, has been a symbol of New York, and indeed of romantic skylines everywhere."

Vincent Laforet/*The New York Times*

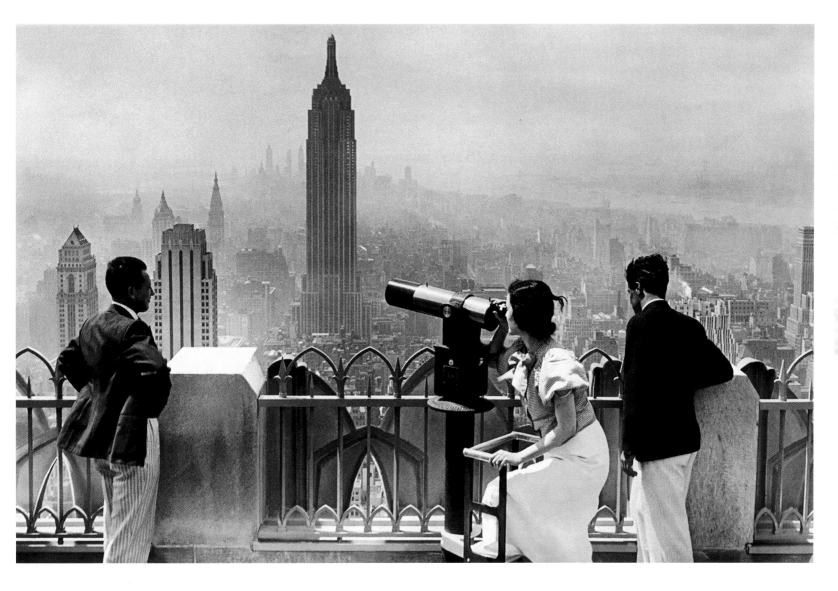

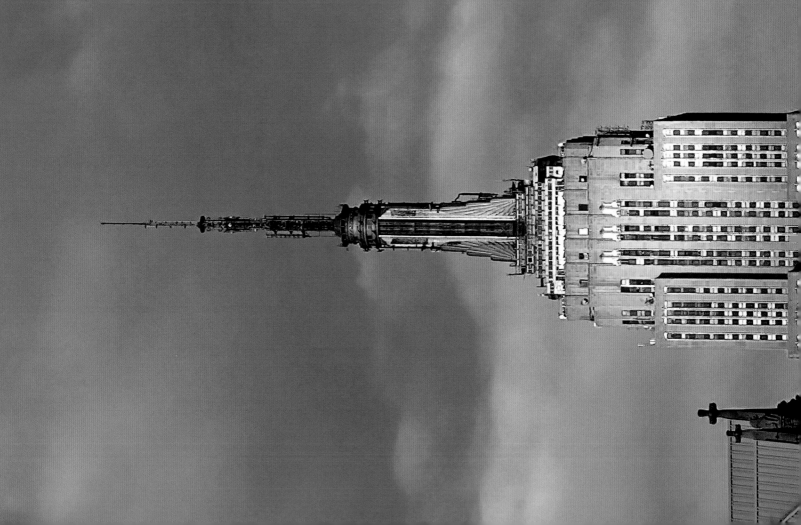

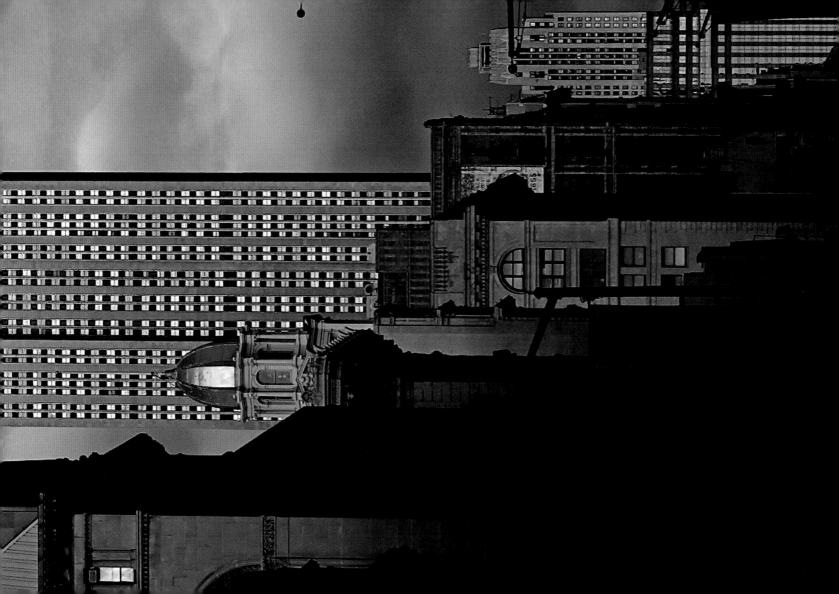

Red for Go

The new red light was supposed to make the Empire State Building legal again. The building had been on the wrong side of federal aviation law (and children who believe the blinking red beacon is Rudolph's nose at Christmastime) for months, ever since the old bulb burned out.

Vincent Laforet/*The New York Times*

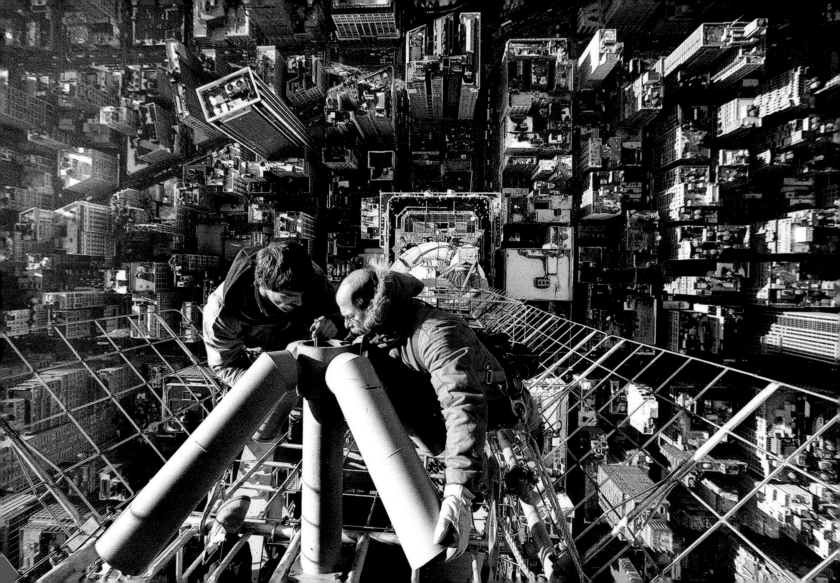

Construction Site

That mostly empty rectangle between Fifth and Sixth Avenues was cleared to make way for the Rockefeller Center complex. As the architecture critic Paul Goldberger noted, "It [became] as much a part of the office worker's New York as of the tourist's, as much a part of the shopper's New York as of the skater's."

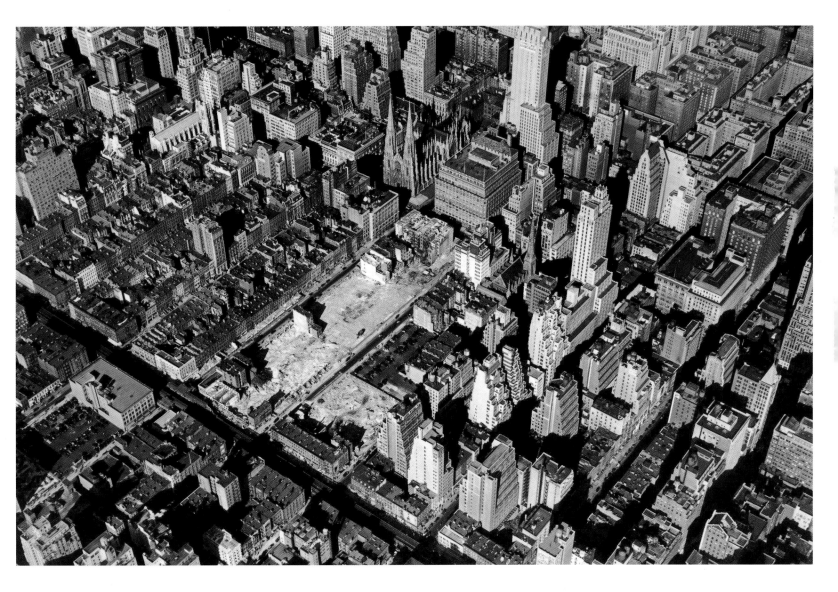

Rockefeller the Riveter

John D. Rockefeller drove the last rivet in the last column of what was planned as the last building at Rockefeller Center. As he himself pointed out, the fourteen-building, $100-million complex was not finished overnight: it was dreamed up in the boom years of the 1920s, but did not take shape until the Depression years of the 1930s.

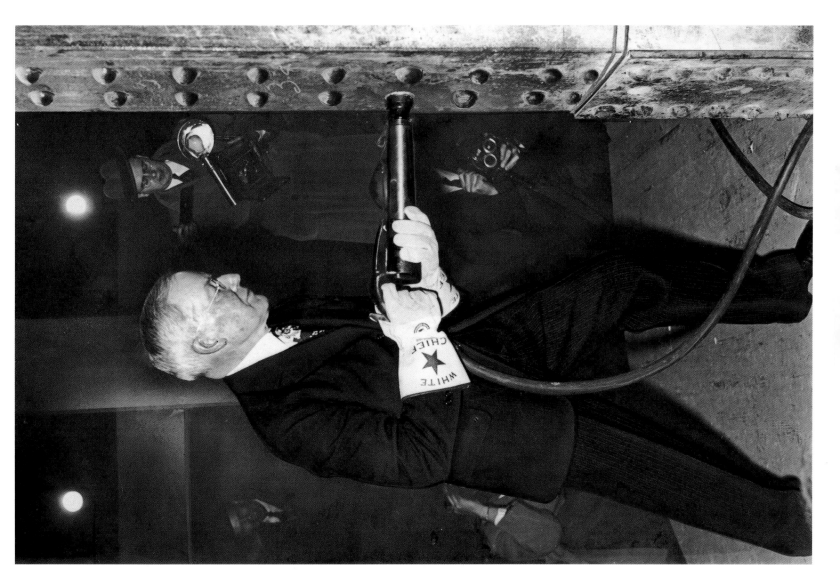

OCTOBER 19, 1924

Opposite

Zeppelin Over Manhattan

Skimming the tops of skyscrapers, airships like this German-made zeppelin looked luxurious and fast — for the Jazz Age. These days, when people measure travel by how many miles they can cover between breakfast and lunch, its sixty-five-knot speed seems lethargic.

The New York Times Photo Archives

OCTOBER 29, 2003

Overleaf

Cleared for Landing

In the final moments of its approach, a jet bound for LaGuardia Airport drops below the clouds and descends to the runway.

Vincent Laforet/*The New York Times*

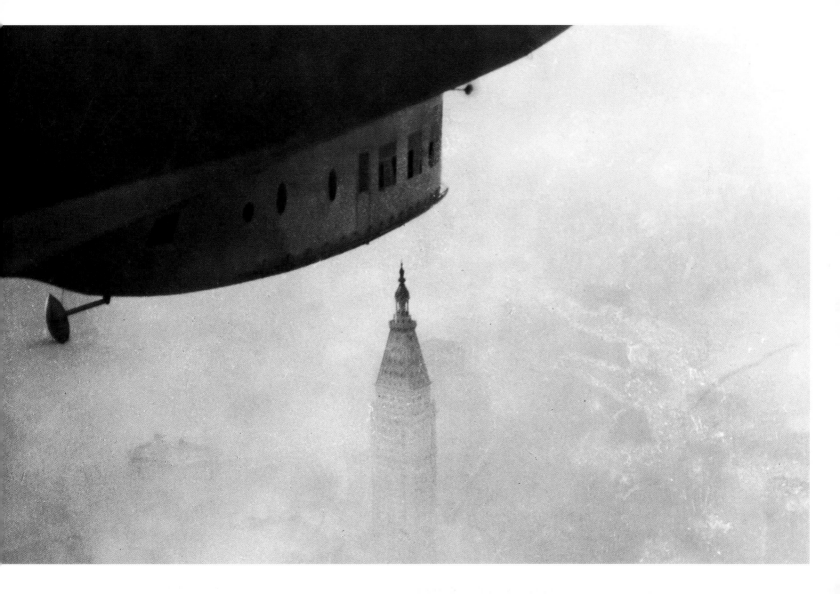

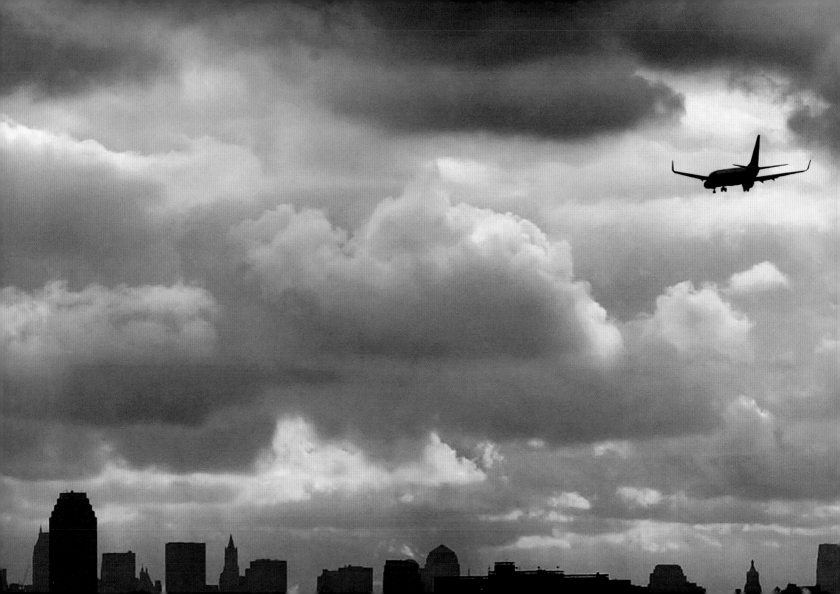

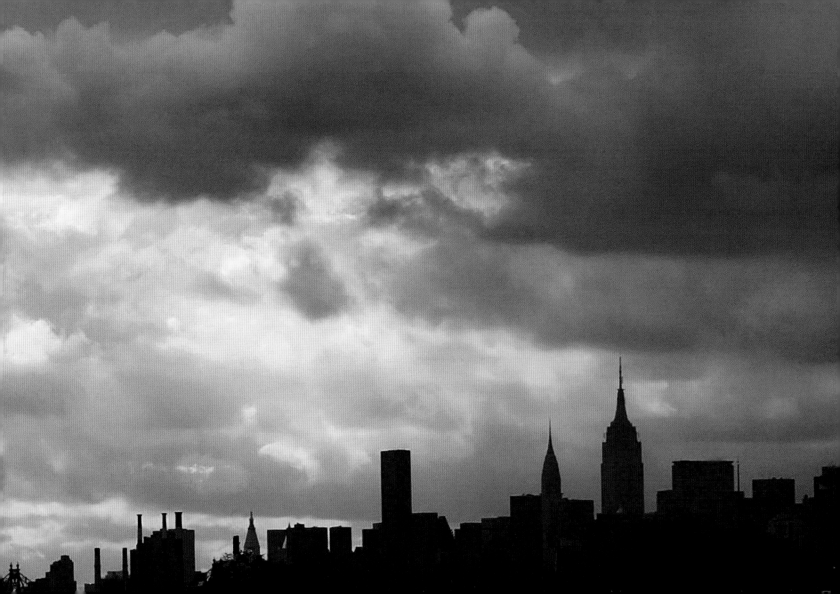

When Fourteen Hours Was Fast

"Down from the stratosphere to busy LaGuardia Field comes one of T.W.A.'s new Stratoliners," *The Times* announced after this test flight of the world's first airplane with a pressurized cabin. The thirty-three-passenger Stratoliner was fast for its day: it flew from Los Angeles to New York in only fourteen hours.

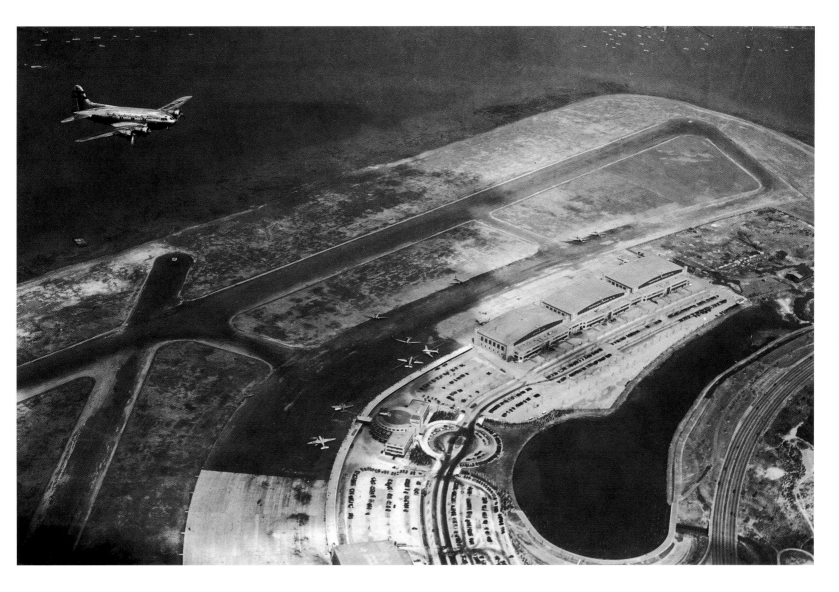

Opposite

NOVEMBER 2, 1931

A Blimp on the Horizon

The *Akron*, the Navy's newest and largest dirigible, made a grand entrance on its maiden voyage over New York. Less than two years later, the *Akron* crashed off the New Jersey coast, killing seventy-three crew-members in the worst disaster in dirigible history.

The New York Times Photo Archives

Overleaf

1906

The Outskirts of Midtown

Behind the original Grand Central, the tracks were out in the open, not underground, and the steam-belching trains chugged through a gritty landscape of factories, breweries, and shantytowns. When this Grand Central was replaced by the Beaux-Arts landmark that became known as the "gateway to the nation," the tracks were routed underground and the paved-over street was given a new name: Park Avenue.

The New York Times Photo Archives

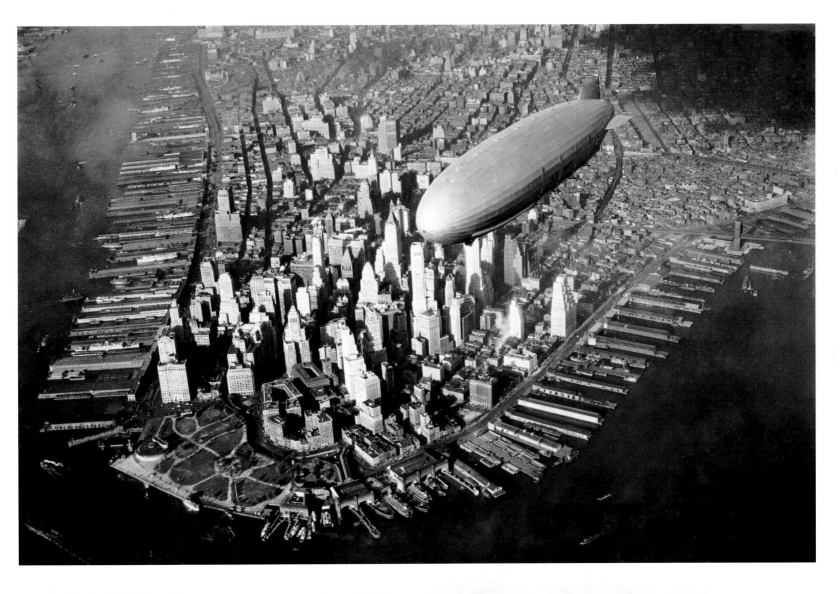

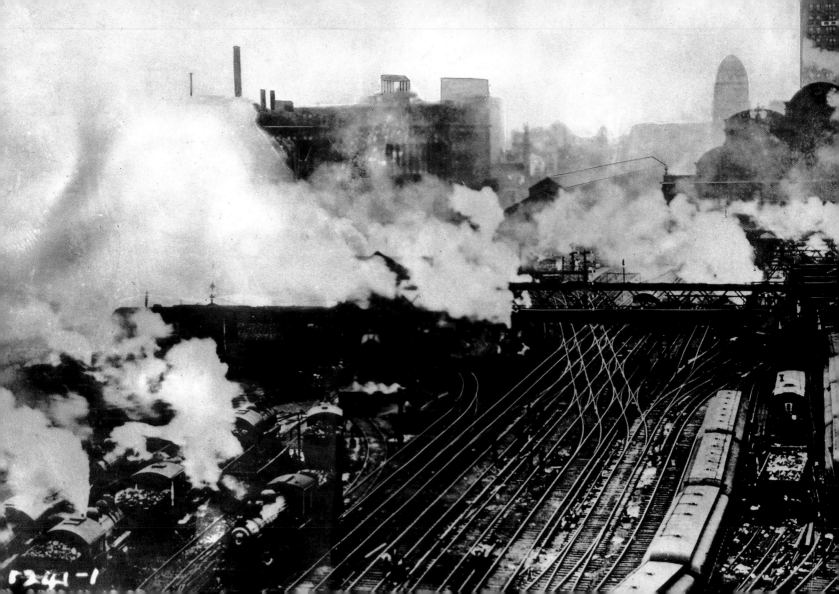

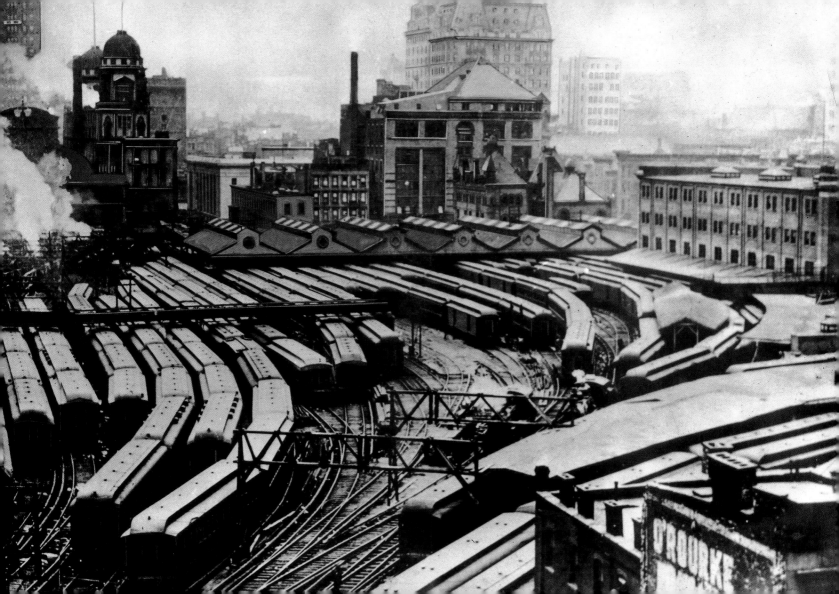

Commuters in the Spotlight

The sun streams in, lighting the main floor as brightly as a Broadway theater, and it is impossible not to think of the opening of a certain old-time radio show: "Grand Central Terminal! Crossroads of a million lives! Gigantic stage on which are played a thousand dramas daily!"

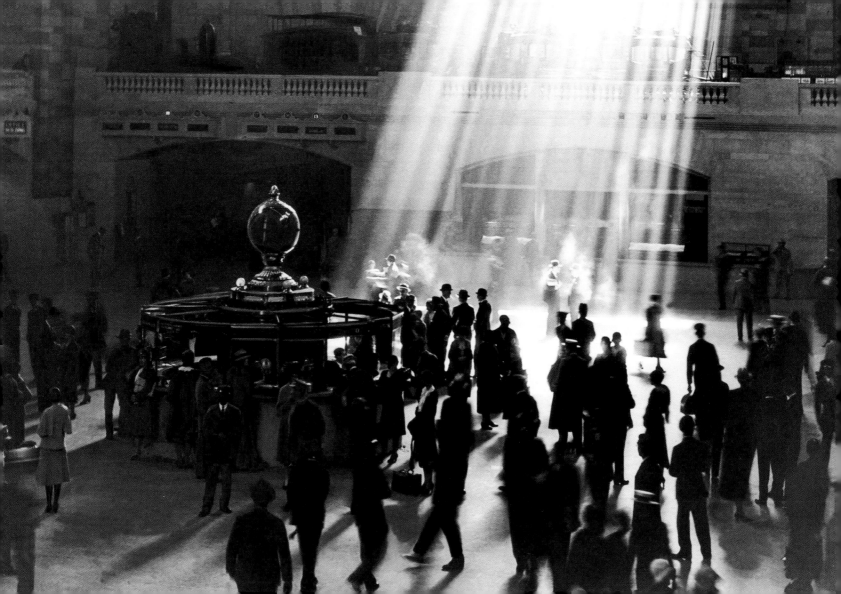

OCTOBER 19, 1951

Opposite

What To Do?

After arriving on the liner *Washington*, a traveler sits with her luggage at Pier 62 and ponders her next move. A wildcat strike of longshoremen paralyzed the city's docks and left passengers shifting for themselves.

The New York Times Photo Archives

JANUARY 30, 1975

Overleaf

To Save a Landmark

Jacqueline Kennedy Onassis helped to make saving Grand Central Terminal a cause for celebrities in the 1970s, when the railroad conglomerate that owned it announced plans to demolish sections of the station to make way for a fifty-five-story skyscraper. Here, Onassis chats with Bess Myerson, the city's former consumer affairs commissioner.

Jack Manning/*The New York Times*

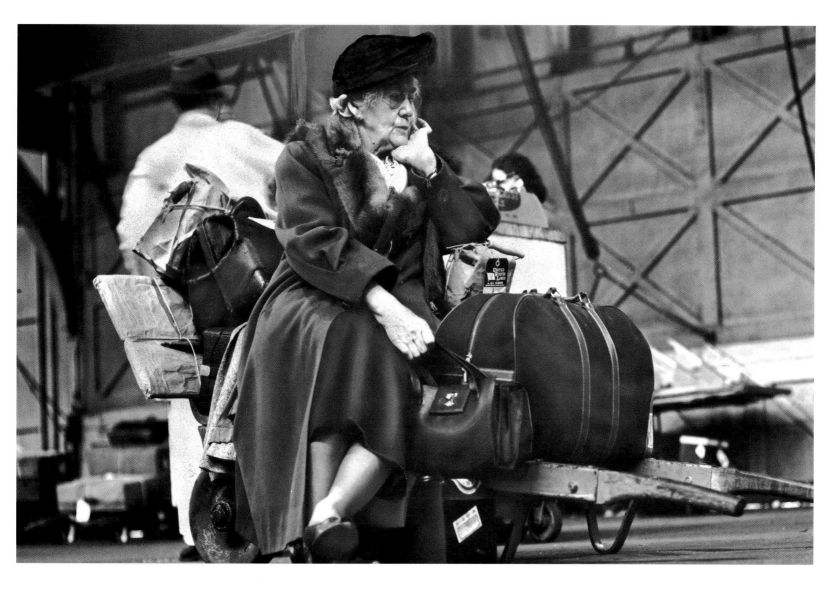

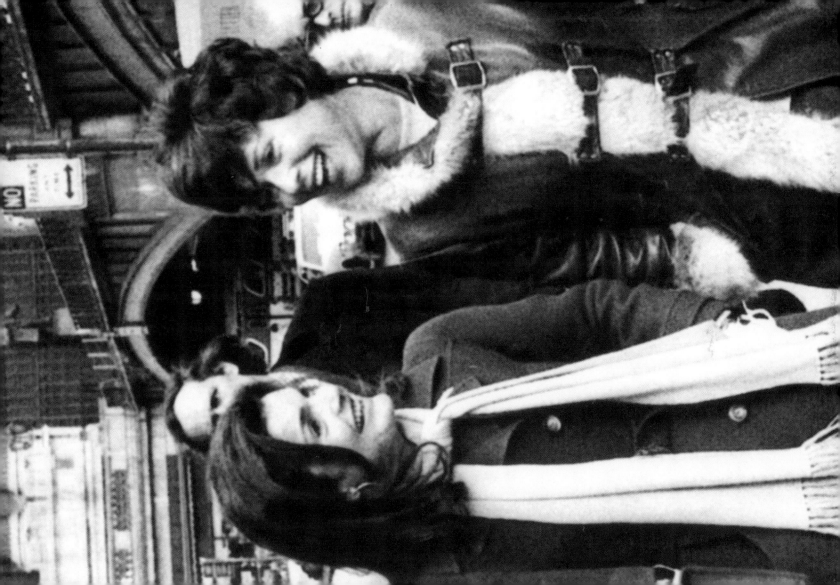

JANUARY 12, 1967

Opposite

Installing the Big Board

The new arrivals-and-departures board at Grand Central Terminal was automatic. The times and track numbers above the ticket windows would no longer be written in hand on blackboards; the numbers and letters would clickety-clack into place by remote control. If only the new board could make the trains run on time.

Meyer Liebowitz/*The New York Times*

DECEMBER 24, 1942

Overleaf

The Way It Was

The original Pennsylvania Station was "built with the grandeur of Rome" and served as "a majestic threshold into the headquarters city," Nathan Silver wrote in *Lost New York*. *The Times* called its intended demolition in 1963 — which helped galvanize the historic preservation movement — "a monumental act of vandalism."

The New York Times Photo Archives

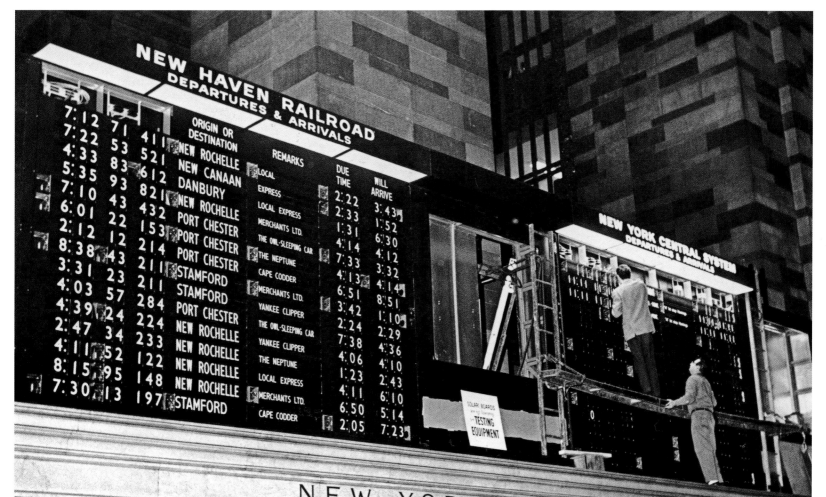

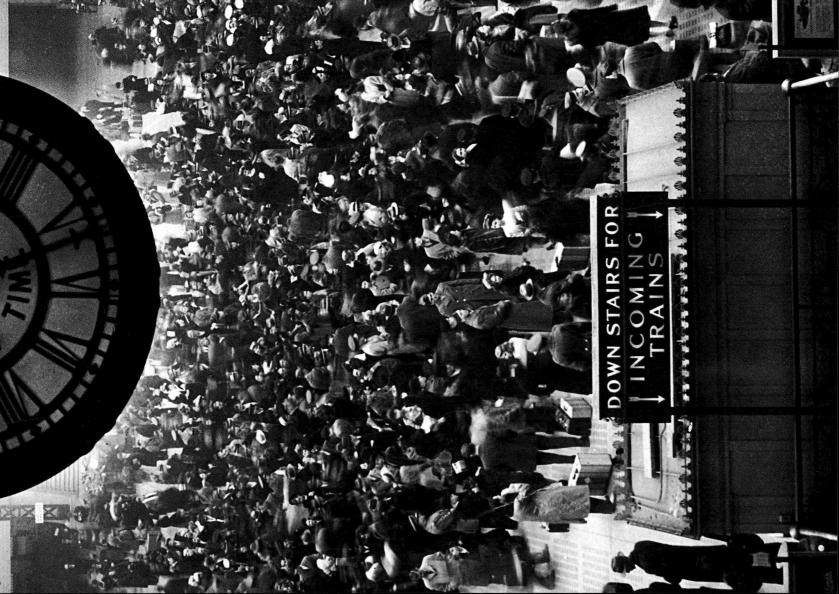

Chugging Along the Bowery

"The Bowery was the boulevard of the Lower East Side, the city's Cosmopolis," *The Times* declared. The street ran through "an area of gaunt tenements," harboring the kind of social misery that inspired reformers like Jacob Riis. Commuters traveled to and from their workplaces in Lower Manhattan on the steam-powered Third Avenue Elevated line, safely above the human sea.

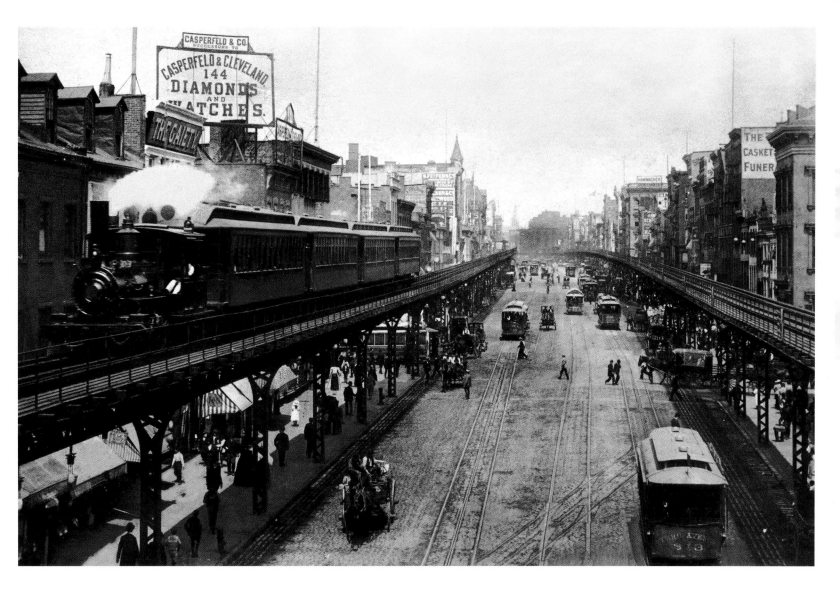

1917

Side by Side on Broadway

In the days before the last of New York's horse-drawn trolleys disappeared from the streets, a photographer snapped one alongside the newfangled thing that had made it obsolete, a "modern electric car."

Brown Brothers

Overleaf

1914

The More the Better

It had been the biggest horse-drawn bus in the world. Then steam- and gasoline-powered engines came along, and George Schlitz — a Brooklyn stable owner who ran a funeral parlor next door to his "garage" — replaced the ten-horse team with a three-wheel tractor. Some things didn't change: the bus still had room for 120 wiggling, squirming passengers, which is why a photographic retoucher apparently painted faces on the bodies on the top deck that were blurred in the original image.

The New York Times Photo Archives

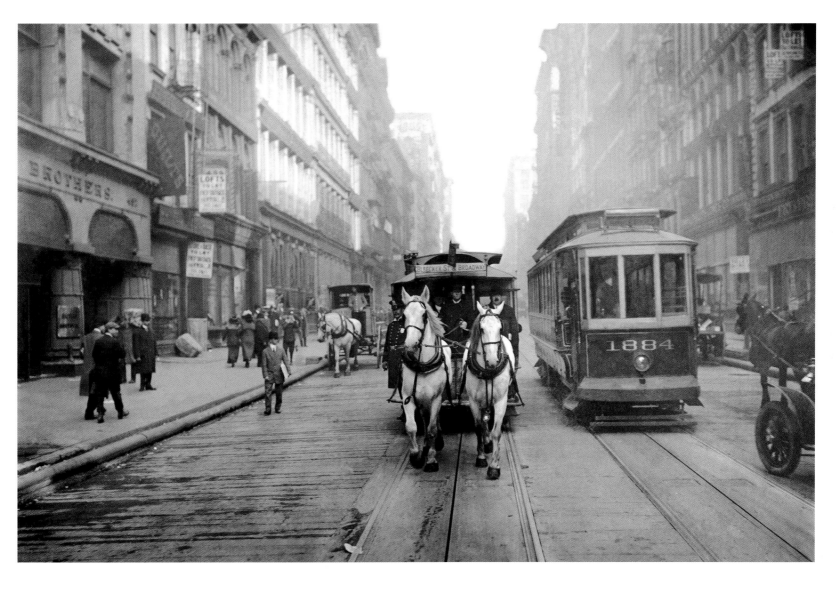

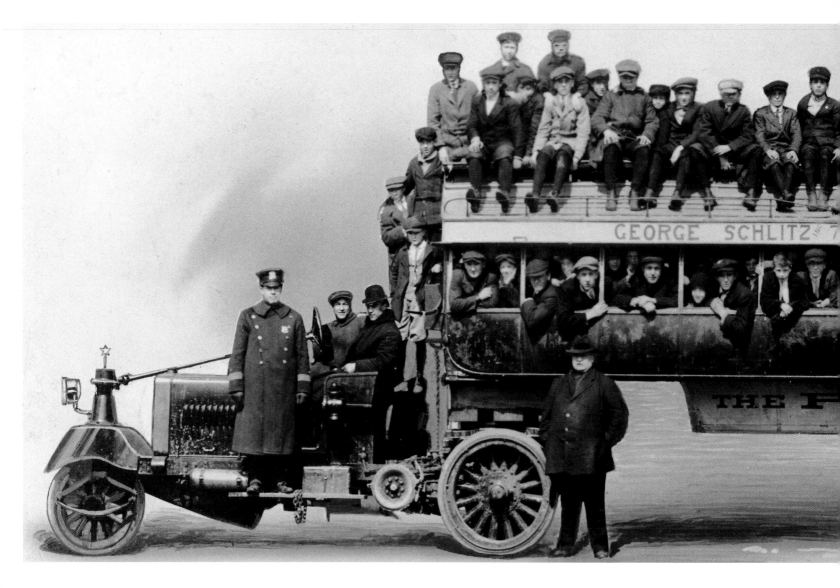

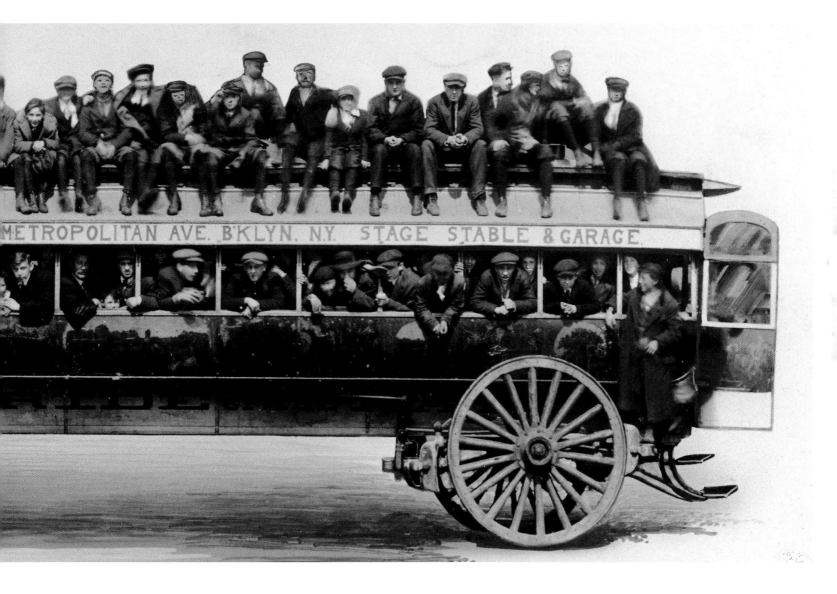

Diagnosis: Breakdown
All that chrome, all that horsepower, and he's going nowhere. A flat tire? An empty tank? Here comes help. This tow truck driver's view of a motorist and his stranded Cadillac is from the days when the city provided free towing patrols on the West Side Highway.

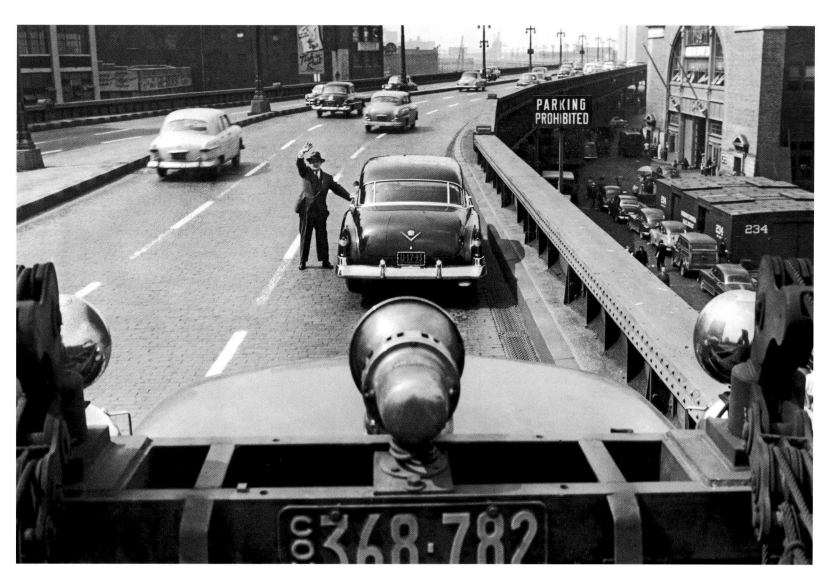

A Man in a Garden

New York is the world's most layered
city and, like a toy-store ant farm, the
layers can be seen only at the exposed
edges. Most of the time, subways rumble
unseen beneath water mains that gurgle
beside steam pipes that hiss beneath
cable-television lines that deliver a
thousand channels to apartment houses
that are themselves layered. After all, an
apartment house is usually the same floor
plan stacked up ten times, or twenty, or
forty. One layer has nothing to do with
the next. A man in a garden on Sutton
Place has no reason to think about drivers
pushing the speed limit on the Franklin D.
Roosevelt Drive beneath his shoes.

Vincent Laforet/*The New York Times*

Subway Centennial

One of the showpieces of New York's subway system was the small but elegant City Hall station. Leaded glass panels lined the ceiling, and brass chandeliers hung above the tracks. It was from this platform that the first official subway train headed uptown at 7:00 p.m. on October 27, 1904. Since 1945, it has been off-limits to passengers, except in the movies. It was too small for new, longer trains, but film crews rented it when their scripts called for a subway scene.

Ruby Washington/*The New York Times*

638

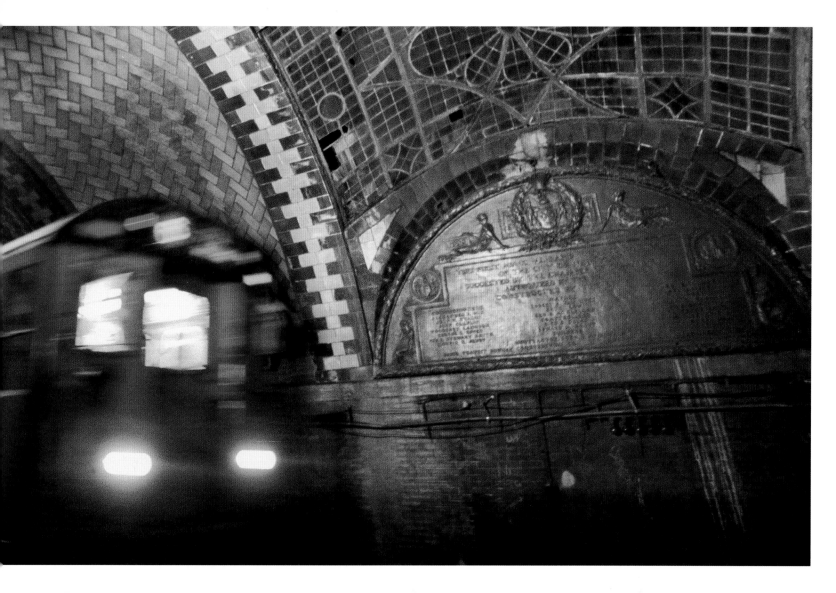

Opposite

A Fare Increase

Since day one, the subway fare had always been five cents. Then the city doubled it, and rush-hour riders had to dig for dimes to put in the turnstiles.

Arthur Brower/*The New York Times*

Overleaf

Last Trolley and First Tramway

Until a few days after the photograph on the left was taken, trolleys rattled across the Queensboro Bridge alongside cars, stopping at Welfare Island. As a way of getting around, *The Times* said, the trolley was, "on its own account, a way of having a good time." Welfare Island was renamed Roosevelt Island in 1972, and in 1976 trams between Manhattan and the island went into service.

LEFT Neal Boenzi/*The New York Times*

RIGHT Ruth Fremson/*The New York Times*

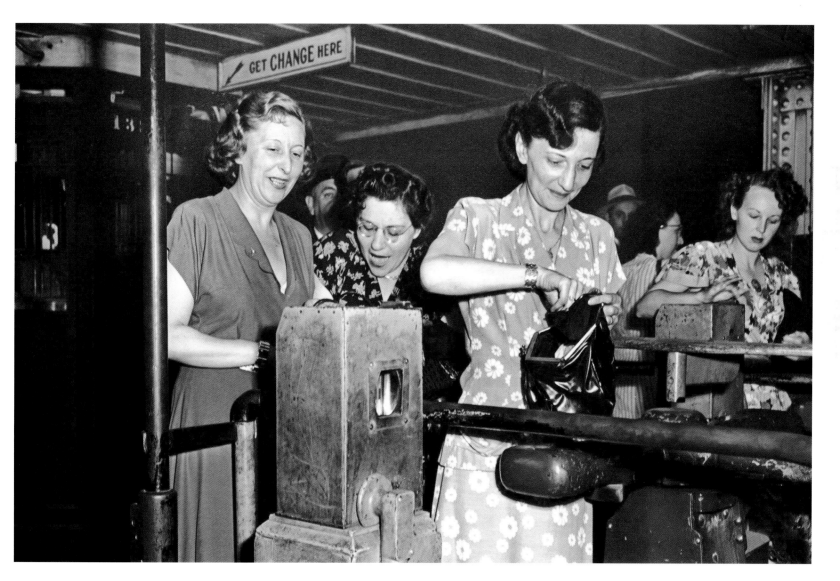

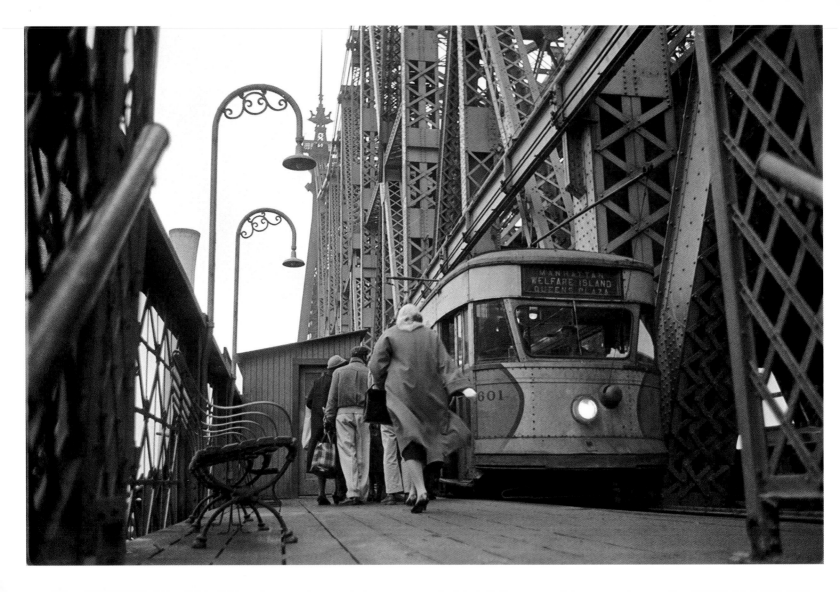

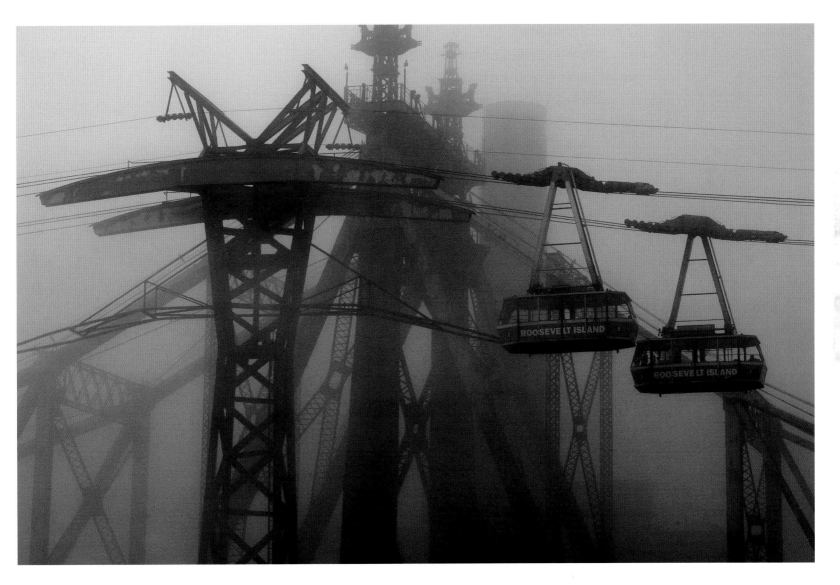

Subway Serenade

It almost sounds like a stand-up comedian's opening line: five transit workers walk into a subway car. . . . This unlikely quintet of carolers — a motorman, a conductor, a transit officer, a trackwalker and a typist — serenaded passengers on a train in Grand Central Terminal.

Ernie Sisto/*The New York Times*

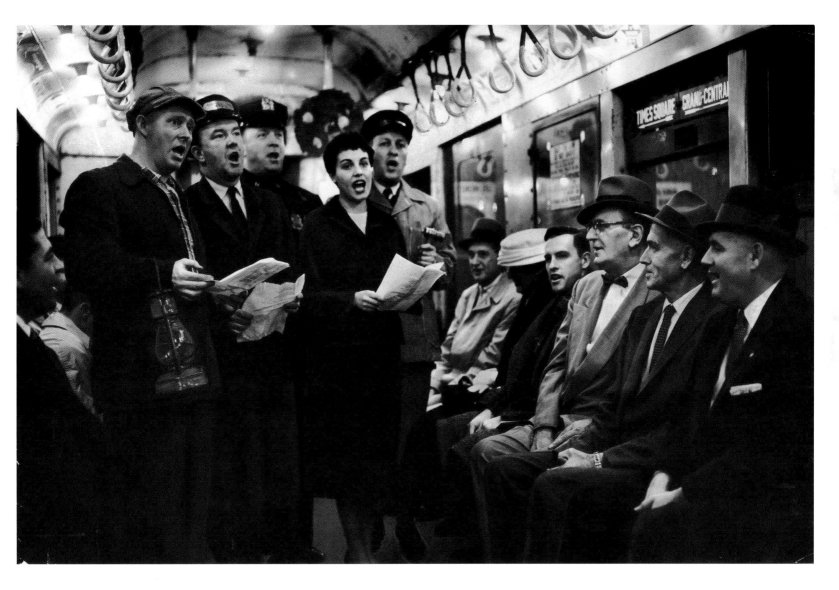

OCTOBER 18, 1982

Opposite

Still Life With Cigarette Butts

A quarter of a century later, this urban still life stands out as a period piece from the days when subway cars were covered in graffiti and passengers could smoke.

Neal Boenzi/*The New York Times*

Overleaf

1960

1948

Please Stand Clear of the Closing Doors

During rush hours, subway passengers are little more than marionettes, tugged and pulled by forces they do not control. They shrug off the horrors and headaches as just another element of the everyday journey.

LEFT Sam Falk/*The New York Times*

RIGHT Neal Boenzi/*The New York Times*

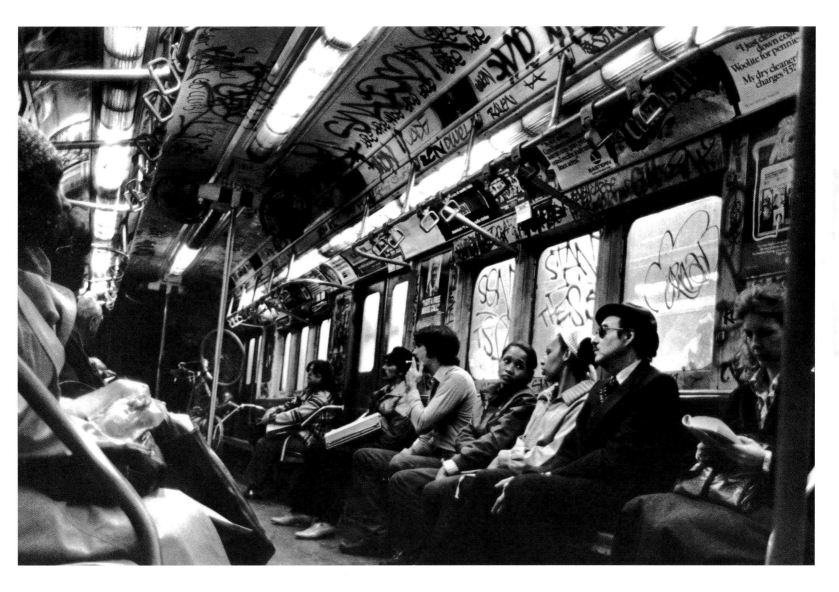

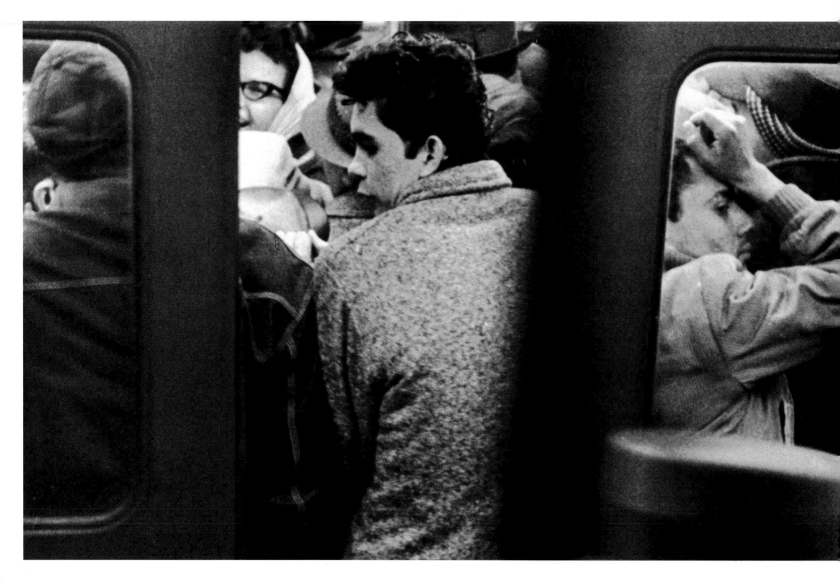

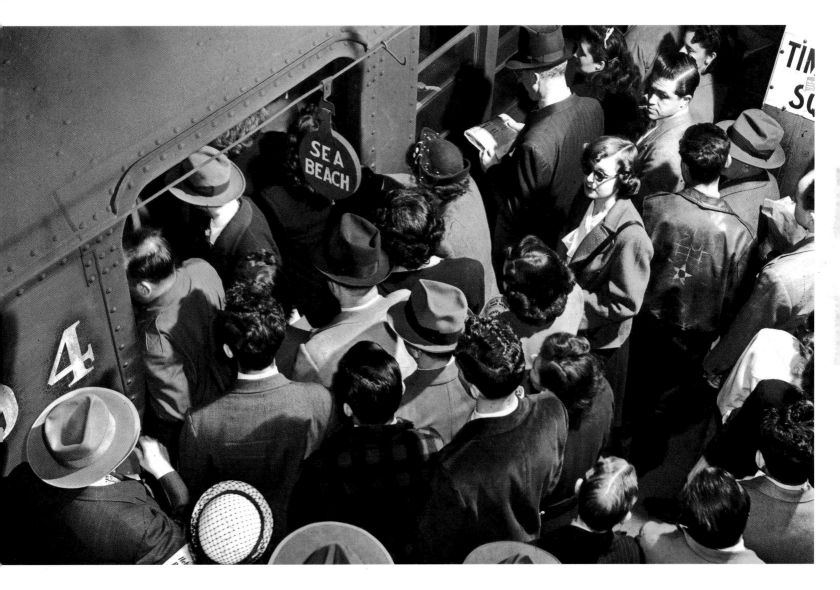

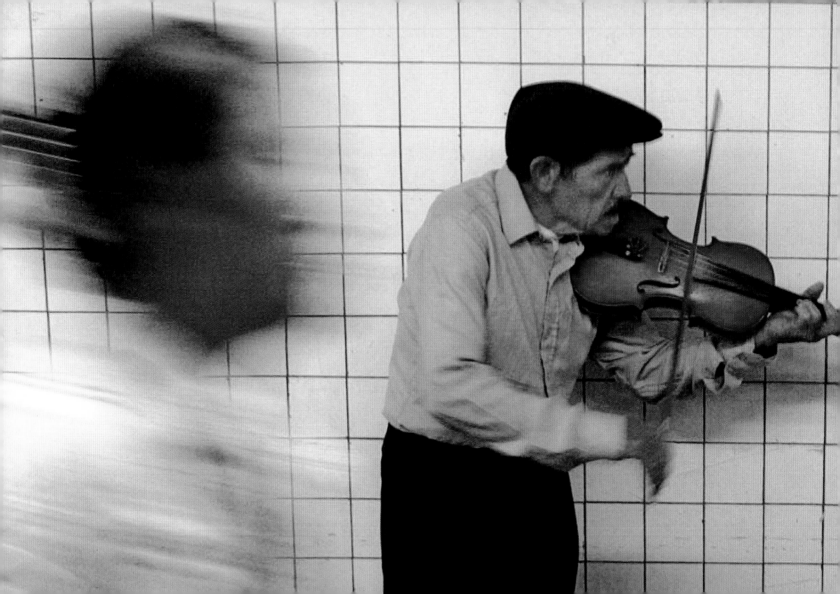

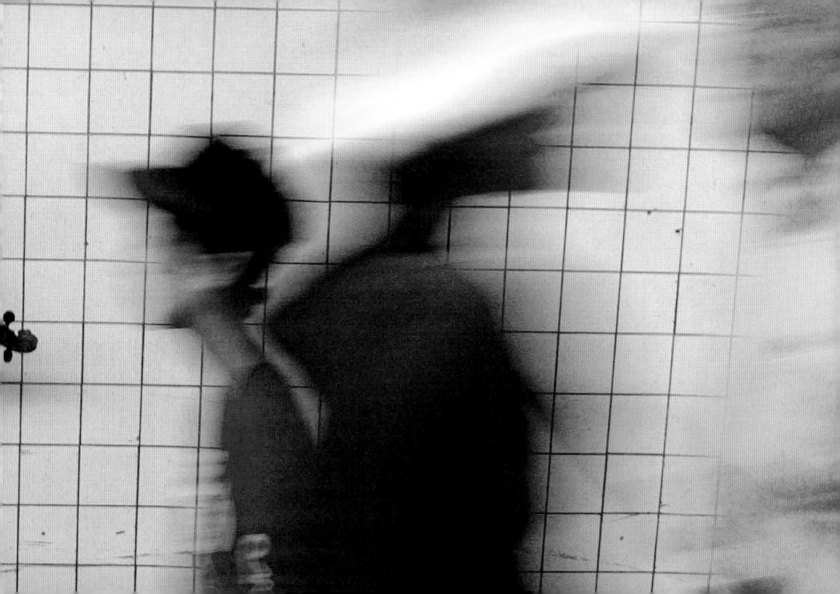

Previous

JUNE 19, 2002

Heifetz of the Subways

He competes with the roar and screech of trains, the static of the public-address system, even the bing-bong of the chimes that signal the train doors are closing — and the audience is fickle if it pays attention at all. "I play every morning, every night, every day," said Juan Quiroz, subway station violinist. "I play because I don't have any other work."

Tyler Hicks/*The New York Times*

Opposite

JULY 7, 1971

Another Time in Another Times Square

A generation would pass before Times Square was cleansed of its *Midnight Cowboy* iniquity and become a family friendly zone of shopping and entertainment in the shadow of tall, new office buildings.

Larry C. Morris/*The New York Times*

They Call This "Multimedia"

"'Total environment' discothèques," *The Times* declared in the article that appeared with this photograph in 1967, "have left the old drink-and-girlie nightclub formulas far behind, turning on their patrons with high-decibel rock 'n' roll combined with pulsing lights, flashing slide images, and electronically tinted 'color mists.'" This discothèque is the legendary Cheetah, at Fifty-third Street and Broadway.

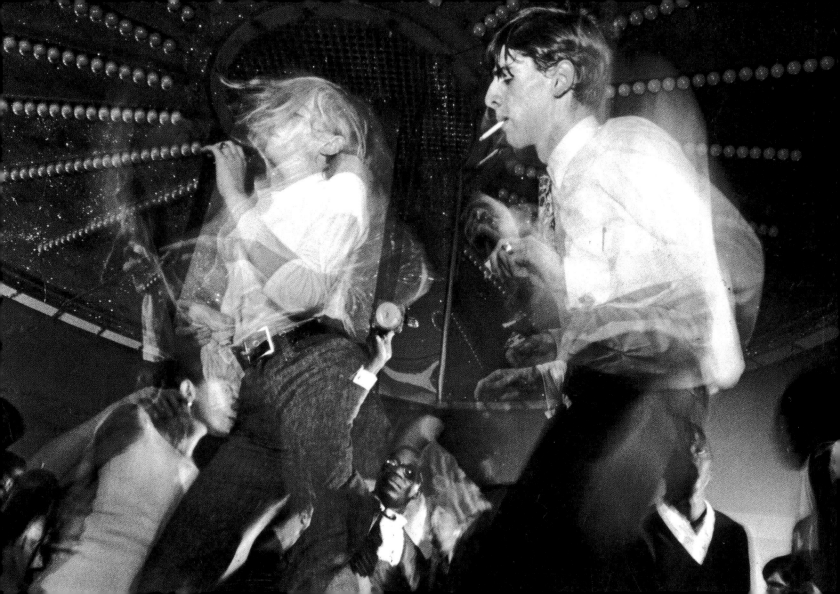

Where Feet Flew

At the Savoy Ballroom in Harlem, crowds perfected the Lindy Hop, the mambo, and other stylish steps while Duke Ellington or Count Basie played on. The heels-over-the-head maneuvers prompted someone — old-timers credit Lana Turner, of all people — to call the Savoy "the home of happy feet." It closed in 1958.

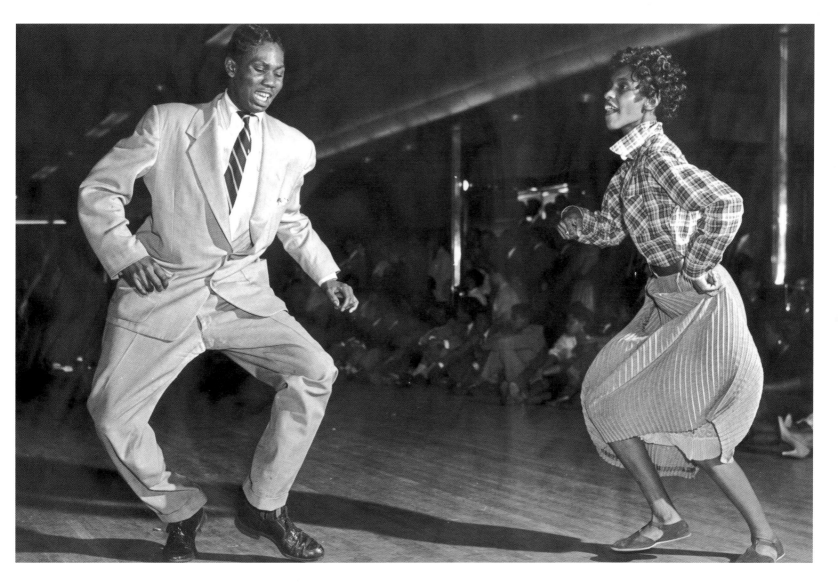

Inside a "Gentlemen's Club"

The high-tech lighting was focused on women who sparkled in their skimpy costumes, but as Mireya Navarro wrote in *The Times*, "Do not call them strippers. In this type of multimillion-dollar 'gentleman's club,' they are 'entertainers.'"

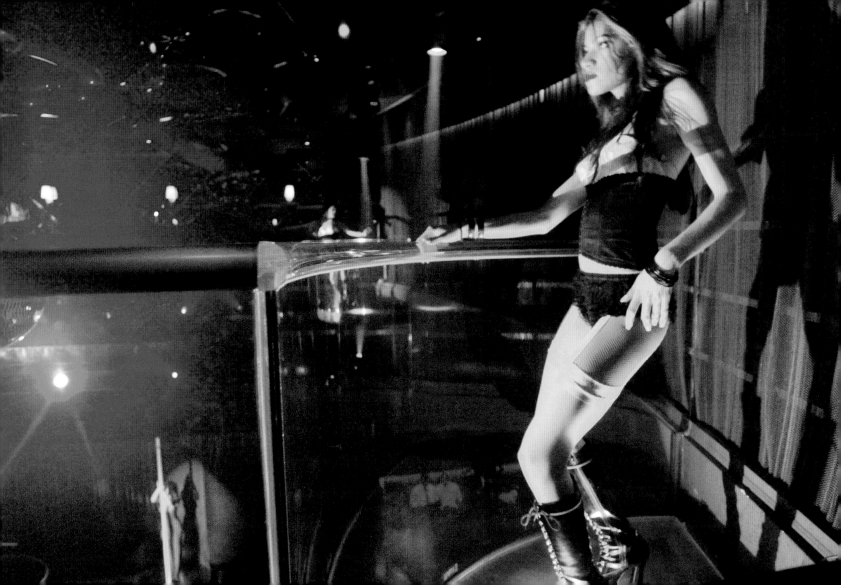

At the Copa

Barry Manilow's song about Lola the showgirl — and Tony and Rico and the fistfight and the gunshot — was a hit in the late 1970s. A generation later, the crowds still danced the night away and the venerable Copacabana still laid claim to being the place where "music and passion were always in fashion."

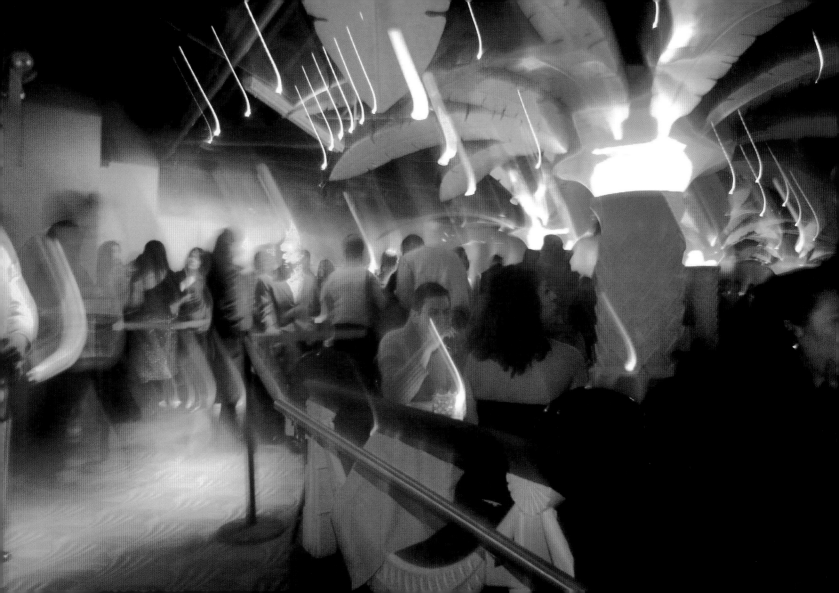

JULY 13, 1967

Opposite

In the Dom

When Diana Ross and the Supremes were on the jukebox, or maybe Martha Reeves and the Vandellas, there was barely room to move on the tiny dance floor in the Dom in the East Village, downstairs from the cavernous Electric Circus discothèque. The experimental Dom was created in 1966 by Andy Warhol and Paul Morrissey, but just a year later, it had become a conventional dance club.

Larry C. Morris/*The New York Times*

JANUARY 25, 1965

Overleaf

Looking for Mr. Right

Three years after Helen Gurley Brown published *Sex and the Single Girl, The Times* reported on "a new type of bar" — the singles bar, where "girls" did not go for mere drinks and conversation but to find a date.

Sam Falk/*The New York Times*

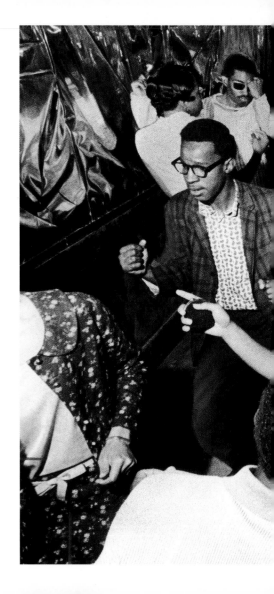

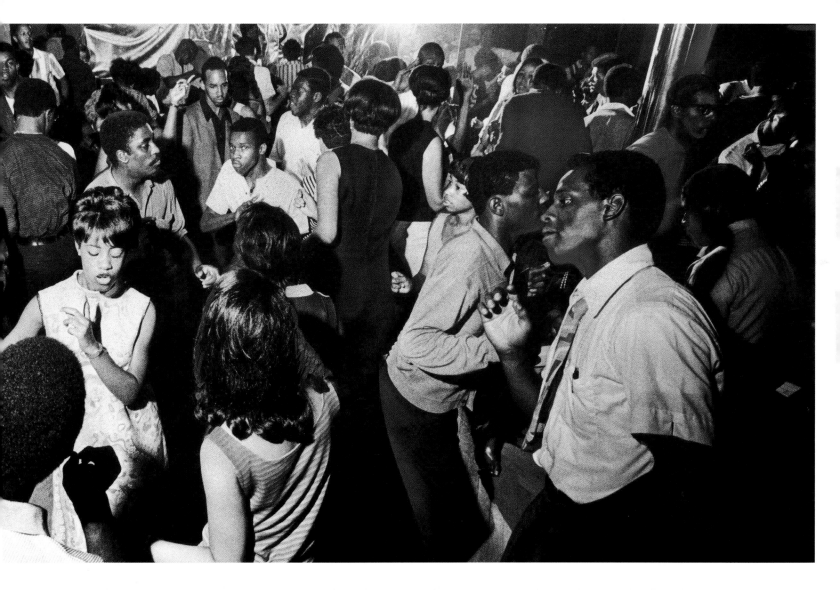

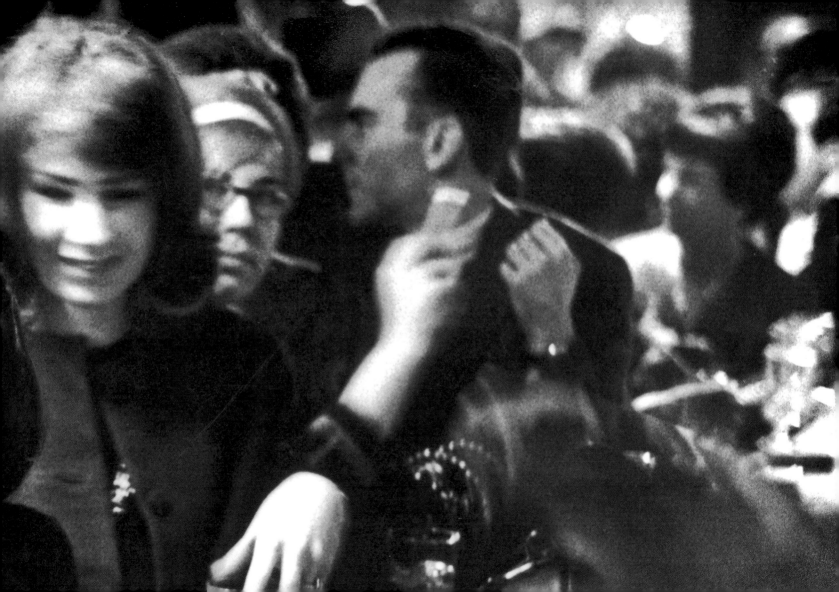

MAY 21, 1934

Legal Again

Prohibition ended in 1933, but for a few months after the ratification of the Twenty-first Amendment, restaurants could serve only customers seated at tables. Finally, in mid-1934, new liquor control regulations took effect that allowed "perpendicular drinking" — restaurants could once again serve people standing at the bar.

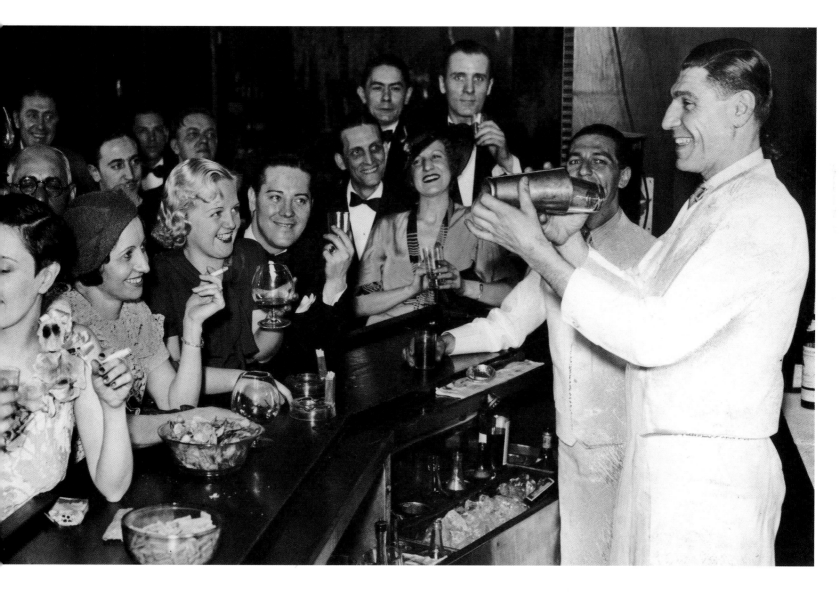

Hot Diggity!

Coney Island, *The Times* observed in
2005, combined "the bracing Atlantic surf
and the gaudy anarchy of the Cyclone,
the Wonder Wheel and Nathan's Famous."
Nathan Handwerker, holding a child in
this photo, started selling frankfurters at
Coney Island in 1916.

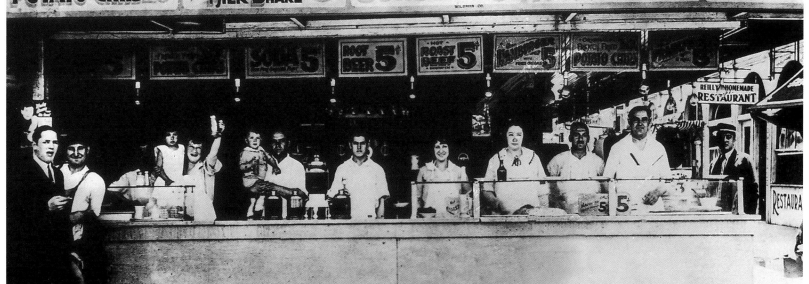

Summer Shower

Right there, in black and white, the morning paper had predicted afternoon and evening thundershowers. But who pays attention to the weather forecast? Not these pedestrians, running through Times Square after a third of an inch of rain fell in five minutes.

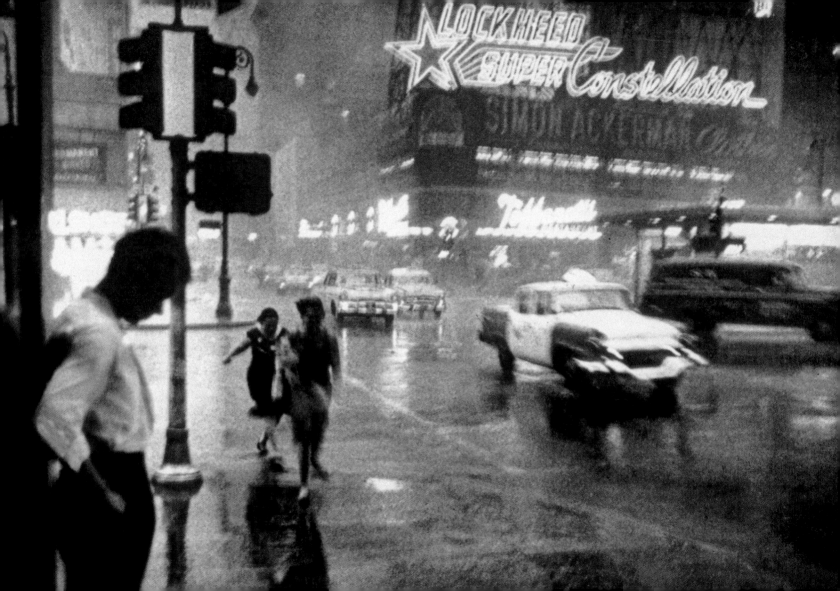

Up to the Axles

In March 1931, the weather was big news: "Midwest Digs Out of Big Snowdrifts," one headline read. "Europe Is Gripped by Snow and Gales," declared another. In New York, which had coped with a water shortage for months, a gale unleashed almost two inches of rain that flooded low-lying areas. Cars like this one floated along South Street, where sewers overflowed and untreated water flooded basements in the Fulton Fish Market.

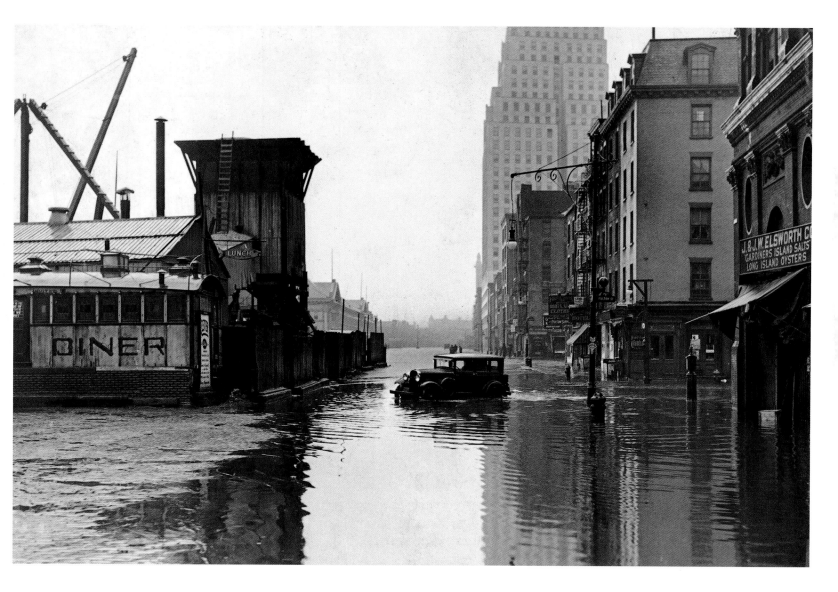

Waiting for Business

On a rainy day, a rumpled man stretched out on the sidewalk beside the Municipal Building, near City Hall in Lower Manhattan. He described himself as an umbrella repairman and said he was waiting for business.

Eddie Hausner/*The New York Times*

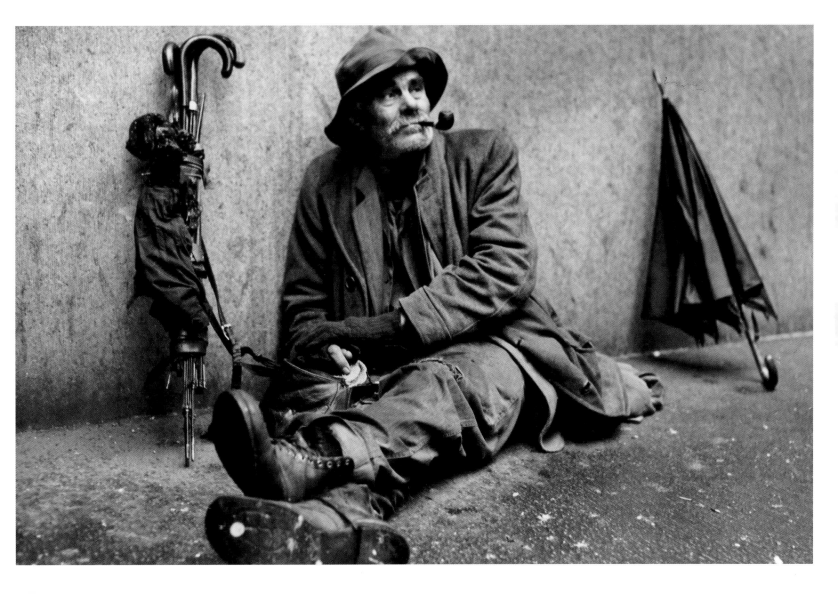

1914

Winter's Fury

And it was a furious winter. A terrific storm in mid-February caused the New York Central's Twentieth Century Limited to arrive in Grand Central two and a half hours late. Two weeks later came "one of the worst snowstorms in [the city's] history." This time, it was the Pennsylvania Railroad's turn: "The Congressional Limited Not Heard From and Hours Overdue" reported the headline in *The Times*. Eventually, the train turned up.

International News Service

Overleaf

DECEMBER 12, 1960

Park View

They had the observation deck of the RCA Building — and that 843-acre rectangle known as Central Park — to themselves after a snowstorm redecorated the cityscape's listless midwinter browns.

William C. Eckenberg/*The New York Times*

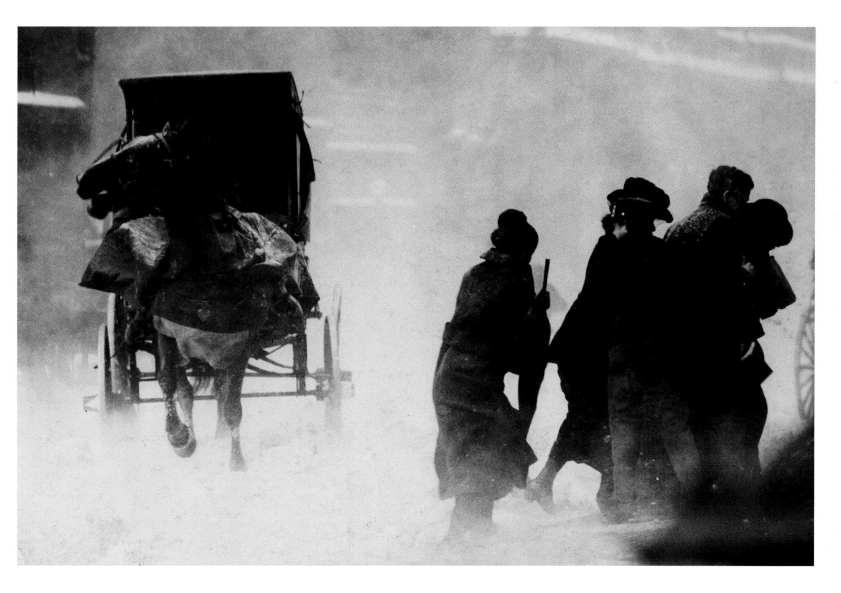

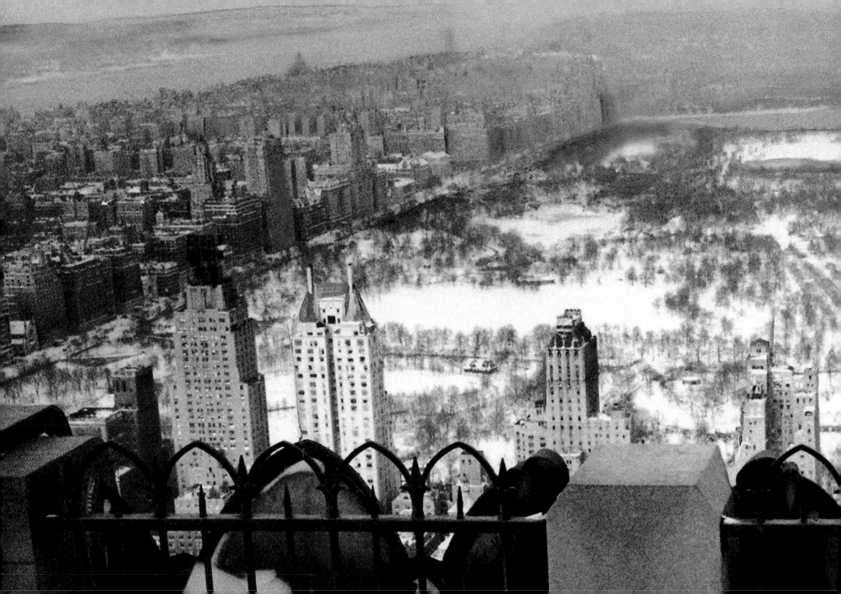

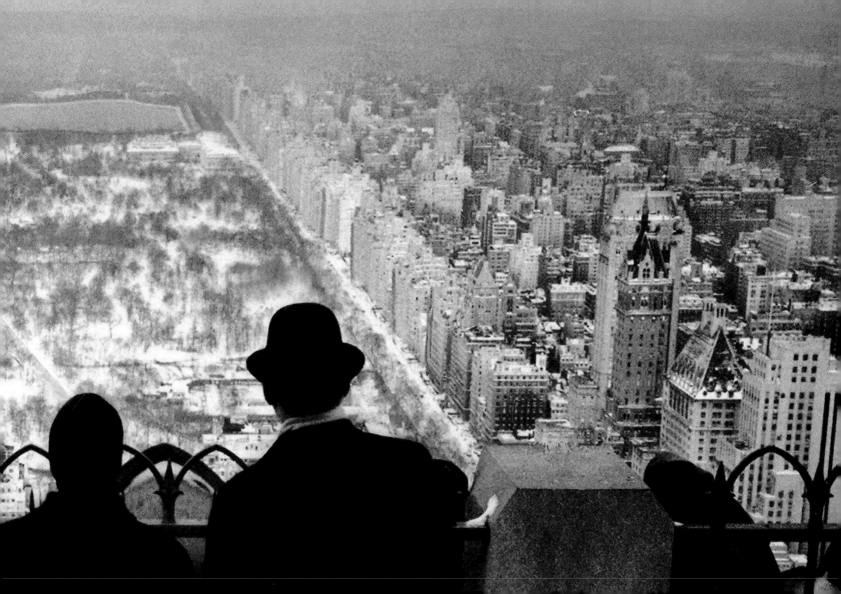

Central Park

This was the view from the 1920s until the late 1960s: the Gapstow Bridge over the Pond in Central Park, the Plaza Hotel on the right, the Savoy Plaza Hotel across Fifth Avenue. The skyline would change in 1968, when the slablike General Motors Building replaced the Savoy Plaza, and again in 1974, when another skyscraper, one with a swooping, dark-glass face, rose behind the Plaza.

John Orris/*The New York Times*

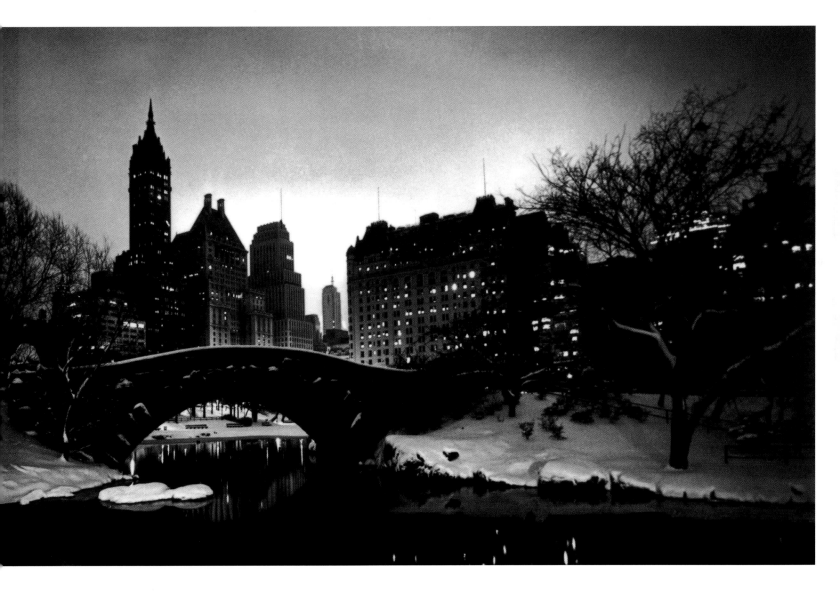

Through the Snowdrifts

Sometimes you cannot wait for the snowplow to clear the way, and the trolleys will not take you where you have to go.

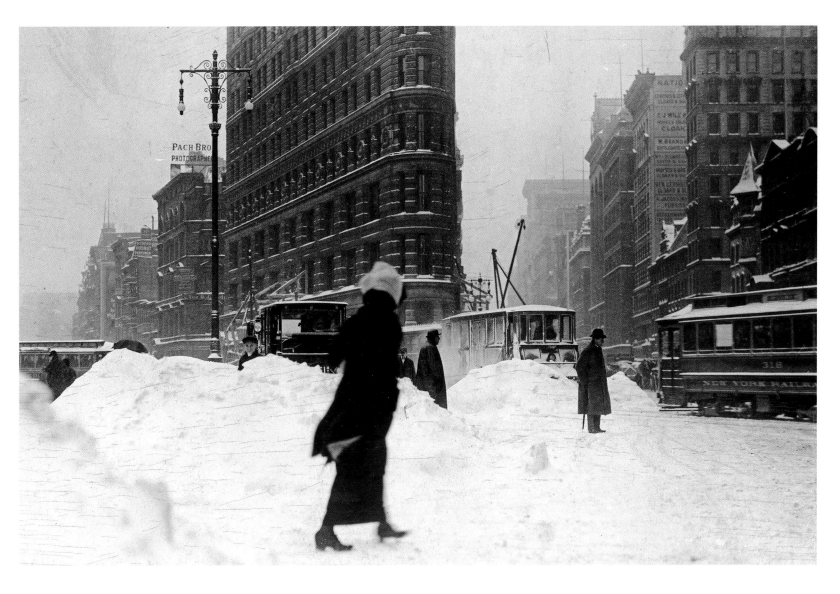

On Duty

The calendar said it was practically spring. But that shovel-width trench in the snow said it was still winter after a storm dropped almost eight inches of snow on the city.

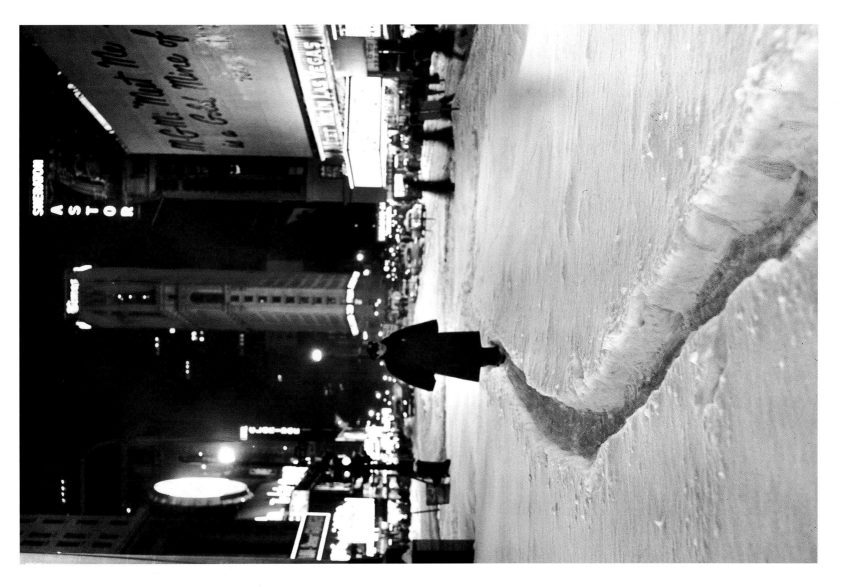

Snow Foils Commuters

They slipped and they slid, these Packards and Studebakers and other automotive ancestors caught in a snowstorm on the West Side Highway, as their owners attempted to get home at the end of a long day. And not one of them had four-wheel drive or traction control.

Meyer Liebowitz/*The New York Times*

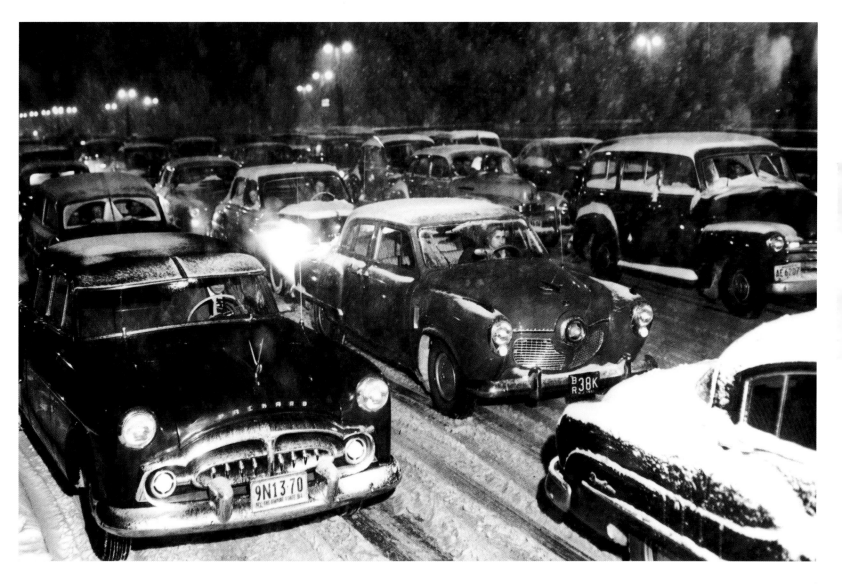

O. Henry's New York

Between 1902 and 1910, when he lived in New York, there was little about its rhythms and routines that O. Henry did not observe. He knew the "early morning people" on their way to work, for example — the "sullen people" with "glum faces, hurrying, hurrying, hurrying." The woman holding a muff in this wintry photo is hurrying south on Broadway toward Thirty-fourth Street.

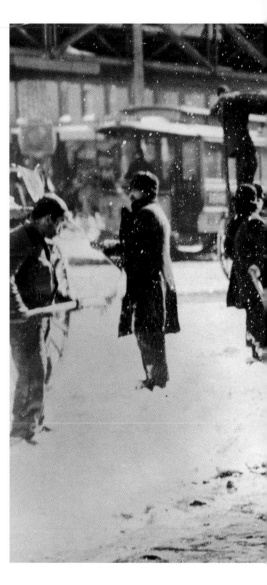

Museum of the City of New York

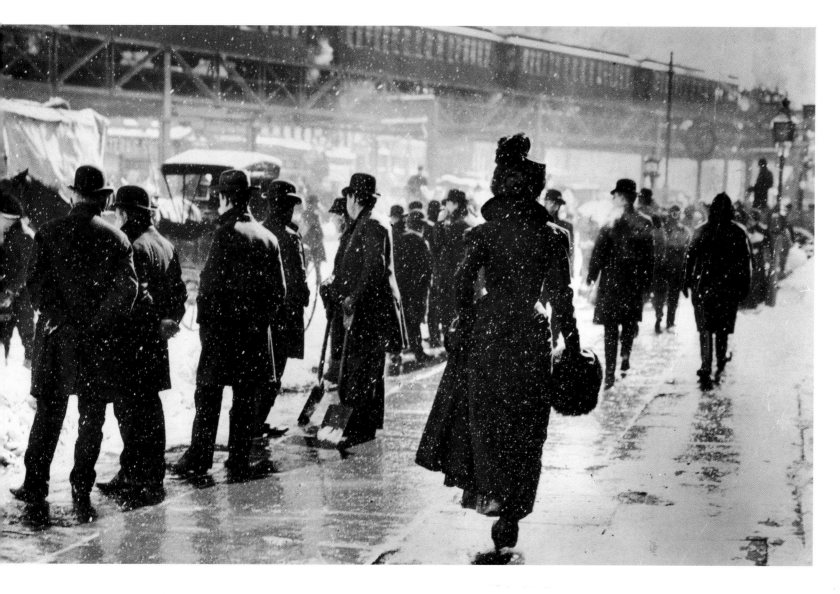

By the Sea

The shorefront carnival that was Rockaway's Playland in Queens was "a jumble of fantasy, food and thrills dominated by a landmark roller coaster." Or so *The Times* said in describing how visitors screamed during the stomach-churning plunge that followed the six-story climb to the top. They also rammed into one another in the bumper cars, shrieked in the haunted house, and gobbled hot dogs on the midway. "Every day it was a big circus," said Walter Roberts, whose family rented a bungalow across from Playland when he was a boy. But it closed in 1986, and was demolished to make room for condominiums.

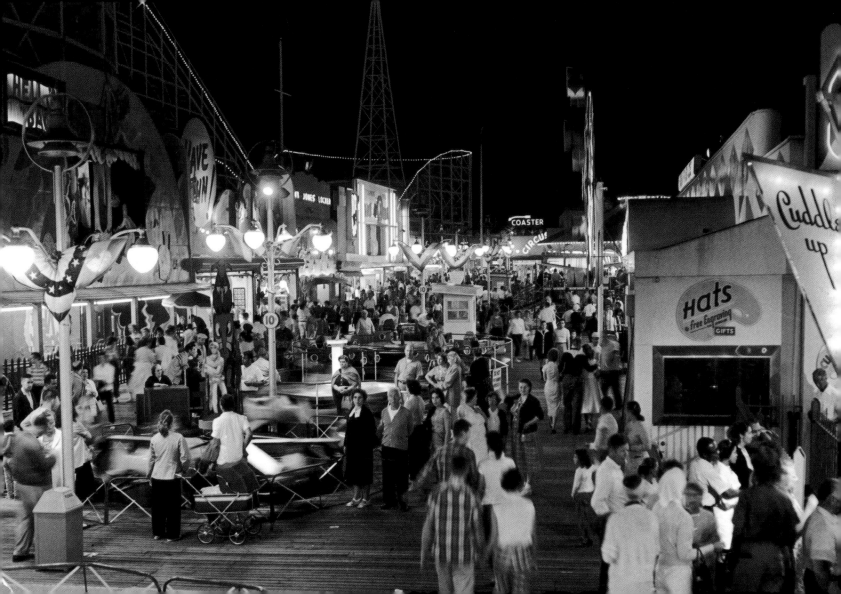

Not Quite Six Feet Under

At Coney Island on the Fourth of July,
some buried bodies live to tell about it.

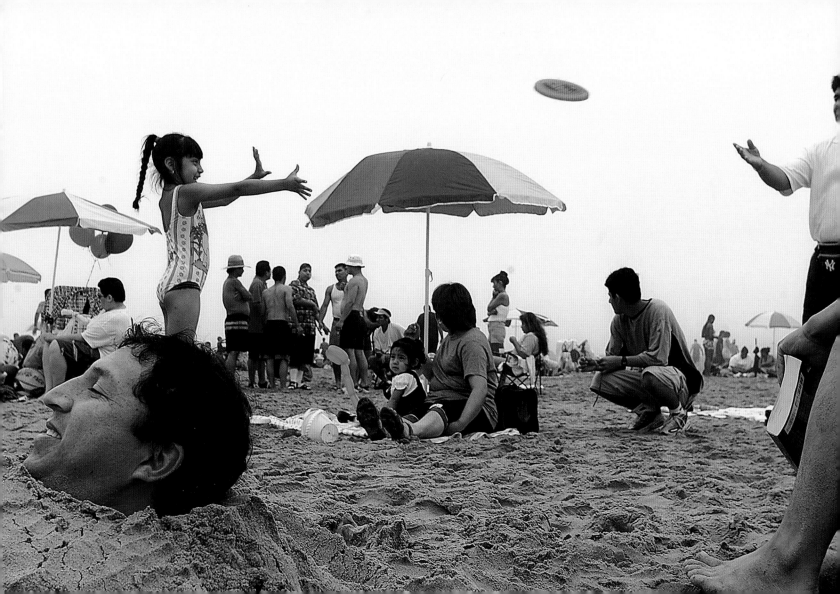

Urban Life's a Beach

Battery Park City in Lower Manhattan was
built on ninety-two acres of landfill, some
of which had been dredged during the
construction of the World Trade Center.
Before the first groundbreaking, these sun
worshipers made the most of the sandy site.

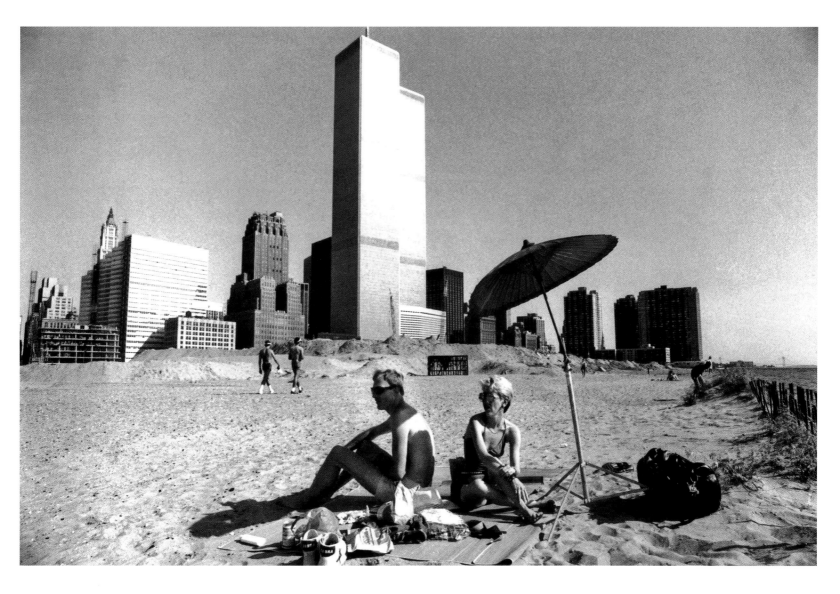

Taking the Plunge

Here is something that was probably not on the minds of these swimmers as they prepared to dive into the East River: the East River is not really a river. A river is a stream of freshwater that feeds into another body of water. The East River is a salty tidal estuary, which means that it's actually an arm of the Atlantic Ocean. Old salts know that is why its current changes direction with the tides. In the background is the Williamsburg Bridge.

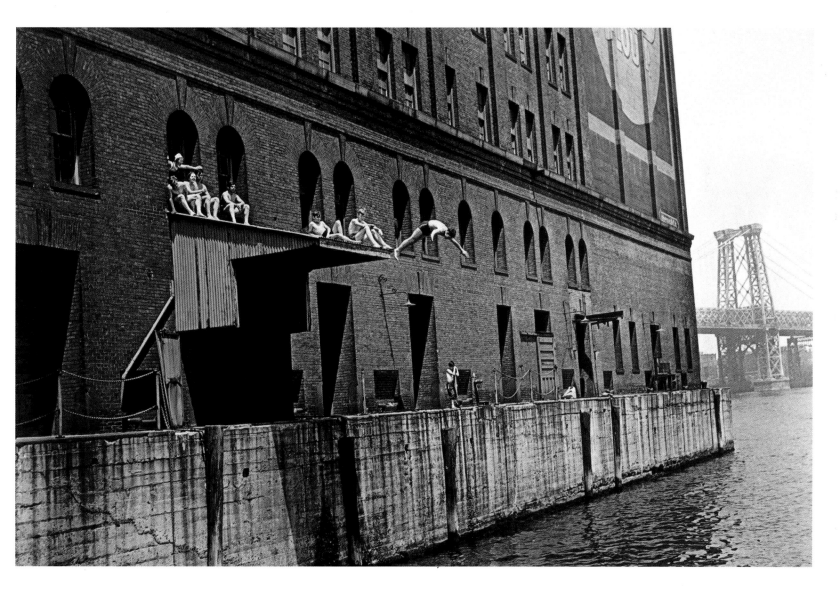

Trying to Beat the Heat

Ah, that life-changing invention, the window air-conditioner. It was yet another appliance that went from being an exotic novelty before the war to becoming a common postwar luxury. No longer did New Yorkers have to sweat out a heat wave by sneaking off to a double feature in a cool theater or lingering over a drink in a restaurant long after the ice had melted.

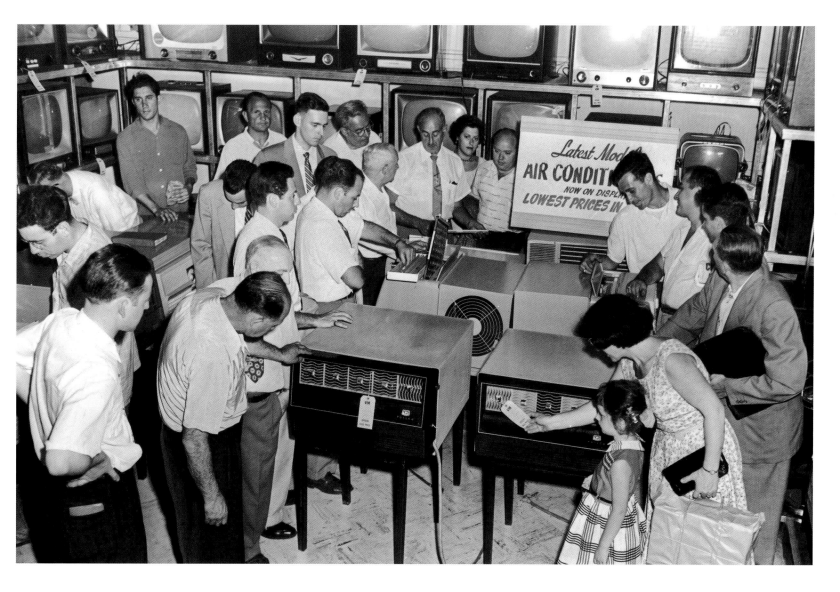

1957

The Bird's-Eye View

Somewhere, in a bookstore for seagulls,
there must be a volume showing the
wacky things they do to see Coney
Island the way people do . . . like ride the
Parachute Jump.

Allyn Baum/*The New York Times*

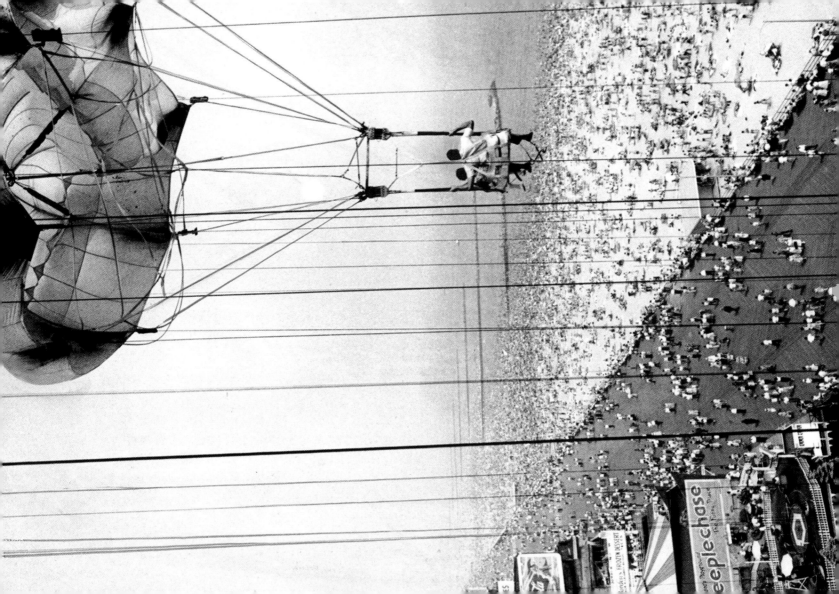

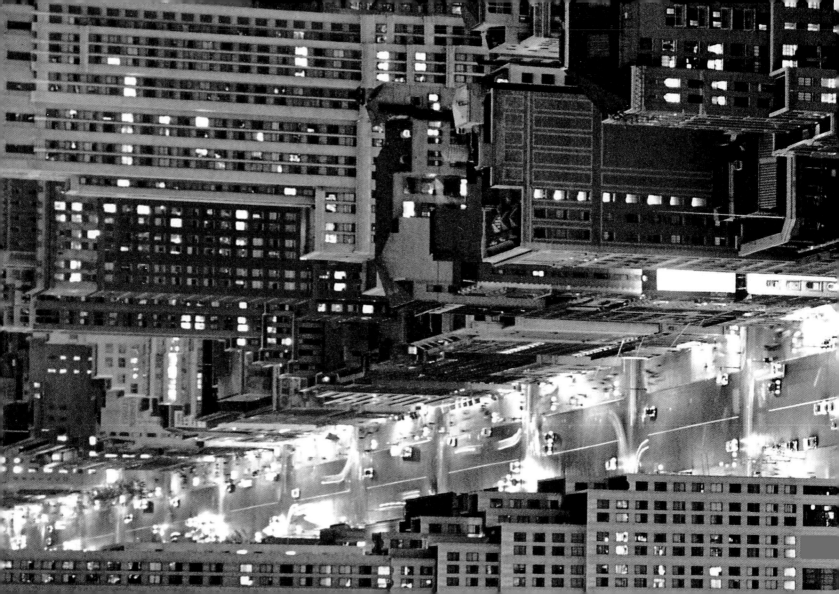

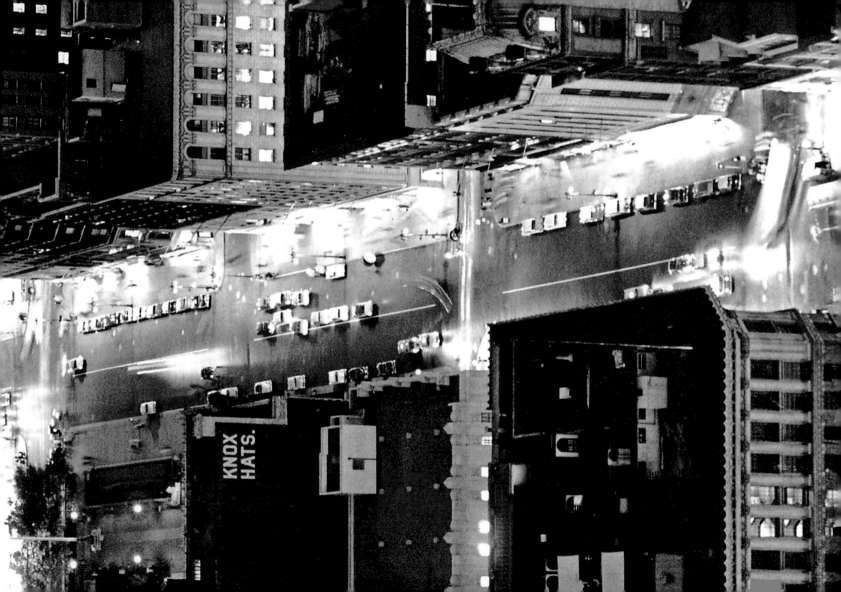

1957

Previous

Fifth

In the nineteenth century, Fifth Avenue developed from an obscure country road to a who's who of society, and the preferred address for anyone with money to burn. Then came the twentieth century, the tall office buildings that replaced the Midtown mansions, and the cars that raced through the intersections — stopping, starting, pulsing in the long moment at dusk.

Sam Falk/*The New York Times*

DECEMBER 24, 1931

Opposite

A Tradition Begins

Before the Rockefeller Center Christmas tree was chosen by a horticulturist who scouts forests from a helicopter, there was something else. The tradition began when construction workers put up this tree, decorated it with tinsel, and lined up under it on payday.

Rockefeller Center Inc.

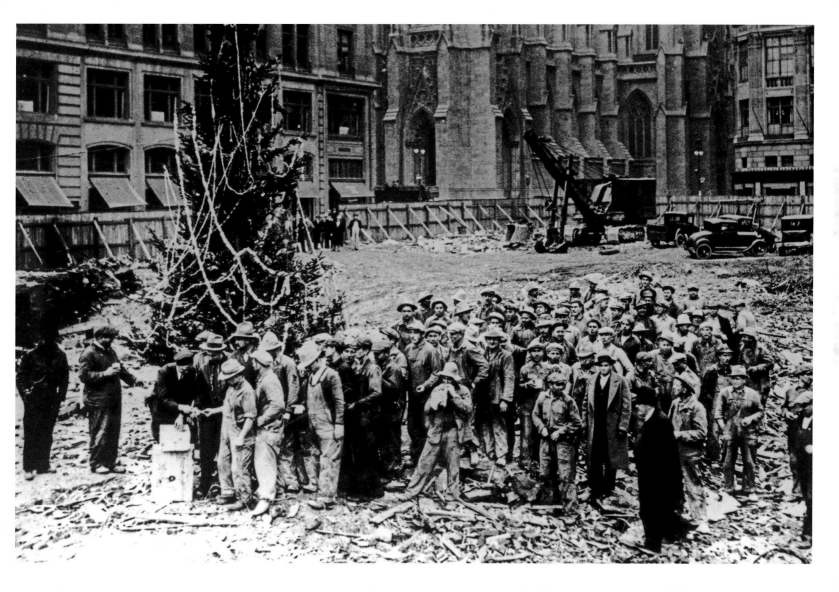

DECEMBER 2, 1992

Christmastime Destination

You've heard it a million times: a guy with a deep voice, a microphone, and a script that begins, "From New York . . ." Thanks to television America knows the tall, floodlit skyscraper that's at the center of Rockefeller Center. But at Christmastime, the crowds go there to see something that's not quite so tall.

Fred R. Conrad/*The New York Times*

Opposite

FEBRUARY 22, 2004

Me And My Human

These skaters were their own silent partners on a wintry afternoon in late-afternoon sun. They were photographed from a helicopter that had been circling over the Lasker Rink in Central Park, waiting for just the right moment

Vincent Laforet/*The New York Times*

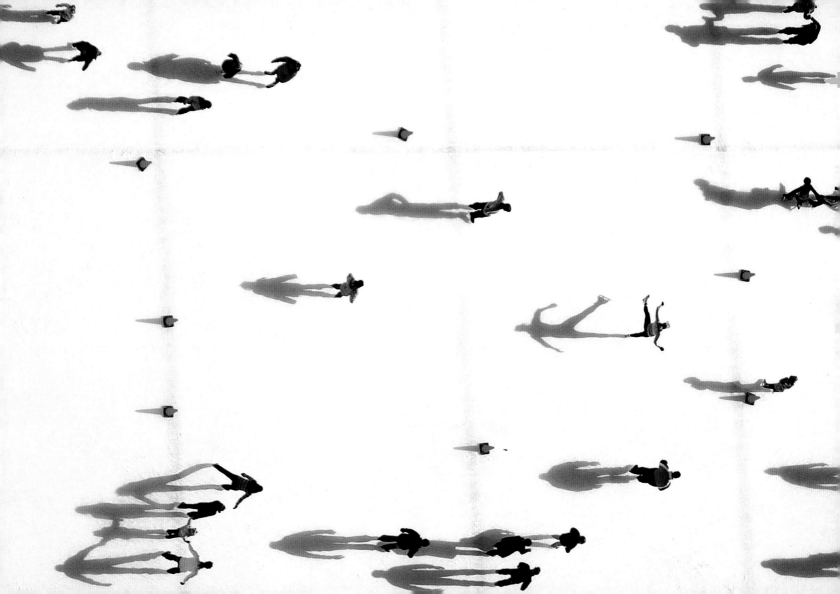

Opposite

DECEMBER 22, 2005

Reflections

When transit workers returned to their jobs after a three-day walkout, it looked as if everybody was trying to crowd onto a single bus. What the walkout meant, besides a lot of walking for New Yorkers accustomed to riding, was three days of no buses on the streets to reflect landmarks like the Chrysler Building in their windshields.

Ruth Fremson/*The New York Times*

Overleaf

JULY 9, 2000

Party Hat

The Chrysler Building's silvery attention-grabber of a crown makes the seventy-seven stories of Art Deco razzmatazz below all the more seductive. Is it any surprise that the speculator who dreamed up the Chrysler Building also built Dreamland at Coney Island?

Ozier Muhammad/*The New York Times*

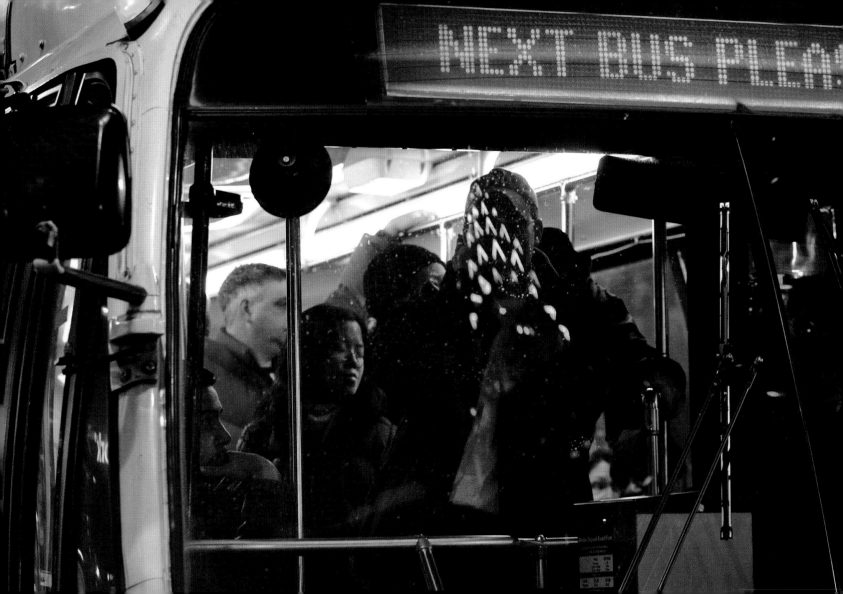

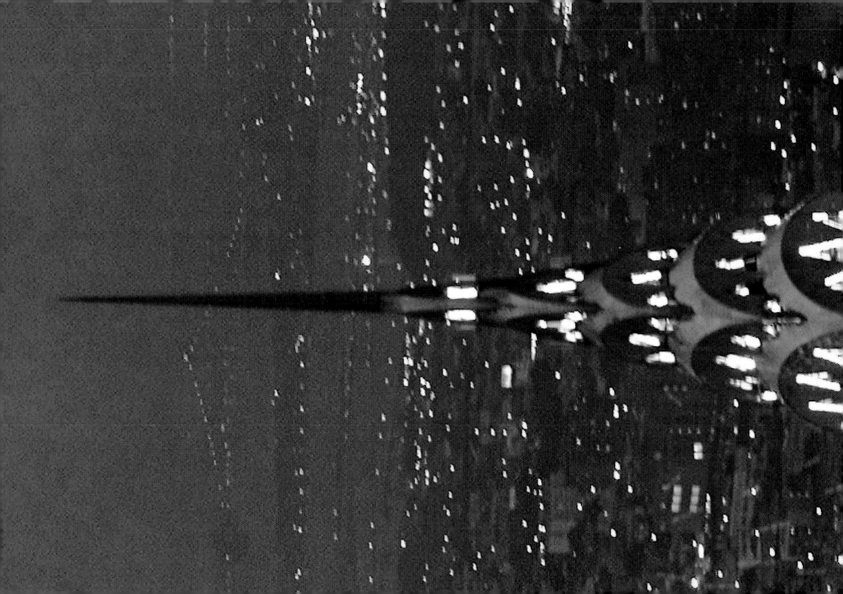

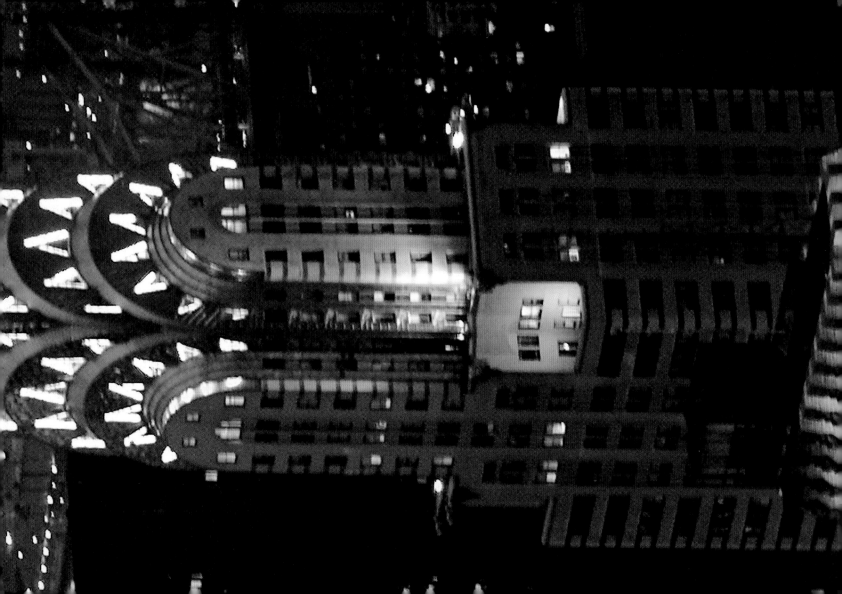

Rite of Passage

For New York café society in the 1950s and 1960s, the Plaza Hotel's Persian Room was a comfortable, predictable destination — the "last of the elegant hotel supper clubs," *The Times* declared in 1964. It was where singers like Eartha Kitt, Peggy Lee, and Liza Minnelli performed, and where the bands featured jazz legends like Miles Davis and John Coltrane. And where parents might take a young man on the brink of adulthood.

Sam Falk/*The New York Times*

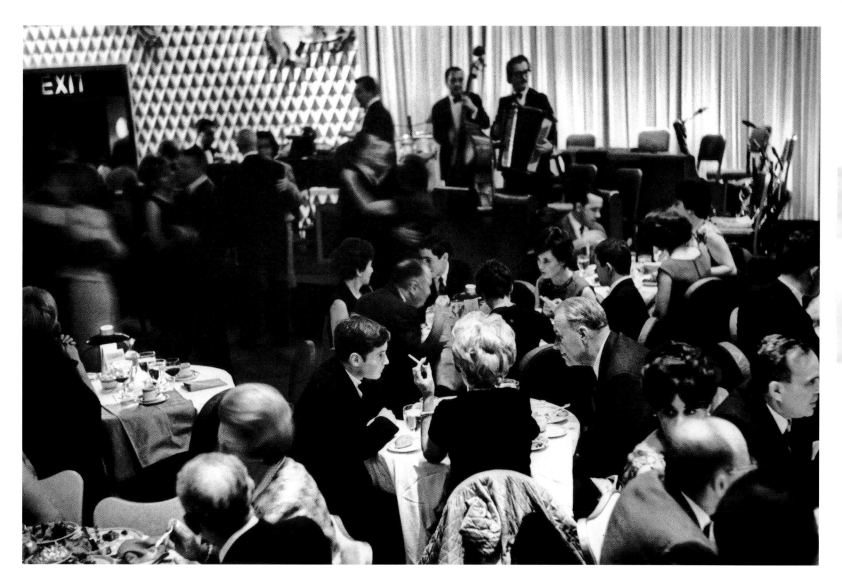

Dining Out at 4 a.m.

Not only is New York the city that never sleeps, it's the city that never stops eating. At four in the morning, couples could snack and schmooze and say whatever the guy in the hat has just said to the woman in the white coat. What, exactly, did he say? The counterman will never tell.

Patrick A. Burns/*The New York Times*

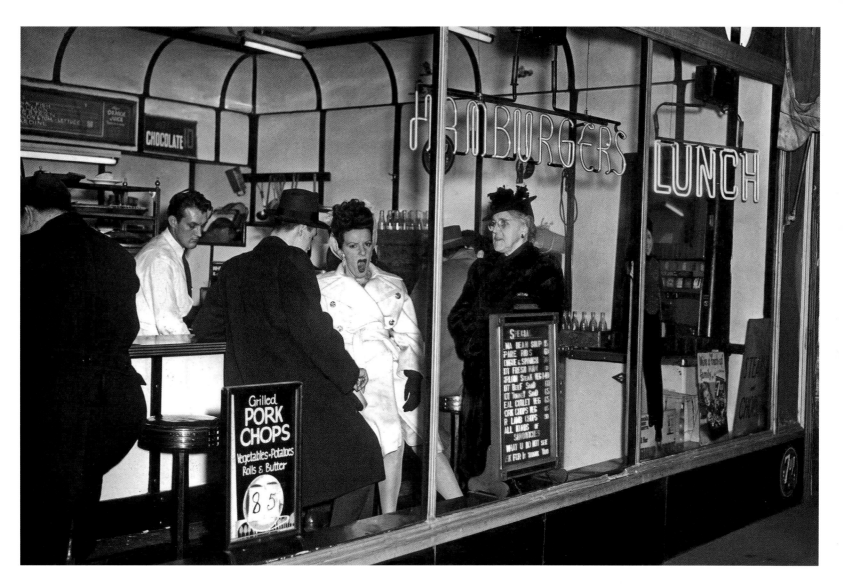

Opposite

NOVEMBER 9, 1965

By Candlelight

The huge chandeliers were dark. The public-address system was useless. But the banquet went on as planned at the Astor Hotel despite a blackout that left an eighty-thousand-square-mile stretch of the northeastern United States and Canada without electricity for as long as twenty-seven hours.

Jack Manning/*The New York Times*

Overleaf

1957

On the Benefit Circuit

The ballroom of the Waldorf-Astoria, where the black-tie crowd all but invented the dinner-dance. Where the latest society bandleader gave the downbeat and couples did the foxtrot or the rumba. Where charities raised big money. And where, tomorrow night, there will be another crowd, another band, and another benefit for another charity.

Sam Falk/*The New York Times*

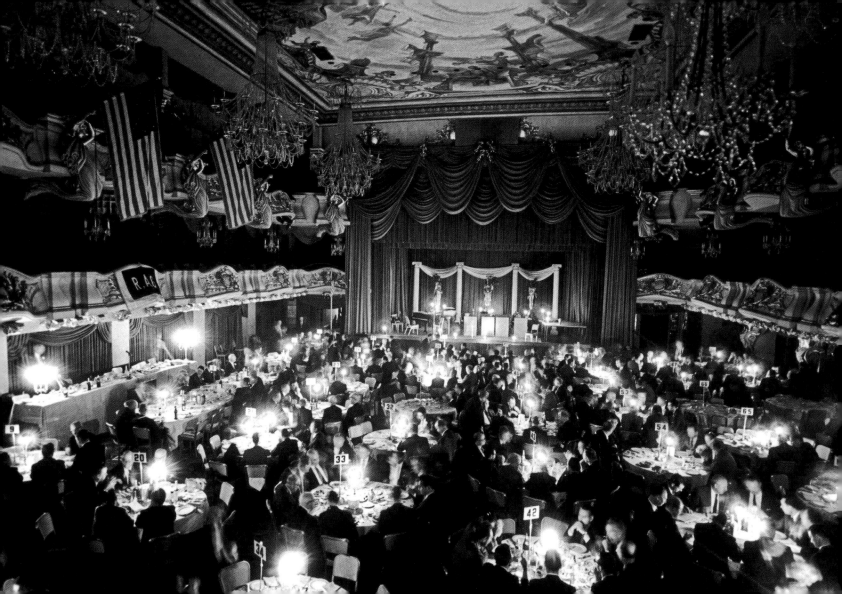

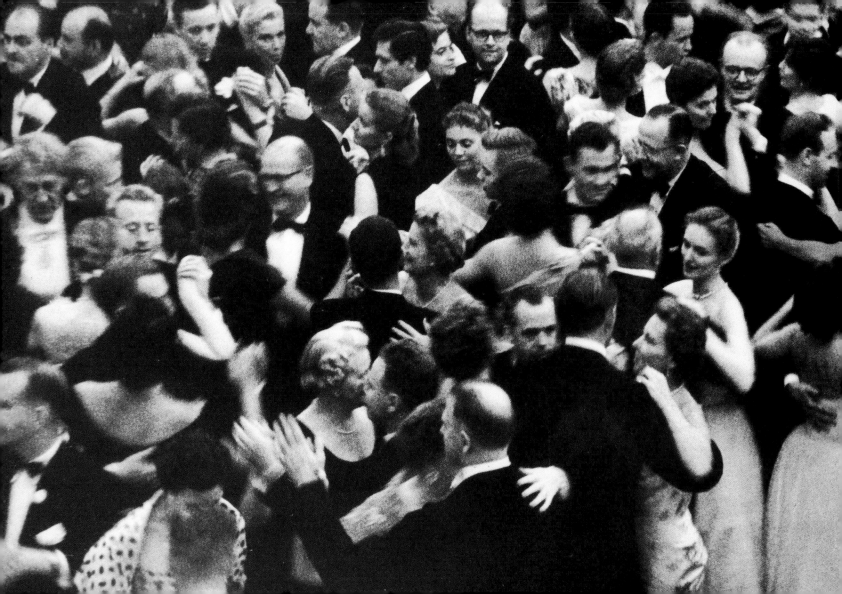

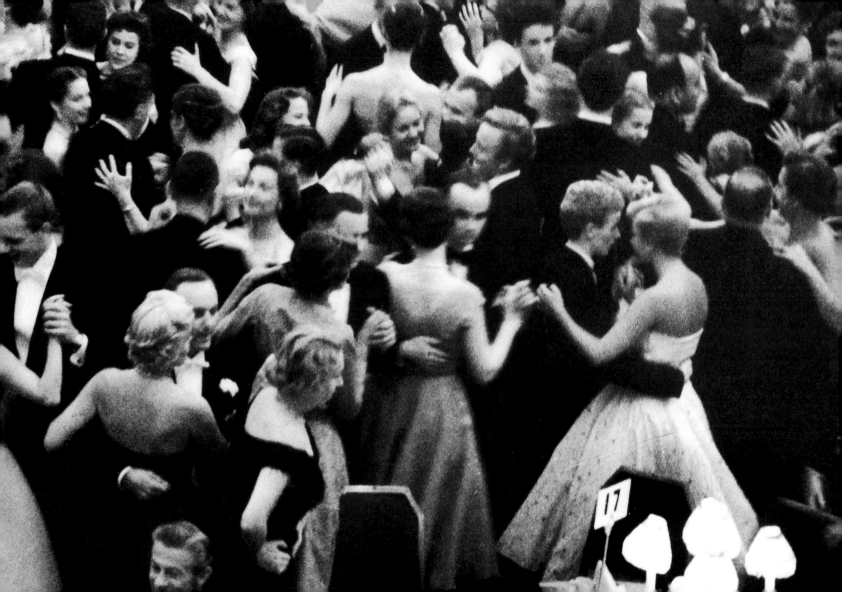

DECEMBER 1, 1932

A Helping Hand

Three years into the Depression and a month after her husband was elected president, Eleanor Roosevelt served soup to jobless people at Grand Central Terminal. "There is a war song that I wish we could get this country to sing again," she said, quoting the opening line: "Pack up your troubles in your old kit bag and smile, smile, smile."

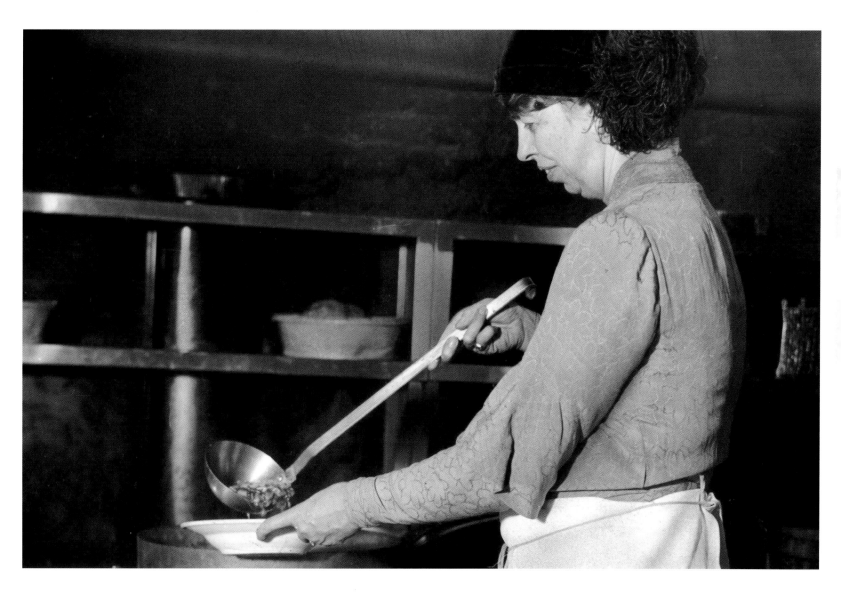

NOVEMBER 23, 1932

A Meal on Thanksgiving

The turkey, that "true original native of America," as Benjamin Franklin described it, is the common denominator of Thanksgiving. These Depression-era New Yorkers cooked theirs in a stew at their colony of shacks near the East River.

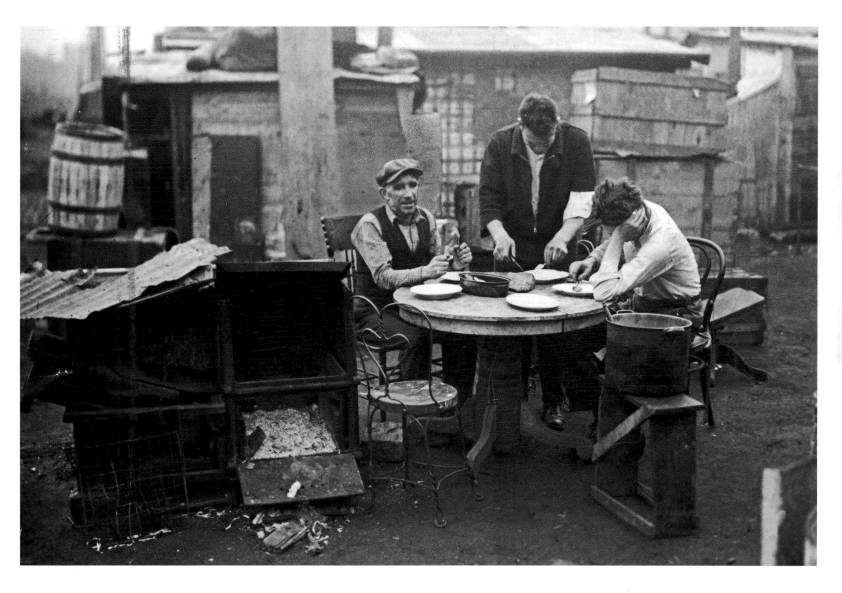

Hot Food on a Cold, Silent Night
These customers at a restaurant in
Greenwich Village were not enjoying just
any snowbound meal — it was Christmas
dinner, New York-style, on a night when
thunder and lightning rocked the sky.

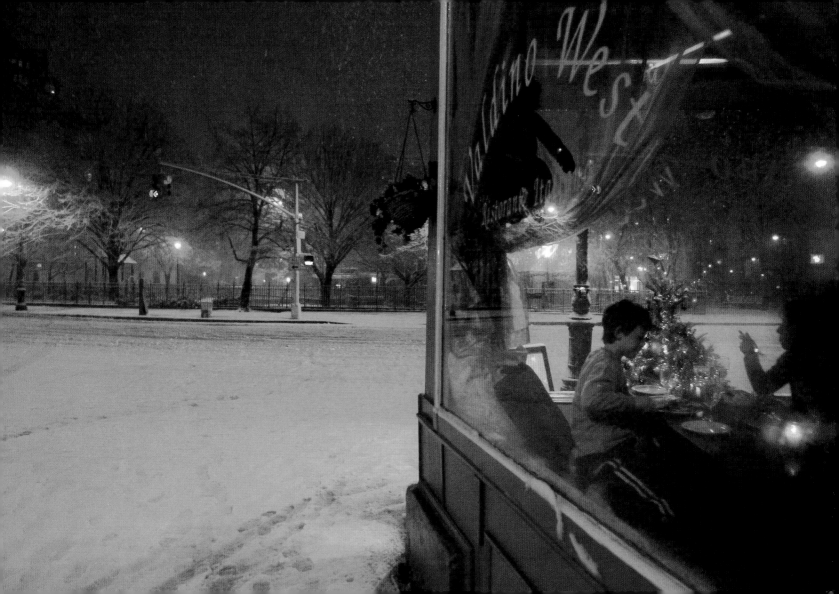

Sophisticated Rhythm

Bobby Short, rehearsing for a New Year's Eve show at the Carlyle Hotel, transcended the role of cabaret entertainer to become a New York institution. "He was a combination of piano and voice — they were married in him," the concert pianist Byron Janis said after Short's death in 2005. "I don't think you could separate the piano-playing from the voice. I don't think anyone did those kinds of songs as he did."

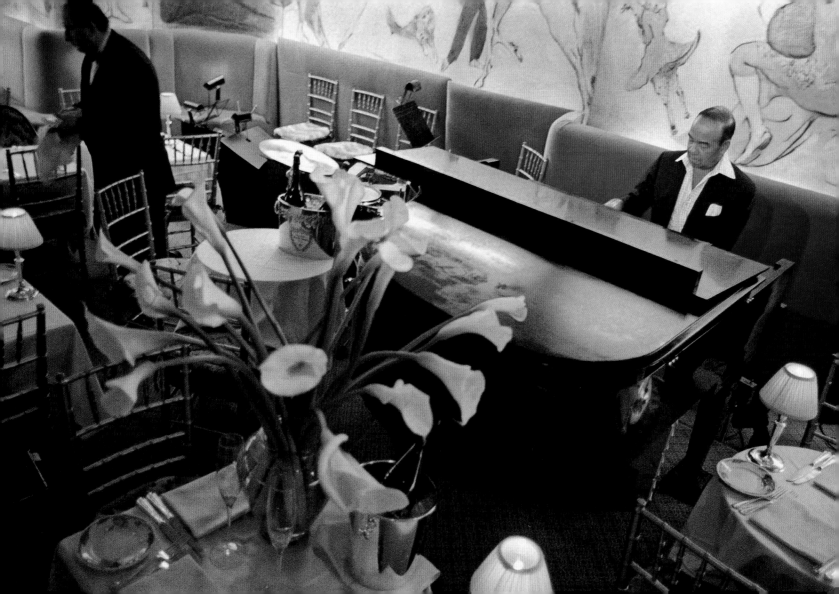

Closing Bell

Wall Street traders celebrated the last closing bell of the year with a paper blizzard — into the air went the foolscap on which they had scribbled their orders before placing them. Of course, this was before the big run-ups of the 1980s and 1990s, so the numbers seem small: the Dow Jones Industrials, up 17 percent for the year, posted their second-highest year-end closing ever, at 1,004.65.

Don Hogan Charles/*The New York Times*

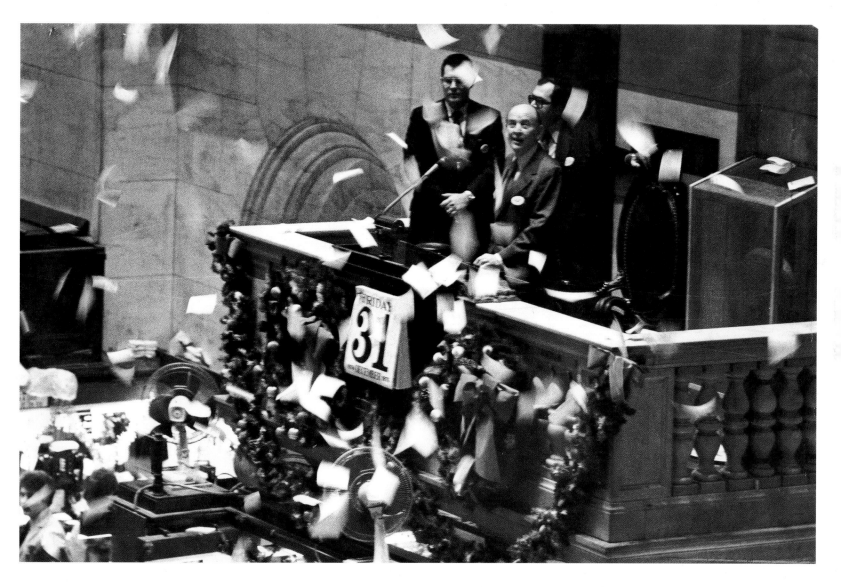

New Year's Eve in Times Square

The most important person in Times Square on New Year's Eve in 1954 was not in this photograph. It was one Thomas P. Ward, an electrician, who gave the signal for the illuminated globe atop One Times Square to begin its descent. When the ball landed, Ward threw the switch that lit the numerals for 1955, just as he had done for 1954, 1953, 1952, and every year since 1914, except for a couple of years during World War II when blackouts kept the lights off. New Year's Eve 1954 had a certain historical significance: it was the fiftieth anniversary of the first New Year's Eve celebration in Times Square. Ward added his own footnote by making 1954 his last New Year's Eve on the job. He retired as the crowd put away their noisemakers and headed home.

Larry C. Morris/*The New York Times*

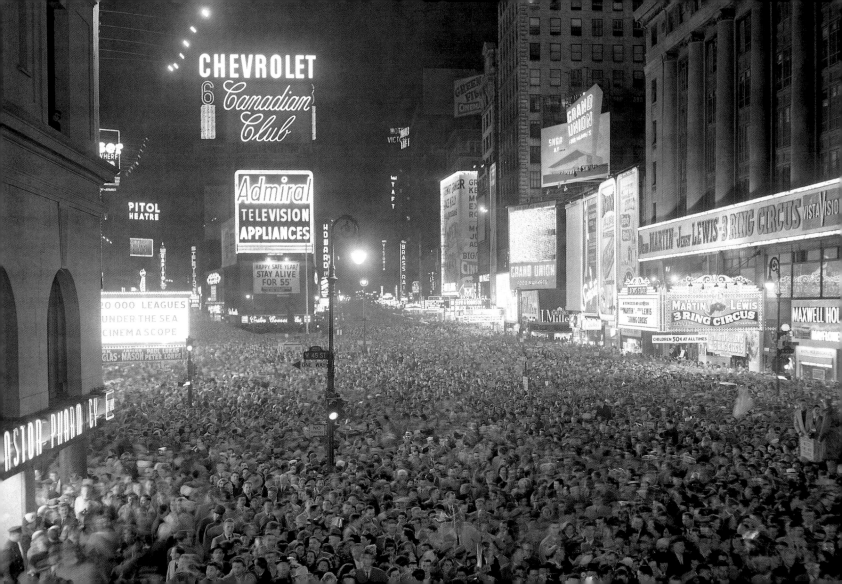

JANUARY 1, 2000

Opposite

The Millennium Arrives

The simplicity of four digits — 1/1/00 — said everything that needed to be said about the new month, the new year, the new century. Well, almost everything. In the waning minutes of the old month, the old year, and the old century, there was time to wear crowns that said "Happy 2000" in Times Square — and to shout "Five! Four! Three! Two! One!"

Nicole Bengiveno/*The New York Times*

July 4, 2005

Overleaf

Celebration

New Yorkers believe that everything in their city is bigger than anywhere else — the buildings they inhabit, the bills they pay, the fireworks they watch with delight on the Fourth of July.

Vincent Laforet/*The New York Times*

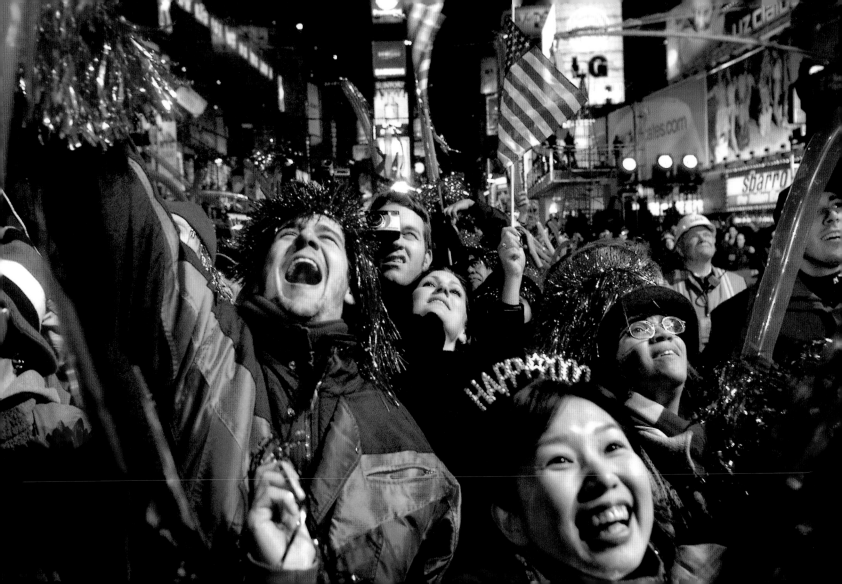

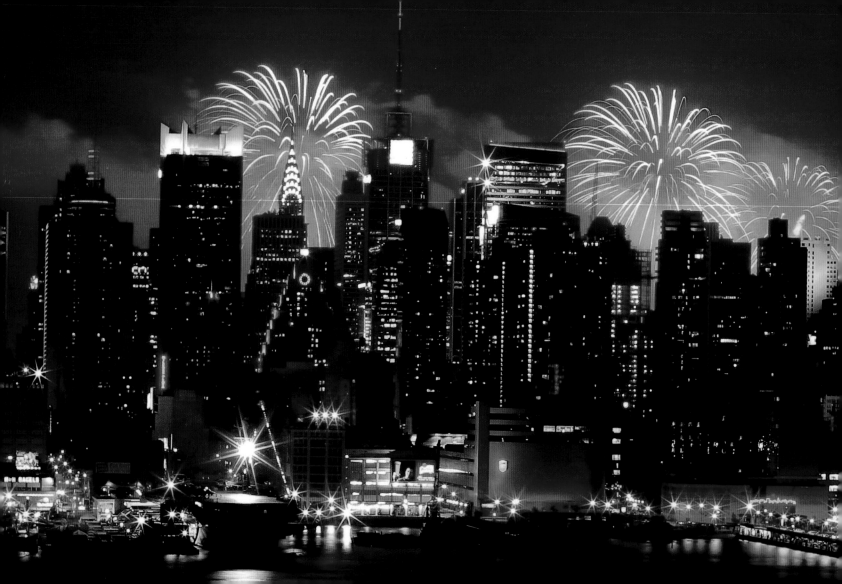

About These Photographs

There's a bias here: These are great photographs of a great city. That's one thread that runs through this book, and also the sole criterion that was used to choose the photographs you see here from among the millions of images in the Photo Archives of *The New York Times*. The editors who made the selections did not set out to cover every subject or every major event or every corner of the city — that would be impossible. The idea was simply to publish memorable glimpses. Some photographs are shown because they remain newsworthy, some because they're historic, some because they're mesmerizing, and some because they tell a story about life in the city. All but a handful were taken by *Times* photographers, who continue to prove that photography can be as compelling today as it was in the days of Speed Graphics.

Poring through historic and contemporary photographs was exhilarating, but narrowing the choice to only 365 photo pages and turning them into a book was a more demanding, complex process. This book would still be in the production stage if not for the heroic efforts of *The Times's* James Barron, Nancy Lee, Jim Mones, Vincent Alabiso, and Merrill Perlman, as well as Eric Himmel of Abrams Books and Gay Talese, who, before writing his many distinguished books, was a *Times* reporter from 1956 to 1965. Invaluable contributions were also made by *The Times's* Jeff Roth, Alex Ward, Mitchel Levitas, William O'Donnell, Peter Simmons, Nancy Weinstock, Lee Riffaterre, William Gonzalez, Ryan Murphy, Carlos Penalba, Hector Roble, Ludmila Kudinova, Phyllis Collazo, and Marilyn Cervino; Abrams's Aiah Wieder, Jane Searle, and Deborah Aaronson; as well as Sally Stapleton, Tim Oliver, and Kayhan Tehranchi. In addition, special thanks to the remarkable photographers of the Photo Desk of *The New York Times*, today under the direction of Michele McNally.

Photo editors: Jim Mones and Vin Alabiso
Captions: James Barron
Designer: Kayhan Tehranchi
Production Manager: Jane Searle

Front cover: Manhattan skyline, September 20, 1962. Sam Falk/*The New York Times*
Frontispiece: Window washer, Chrysler Building, April 18, 2002. Vincent Laforet/*The New York Times*
Back cover: Lunchtime crowd on Fifth Avenue, March 30, 2005. Vincent Laforet/*The New York Times*

Many of the images in this book can be purchased as prints through The New York Times Store (www.NYTStore.com).

Library of Congress Cataloging-in-Publication Data
New York : 365 days from the photo archives of the New York times / Introduction by Gay Talese.
p. cm.
Includes bibliographical references and index.
ISBN-13: 978-0-8109-4942-3 (hardcover : alk. paper)
ISBN-10: 0-8109-4942-3 (hardcover : alk. paper)
1. New York (N.Y.)—Pictorial works. 2. New York (N.Y.)—History—Pictorial works. 3. City and town life—New York (State)—New York—Pictorial works. 4. New York (N.Y.)—Social life and customs—Pictorial works. I. New York times.

F128.37.N5155 2006
974.7'100222—dc22
2006016408

Introduction copyright © 2006 Gay Talese
Photographs and captions copyright © 2006 *The New York Times*

Printed and bound in China

10 9 8 7 6 5 4 3 2 1

HNA
harry n. abrams, inc.
a subsidiary of La Martinière Groupe

115 West 18th Street
New York, NY 10011
www.hnabooks.com

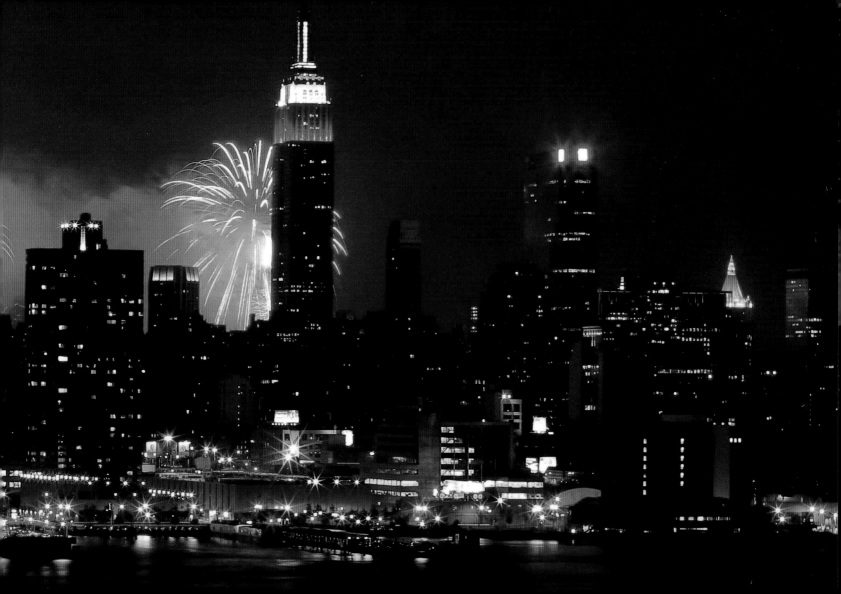

Index
Italics refer to photographs

Index of photographers